Home Study
Darkroom
Course

John S. Carroll

AMPHOTO
American Photographic Book Publishing Company, Inc.
New York, New York

Library of Congress Cataloging in Publication Data

Carroll, John S 1911-
 Home study darkroom course.

 Includes index.
 1. Photography—Processing. I. Title.
TR287.C375 1980 770'.28'3 80-11800

ISBN: 0-8174-3687-1

Manufactured in the United States of America

CONTENTS

General Introduction

The *Home Study Darkroom Course* is a set of 10 self-teaching lessons in the processing of amateur photographs. The lessons are arranged in groups of five as follows:

Group 1 **Lessons 1–5 Elementary**
 Black and White
Group 2 **Lessons 6–10 Advanced**
 Black and White

While these lessons are intended for beginners and amateur photographers, emphasis is placed upon the attainment of optimum image quality. Step-by-step instructions are given for each procedure and are the same as those used by most professionals.

To ensure success from the very beginning, this course, unlike others, makes specific recommendations of films, chemicals, and papers to be used in each lesson. This makes it possible to give precise working instructions with times and temperatures for each step instead of referring the reader to the instruction sheets that (sometimes!) accompany the materials. Since the latest films, chemicals, and papers are recommended in all cases, the instructions given are correct for these materials. This is important because some readers may have had previous experience in developing and printing and may find that our instructions are not the same as those which they were previously taught.

We repeat: The instructions in these lessons are correct and should be followed in preference to any methods the reader may previously have used. For example, some persons have been accustomed to developing "bromide" papers in a diluted developer for times as long as three to four minutes. They may be startled to find that we recommend a strong developer (Kodak Dektol 1:2) and developing times of about one minute. Modern enlarging papers must be processed in this manner; if they are handled in the older fashion, they will produce inferior results, which some people mistakenly attribute to a

lack of silver in the paper. There is more than enough silver in *any* modern enlarging paper to produce fine, velvety blacks.

The same admonition applies to negative development; we recommend a single negative developer used full strength. Using a weaker type of developer, such as a so-called "fine-grain" developer, or diluting the developer we recommend will produce inferior quality in the negatives and "mushy" prints.

All of these recommendations have been checked by practical work. In the first group of five lessons, all illustrations were made using the recommendations given. Films were developed in Kodak Developer D-76 and the resulting negatives were printed in the "dry-bench" darkroom shown in the illustrations, with the Omega B-66 enlarger shown, on Kodak Polycontrast Rapid RC Paper, and proc-essed in Kodak Dektol Developer, diluted 1:2, for times averaging one minute.

While some quality is inevitably lost in the reproduction of these pictures by the offset process, the original prints were of excellent brilliance and gradation. We can therefore assure the reader that he too can attain such results simply by following the instructions, step by step, exactly as given, even to the placement of the tongs in the individual trays. This may seem sheer pedantry, but this is the routine used by every top professional photographer. The professional has learned that it is better to take a little more time and trouble and get a picture right the first time than to waste a great deal of time and trouble to make over a bad one. It is good advice to the amateur too.

John S. Carroll

Emlenton, Pa.

GROUP 1—
Elementary Black and White

LESSON 1

Introduction and Negative Development

Traditionally, we would open this discussion with a list of reasons why you ought to process your own films. Since, however, you are reading this material, it is obvious that you are already convinced of that point, so we need not waste time discussing it.

There are a few things about which you may not be completely convinced, though; also a few peripheral questions that need answering. For instance, you may be wondering whether you really can process your own films and make your own prints with results as good as those you have been getting from photofinishers.

Unless you have been dealing with the biggest of the "pro" photofinishers—those who develop and print pictures for the big-name magazine photographers—chances are, you can not only turn out work as good as what you have been getting, you can even do better. The reason is more economic than anything else. The commercial finisher has to watch his pennies to make a profit; that means, he must use his chemicals till they are exhausted, and

he can only afford to make over a print when it is hopelessly bad. You, on the other hand, can afford to use fresh chemicals for every roll and every batch of prints. More important, if you make a print that is just not quite good enough, you can afford to make another one and get it exactly right.

There is another reason why your own prints can be better than those made by a finisher, and that is, simply, you know the subject matter and what you want it to look like. The finisher usually prints on automatic machines that bring everything to a single level. Suppose, for example, you have photographed your girl friend just after a trip to the beach. She is heavily tanned, but you can choose to make your print for her natural, light complexion; or you can print it dark to emphasize the tan. The finisher's automatic machines can only strike some kind of average, which may not satisfy either condition.

To an automatic printer, a "normal" negative is one which transmits a certain amount of light overall; such a negative will produce

what the manufacturer of the printer considers to be a normal print. "Abnormal" subject matter—a black cat on a white rug or a blonde girl in a white bathing suit on a sunny beach —confuses the computer mechanism of such printers, and the prints may not resemble the subject matter at all. But since you took the picture, you know what you want it to look like and can print it accordingly.

Another question frequently asked is: Must I figure on spoiling a lot of film and a good deal of paper learning how to process? The answer is, very simply, no. The usual cause of spoiled negatives is an accident in processing; accidents. can happen, but with care they should be very infrequent.

What it all amounts to is that developing a negative is a chemical process, and in chemistry, usually, if you do the same thing each time, you get the same result each time. It does take a little extra time to prepare all your solutions, to adjust the temperature of each bath to the recommended level, and to watch the clock carefully while agitating the film in the developing tank. But the small expenditure of time pays off in vastly improved results.

It doesn't really take much extra time; what it does take is concentration—that is, you can't wind the film into the tank, pour in the developer, and then watch a football game on TV. It takes less than half an hour to develop a roll of film, and you must be prepared to spend that half hour on that one task. It is a small price to pay for high-quality negatives.

One other thing is important. Read the instructions for the entire process before you begin, and be sure you have everything you are likely to need on hand. Otherwise, it is just possible that you will start to develop a roll of film, and then while it is in the developer, find out you don't have any "hypo." This is oversimplified, of course, but some of the more complicated procedures to be described in later lessons do require a variety of ingredients, some of which cannot be obtained at the corner drugstore, and none of which can be gotten on a Sunday night.

What it all adds up to is this: Like any other art or craft, a good deal of the procedure is repetitive, and such things should become matters of habit, so you do them without thinking about them. Once you get to doing a procedure, step by step, the same way every time, you will find your results are consistent, and consistently good. It is as well to learn this in the beginning with the simple black-and-white procedures; the habits thus learned will later pay off when you start to work in color.

One last caution: Some people think that merely reading will make them better photographers. That is only half the process; the other half is practicing what you have read about.

PHOTOGRAPHIC LANGUAGE AND THEORY

We have already used some words in their photographic contexts: "negative," "development," and so on. There are a lot of similar words used in photography, and none of them are any more difficult than the ones quoted. There aren't any really mysterious words in photography, simply because most of the words we will have to use are the names of *things,* and it is just as easy to use the right name for a developing tank as to call it a "dingus." The innards of the tank is called a "reel." Prints are developed in "trays" (though our English cousins call them "dishes"), and the darkroom is illuminated by a "safelight." All this is so simple as to be obvious, and you'll pick up most of the language as you go along. Likewise, there are words that describe things that happen, but they will be found to be just as easy.

As for photographic theory, this is also nothing to be concerned over. Photographic theory is merely a way of explaining why things hap-

pen. This is good to know, because if something doesn't work as it should, you can do a little detective work and figure out what happened. A lot of people are fascinated by what makes things go, and so we will usually preface each lesson with a short discussion of the underlying principles.

The big problem with theoretical discussions on an advanced level is that scientists use a sort of shorthand known as mathematics. But as far as we are concerned, we will not have to use any mathematics beyond some simple arithmetic, and then rather rarely.

WEIGHTS AND MEASURES

For a start, you will buy all your photographic chemicals in packaged, premixed form, and you won't have to weigh anything. You will have to measure out liquids, though, and you will have to know the temperatures of your baths.

Celsius and Fahrenheit Equivalents Formula: $(C \times 9/5) + 32 = F$ $(F - 32) \times 5/9 = C$

C	F	C	F	C	F	C	F
+120	+248	+80	+176	+40	+104	± 0	+32
119	246.2	79	174.2	39	102.2	− 1	30.2
118	244.4	78	172.4	38	100.4	− 2	28.4
117	242.6	77	170.6	37	98.6	− 3	26.6
116	240.8	76	168.8	36	96.8	− 4	24.8
115	239	75	167	35	95	− 5	23
114	237.2	74	165.2	34	93.2	− 6	21.2
113	235.4	73	163.4	33	91.4	− 7	19.4
112	233.6	72	161.6	32	89.6	− 8	17.6
111	231.8	71	159.8	31	87.8	− 9	15.8
110	230	70	158	30	86	−10	14
109	228.2	69	156.2	29	84.2	−11	12.2
108	226.4	68	154.4	28	82.4	−12	10.4
107	224.6	67	152.6	27	80.6	−13	8.6
106	222.8	66	150.8	26	78.8	−14	6.8
105	221	65	149	25	77	−15	5
104	219.2	64	147.2	24	75.2	−16	3.2
103	217.4	63	145.4	23	73.4	−17	1.4
102	215.6	62	143.6	22	71.6	−18	− 0.4
101	213.8	61	141.8	21	69.8	−19	− 2.2
100	212	60	140	20	68	−20	− 4
99	210.2	59	138.2	19	66.2	−21	− 5.8
98	208.4	58	136.4	18	64.4	−22	− 7.6
97	206.6	57	134.6	17	62.6	−23	− 9.4
96	204.8	56	132.8	16	60.8	−24	−11.2
95	203	55	131	15	59	−25	−13
94	201.2	54	129.2	14	57.2	−26	−14.8
93	199.4	53	127.4	13	55.4	−27	−16.6
92	197.6	52	125.6	12	53.6	−28	−18.4
91	195.8	51	123.8	11	51.8	−29	−20.2
90	194	50	122	10	50	−30	−22
89	192.2	49	120.2	9	48.2	−31	−23.8
88	190.4	48	118.4	8	46.4	−32	−25.6
87	188.6	47	116.6	7	44.6	−33	−27.4
86	186.8	46	114.8	6	42.8	−34	−29.2
85	185	45	113	5	41	−35	−31
84	183.2	44	111.2	4	39.2	−36	−32.8
83	181.4	43	109.4	3	37.4	−37	−34.6
82	179.6	42	107.6	2	35.6	−38	−36.4
81	177.8	41	105.8	1	33.8	−39	−38.2

We don't have to worry about time—it's measured in minutes and seconds in photography, as everywhere else. An ordinary clock will do if it is all you have. A good photographic timer that can be started and stopped is better, and we suggest you get one at the outset. A good one will last for your photographic career, and you'll never outgrow it. The kind that reads in seconds and minutes to a total of an hour is about the best; there are few darkroom procedures that last longer than an hour, anyway. The timer should be made so you can stop and restart it without setting it back to zero if you wish, or so that you can set it back to zero at any time. You'll need both capabilities when you start doing color.

Liquid measures are simply cups of various sizes with markings on them. They are variously made of glass, plastic, white enameled steel, or stainless steel. With care the white enameled kind will last for years, and you will need to have about three of them. The smallest of these ought to hold about a half pint and be marked off in smaller amounts. Then there ought to be a bigger one, which holds about a quart, and a real whopper, which holds a gallon. This latter is needed mainly as a mixing vessel, but it's nice if it is marked inside, so

you know how much of a bath you are mixing. You'll see why a bit later.

Metric Units

Now we have deliberately been vague in saying "about a half pint," and so on. There is method in our madness here. We want to suggest very strongly that this is as good a time as any to "go metric." That is, instead of a quart, your middle-sized measure should be one made to hold one litre, and it should be subdivided into *cc* or *ml—cubic centimetres* or *millilitres* (they are the same thing, for all practical purposes). This is easy to handle, because there are 1000cc in a litre, and you work entirely with the decimal system; a quart, on the other hand, contains 32 ounces, and you have to use fractions. Then our little measure ought to hold about 125cc or ml, and our really big one should hold four litres, which is close enough to a gallon for all purposes.

Once you have these, you can proceed to forget all about ounces, pints, quarts, or gallons, because you are not going to use them again. You are going to measure everything with these three measures, and in about a day you'll find it just as easy, if not easier, to use

Metric and American Customary Equivalents of Liquid Measures

1 minim (water)	= 0.06161 cubic centimetre
1 fluid dram	= 3.6966 cubic centimetres
1 fluid ounce	= 29.5729 cubic centimetres
1 ounce apothecary (water)	= 31.1035 cubic centimetres
1 pint (16 ounces)	= 0.4732 litre
1 quart (32 ounces)	= 0.9463 litre
1 gallon (128 ounces)	= 3.7853 litres
1 cubic centimetre	= 16.23 minims
1 cubic centimetre	= 0.2705 fluid dram
1 cubic centimetre	= 0.0338 fluid ounce
1 litre	= 1.0567 quarts
1 litre	= 0.26418 gallon
1 litre	= 33.8147 fluid ounces
litres ÷ 3.7853	= gallons (231 cubic inches)
cubic centimetres ÷ 3.6966	= fluid drams
cubic centimetres ÷ 29.5729	= fluid ounces
1 cubic metre	= 264.15 gallons
litres ÷ 3.7853	= gallons

the metric system, as long as you don't have to worry about the bugaboo of conversions.

We appreciate that some people already have the required utensils, and others simply do not want to learn too many new things at once; so in the following pages, we will give both metric and English measures, but we're going to give the metric measures first, so you will get used to them, even if you don't use them.

By the same token, we think you ought to begin with a metric thermometer marked in degrees C (correctly, "Celsius," but some people take the C to mean "Centigrade"). Most photographic processes are done at a temperature of 20 C, which is easy to find on a metric thermometer, and because the degrees are rather widely spaced, easy to read and check. If all you have is a Fahrenheit thermometer, the same temperature is 68 F; it is not as easy to find, and the gradations are rather close together and less easy to read.

Very well, now you have a clock, a thermometer, and a set of measuring cups. These are your most useful tools, and we suggest that you take reasonably good care of them, especially the thermometer. The best of thermometers gets inaccurate with age, and even more so if roughly handled. It almost pays to have two, and to check one against the other from time to time. If they don't agree, buy a new one, check all three, and "odd man out . . ."

Next you need a place to work.

THE DARKROOM

By definition, a darkroom is a room that is dark—not merely dim, not merely dusky, but dark. If you can see any light anywhere, it isn't dark. Almost any room looks like this when you first enter it at night, with the lights out. But as you get used to it, the darkness gradually lightens up and you begin to see things; and this means the room is not really dark.

If you are going to build a room in the basement or some such place especially for photography, and it has no windows and a tight-fitting door, then it will be dark indeed, and you will have no problems. But otherwise, you are going to have to work, usually at night, in the kitchen or bathroom, and this may take a little work to make it really suitable. What you will have to do is to enter your chosen room, close all the doors, pull the shades, and shut off the lights. Now just wait.

After about five minutes, you may begin to see a bit of light coming around the edges of the shades or under the door. If you do, make a note of the place the light is coming from. If you don't, then you've found your darkroom. But by and large, the problems won't amount to much and will be easy to solve. In many apartments, the bathroom has no window— any light you see will be coming under the door. All that's necessary in that case is to roll up the bathmat and put it against the doorsill, and that is that. Cures for other light leaks may involve bits of black sticky tape or anything else that will block the light.

Now how important is all this? Well, if you remember that you often take a picture in 1/100 sec. or less, through a lens that is closed down most of the way, you can appreciate that films are very sensitive indeed, and that it takes very little light to affect them. So you most certainly need an absolutely dark place in which to handle film.

Alternatives

Well, that is not as bad as it sounds. These days we develop films in lighttight tanks that can be handled in full room light. All you need a really dark place for is to load the tank, and that takes only a few minutes. Under the circumstances, you can even go into a clothes closet to load your tank. There is also a gadget called a "changing bag," and you can load a tank in full room light in one of these. But they are not as easy to use as some people make

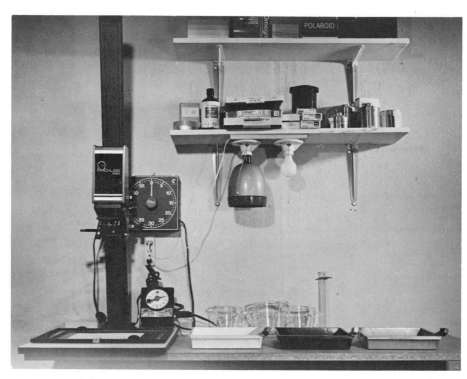

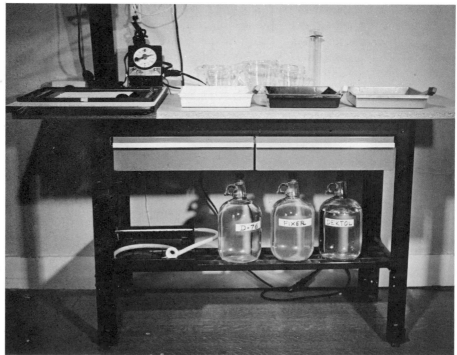

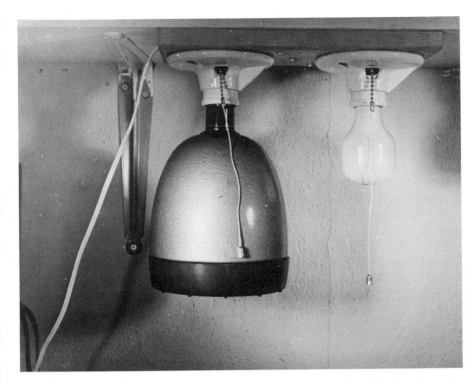

(Left) A "dry-bench" type of darkroom, where a sink or plumbing is not possible. The enlarger, in this case, is at the left. The large timer is for timing development of negatives and prints. The smaller timer is connected to the enlarger and turns the lamp on and off at present intervals; it also ticks off the seconds loudly to aid in timing certain special exposures. (Below left) The shelf under the bench serves as storage for mixed chemicals, the print washer, and other items. Two large drawers contain accessories, such as enlarger lenses, filters, negative carriers, and other items that should be kept clean. (Above) Over the bench is suspended a safelight housing and a white light bulb for inspecting prints, exposing contact papers, and other purposes. Note that the pull cords are made of string instead of chain, to avoid any danger of shocks when touched with wet fingers.

out, and we won't discuss them at this point. The changing bag is valuable when you have to develop a sample roll away from home, and we'll discuss it further in the advanced part of this course.

As for printing and enlarging—we're getting a bit ahead of ourselves here, but if you are going to build a darkroom, you will plan to do everything in it. Again, it will have to be really dark, at least as far as stray light is concerned, though we will have plenty of illumination from a safelight to work by. Papers are less sensitive than films, but on the other hand, only a very tiny trace of stray light can make a print look pretty poor. So let's plan on a proper, really dark place to work from the beginning.

There are a lot of other things to think about when planning a darkroom, once you have found a place, and at this point we may as well say, all you really need is darkness. Everything else is luxury, and you can do without most of the things people plan on having in "dream" darkrooms.

Water

There are those, for instance, who make a fetish of having running water in the darkroom. One suggestion that is offered, over and over, is to make a darkroom in the bathroom by putting a board or tabletop over the bathtub. This idea sounds good until you try it. First of all, unless you have an old-fashioned cast-iron tub with ball-and-claw feet, you'll find a modern bathtub is only about 15 inches high. Put a board on this, and you'll find yourself working on hands and knees, which gets pretty tiring after a while. If you do have the old-fashioned bathtub, you'll find all the faucets and stuff are inside, and when you put a board over it, you can't get to them. Then, of course, you have the main trouble with bathrooms, and that is, unless you have more than one, or you live alone, you'll find someone wanting to use the facilities just as you are in the middle of loading a roll of high-speed film.

If you're a good carpenter, you can make a table on struts, which fits over the tub and gets up to working height. This, however, doesn't cure the other faults of bathrooms, and if you are a good carpenter, there are better things to build, and we'll come to a few of them shortly.

Let's dispose of the question of running water once and for all. Just why do you need water in the darkroom? To mix chemicals? The darkroom is the worst place in the world for chemical mixing—powdered chemical is almost certain to get into the air and spot your films and papers. Professionals always have a separate room for chemical mixing. For the amateur, though, a separate chemical mixing room is a luxury hardly worth considering. The cleanliness problem is solved simply by mixing all chemicals in advance, keeping them in stock solution form in large bottles, and cleaning up immediately after preparing the stock solutions.

This being the case, there are few other needs for running water in the darkroom. All you need for intermediate rinses can be prepared in advance, by filling a large jug with a mixture of warm and cold water to get it exactly to 20 C (68 F). For making prints on paper, you don't use any rinse water at all; you use an acid stop bath.

So you need running water only for final washes, and since there is no need for darkness at that time, you can do your washing anywhere it happens to be convenient. For washing films, in fact, running water is not necessary at all; there is a better way, which we will explain later in this lesson, which uses much less water and washes much more efficiently.

Naturally, it is nice to have everything in one spot and more or less private, so people won't be interrupting you by coming in for a glass of water just as you have the tap water adjusted to 20 C (68 F) to wash your prints. So when you build a permanent darkroom, you should have a sink with hot and cold running water; if you can afford it, you can even have a plumber install a thermostatic water mixer, which is like the gadget found on hotel showers. This can be set to produce water at 20 C (68 F) continuously and without attention, and is certainly nice to have.

The Non-Darkroom

At the other extreme, if you can't have a regular darkroom of any kind, you can still do a great deal of photography by setting up in the kitchen. Cover all the table- or countertops with several layers of newspaper to absorb drips, keep a mop and pail handy to cope with minor spills, and that will do just fine.

There is an intermediate solution, which has been used for years by apartment dwellers, that works very well indeed. This is a kind of portable darkroom; actually, not a room at all, but a cabinet on wheels, containing drawers and cubbies for bottles, trays, and other utensils. Such a gadget is easily built to order by a cabinetmaker; usually, the top is in the form

of a shallow sink lined with stainless steel, formica, or some other waterproof material. A small drainpipe is soldered or cemented into one corner of this; on the underside, a short piece of rubber tubing carries off any spills into a gallon jug placed in one corner of the cabinet, and it is emptied at the end of each working session. This is really all the sink you need for most work.

The value of such a gadget is mainly that it saves the time and labor of pulling out materials and tools from closets for each session and putting them away when finished. If this cabinet is on small wheels or large casters, it can be rolled into a closet when not in use.

You do not even have to do a fancy job of cabinetmaking to have such a portable darkroom. Many lumber yards sell unpainted kitchen base cabinets in knock-down form; you need only a hammer and nails to assemble one. If you get one about 48 inches long, it will be just about right, and only a slight modification is needed to the top to make a shallow sink out of it. These cabinets are almost always about 34 inches high and about 21½ inches front to back, and this is quite convenient.

Try to find such a cabinet with four or five shallow drawers at one end and a large compartment at the other; in the latter, you can keep tall bottles, and if you are handy, you can make a rack for trays to fit in this space too.

The sink top of this device will be about 20″ × 46″ in size and will easily accommodate three 11″ × 14″ trays. You will then need something like a wheeled typewriter table, sold at most stationery stores, on which to stand your enlarger.

To the back of the cabinet you can hinge a lid that closes down over the sink when not in use; when raised, it carries with it a shallow shelf for clock, safelight, and small utensils. And as mentioned, the whole thing should have wheels at the corners, so it can be rolled into a closet; it is going to be pretty heavy when finished.

When, finally, you get to building a permanent darkroom, this does not go to waste; all you do is remove the wheels, and it becomes a permanent worktable, even if you get a new sink. On the other hand, such a cabinet can be the entire fitting of a semi-permanent darkroom built into the 4′ × 6′ "dressing closets" found in many city apartments. You'll have to carry in your solutions, but print washing can be done in the bathroom, which is usually adjacent to the dressing closet. Many professional photographers have worked for years in such tiny "dry darkrooms."

Leaving only the washing to be done in the bathroom solves another problem of bathroom darkrooms; when more than one person is around, someone is always wanting to use the facilities just as you reach a critical part of the process. We have mentioned this before; we repeat it here because it is important. Once you start to process a roll of film, you should be uninterrupted and free to concentrate on the process, at least up to the fixing-bath stage.

Another good point in having a cabinet of this type is that while none of the photographic chemicals is a violent poison, none of them is good to drink, either. If you have small children around, it is easy to fit a hasp and padlock to the cabinet and keep the chemicals and sensitized papers safe from little fingers.

DARKENING THE ROOM

If you have a bathroom or dressing closet that has no windows, there is little problem in darkening it, other than to see that no light leaks in under or around the door. If you are using a spare room, you will have to cope with windows. The easiest way to handle this is to get several sheets of black cardboard—black poster board will do for occasional use—and a roll of black photographic Scotch tape. If pieces of cardboard are cut exactly the size of the windowpanes, they can be taped in place

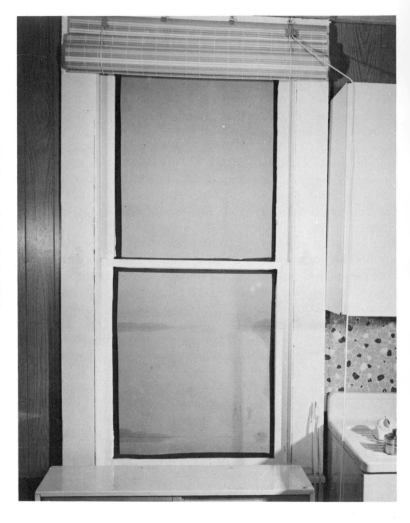

(Right) Lightproofing a window. Here, sheets of heavy corrugated board have been taped over the panes with black Scotch masking tape. (Far right) Darkening the permanent darkroom. Plywood panels with light-trap strips on back mesh with light-trap strips nailed to window frame. Some weather stripping may be needed for maximum light tightness. Panel is held in place by wooden turn-buttons. (Below right) The panel in place. It is neat and attractive and can be removed easily for cleaning or airing out the room.

with the opaque black tape, and you will have a totally dark room with little fuss. These can easily be removed when the room is needed for other purposes.

For a permanent darkroom, it is just as well not to block out the windows permanently; it is a good thing to have daylight in the room for the occasional clean-up and when you are working at things that do not need darkness. Masonite panels, large enough to cover an entire window and fitted with weather stripping all around, are the best answer to this situation; they are held in place with turn-buttons or screen-door hooks and eyes and are thus easily removed.

THE PERMANENT DARKROOM

We do think that you ought to use some kind of temporary set-up for a while, before building a permanent darkroom. Each photographer develops his own habits of working, and you might as well see what yours are before freezing a design. For example, most

photographers work from left to right, as is natural; they place the enlarger at the extreme left, then developer, stop-bath, and hypo trays in that order, left to right. If you are left-handed, you may find the opposite way of working to be more convenient for you. Some workers prefer an L-shaped arrangement, with the enlarger on a table along one wall, and the sink with its trays along the adjacent wall at right angles to the enlarger table. This latter arrangement is frequently found where the photographer uses several enlargers and wants them all side by side on one table; this is convenient because all can share one timer and one easel.

If you wish to build a darkroom at the outset, then it may be well to plan on using movable tables, a portable sink, and easily replaceable shelving in the beginning. This makes it possible to rearrange the room as you gain experience and find out what you like.

The usual choices for a permanent darkroom in the average home are the attic or the basement. Of the two, the basement is the better choice. Attics have a tendency to be too hot in summer, too cold in winter, and they usually lack plumbing and electrical facilities. In the average northern home, the heating plant is usually in the basement, so it is comfortable in winter, and being below ground, it tends to stay cool in summer. In some parts of the country, notably Florida and Arizona, houses do not have basements but almost always have a laundry room or utility room of some sort, and a darkroom can be built in one of these with little difficulty. Plumbing and electric wiring are usually already installed, and this simplifies the setting-up. For a start, a simple tabletop can be built to fit over the washer and dryer until you get a chance to build permanent facilities.

The essential thing is to avoid making the room too big; most professionals tend to have fairly small darkrooms, to avoid too much walking. If the enlarger and sink are at right

angles, you can expose a print and process it by simply turning on your heel. One "dry" table at the other end of the room is handy for activities that do not need water, such as loading film holders. If you do have ample space, it may be preferable to partition it into two rooms: one small one with water, allowing total darkness for developing and printing; and the second room rather larger, fully lighted, and used for mounting, retouching, and other activities that do not need darkness. If this latter room also has water supply, it may be well to have the print washer in it and bring the finished prints out from the darkroom for washing in full light. The print-washing sink can also be used for mixing chemicals, thus avoiding the problems of chemical dust in the darkroom proper.

DARKROOM ILLUMINATION— SAFELIGHTS

We call it a "darkroom," more out of tradition than anything else. Actually, the darkroom is dark only when loading a developing reel with film or when loading sheet-film holders or cassettes. Otherwise, the room should be well illuminated, the criterion being simply that the illumination in question should be of a type that does not affect the sensitive material being handled.

When photographers used either *color-blind* or *orthochromatic* films, they developed films by inspection under a dim ruby light. When *panchromatic* films came along, there was no really safe light possible, though a few workers tried a very dim green lamp, which could be used for a few seconds at a time. Eventually, it was agreed that there was nothing to be accomplished by watching a film develop, so the present practice is to develop all negative films by time and temperature in a closed tank; this can be done in full room light, and darkness is needed only to wind the film into the reel and insert the latter in the tank.

For printing, however, a good deal of fairly bright light can be used. Few photographers today use contact-printing papers, even for contact prints; it is simpler to stock one kind of paper and use it for both contact prints and enlargements. Thus the bright yellow light suitable only for contact papers has little use. Most enlarging papers can be handled under the light of a Kodak Wratten Series OA lamp, which is yellow-green and quite bright; obviously, this is also safe for contact papers if you do have occasion to use them. More and more, though, photographers are turning to the *variable-contrast* type of paper, which is sensitive to both blue and green light. These will be fogged by the Wratten Series OA safelight, and several special types of safelights are available for these papers; among them are the Wratten Series OC and the DuPont S-55-X,

Premeasured darkroom chemicals in powdered form are convenient to store, and they have a long shelf life.

both of which are brown in color. Inasmuch as these latter safelights are just as safe with ordinary papers, it is probably the best deal to install either of them in the beginning, then you can work with any kind of paper without having to change safelights. They are still amply bright for comfortable working.

Safelight filters fade with age and ought to be replaced now and then. If you have an old safelight that Pop or Grandpa used, the fixture will be OK, but throw the safelight filter away and buy a new one. And remember, these lights are safe only if they are used with the right size bulb in the fixture. If the light shines directly on the trays, use a bulb no bigger than 15 watts, and be sure the light is at least four feet from the nearest tray. A fancier device is the "indirect" safelight, which shines up against the ceiling and illuminates the whole room. Such lamps use larger bulbs, usually 25 watts, and are good for general illumination; the heat of the lamp in this position tends to fade filters faster, and a new filter should be installed at least once a year.

MIXING CHEMICALS

As we pointed out in the beginning, you are going to start out by buying chemicals in packaged form. Various brands are available, some in powdered form, some in liquid. There is no question that the liquid form is convenient—all you have to do is add a certain amount of additional water to it. If you do only a little work, liquid chemicals may be preferable, but in the long run you'll find them too expensive. Liquid developers and fixers generally cost up to twice as much as the same formula in powdered form, so why pay for water?

Another point is, packaging costs a good deal these days, often as much as the product, and you will find that a large package of chemicals costs very little more than a small one. The little one-time packets of chemicals cost the most and should be used only in emergencies. We have found that the best compromise is to buy most chemicals in one-gallon sizes; more than that will pose storage problems, and less will cost a good deal more.

It is true that some photographic chemicals spoil with age, even if not used; what happens is that the oxygen in the air combines with some of the chemicals in some developers. The easiest way to avoid this is to store the chemicals in full bottles, tightly corked, so there is little or no air in the neck.

In any case, this does not apply to the fixing bath, or "hypo," which keeps quite well for very long periods; thus you can get a one-gallon package of fixer, mix the entire thing in a gallon jug, and pour it out as you need it, without worry about spoilage.

As for developers, different developers have different spoilage rates. For the moment, we recommend that you use Kodak Developer D-76 for your first sessions of negative development. This formula has excellent keeping qualities, and if you can use up a gallon in one to two months, you can treat it the same as the fixer.

If, however, you do not intend to develop many rolls of film in a short time, it is still more economical to mix a gallon of Kodak Developer D-76 at one time. All you need do, after it is mixed, is to store it in four 1-quart bottles, full to the neck. This way the developer will keep for as long as a year. You use up one bottle at a time, and in the smaller bottle, you can expect the developer to last at least two months; you should certainly use it up in that time. (If your developing tank is the typical small 35mm tank, it holds about eight ounces of developer, so your quart will develop four rolls.)

There are many brands and types of developers and fixers on the market, and most of them are good. We would prefer, at first, that you use exactly the brand we specify, if it is at all possible to get; actually, you are more likely to find Kodak chemicals at the average camera shop than other brands.

This is not to say that the others are no good; on the other hand, none of the others is likely to be noticeably better. The reason is that developing negative films is a simple task, and the developer formula actually has very little influence on the process other than to produce much the same result faster or slower. You can experiment all you wish later on, but for now, stick to the recommended brand; that way the instructions that follow can be depended upon to produce results.

Mixing Tools

As mentioned previously, you need a few measuring cups; they can be glass, stainless steel, plastic, or enamelware, but avoid aluminum or copper. You also need one or two larger containers for mixing chemicals; a gallon pail made of white enamel, stainless steel, or plastic will serve well. A galvanized iron bucket will ruin a developer or a fixing bath at once, as will anything with a copper lining.

The long plastic spoons sold in most housewares stores are good for stirring chemicals; you can get real chemist's glass stirrers in big cities, but they are fragile. Avoid wooden spoons, because chemicals soak into them and later cause contamination.

Chemicals dissolve faster in warm water than in cold; very hot water will not do, though, because it may cause decomposition of some chemicals. While the exact temperature of mixing is seldom very critical, it is well to get into the habit of measuring everything from the beginning and leaving nothing to guesswork. So all that is necessary is to mix hot and cold water in your mixing vessel, checking the temperature as you go. On a Celsius thermometer, the temperature should be around 50; on a Fahrenheit instrument, the corresponding reading is 120, more or less.

Even though the chemicals dissolve completely and seem to disappear as they do so, they do take up room in the solution; if you start with a gallon of water and mix your chem-icals in it, you will end up with more than a gallon of solution. Again, there is nothing critical about this; the easy way is to start with about three-quarters of the final amount, dissolve all your chemicals, and then add enough cold water to make the final volume exactly a gallon.

We are not being inconsistent here, suddenly changing from litres to gallons. It is simply that while you will have no trouble finding measuring cups marked in litres, it will be almost impossible to find four-litre jugs. Furthermore, the packages of chemicals supplied for general use are made to produce a gallon of finished solution. So at this point, mix your chemicals in about three-quarters of the final amount, and when fully dissolved, pour the mixture into a gallon jug, and add cold water until the jug is full. Then shake gently to mix the whole thing together.

PREPARING CHEMICALS FOR THE FIRST LESSON

The first lesson is on negative developing, and for this we will need just two baths. We will, for the time being, stick to a single negative developer, Kodak Developer D-76 (this is also sold by DuPont as DuPont Developer 6-D, by Ilford as Ilford Developer ID-11, and by FR as X-Trol 76 Film Developer). There are, as mentioned, other good negative developers, but to assure consistent results from the very beginning, we'd like to have you use one of the above.

You will also need a hardening fixing bath; this is available in many brands, all of which are equally good. For economy, we recommend Kodak Fixer, which is sold in powder form and is usually cheapest, but any other will do.

No particular skill is needed to mix these two baths; if you use the recommended Kodak baths, you will find that each comes in a can containing a single white powder. Make sure

that your mixing pail and stirrer are clean and that you have about ¾-gallon of water at 50 C (120 F).

Having opened the can of developer, begin stirring the water, and when it is fully in motion, pour the powdered chemical into it, a little at a time, while stirring steadily. This seemingly simple step is important. If you simply dump the contents of the can of powder into the water, it will sometimes form a hard cake, which takes a very long time to dissolve; stirring steadily, however, it dissolves quickly and smoothly. When it is completely dissolved, pour it all into a clean one-gallon jug, and add enough water to fill the jug to the neck. Cork the jug, shake it gently a few times, and set it aside to cool. Before going any further, take a piece of waterproof adhesive tape, stick it to the outside of the bottle, and mark it "Developer D-76" with a black Magic Marker.

Now wash all your utensils quite thoroughly, and proceed to mix the fixer in the same way. There is one problem, though; with a hardening fixer, such as the Kodak type, where all chemicals are mixed together into

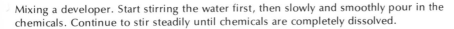

Mixing a developer. Start stirring the water first, then slowly and smoothly pour in the chemicals. Continue to stir steadily until chemicals are completely dissolved.

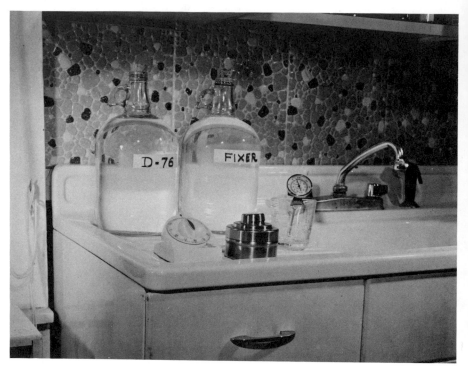

This is all you need to develop your own negatives, in your kitchen if necessary. The kitchen timer is as good as any, and all you need is one small measuring cup, a thermometer, and a jug each of developer and fixer.

one powder, slight decomposition may occur if the water used is too warm; even 50 C (120 F) is too high in this case. On the other hand, dissolving hypo in water has the peculiar effect of chilling the solution, making it harder to dissolve chemicals in it. Try to have the water at exactly 27 C (80 F) and there will be no difficulty. In some cases, if the solution is mixed a little too warm, it may turn milky at first, but will usually clear up if left to stand overnight.

Again, as soon as all the chemical has dissolved, pour the solution into the second gallon jug, then add enough cold water to fill it to the neck, and cork it up. Stick a piece of waterproof adhesive tape to the outside of the bottle, and mark it "Fixer."

These two solutions keep quite well, and if you use them up within one or two months, there will be no trouble. There is just one thing to remember: Both developer and fixer are to be used once only; never pour used chemicals back into the stock bottle.

Now we have all we need for negative development, but before beginning, let the mixed solutions cool, and wash all mixing cups, buckets, stirring rods, and thermometer.

DEVELOPING TANKS

There is a variety of developing tanks for roll films available at most camera shops. The majority of them are stainless steel cups with lighttight lids, containing a reel made of stain-

less steel welded into a spiral. These are called "daylight" tanks, because once the film has been loaded and the cover firmly attached, all the remaining steps in development can be carried out in full room light. But it must be remembered that they are *not* daylight loading.

A few very simple tanks are available, which use the so-called "apron" method. In these, a strip of plastic is used as a separator between the turns of film, instead of a reel; the plastic strip is crimped along both edges so that when the film is wound into a roll with the strip, neither side of the film touches the plastic separator. These are very easy to use and cost very little, but they have a short life; if you intend to take up photography seriously, it is best to start right out with a stainless steel tank and wire reel.

Years ago, there were several tanks with ingenious mechanisms by which the film could be loaded into the tank in full room light; none of these is currently available. The probability is that the loading mechanism was not 100 per cent reliable, and the danger of losing an entire roll of pictures, if it did not work, militated against these devices.

Also available, at one time, were tanks using a spiral reel in which the reel was molded of plastic. The idea behind these was that they were supposedly easier to load; it was often recommended that the film be simply pushed into the reel from the outer end. These, too, were unsatisfactory, and they no longer are recommended.

An unusual type of developing tank, which can be loaded in full room light. While no longer made, these sometimes turn up on the used-equipment counters of camera stores.

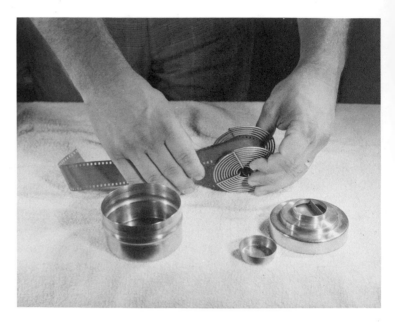

Loading film into a stainless-steel, spiral-reel developing tank. If the film is cupped slightly between thumb and finger, it will usually wind into the turns of the spiral quite easily.

Wider films are not as easy to load into spiral steel reels. An inexpensive loading accessory does the job quickly, with just a few turns of a crank.

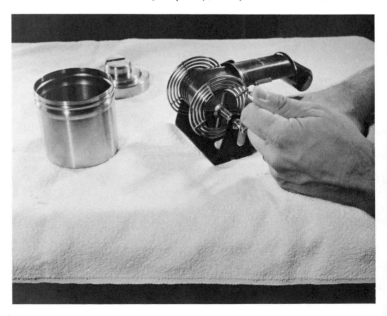

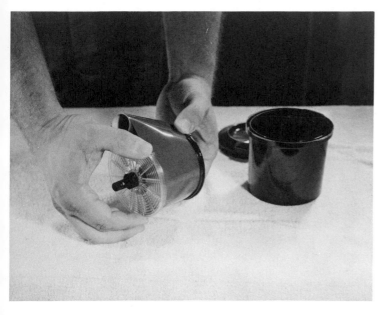

An inexpensive plastic developing reel. This loads by inserting the ends of the film into a slot at the beginning and ratcheting the end flanges back and forth, which slowly feeds the film into the grooves.

Loading the Reel

The right way to load any spiral tank, even the plastic ones, is to start the film from the inside and wind it outward. This seems strange at first, but it works smoothly and easily, with a little practice.

Secure from your dealer a roll of spoiled film or even a roll of outdated film, which can be used for practice. As a last resort, of course, you can use a perfectly good roll of film for preliminary practice; it is a small investment and well worth while.

The object is to practice loading the reel in full room light, watching exactly how the film finds its way into the grooves of the reel. The method is simple: You cup the end of the film between finger and thumb, and push it between the side flanges of the reel. There is usually some kind of catch in the middle of the reel to hold the end, but if there is none, just be sure the film goes between two spokes of the hub, into the center hole of the reel itself. This will hold it well enough.

Now keeping the film gently cupped, rotate the reel slowly with the other hand; you will find that if the film was properly started, it will find its way into the spiral of the reel as it straightens out. It is particularly easy with 35mm film, which tends to be a bit stiff because of its narrow width. Loading size 120 roll film is not as easy, but a little extra practice is all that you need. For those who use a great deal of size 120 film, a little loading machine is available at small cost, which winds the film into the reel with a few turns of a crank.

Whichever you do, do it a number of times. Start by loading the roll in full light, with both eyes open. Watch to be sure the film runs smoothly into the spiral and that there are no "crossover" spots where two successive

turns get into the same groove. Also be sure that the film is not kinked or buckled at any point; a kink in the film will usually cause a small but nasty dark spot in the shape of a crescent on the film when it is developed.

After you have the knack of loading a roll very smoothly with eyes open, try closing your eyes and loading a roll entirely by feel. If something goes wrong, of course, you can open your eyes and see what happened. And after a few "eyes-shut" trials, take the reel and film into a dark place, such as a closet, and do it several times.

This preliminary practice will pay off later on, when you will find that you can load reels accurately in total darkness, without even having to think about it. Often on location, you have to develop a roll where no darkroom is available. For this purpose, there is a gadget called a "changing bag." This is a lightproof cloth bag with a zippered bottom and sleeves with elastic cuffs. You put your film and tank inside and zipper up the end, then insert your hands through the sleeves and proceed to load the reel and insert it in the tank. This gadget looks rather formidable at first glance, but since you can't see anything in a darkroom anyway, the real obstacle with the changing bag is simply unfamiliarity. If you intend to use one of these, a half-hour of practice will probably suffice; that is, IF you have already mastered the smooth and easy loading of the reel in a darkroom.

Filling the Tank

One other matter needs a little practice. In using these tanks, you are supposed to pour the developer in through a light-trapped funnel in the lid. The only problem is, the air in the tank has to escape through this same funnel; if you try to pour too fast, the tank becomes "air-locked" and the developer will splash and overflow. If you pour too slowly, however, you will get streaks on your negatives. So again, a little practice is in order.

For this, you need only the tank cup and lid; there is no need to put the reel inside. Place in a measuring cup a quantity of plain water equal to the capacity of the tank (you can find this out by filling the tank with water and pouring it into the measuring cup). Hold the tank in one hand, the cup in the other; tilt the tank to a small angle and start pouring in the water, just as fast as the tank will take it, but no faster. Do this several times, to be sure you can fill the tank with the right amount of developer in one smooth motion.

One last thing: You should also practice emptying the tank. This is done by inverting the tank and letting the liquid flow out. Again, there is a danger of air-locking, so to prevent this, keep tilting the tank to different angles until it is completely empty. Fill and empty the tank several times till you are sure you can do it smoothly.

At this point, you are ready to develop your first roll of film. We would recommend, for the first try, that you don't begin with your vacation pictures or some other valuable exposures. Instead, get a roll of your favorite film; any one of the following will do:

> Ilford HP-5 Roll Film
> Kodak Tri-X Panchromatic
> Roll Film
> Kodak Verichrome Pan Roll Film

Take a lot of unimportant pictures on this roll; do not, however, just "bang it off." Be sure the exposures are all reasonably correct, using your exposure meter to be sure, and get a variety of subject matter on the roll. It is obvious that you can't judge how well you have developed a roll if the exposures on it are not somewhere near right.

DEVELOPING THE FILM

Basically, there are just two things that are done to a film in developing it. First, it is

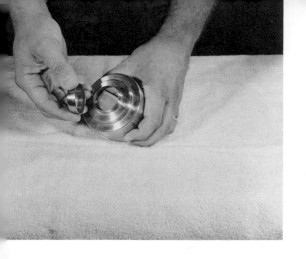

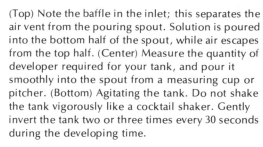

(Top) Note the baffle in the inlet; this separates the air vent from the pouring spout. Solution is poured into the bottom half of the spout, while air escapes from the top half. (Center) Measure the quantity of developer required for your tank, and pour it smoothly into the spout from a measuring cup or pitcher. (Bottom) Agitating the tank. Do not shake the tank vigorously like a cocktail shaker. Gently invert the tank two or three times every 30 seconds during the developing time.

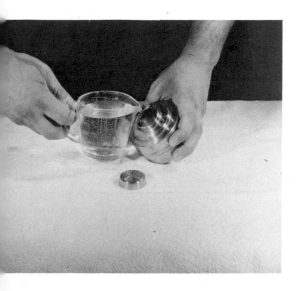

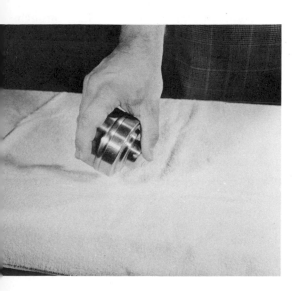

treated in a developer, which transforms exposed silver bromide into metallic silver. This brings out the image of whatever you have exposed on the film. When this is done, there is still a good deal of unexposed silver bromide in the film, which must be removed to make the image permanent. This is done by the fixing bath, which removes only unexposed silver bromide but does not affect the silver image.

These are the essential steps; there are a few minor ones, though, that are important as well. For instance, after development, if you transfer the film directly to the fixer, some development will continue while fixation is going on; the result can be streaks and stains. So it is necessary to have a short wash after development and before fixing.

More important, the fixer does not actually remove the silver bromide from the film; it transforms it into a transparent—hence invisible—salt, which is soluble in water. This, plus the hypo, which has soaked into the film, must be removed by a thorough final wash, if the resulting negatives are to be permanent.

None of this is difficult nor complicated. Nevertheless, times and temperatures must be exact, because chemical processes go faster or slower according to the temperature; to get the exact result desired, a given bath must be used at a certain time, at a definite temperature. This is very important in the developer but less so in the case of the fixing bath, where

the process can be watched. Even so, temperatures of the fixing bath and wash water should be controlled just as carefully. Excessively warm fixer or wash water can damage the coating of the film and spoil the image.

DARKROOM PROCEDURE

You have already mixed developer and fixing bath. You have your tank and a couple of small measuring cups that hold about the same amount as your tank. You have a thermometer and a timer. And you ought to have a deep pan or bowl that is not quite as deep as your tank or measuring cups.

When you are ready, darken the room, or go into a dark closet or wherever you intend to load your tank. Take with you the tank, with its reel and lid, and the roll of film you intend to develop.

In the darkroom you open the cartridge (some 35mm cartridges can be opened by striking the end of the spool sharply on the table, which causes the opposite end to pop off; others have to be opened with a tool, such as a bottle opener). If you are developing size 120 roll film, simply break the seal, unwind the paper, and separate the film from the paper backing and spool. You've already done this in your practice with loading the reel, so you can recognize the film in the dark by its feel.

Wind the film into the reel, insert the reel in the tank, and put on the cover. Once the film is in the tank and the cover firmly attached, you may come out of the dark into the lighted room (or turn on the darkroom lights), and the rest of the procedure is carried out in full light. The steps are as follows:

1. Take your first measuring cup and pour the correct amount of Kodak Developer D-76 into it from your jug. Put the thermometer in the cup and wait a minute or so. The developer must—repeat *must*—be at 20 C (68 F). If it is not, take the deep bowl already mentioned and put in enough water to come up to the sides of the measuring cup. If the developer is too warm, use cold water, with a few ice cubes if needed. If the developer is too cold, use warm water. Put the cup of developer in the water, and keep stirring it with the thermometer until the temperature is exactly 20 C (68 F).

2. Put the developer aside for the moment, and fill a second measuring cup with fixing bath; adjust its temperature in the same way, to 20 C (68 F).

3. Wash the thermometer very carefully, recheck the developer temperature, and if it is still at 20 C (68 F), pour it into the tank. Start the timer, and set it to one of the following times:

Ilford FP4 Films	6 minutes
Ilford HP-5 Films	7 minutes
Kodak Tri-X Panchromatic Films	8 minutes
Kodak Verichrome Pan Roll Films	7 minutes

4. As soon as the developer is in the tank, put the cap over the filler hole, and invert the tank three or four times. This agitation is extremely important and must be done throughout the entire developing time, at uniform intervals. Every half minute, invert the tank two or three times, and set it down again. Do not shake the tank like a cocktail shaker; gentle agitation is all that is necessary.

5. When the timer rings, remove the filler-hole cover, and pour the developer out of the tank; if you have a sink, pour it down the drain, otherwise into a bucket that can be emptied later. Do not attempt to save the used developer.

6. Fill the tank with cold water from the tap or from a cup; put the filler cap on and invert several times; then remove cap and empty the tank immediately. Again, fill the tank with water, agitate, and empty.

7. Now pour the fixing bath into the tank, and again, cover and agitate. After about two minutes, you may remove the lid of the tank completely, wash it and the filler cap, and put both aside.

8. At this point, the film has lost about all of its sensitivity, and you may gently lift the reel from the tank and examine the film. It will still be somewhat milky, since the fixer has not yet completely removed all the remaining silver bromide.

9. Drop the reel back into the tank, and turn it several times with a fingertip. Examine the film at intervals, and note approximately how long it takes for the milkiness to clear completely. If, say, it does so in four minutes, then leave the reel in the tank for another four minutes.

10. At this time, empty the tank of fixing bath, and fill it with plain water, checking the temperature with your thermometer. This is not critical, but it should not be less than 18 C nor more than 24 C (between 65 and 75 F). If your tap water tends to be much warmer or colder than that, it is well to prepare a bucket full of water at exactly 20 C (68 F), in advance of this step. A gallon will be quite sufficient.

11. Agitate the reel in the water for about three minutes, then empty the tank and refill it.

12. Again, agitate now and then for about three minutes, empty the tank, and refill with fresh water.

13. Continue this process, filling and emptying the tank and agitating the reel by spinning it with a finger, until you have used up the gallon of wash water.

14. Now you may remove the film from the reel, wipe it carefully with a soft viscose sponge, and hang it to dry.

Water droplets must be sponged off the film before hanging it to dry. Some workers use a final rinse of a wetting agent, such as Kodak Photo-Flo, and eliminate this step.

ON WASHING AND DRYING

There are a few points to be covered here. For one thing, some persons simply place the reel and tank under a faucet and let running water do the washing. This is not as efficient as it looks; most of the water flows over the top of the tank, and little gets into the reel to do the actual washing.

The system we recommend above is not only more efficient, in that the film is changed through half-a-dozen batches of fresh clean water; it is also more economical. The ordinary faucet will fill a gallon jug in about a minute; that is, a running-water wash will use water at the rate of a gallon a minute. The method given above, on the other hand, uses only a total of a gallon of water, yet it washes the film better than you possibly could with running water; your total expenditure of water has been only one gallon, as against the 10 to 15 gallons that would have been used up in running-water washing.

When washing is complete, all that is necessary is to hang the film to dry in a clean, breezy place. There is one nicety left, though. Most local water supplies have some dissolved mineral matter in them; these do no harm in washing. But if you hang the film to dry as it comes from the tank, you will find that while most of the water runs off, what is left collects in droplets, and as these evaporate, they leave small water spots, which mar the image on the film.

You can hang the film in a doorway to dry. Fasten the upper end with a pushpin or film clip, and use a second film clip as a weight at the bottom of the film strip to keep it from curling up.

The easiest way to avoid this is to have a clean viscose sponge on hand. This is to be soaked in water until it is soft, then wrung out carefully. Now if the sponge is doubled over and the film drawn through it, pressing the sponge very gently, all the surface water will be removed and the film will dry free of droplets and marks.

Another way, and possibly a better one, is to use a wetting agent as a final rinse; this avoids touching the film with anything that could possibly cause scratches and damage. The procedure is very simple; you merely prepare a quantity of plain water sufficient to fill your tank, and add a few drops (the exact amount will be marked on the bottle) of Kodak Photo-Flo, Agfa Agepon, or some other similar wetting agent. When washing is complete, fill the tank with this wetting agent solution, and agitate the reel for a minute. Then hang the film to dry; you will note that the wetting agent causes the water to run off smoothly, without leaving any droplets at all.

To hang the film to dry, you need a pair of steel film clips; wooden spring clothespins will do as well if you can't get the regular clips. One clip is hung from a clothesline, or from a nail driven into the top of a window frame, or from any other convenient place. The remain-

ing clip is used as a weight at the bottom of the film strip to make it hang straight.

The safest way to hang film is to put up the clip first. With the film still in the reel, draw out enough of the end to fasten to the clip. Now slowly unroll the film from the reel, allowing the weight of the reel to do most of the work. As the end of the film comes out of the reel, catch it so it doesn't spring back and scratch the upper part of the film. Take the remaining clip and fasten it to the lower end of the film, and let it hang until dry.

During drying, the film will go through various gyrations, curling and twisting while parts are still wet. This is an additional reason why weight is needed at the bottom; it restrains the twisting to some extent. As the film dries, it straightens out again, and when it is completely straight, it is usually quite dry. Allow an extra five minutes or so, to be sure, although you can usually tell when the film is dry by its appearance.

There may be a bit of water trapped in the clips, though, and to avoid spattering this on the film and making spots, it is best not to touch the clips at all; simply take a pair of scissors and cut the film away from the clips, first bottom, then top. Do this as close to the clips as you can, to avoid cutting into any picture area.

For the time being, 35mm film should be rolled up and put in its original container; 120 roll-film negatives are best cut into strips of three or four negatives. Eventually, you should buy some kind of negative filing system, and you will find that these come with envelopes holding three or four negatives in the 120 size, or four or six negatives in the 35mm size. At that time, you will find it best to cut your negative strips to fit your filing system.

This is the end of Lesson 1. At this point, you should have a roll of good negatives, ready to use in Lesson 2, where we will discuss, first, how to judge negative quality, and second, how to make contact-proof prints.

LESSON 2

Contact Printing

You finished Lesson 1 with a roll of negatives, dried and cut into strips for storage. We assumed that you had taken pictures before, and that having had them processed outside, you did know what a negative was and what it looked like. Now that you are going to do your own work, we ought to discuss a few fundamental points at this stage.

When you take a picture, you are causing light reflected from the subject to be focused by a lens into a smaller image and to fall upon the surface of a sensitive film. Just what happens there is not entirely clear, even to the scientists, but that does not matter; we do know that if the film is then treated with a developer, followed by fixing and washing, we will find on the film a visible image. This image is composed of very tiny grains of silver (it *is* pure silver, but because it is granular instead of solid, it appears black instead of shiny). Obviously, where the most light fell upon the film, the most silver was deposited by the developer; where little or no light fell, little or no silver was produced.

LIGHT AND DARK

The result, then, is that we have a reversed image; white objects appear black, and black objects appear transparent and this is why we call it a *negative*. This was discovered very early in photography, and it didn't take very long before William Henry Fox Talbot (1800-1877) figured out that if the whole process were repeated and a copy made of the negative, things would be reversed a second time; this is one of those instances where two wrongs do make a right. Of course, you don't have to rephotograph the negative image; all you need do is put it in contact with a sheet of sensitized paper and expose the whole thing to light. The most transparent part of the negative will transmit the most light, producing the black in the print; the darkest parts of the negative transmit little light and produce the whites in the print.

In the discussion that follows, we will have some difficulty if we keep saying "black" or "white" without referring to which we are

discussing, the negative or the print. Let us therefore substitute two other words: the white parts of the original subject are *highlights,* and the darkest part of the original is the *shadow.* In between we have *middletones.* This improves matters because, from now on, we will refer to "highlights" and "shadows," without regard to whether we are talking of negative or positive, simply because highlights and shadows always take us back to the original subject matter and provide a definite reference. A highlight is always a highlight: the whites of the subject, the blacks of the negative, and the whites of the print are all highlights. Likewise, the blacks of the original, the transparent parts of the negative, and the blacks of the print are all called shadows. Now we are always talking about the same *area* of the subject, the negative, or the print, when we refer to a "highlight" or a "shadow"; it makes no difference whether it happens to be black or white at the moment.

We haven't said anything about "middletones" here beyond mentioning the word; this is because for most photographic purposes middletones are not very important; we just remember that they exist between highlights and shadows.

Density and Contrast

Another word used a great deal in photography is *density.* Generally, density is taken to mean the blackness or darkness of a given area of negative or print. Technically, the word "density" refers, not to the blackness of the image, but to the actual weight of silver present. This makes no difference at this point, but becomes of some importance in more advanced work.

The most important term to understand right now is *contrast.* Contrast, of course, refers to a difference, and in the case of a negative, it refers specifically to the difference in density between highlight and shadow. If a negative is mostly gray, with little real black

or white in it, we say it has little contrast, or it is a "low-contrast" negative. If, on the other hand, a negative has strong blacks and clear shadows, we say it is a "high-contrast" negative. Obviously, somewhere between the two extremes we have an average case, which we can call "medium contrast" or "normal."

Notice that the judgment of contrast is made from the difference between the extremes—the highlight and shadow densities. We are not concerned with middletones at this stage; they pretty well take care of themselves.

The importance of all this is that we are going to have to learn to control contrast in making our prints, and we can't control something unless we know what it is. So let's sum up. We are concerned *in a negative* with the density of the highlights (black areas, remember?) and the density of the shadows. And the difference between them is called "contrast." For the moment, we will not try to be any more precise than that. We can think of three broad classes of negatives—of high, normal, and low contrast—and beyond that we need not go just yet. All we want you to do is to remember the meanings of the words:

Highlight
Shadow
Middletone
Density
Contrast

PRINTING METHODS AND MATERIALS

There are two basic ways of making a positive from a negative. The first, and simplest, is merely to place the negative in contact with a sheet of sensitive paper and expose the whole thing to light. As you would guess, this is called *contact printing.*

The second method is to put the negative into some kind of projector and then image the negative on a sheet of paper placed at some distance from it. This is usually known as

enlarging, since most of the time it is used to make an image bigger than that on the negative. However, since it is also possible to use such an arrangement to make small prints from big negatives (in which case it would be called *reduction*), it is probably better to use a general term like *projection printing*. Still, most people call it "enlarging," and there is no reason why not.

Papers

Printing is done on paper coated with a mixture of silver salts, which we call the *emulsion*. This differs from the emulsion on a film in two ways. First, it need not be sensitive to colors, and so it can be handled under safelights. Second, it does not have to be as sensitive as a film, since we usually have ample light by which to expose it; in addition, exposures are much longer than those in a camera.

In the beginning, prints were made on a type of paper called "printing-out" paper, because the image appeared on it while it was being exposed and did not need to be developed. Printing-out paper produces a deep red image and is still used by professional photographers to make temporary proofs to show customers. It is not very sensitive and requires daylight or even sunlight to make a print.

A print on printing-out paper continues to darken as it is exposed to light, and eventually, the paper turns black or deep red all over; thus these prints are not permanent. You may ask, Why don't we treat these prints in a fixing bath, as we did with our negative films? While this could be done, the emulsion of printing-out paper is not intended to be fixed, and the action of the hypo on it turns the image from the rather attractive red color to a dirty yellow-brown. While there are ways of improving the color, they are a good deal of trouble, and most people just don't bother with them; printing-out paper today is used only for temporary proofs that are discarded when they have served their purpose.

Modern printing methods employ "developing-out" papers, which do not produce a visible image on exposure; they are developed and fixed, just as are films, to produce the final, permanent image. This image is black in color, though a few types of paper produce brown and sepia images; it is also possible to modify the neutral-black image to various colors by chemical treatment, which we will learn in the advanced part of this course.

All developing-out papers are coated with an emulsion of *silver chloride, silver bromide,* or mixtures of the two, and the different coatings are mainly to secure different degrees of sensitivity. If the paper is coated entirely with silver chloride, it will not be very sensitive; it is used mainly for contact printing, where strong lights are available. Thirty years ago, there was a paper coated entirely with silver bromide that was quite sensitive and was used for enlarging. Today's enlarging papers are coated with a mixture of silver chloride and silver bromide—the silver bromide gives it the greater sensitivity needed for projection printing, while the silver chloride produces richer blacks in the print than can be obtained from pure silver bromide.

There is no real distinction between contact and enlarging papers other than the simple one of sensitivity. Contact papers could be used for making enlargements, if the enlarger in question had enough light; photofinishers making "drugstore" prints do use contact papers in their high-speed printers.

By the same token, enlarging papers can be used to make contact prints, by using a weaker light, shorter exposure, or both. Many photographers use nothing but enlarging paper in their work and make contact prints with the same paper, simply by using the enlarger as a light source. In this case, it will be found that exposures on a given paper are pretty much the same, regardless of whether the negative is in contact with the paper or being projected upon it.

Since either type of paper can be used for contact printing, we think you might as well start right out using enlarging paper; you will not be making many contact prints after a while anyway, and there is no need to learn to handle two different kinds (though, except for speed, there is little difference between them). Because enlarging papers are much more sensitive than contact papers, you will have to use a fairly dim light for exposure. Most people simply set their enlarger nearly up to the top of the column, stop the lens down a bit, and use it as a contact-printing light source. The paper and negative are placed on the easel of the enlarger.

If you don't yet have an enlarger, you can make contact prints with nothing more than a light bulb; it should be pretty small, and probably a 7½-watt round white bulb or even a night-light bulb will be found amply bright. The only equipment you will need is a contact-printing frame, and even that is not entirely necessary; a sheet of heavy plate glass and a foam-rubber pad make an adequate substitute.

For this first lesson, then, you will need a package of paper, and any one of the following will do:

Agfa Brovira Paper
DuPont Velour Black Paper
Ilford Ilfobrom Paper
Kodak Kodabromide Paper

The various manufacturers use different codes, but they are all easy enough to figure out. In the case of Kodak papers, the letters represent the surface of the paper, and the numbers represent contrast grades. Thus "Kodabromide F-2" means glossy surface, medium or normal contrast.

Contrast Grades

In this case, the word "contrast" does not actually refer to the paper *image*—all papers have the same contrast, in that they all produce a full black when exposed, and all

remain clean white when unexposed. So the word "contrast" here refers *to the negative you are going to print* upon that paper. Thus, for instance, a paper marked "No. 3" or "No. 4" is intended to boost the contrast of a print from a negative that is lacking in that property; it is called a "hard" or "contrasty" paper for that reason. Conversely, a paper marked "No. 0" or "No. 1" is intended to produce a softer print from a very high-contrast negative, and so is called a "soft" or "low-contrast" paper. The middle grade, "No. 2," is considered "normal" or "average" or "medium contrast," and is used to print most average negatives.

For this lesson, we will leave this matter in abeyance; for the sake of learning the printing process, we will print our first negatives on No. 2 paper, regardless of what they happen to look like. This will prove to be very instructive.

As for surface codes, they vary with different manufacturers, but for the moment we will ignore them; merely get a pack of glossy paper. Kodabromide F-2, which is glossy and of normal contrast, is available almost everywhere, and you may as well begin with it. We also suggest you get your first package in the 8" × 10" size. You can print an entire roll of negatives on a single sheet, and for trials or smaller single prints, you can easily cut a sheet into quarters—in safe illumination, of course.

Safelights

Papers are sensitive to blue, violet, and ultraviolet light, and so cannot be handled under ordinary room light. On the other hand, they

Exposure of a contact sheet can be done with nothing more than a bare light bulb. The 60-watt lamp shown is required for slow contact papers, such as Azo or Velox. If the print is being made on a faster enlarging-type paper, a much smaller bulb is required. A 7½-watt round white bulb or a night-light bulb is often adequate.

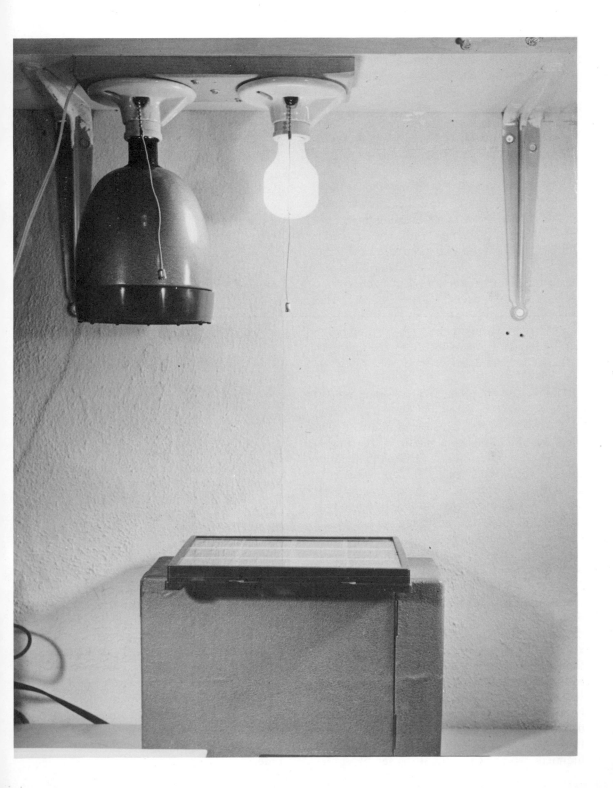

are much less sensitive than films and need not be handled in total darkness either; a good deal of light can be used, provided that it does not contain blue, violet, or ultraviolet radiation.

Few photographers do much contact printing anymore; those who do are mainly commercial photographers who have to supply hundreds or thousands of prints for publicity purposes or advertising. They make these prints on high-speed automatic contact printers, and their workrooms are illuminated by special types of lamps with sodium-vapor sources, which emit only a pure yellow light.

But the bright yellow safelight filter formerly used for contact-printing papers is no longer available, except on special order. This poses no difficulty whatever; any paper that can safely be handled under such illumination can be handled just as safely by the light of a safelight intended for bromide enlarging papers.

The Series 00 safelight for contact papers being obsolete, we are left with a choice of two. Most enlarging papers can safely be handled by the light of a small bulb, filtered through a Wratten Series OA safelight filter; this is a yellow-green color and provides a good deal of light to which the eye is most sensitive, making it easy to work under. It is suitable for almost all enlarging papers and all contact-printing papers as well; until recently, it was the most popular safelight for black-and-white printing.

In recent years, a newer type of paper has come into use; it is called *variable-contrast paper* and has a mixed coating, containing two different batches of silver bromide/chloride emulsion. One batch is sensitive to blue only, the other to green, and by adjusting the color of the enlarger light, its contrast can be varied within wide limits. Since this paper is sensitive to green light, though, it cannot be handled under the Wratten Series OA safelight illumination. At first, only a dim red light was recommended, which was difficult to see by. Later

on, a new safelight filter was made available; it emits a brownish-yellow light and is safe for all kinds of black-and-white printing papers. This filter is available from Kodak and is known as the Wratten Series OC filter; it is also available from DuPont, who calls it the S-55-X filter. They are interchangeable, for all practical purposes.

Obviously, then, if you are setting up a new darkroom, the best thing is to install the Wratten Series OC or S-55-X safelight at the very beginning. You can use it with any kind of paper, and you will not have to be changing safelights for different materials, as long as you are working in black-and-white. This is not only economical; it also gets you used to a single type of darkroom illumination, which will make it easy for you to judge your results as you go on to more advanced procedures.

CHEMICALS

The papers we are about to use have to be developed; we have already made that clear. We can't use for papers the Kodak Developer D-76 we used for our negative; it isn't strong enough. For papers, we need a different developer, made especially for the purpose. We also need a stop bath, which is just a weak acid rinse that takes a minute or two to prepare. And we need a fixing bath.

The Developer
Let us begin with the developer, as before. There are many paper developers, and most of them are quite satisfactory; but they do differ one from another, mainly in strength. Since we are going to give you some rather precise directions on developing papers, we'd rather you began by using exactly the developer we recommend; and again, it is one you can buy almost anywhere. So go to your dealer and buy a can of Kodak Dektol Developer, to make a gallon. At the same time, buy a bottle of acetic acid, glacial, 99%; a 500cc (16-ounce) bottle will be plenty and will last you for a long time.

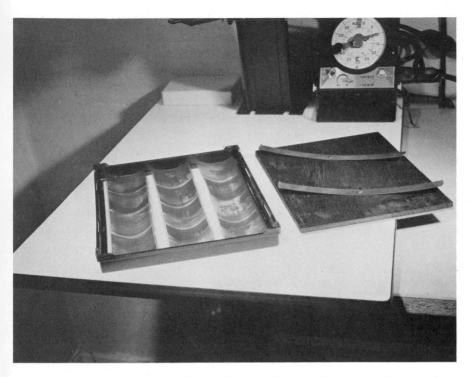

A group of negatives in a printing frame will make a contact sheet, or proof sheet, of an entire roll on one sheet of paper.

Kodak Dektol Developer is much stronger than the Developer D-76 you used for your films; in fact, after you have dissolved the contents of the can of powder in a gallon of water, it is still stronger than needed and will be further diluted when you go to use it. A strong solution intended to be further diluted is known as a "stock solution" and has certain advantages in use; in this case, the developer happens to be highly alkaline and loses strength rather rapidly when fully diluted. On the other hand, it keeps quite well at stock strength. A gallon of stock solution makes about three gallons of working developer.

That may seem like a lot, but you use more paper developer than you do film developer; while film tanks hold from 8 to 16 ounces, an 8″ × 10″ tray holds at least a quart and preferably more for comfortable working. If you try to use less than a quart of developer in an 8″ × 10″ tray, you will find that there is so little liquid in the tray that it barely covers the bottom, and it will be nearly impossible to immerse the paper smoothly without producing streaks.

Kodak Dektol Developer is mixed like any other. Put about three quarts of water at 37 C (100 F) in your mixing vessel; open the can of

39

developer, and start stirring the water with one hand while slowly pouring the powdered chemicals into it with the other. If this is done, the chemicals will dissolve smoothly and easily. When they are dissolved, pour the developer into a gallon jug, add enough cold water to fill it to the neck, cork it tightly, and set it aside to cool.

When fully dissolved and cooled, the solution should be quite clear with, at most, a faintly pinkish tinge to it. Any significant brown color indicates an error in mixing, usually from using water too hot. Mark this jug "Dektol Stock Solution" with tape and Magic Marker.

The stop bath need not be mixed in advance; it is prepared in the tray as needed.

The Fixing Bath

The fixing bath is exactly the same as the one you mixed for film developing, and you can use the solution right from the bottle. Note, though, this means only that you do not need a different formula; it does not mean that you can save a fixing bath that has been used for film, and later use it for paper. This will, in all likelihood, cause bad stains if you try it. The secret of consistent results in photography is to use fresh chemicals for every step, to discard the used baths when you are finished, and to never attempt to save a used chemical bath of any kind for future use.

You will need a quart of fixing bath for an 8″ × 10″ tray, and this will safely fix about 20 sheets of 8″ × 10″ paper. There is one little

With the paper inserted and the back fastened, the frame is ready for exposure.

trick sometimes used when you want to make only a few prints and wish to conserve chemicals. If, say, you intend to make no more than a half-dozen 8″ × 10″ prints, you can take 500cc (16 ounces) of fixing bath, and add 500cc (16 ounces) of water to make a litre (about a quart) of diluted fixing bath. This weaker bath is still strong enough for papers (but NOT for films), and you can economize this way when you have to. But remember that it does not have the fixing capacity of a full-strength fixer and must not be used for more than a half-dozen prints. If you intend to make more than that, use a full quart of full-strength fixer.

CONTACT-PRINTING EQUIPMENT

The original device for making contact prints was called a "printing frame"; it was a wooden frame with a glass front; a removable back was hinged in the middle with two strong springs to hold it shut. The main reason for the split, hinged back, was to make it possible to open half the back and examine a print while it was being made on printing-out paper. The other half of the back, remaining locked, prevented the paper and negative from shifting position while being examined. This reason for a split back has ceased to exist, but printing frames are still being made that way; it makes it easier to align negative and paper while closing the back of the frame.

If you expect to do much contact printing, it pays to own one good printing frame in the 8″ × 10″ size. It is quite possible to make smaller prints in a big frame, and the 8″ × 10″ paper size is convenient for proofing an entire roll of 35mm or size 120 negatives on one sheet of paper.

This frame is placed under or near a light source for printing; a more convenient arrangement, used by those portrait photographers who still use large negatives, is a "printing box." This is a simple wooden or metal box

containing one or more lamps and a glass top; over the glass is a hinged pressure pad covered with felt and fitted with springs much like those used on the back of a printing frame. For making prints in quantity, this is convenient, and the amateur who wants one can often find second-hand ones quite cheap; in addition, there is a variety of surplus Air Force contact printers to be had, and these have certain other interesting features, such as built-in timers. Inexpensive amateur printing boxes are made in small sizes, even today, and are handy for making 2¼" × 3¼" prints in quantity. Old-time amateur printing boxes sometimes turn up in the used equipment sections of camera shops; many of these were made in the 4" × 6" size, for printing up to 4" × 5" negatives and also for 3¼" × 5½" postcards.

For this first lesson, however, we need only a simple printing frame, and even this is not essential. To make contact prints with the least equipment, all you must have is a piece of heavy plate glass—at least ¼-inch thick—and a foam-rubber pad, such as is sold in stationery stores to put underneath typewriters. The sheet of glass should be at least 9" × 11" and if possible should be purchased from a glass shop that makes tabletops. They have the equipment to grind the edges of the plate smooth, so you will not cut your fingers while handling it. If all you can get is a fresh-cut piece of plate glass, simply cover the edges with thin cloth or plastic tape—the flexible black plastic tape made for electrical work is excellent, but in a pinch, ordinary adhesive tape or gummed paper tape will do.

The piece of foam rubber is either placed on the tabletop or glued to a sheet of plywood. When in use, the sensitive paper is placed on the foam-rubber pad, with the coated side of the paper up. The negatives to be printed are placed on the paper, coated side down. Then the glass is gently pressed down over the entire thing, producing tight contact between negative and paper.

We also need a light source for the exposure. For contact printing on enlarging paper, you may, if you already have an enlarger, use it as a light source, without any negative in the carrier. If you don't have an enlarger, use a 7½-watt white bulb suspended above the table at a distance of from 1½ to 2 feet. Keep a record of the exact distance from light to paper, and in the case of the enlarger, the f/stop at which the lens is set, so you can get repeatable results.

If you find the distance of the 7½-watt bulb results in too short exposures, you may increase it; if times are too long, it is better to change to a larger bulb, say, a 15-watt. The distance should not be reduced in the latter case; the light will be uneven, and you may get more exposure in the middle of the paper than at the corners.

Other Equipment

Having a light source and a printing frame, or a piece of heavy plate glass and a rubber pad, we also require a set of three 8" × 10" developing trays (actually, they are a little bigger, so you can get a sheet of 8" × 10" paper into them and have room to move it around with the print tongs) and a set of tongs—that is, three pairs of print tongs, one for each tray. Never immerse any pair of tongs in any tray but its own; that way, there is no danger of contamination, which causes stained prints.

Preparing a developer for print papers. The graduate on the left contains 500cc (16 ounces) of water, and the one on the right contains 250cc (8 ounces) of Kodak Dektol stock solution. Mix them together in a tray.

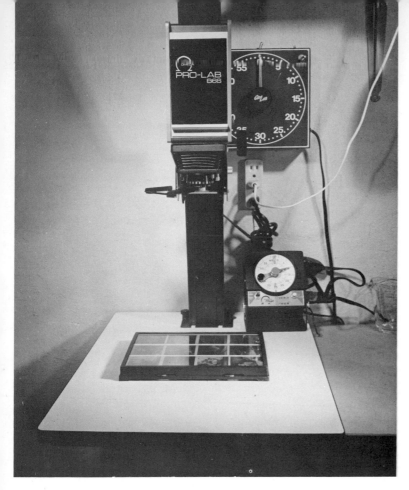

An enlarger can also serve as a light source for contact printing, using fast enlarging papers. The head is placed fairly high on the column to secure adequate light coverage of the whole frame. Exposure can be controlled with the enlarger timer, and if too short or too long, additional control is possible using the lens diaphragm.

PREPARING THE DEVELOPER

As mentioned, the developer solution is stronger than we need. Therefore, to make a litre (about a quart) of Kodak Dektol Developer, take 330cc (about 11 ounces) of Dektol from the stock solution bottle; pour this into the tray, then measure out 660cc (about 22 ounces) of water and pour that into the tray; stir with the first set of print tongs. This will make a total of 990cc (about 30 ounces), which is close to a litre. Since we have added twice as much water as stock solution, we can say that we have diluted one part of developer stock with two parts of water, or that this is a 1:2 dilution. Check the temperature of the mixed developer with your thermometer; it should be about 20 C (68 F) but need not be exactly that temperature. If it is within the range of 18 to 22 C (65 to 72 F), that is close enough, but if it is much colder or warmer, then set the tray in a larger tray filled with hot or cold water, to adjust the temperature to the proper range. Excessively cold developer will not produce good black tones in the print; if it is too hot, it may cause stains or fog.

PREPARING THE STOP BATH

In your second tray, you will need a stop bath. As we suggested earlier, you have bought a bottle of acetic acid, glacial, 99%. Some dealers only stock a weaker form, known as No. 8, or 28% acetic acid. This will do, but you will have to use more of it. It is also a bit safer to handle; the 99% acetic acid can cause blisters if you spill it on your hands, but you ought to be careful in any case.

To make a stop bath, simply pour 970cc (about 1 quart) of water into your second tray, then measure out 30cc (1 ounce) of 99% acetic acid, pour that into the tray, and stir with your second pair of tongs. If you could only get 28% acetic acid, then you will put only 880cc (about 30 ounces) of water in the tray, and add

120cc (about 4 ounces) of 28% acetic acid. Either way, you end up with a 3% solution of acetic acid, which is mild and will not hurt your hands if you get any on them. A litre of this is good for about twenty 8″ × 10″ prints.

Again, check the temperature of this bath with your thermometer, and if it is between 18 and 22 C (65 to 72 F), that is good enough. Rinse your thermometer before you use it to check the developer again.

PREPARING THE FIXING BATH

Your third and last tray should contain a litre (about a quart) of fixing bath; as previously mentioned, this is the same fixer that you made up for developing negatives. If you are going to make more than a dozen prints, use a full litre of fixer; if you intend to make only a few prints, then you may take 500cc (16 ounces) of fixing bath and add 500cc (16 ounces) of water to it. Check the temperature, and bring it to somewhere between 18 and 22 C (65 to 72 F). Wash your thermometer before using it again or before putting it away.

This order of mixing, starting with the developer and ending with the fixing bath, is prescribed for several reasons, one of which is that you will have time to adjust the temperature of the developer while mixing the other baths. By mixing in this order, also, there is less danger of contaminating the developer with stop bath or fixing bath. Just the same, cleanliness is the most important thing, and each utensil, including measuring cups, stirring rods, thermometer, and so on, should be carefully washed each time it is used, even if you intend to use the tool again in the same bath. The important thing is to get in the habit of keeping all your tools clean all the time.

With all the baths mixed and at the right temperature, you are now ready to make your first print. Be sure, before beginning the next step, that your hands are clean and dry; handling a negative with wet fingers can ruin it.

Preparing a stop bath. The large cup contains 1 litre (32 ounces) of water, and the graduated cylinder contains 30cc (1 ounce) of 99% acetic acid glacial. First pour the water into the stop-bath tray, then add the acid. Stir the solution for one minute with the print tongs for the stop-bath tray.

MAKING THE FIRST PRINT

Choose a negative that you would like to make a print of; preferably, find one that is neither too light nor too dark and neither too high nor too low in contrast. For this first lesson in printing, we will not attempt to correct the contrast of the negative at all, and our prints will serve as tests for the next lesson on enlarging. If you have some reasonably good negatives, you should get some excellent small prints to give your friends, relatives, and neighbors.

Turn on the safelight and turn off the room light. The Series OC safelight is pretty bright, and in a minute or two you should be able to see very well indeed.

Now you may open your package of paper. Take out one sheet, fold it in quarters, and tear (or cut) it into four pieces, each about 4″ × 5″. Return all but one piece to the package, and close the envelope tightly.

You will note that your piece of paper is quite shiny on one side—this is the coated side, or technically, the "emulsion" side. Your negative, contrariwise, has a shiny side and a dull one, and in this case, the dull side is the emulsion, or coated, side.

To get the picture the right way around, it is necessary that the coated sides of negative

1. Slide the paper into the developer tray, face up.

2. Press the paper below the surface of the developer with the tongs, making sure it is completely covered.

3. Now turn the paper face down with the tongs.

and paper be in contact with each other. If you are using a printing frame, take out the back and put the negative on the glass, emulsion side up. Then place a piece of paper over the negative, emulsion side down, and attach the back.

If you do not have a frame and are printing on the tabletop with a piece of plate glass and a sheet of foam rubber, then you have to do it the opposite way. Put the paper on the foam backing, emulsion side up, then put the negative, emulsion side down, on the paper, and finally place the glass on top of them, pressing it down gently to get good contact between film and paper. It is not necessary to hold the glass down during exposure; the preliminary squeeze is just to expel any air bubbles and assure good contact.

Double check to be sure all other paper has been returned to the package and the package is tightly closed. Place the printing frame under the hanging lamp with the 7½-watt bulb, or put it on the easel of the enlarger. Now proceed as follows:

1. Turn on the lamp and expose for exactly ten seconds, using a clock or timer; don't guess. This will not necessarily be the right time or anywhere near it; it is just a trial to determine the true exposure.

2. When the ten seconds are up, shut off

the light. Under safelight illumination, take the paper out of the printing frame or from under the glass.

3. Having the chemical trays arranged from left to right—developer, stop bath, fixer—take the exposed sheet of paper in your right hand, emulsion side up, and slide it into the developer tray with a sweeping motion so it becomes completely immersed, but let go of it before your fingers touch the liquid in the tray.

4. Pick up the tongs that were in the developer tray, grab the paper by one corner and turn it over, face down, in the developer. Gently move the paper around in the tray, but don't press it all the way to the bottom. It should float just under the surface. What is important is that you immerse the paper face up, and then turn it over after it is wet; if you try to immerse it face down, you will almost certainly trap air bubbles, which will cause white spots on the print where the developer did not act upon the emulsion.

5. Watch the timer or sweep-second clock while you are doing this. At the end of about a half minute, turn the print face up again, keeping it under the surface of the developer. If the print is anywhere nearly correctly exposed, it will be about half developed at this point but still darkening rapidly. Don't worry about this right now; it won't run away with you.

4. Press the paper under the surface of the solution, and move it around gently with the tongs.

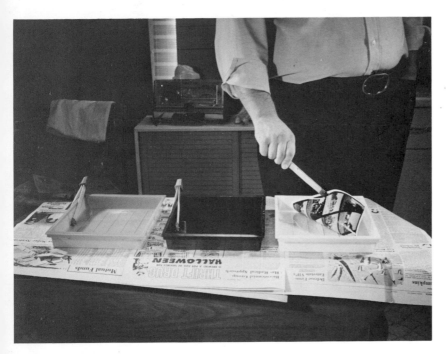

5. At the end of 30 to 45 seconds, turn the print right side up again, and drop it back into the tray.

6. Again press it below the surface of the solution, and agitate it gently with the tongs.

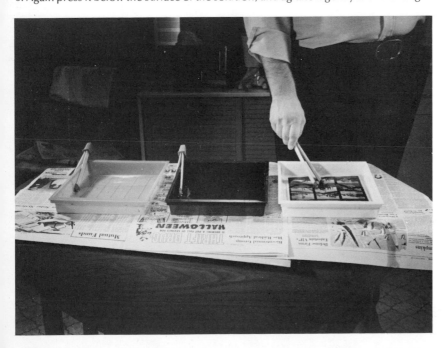

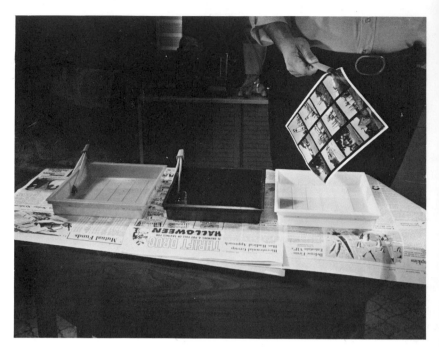

7. When developing time is up, lift the print from the tray, and allow it to drain for a few seconds.

8. Now drop the print face down into the stop bath, and return the developer tongs to its tray.

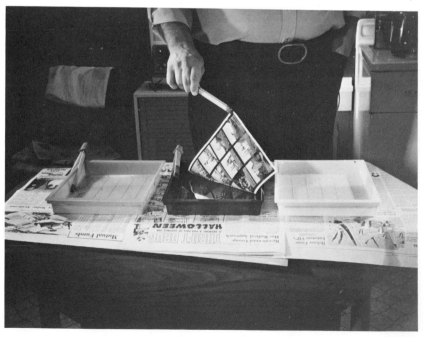

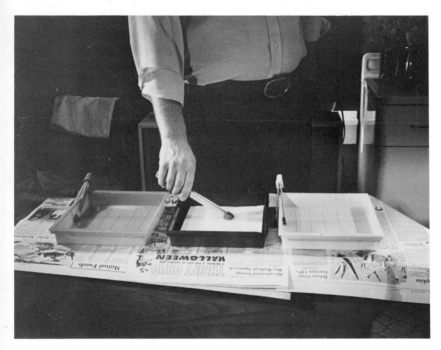

9. Agitate the print gently, face down, with the stop-bath tongs.

6. If the print is already too dark at the end of the first half minute, lift it out of the tray, drain it, and transfer it immediately to the wastebasket. If, on the other hand, only a faint gray image appears by the end of the first half minute, again lift, drain, and discard the print. It is not possible to save a flagrantly over- or underexposed print.

7. As mentioned in Step 5, if the exposure is nearly right, the print will be about halfway developed and darkening rapidly. You will note, though, that the increase in darkening slows down quite markedly, and by the end of a full minute of total developing time, the development will have come nearly to a stop. In this case, if the print is about right in appear-

ance, you may transfer it to the stop bath; if it still needs a bit more darkening, development may continue for another half minute or so. By the end of 1½ minutes, development will just about come to a complete standstill, and no more density can be gained by continuing to develop.

Since you are using enlarging paper in this test, there is one thing to keep in mind. Enlarging papers have a faint "veil," or cloudy appearance, while developing; this disappears in the fixing bath, at which point the print will be noticeably darker. So do not attempt to obtain really intense blacks in the developer, and more important, don't force the print; all you will get is stains.

8. When development is complete, pick up the print with the tongs, allow it to drain back into the developer tray for a few seconds, then drop it, face up, into the stop-bath tray. Do not let the developer tongs touch the stop bath.

9. Put the developer tongs back into the developer tray, pick up the stop-bath tongs, grasp the corner of the print and turn it face down, then face up again, moving it around a bit as you do so. Then pick up the print, allow it to drain, and drop it into the fixing bath. Return the stop-bath tongs to its tray.

10. Pick up the fixer tongs, and move the print around in the fixer for about a minute, making sure it is completely immersed and face up.

Now, of course, you can turn on the white light and get a better look at your print. Prints can stay in the fixer at least 15 minutes without harm, so you have ample time to decide what to do next.

At this stage, it is important to set up the routine of development, using one pair of tongs for each bath, never letting any pair of tongs touch any solution except its own, and never getting your hands wet. The whole routine should be repeated until it becomes habitual. If, by accident, a pair of tongs gets contaminated with any other solution than its own, it should be washed at once, before being returned to its tray. Contamination is the greatest source of fog and stains, and a very small amount of hypo on a pair of tongs can

10. At the end of 30 seconds or so, lift the print from the stop bath, and drain it for a few seconds.

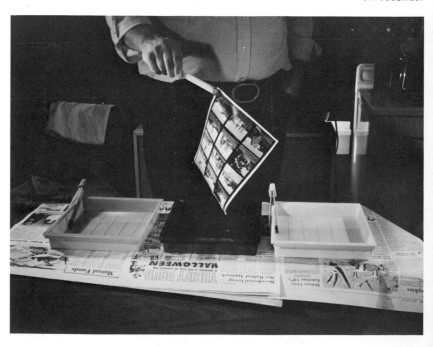

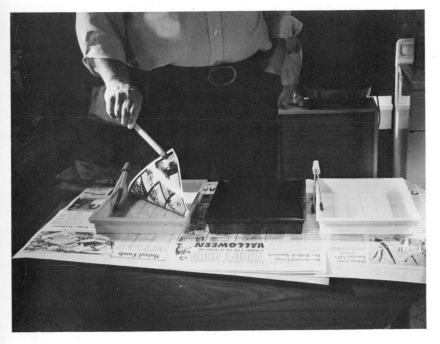

11. Drop the print face down into the fixer, and return the stop-bath tongs to its tray.

12. Agitate the print gently in the fixer with the fixing-bath tongs.

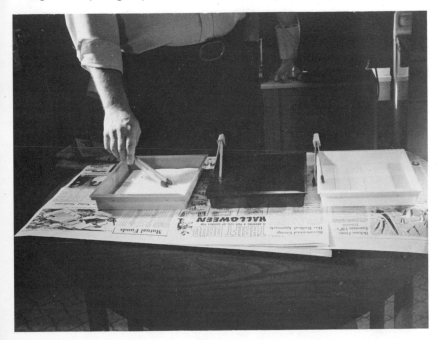

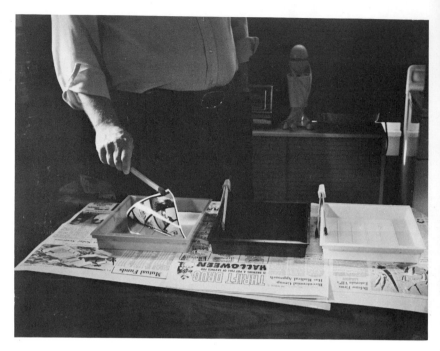

13. Turn the print face up in the fixer.

14. Now press the print below the surface of the fixer, and leave it there while you proceed to make your next print.

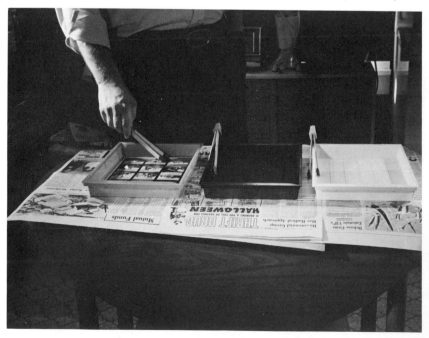

15. Washing prints in an inexpensive washing tray attached to the faucet of the kitchen sink.

do a great deal of damage if it touches a print in the developer. Absolute cleanliness is the main rule, and one followed by all professionals.

THE CORRECTED PRINT

Suppose, now, that your first print was no good. This is nothing to worry about; it was only a test, anyway. What you do now is to take out another 4″ × 5″ sheet of paper, and print the same negative with a different exposure. Obviously, if your test print was too dark, you must give the second print less exposure; if it was too light, then your second print will need more exposure.

The question is, of course, how much more or less? It is well to understand from the very beginning that small changes in exposure produce very little difference in results, and this is what makes the whole process easy; if your exposure is somewhere near right, a slight adjustment in the developer will finish the job. On the other hand, it means that if you were wrong, you have to make a pretty big change in exposure to make a real difference in the results.

Thus if your print was too light with a 10-second exposure, you will have to go to at least 20 seconds to make it much darker. If that is not enough, then the next jump is to 40 seconds rather than to 30. In short, first adjust-

ments must double or redouble. And by the same token, if the print was much too dark, you have to cut the exposure in half or even to one quarter the original.

In the latter case, though, it gets pretty hard to control exposure when it gets to five seconds or less, and instead of cutting the exposure down, try moving the lamp farther away —it will be found that moving it from 24 to 36 inches will be the equivalent of cutting the exposure in half. Moving it from two feet to four feet will give, not one half, but one quarter the exposure.

So make a second print of the same negative, with a corrected exposure, and again develop, stop, and fix it, and examine it by white light. If it is still not right, make still another change of exposure, and make a third print.

This reprinting of the same negative several times is good practice and is worth the paper that will be used; you are learning how to judge an exposure and also how to decide on what your particular set-up requires in the way of a normal exposure level. Once you have done these first few prints, you will find that the next time it is much easier—you can start right out with the last exposure you used.

Development Time

At the beginning, you will make all your corrections by changing the exposure, keeping the developing time constant. If you try to vary both at the same time, you will never arrive at a consistent way of working. It is for this reason that we suggested you turn the print face down as soon as it is placed in the

16. Wipe the face of the print with a soft viscose sponge.

17. Then wipe the back of the print with the same sponge.

18. Dry the print face up on newspapers.

19. Dampen the back of the dry print with a moist sponge.

developer, keeping it face down for at least the first half minute. This will prevent your trying to save an overexposed print by snatching it from the developer before it is fully developed; a print cannot be saved that way. All that happens is that you get a streaky, unpleasantly greenish-colored print. There is very little control possible in the developer; only after you have the exposure very nearly right can you shorten or lengthen the developing time just a bit to get the exact density you want. When you turn the print face up, if it is either already too dark or much too light, you might as well discard it right then and there; it is a waste of time to attempt to save it.

We want to repeat something we said a while back. Paper develops a lot faster than film; the times are between 45 seconds and 1½ minutes, never less and seldom more. This may seem a bit scary at first, but after you have done it a couple of times, you will find you have ample time to carry out the various steps; moreover, the speed of the process makes it possible to turn out a fair number of prints in a short time. There is no time to waste, but you need not hurry or skip any steps; the exact developing time is not at all critical, just so it is somewhere between the times given. The reason is this: As we have already pointed out, unlike films, which are only partly developed, papers develop completely, and so at the end of a minute, development is just about finished. You can leave it in the developer a bit longer without much effect on the density, and so you don't have to snatch the print out the minute it looks right.

20. Place the dampened print in a telephone book to flatten out.

You can take your time and do the job smoothly and without splashing chemicals around.

Professional photographers, in fact, usually develop all prints by time, without even watching them as they develop. If you have the correct exposure, you can do the same thing; that is, after you have gotten a good print from your first negative, you can pick out a handful of other negatives that look much the same in density, and print them all at the same exposure. Doing it this way not only saves materials, it also ensures the best possible print quality.

You should get in the habit of developing by time for another reason. While contact papers produce an image in the developer tray that is just about the same as it will look after fixing,

this is not the case with enlarging papers. Some enlarging papers, such as Kodabromide and Velour Black, tend to have a whitish veil over the image, and become noticeably darker when they are put into the fixing bath. Others, like Kodak Polycontrast Rapid, are just the opposite; they appear very dark in the developer, and lose some density in the fixer. Thus you can't judge the quality of a print on enlarging paper while it is developing, and it is best to handle all papers alike.

We suggest that you print the same negative over several times, even after you have arrived at what appears to be the correct exposure. Very small changes in exposure and developing time will make only small changes in the final print, but you may find you like one better than another. More important, you will

(Left) A sample of a proof-sheet print made from an entire roll of size 120 negatives on a single sheet of 8″ × 10″ paper. (Above) A contact sheet of 35mm negatives.

61

learn that the process is quite consistent; if you do the same thing every time, you will get the same result every time, and this is what we told you at the very beginning.

FURTHER CONTACT PRINTING

The print you get at this point will be a good one, though it may not be the best print that could possibly be gotten from that negative, for reasons we will go into in the next lesson. Papers are made in several contrast grades, and sometimes a better print can be made on some grade other than No. 2. But for the moment, we want you to print all your negatives on No. 2 paper; the prints you made will help you in learning to judge the negatives from which they were made.

Once you have gotten a good print from the negative you used for practicing, you can proceed to print the others in the same batch. As we suggested, you can first pick out all the other negatives that seem to be about the same density as the one you printed first; these will obviously require just about the same exposure, but after you get the feel of things, you will probably find yourself automatically noting that a given negative is just a bit lighter and will need a little less exposure; that another negative is a bit darker than the average and will need a bit more exposure. And from there to printing those negatives that are a goodly bit darker or lighter than normal is just a matter of practice.

The Proof Sheet

Once you have done this, then you can save some time; if, say, your test roll of negatives was well exposed and fairly uniform in density, you will want to try making a *proof sheet,* that is, printing the entire roll of negatives on one sheet of paper. An 8″ × 10″ sheet of paper will accommodate an entire roll of 120 film or 36 exposures of 35mm. Simply cut your negative roll into strips. There will be four 2¼″ ×

2¼″ negatives on a strip or six 35mm negatives on a strip, and you can print three strips of size 120 lengthwise on the 8″ × 10″ sheet. Six strips of six 35mm negatives will go lengthwise on the same sheet. A test exposure should first be made on a 4″ × 5″ piece of paper of a representative strip of negatives, then the entire sheet can be exposed and developed.

All through this we have assumed that you have arrived at a fixed distance for the light to the paper frame or glass. Once this has been arrived at, it should not be changed; only by keeping as many factors as possible constant can we be sure of consistent results. In the case of lamp distance, small differences in distance make large changes in intensity, so we should make an effort to be exact.

The value of making a proof sheet of an entire roll of negatives is that the resulting print shows almost exactly the variations in exposure throughout the roll and how much compensation will have to be made when printing each negative individually. Thus the proof sheet will be a good guide to making enlargements of the same negatives later. Most photographers always make a proof sheet of every roll before making enlargements. After the proofs have served their purpose, they can be filed with the negatives for reference; there are a number of good negative filing systems on the market, which have accommodation for both the negatives and the proofs.

The Holding Bath

If your entire printing session lasts about 15 to 20 minutes, you can let the prints accumulate in the fixing tray without harm. If you intend to work longer than this, you should take the prints from the fixer after five to ten minutes and put them in another tray containing plain water; this is called a *holding bath.* The reason is that extended fixing may bleach the prints slightly and will also affect the tone of the blacks to a small degree. The prints can remain in the holding bath as long as you wish, till you are ready to wash them.

WASHING AND DRYING

When you have made all the prints you want to make at this session, give the last few prints a few extra minutes in the fixing bath. Then they must all be washed and dried. There are several ways to wash prints, of course, and the simplest is in running water.

This does not mean that you can simply put a trayful of prints under a faucet and let water run over them. What will happen is that the prints will bunch together, and the water will simply flow across the top of the stack and overflow without washing the paper at all.

Print Washers

There are print-washing trays of various kinds, which do a fairly good job; they are all designed so that the incoming water runs between the prints and keeps them in motion for best washing. The best washers are fairly large and are round rather than rectangular. These are so made that the water keeps the prints spinning around in the tray so they do not cling together. In such a washer, prints on lighter-weight papers will wash in 15 to 20 minutes; heavier papers will take a little longer. The new RC (resin-coated) papers will wash in five to ten minutes, regardless of weight. If you can't afford such a washer, an ordinary tray, fitted with a Kodak Tray Siphon, will do a pretty good job too. For this, the tray should be rather larger than the prints, say, about 16″ × 20″ for 8″ × 10″ prints.

If you can't get that, you can use the same system you used for washing negatives. Fill an 8″ × 10″ tray with water and immerse your prints in it, one at a time, till all are in the water. Then let them lie there for five minutes. Now fill another tray with fresh water and transfer the prints, one by one, to the second tray. Discard the water from the first tray, refill it with clean water, and transfer the prints back to it, after they have been in the second tray about five minutes. If you do this for six to eight changes of water, you will have washed the prints as well as any regular washing device could have done.

While the prints are being washed, empty all your chemical trays, and wash out the trays with clean water. Also wash all the tongs and everything else that has come in contact with the chemicals. Now you can mop up your tabletop or wash out the sink, and all is in readiness for your next printing session.

Drying the Prints

After the prints have been washed, they must be dried. The paper is removed from the water, one print at a time, and both sides wiped with a clean cellulose sponge (NOT the one you washed the sink with!). With all surface water removed from both sides of the prints, they can be laid out, face up, on dry newspapers, where they will finish drying quite rapidly. This recommendation may cause some raised eyebrows among those who know that newsprint paper contains some chemicals that are likely to be harmful to prints, but in fact, if the print is wiped nearly dry at the outset, there is little chance of transferring anything from the newsprint to the backs of your prints. If you have printed on resin-coated papers, they are quite impervious and can be dried, face up, almost anyplace. If your prints are valuable and you wish to ensure permanence, you can dry them on chemically clean blotters that can be bought at the larger photo stores.

The trouble with blotters is that they are fairly expensive, and thus you will save and use them over and over again. Yet even tiny traces of chemicals left in prints will accumulate in the blotters after a time. So pretty soon they will be no purer than newsprint paper. The best process is simply to get the prints as dry as possible before laying them on anything.

There are machines for drying prints, but until you get to making a great many prints, they are not necessary, and in the case of RC papers, they aren't very useful.

The dried prints will have curled up somewhat and will need to be flattened. This is easy enough; all you need is a telephone book and a cellulose sponge. Wet the sponge and then wring it out as hard as you can; it should be only slightly damp. Now wipe the backs of the prints with the damp sponge; be especially careful not to get any water on the face of the print. As you dampen the back of each print, slip it into the telephone book. Give the whole stack a half hour or so to dry, and when you take them from the book, they will be nearly perfectly flat. Again, we repeat, DON'T get any moisture on the front of the prints; if you do, they will stick to the pages of the book and be ruined. Likewise, do not place them in immediately adjacent pages of the book, because some moisture may seep through and cause damage. Once all the prints have been dampened and placed in the book, wait about 15 minutes and take them out; they should be quite flat, with a trace of moisture in them, so they will not be too stiff and hard to handle.

This ends the making of contact prints. If you have followed instructions exactly, you should have a handful of good prints to show for your efforts. These prints will serve a more important purpose, though; they will be used in the next lesson to judge the contrast of your negatives before you make enlargements from them.

LESSON 3

Basic Enlarging

Once you have made some contact prints, you will find there is little new to learn when you turn to making enlargements. The difference is that the negative is not placed in contact with the sensitive paper; instead, an image of the negative is projected onto the paper. By adjusting the distance from the projector to the paper, the size of the enlargement can be varied as desired.

In general, projected images are not as bright as those made with negative and paper in contact; one reason is that the same amount of light is spread over a larger area of paper. Be that as it may, the situation is taken care of simply by making papers for enlarging purposes rather more sensitive than those used for contact printing. Since enlarging papers are more light-sensitive, it is necessary to use a deeper-colored safelight to avoid fogging them. If, however, you followed our advice in the previous lesson, to use a Wratten Series OC or DuPont S-55-X safelight, it will be safe for nearly any kind of enlarging paper commonly in use with black-and-white negatives.

ENLARGING PAPERS

A number of enlarging papers are available; they differ in various ways. Some produce cold, blue-black tones, others neutral-black, warm-black, and even brown-black tones. Usually, the warm-toned papers are less sensitive than the cold-toned ones; they need more exposure in printing. Often, the warm-toned papers also require a different developer to produce the specific image tone for which they are designed.

Like contact-printing papers, enlarging papers are made in a number of surface *textures* and also in two or more *weights*. The term "weight" refers to the thickness of the paper on which the emulsion is coated, and most papers are available in "single-weight," which is rather thin, and "double-weight," a heavier stock. Single-weight papers are generally used for smaller-size prints or for prints that are to be mounted on cardboard. Double-weight paper is used for the larger sizes and unmounted prints.

Finally, enlarging papers are often made in several degrees of contrast. "Contrast," in this case, refers not to the paper but to the negative intended to be printed on it. *Variable-contrast* enlarging papers are made so that the contrast of a single sheet can be adjusted by changing the color of the enlarging light with filters; many modern enlargers have provision for inserting such filters in the lamphouse.

Interestingly, though, these papers can be used without any filter at all; in this case, the paper will react almost exactly like a No. 2 grade of an ordinary enlarging paper. If all you can get is one of the multi-contrast papers, you need have no hesitation in using it for this lesson, without any filters at all.

For this lesson, it is suggested that you buy a package of 8″ × 10″ sheets of any one of the following papers; they are all essentially alike and handle the same way. Choose the glossy surface, single-weight, and normal No. 2 contrast. There are, according to some photographers, subtle differences between the papers of various makers, but you will not notice these at first, and any one of the following will do nicely.

> Agfa Brovira Paper
> DuPont Velour Black Paper
> Ilford Ilfobrom Paper
> Kodak Kodabrome II RC or Koda-
> bromide paper
> Luminos Commercial F Paper

And as we have mentioned before, if all your dealer has in stock is a variable-contrast paper, such as

> DuPont Varilour Paper
> Kodak Polycontrast Rapid II RC Paper

you may use any of them, without any filter whatever, to print negatives of normal contrast. Exposures will be fairly short with these latter papers, because they are made faster than normal to allow for the loss of light in the filters. But this will make no real difficulty, and you can get used to variable-contrast papers immediately; all you will need for later lessons is a set of filters.

CHEMICALS

If you prepared a gallon each of the developer and fixing bath recommended for contact printing, you will need nothing new for this lesson. All chemicals are the same as for contact printing. The developer, again, is Kodak Dektol Developer, the stock solution being diluted 1:2 as before; the stop bath is 30cc (an ounce) of acetic acid, glacial, to one litre (a quart) of water, and the fixing bath is taken right from the stock bottle. By now you may have been offered various other chemicals by your dealer, and while most of these are probably just as good as the ones we recommended, others may not be.

The problem is this: Years ago, enlarging papers were made with a somewhat different emulsion coating composed mainly of silver bromide, much like the coating on a film. These papers required a rather dilute developer and had to be developed for anywhere from three to four minutes. Since that time, paper emulsions have changed; they are now mixtures of silver bromide and silver chloride and certain additives. Today's papers resemble contact papers more than they do films; like contact papers, they require a strong developer and are intended to be developed for a very short time, from 45 seconds to 1½ minutes at most.

If you use Kodak Dektol Developer, you can mix and dilute the stock solution so as to secure the strength you need for best results. The same applies to corresponding products made by other manufacturers, such as Dupont Developer 53-D, which is diluted with water in the same way to produce much the same results. Ilford Bromophen will also work well but needs to be diluted only with an equal

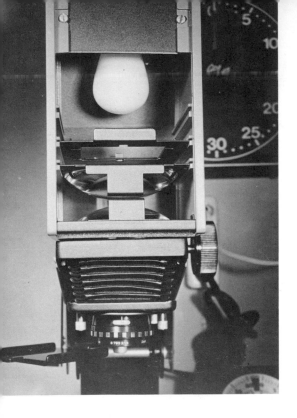

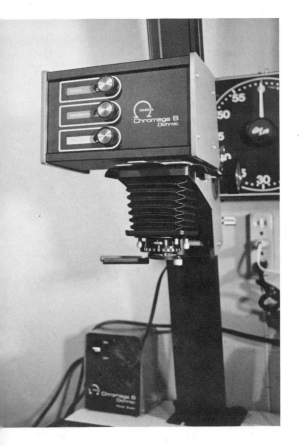

part of water. Some trademarked paper developers are already too dilute to produce really good results on most enlarging papers—any developer that calls for development for two to three minutes or longer should be avoided at this time. (Such developers sometimes are useful with warm-toned papers, and warm-toned developers usually require longer developing times at greater dilution.)

ENLARGERS

An enlarger is simply a kind of projector; it differs from slide projectors in that it is made quite lighttight so that no stray light escapes from the lamphouse to fog the paper. More important, its lens is designed to produce an image on sensitive paper, not a visual one; it is much like a camera lens in that way. Like a camera lens, it has a diaphragm to control the exposure; but unlike a camera lens, it is designed specifically to work at short distances. Finally, for the sake of convenience and compactness, enlargers are usually designed to work vertically, projecting the image downward to the sensitive paper.

Enlargers are made in a variety of sizes, from small machines accommodating only neg-

(Above) Interior of a condenser-type enlarger lamphouse. In this case, there are two thick condenser lenses, but a third lens is added when printing small negatives. This third lens directs all the light through the smaller negative and makes printing faster. (Left) A similar enlarger, but this one is fitted with a diffusion-type lamphouse, producing somewhat softer prints. This particular lamphouse is intended for color printing and has built-in filters in three colors. It can also be used for black-and-white printing by setting all filters to zero. The built-in filters can be used to control the contrast of variable-contrast papers within limits (a No. 4 contrast is not possible).

atives from Pocket Instamatic size (11 × 17mm) to double-frame 35mm negatives (24 × 36mm); to medium-size machines accepting 2¼″ × 2¼″ or 2¼″ × 3¼″ negatives; and on up to big professional machines handling 4″ × 5″ negatives and even bigger.

It would seem that the best thing is to get the biggest enlarger you are likely to need, since you can always put smaller negatives in a big machine. This, however, is not always practical. A 4″ × 5″ enlarger, unless fitted with a second set of condensers and a short-focus lens, will not be very useful with 35mm negatives. On the other hand, a miniature enlarger is likely to have limited use if it is the only one you own. Probably the best compromise is a machine, such as the Omega B-66 or the Bogen 22A, either of which will accept negatives up to 2¼″ × 2¼″. If fitted with two lenses —a 50mm lens for miniature negatives and a 75mm lens for the larger negatives—it will serve all purposes well enough.

If you do expect to be doing much printing from larger negatives up to 4″ × 5″, it is probably best to consider owning two enlargers; in this case, the smaller of the two may well be a true miniature machine for 35mm and smaller negatives only. The larger machine, for 4″ × 5″ negatives, can easily handle anything down to 2¼″ × 2¼″ simply by providing the appropriate negative carrier; it may be well to have two lenses for the larger machine, such as the 5½-inch or 6-inch lens for the bigger negatives, and a 90mm lens for the 2¼″ × 2¼″ originals.

(Above) Where the enlarger has provision for placing a filter in the lamphouse, then less expensive plastic filters can be used, and a small amount of dust on the surface will not affect the quality of the prints noticeably. If you plan to do much printing with these filters, then you should install a heat-absorbing glass in the lamphouse above the filter holder. (Right) If the filters are placed under the lens, as shown here, they must be of optical-quality gelatin, and they must be kept spotlessly clean.

In any case, buy the best enlarger you can afford; enlargers do not come out in annual models like automobiles or some cameras, and a good enlarger can last you for your entire photographic career. More important yet, buy the best lens you can afford for your enlarger. An inferior enlarger lens can ruin the definition of pictures made with the finest of camera lenses; hence your enlarger lens should be at least as good as the lens of your camera. It will not be as expensive, though, simply because enlarger lenses need not be of very large aperture; many of the best of them work at $f/4.5$ or $f/5.6$ maximum.

Some enlargers will accept the lens from your camera. This should be avoided. For one thing, camera lenses are not designed to work at close range and do not produce their best images at short distances. More important, enlargers do develop some heat, which may damage the cemented elements of some camera lenses. Enlarger lenses are usually designed to avoid the problem of cemented elements and often have heat-resistant diaphragms, too.

TIMERS

One important accessory you should consider at the outset is the enlarger timer. Exact exposure control is very important with enlargers, simply because big sheets of paper are expensive. It will do little good, for instance, to make a test exposure of 15 seconds, if the exposure of the final sheet is likely to vary from 13 to 18 seconds.

A clock with a sweep-second hand, like the one you used for your contact-printing work, will do well enough, if you can't afford anything better in the beginning. But later on, there are procedures you will be following where you must watch the projected image on the paper, and it will be hard to watch a clock at the same time.

One compromise is an audible timer; some are made for photography and emit loud ticks or pings at one-second intervals. If you have a musician in your family, you may be able to borrow a metronome, which also ticks loudly, and if set at "60" will tick off seconds quite satisfactorily.

The best device, though, is some kind of mechanical or electrical timer that actually turns the enlarger on and off. The cheapest and simplest of these is a spring-wound clock-timer similar to the Mark-Time gadgets used in the kitchen. To use one of these, you merely turn the pointer to the number of seconds required; then when you press a button or latch, the enlarger lamp lights up, the pointer moves back to zero and shuts off the lamp at the end of its travel. These timers are perfectly practical, and their only disadvantage is that they have to be reset to the correct time for each exposure.

Better, though more expensive, are such timers as the Time-O-Lite, which use electric-clock mechanisms for timing. With these, setting the pointer to a given exposure merely presets an internal mechanism; once the pointer is set, pushing the button causes the timer to make that exposure. The setting does not change by itself, and the timer will repeat a given exposure over and over again, without variation, until it is reset. A still more expensive device is the entirely electronic timer, such as the Lektro-Lab; this uses a series of dials to make settings in steps as small as 1/10 sec. and up to several minutes in length.

All darkroom enlarger timers have a switch that allows you to turn the enlarger light on for focusing; this can also be used for manual control of very long exposures on occasion. Some have other conveniences; for example, an outlet for the darkroom safelight. When the safelight is plugged into the timer, it automatically goes out when the enlarger is turned on; this makes focusing easier, especially for dense negatives.

Another convenience is an outlet for a foot switch. When this is used, a tap of the foot switch starts the timer, which then makes the

exposure in the normal way. This is convenient for procedures such as *dodging* (to be covered in the next lesson), because it leaves both hands free.

EASELS

The only other piece of equipment you will need at this time is an enlarger easel. This is a simple gadget that holds the paper flat on the baseboard of the enlarger; it usually has masking devices of one sort or another to produce a white margin on the print.

If you plan on making only one or two sizes of prints, you can get "single-size" easels quite cheaply; these are very convenient to use, since they do not require any adjustments.

The usual adjustable easel is more flexible because it allows adjustment both of image size and width of white border. Generally, setting the position of the paper clamp adjusts the width of the margin, while sliding the masking bands adjusts image size. So to make a print on $8'' \times 10''$ paper, with a ¼-inch white margin all around, you simply set the paper clamp (or corner guide) to ¼ inch. Then you set the masking bands to 7½ and 9½ inches respectively, thus allowing for the ¼-inch margin on the opposite edge as well. Likewise, should you want ½-inch margins, you set the corner guide to ½ inch and then move the masking bands to 7 and 9 inches respectively. Other sizes are done the same way.

Finally, we assume you have already provided yourself with a safelight lamp containing a 15-watt bulb and a Wratten Series OC or DuPont S-55-X filter, three trays, and a set of three print tongs.

OPERATING THE ENLARGER

Before making any actual prints, it is a good plan to familiarize yourself with the enlarger. There are minor differences in detail between the various makes, and different devices are used for focusing, raising and lowering the head, inserting the negative, and so on. In all cases, however, the major controls are three: one to raise and lower the entire enlarger head, one to focus the lens, and one to adjust the lens aperture.

Set up the enlarger in your working area; most people like to have the enlarger at the left end of the table or sink, so they can work from left to right. Unless you have reason to prefer the opposite arrangement, this is as good a beginning as any. Plug in the enlarger and the safelight, and shut off the white room light. Adjust the easel for $7½'' \times 9½''$ and for a ¼-inch margin, and if it does not have a white focusing surface, insert a piece of plain white typewriter paper to focus upon.

Focus and Image Size

Choose a sharp, well-exposed negative from those you have already contact-printed. Insert it in the negative carrier, and place the carrier in the enlarger so that the emulsion side of the negative is facing downward. Set the enlarger head about halfway up the column, and make sure the lens diaphragm is wide open. Turn on the lamp; a bright image should appear on the easel.

Slide the easel to such a position that the image falls in the open area between the masking bands. Since the image at this point will most likely be out of focus, adjust the lens barrel or focusing mount to get as sharp an image as possible.

The image will probably also be of the wrong size; if too big, lower the enlarger head, if too small, raise the head. This will put the image out of focus again, and so you will have to refocus. What is mildly disconcerting at first is that the image goes out of focus when you change the size, and it changes its size when you focus it. This latter change is pretty small, though, and only a slight additional raising or lowering of the enlarger head should get the exact size you want. Now touch up the focus once more, and you are ready to print.

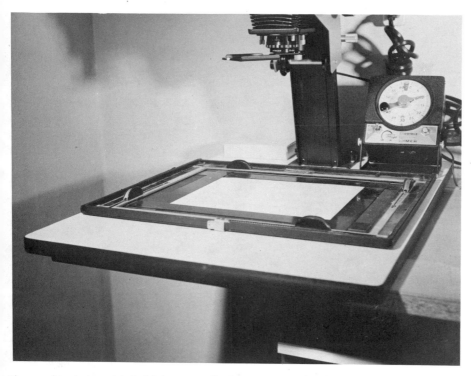

The easel is designed to hold the paper flat for exposure; the sliding masking bands produce even, white borders on the prints. Other types of easels are made for borderless prints, and some very simple ones, which use only one size of paper, are available.

Actually, while you will be printing the entire negative in this first lesson, make the projected image just a trifle larger than the opening between the masking bands, allowing it to overlap onto the bands on all sides. This will give clean, sharp edges to the printed area.

You will also note that the proportions of the negative are not the same as those of the paper. For instance, you cannot print all of a 35mm negative on 8″ × 10″ paper. If you set the length of the image to 9½ inches, you will find the width will come out only about 6½ inches. Setting the width to 7½ inches, you will find the length about 10½ inches or too big to fit the paper. By the same token, a 2¼″ × 2¼″ negative cannot be printed to 8″ × 10″ either—it will either produce an 8″ × 8″ image or a 10″ × 10″ image.

This is of no great importance; you will probably note that you can easily afford to sacrifice a bit of the original picture to make it fit the 7½″ × 9½″ print area. This will possibly allow you to correct slight mis-centering of the image. More important, this ability to print only part of the negative and make the image the exact size you want it is the most powerful tool in photography. It is called *cropping* and will be discussed more fully in later lessons; for now, simply try to print all or as much as you can of the original negative in the size you prefer. (We suggested 8″ × 10″, but you may wish, for economy's sake, to do this first lesson on a smaller-size paper.)

A few minutes of practice here is all that is necessary; it is just to get used to handling the adjustments on the enlarger. Try it first with

(Above) This picture needs cropping; there is a large amount of unnecessary background. (Right) Enlarged to a great magnification and cropped to a vertical composition, this print is much more interesting. A very small amount of dodging was done on both faces, but the shadow effect was maintained.

the room lights on, then after you can find all the controls by feel, try it in darkness or by the light of the safelight.

Lens Aperture

The one problem with some enlargers, when it comes to handling in darkness, is the setting of the lens diaphragm. The better enlarging lenses have a device by which some of the light from the negative is diverted through a little window to illuminate the diaphragm scale. One make has translucent aperture numbers that light up in red or green as the adjustment is made. The less expensive enlarging lenses usually have "click" stops, and you can get used to adjusting them simply by counting clicks. To avoid confusion, always turn the lens to its widest opening first, then stop down one, two, three, or more clicks as needed; thus if the lens is marked $f/4.5$, $f/5.6$, $f/8$, $f/11$, $f/16$, and $f/22$, to stop down to $f/8$, open the lens wide first, then close it down two clicks.

MAKING AN ENLARGEMENT

With all preliminaries out of the way, the first prints can be made. Begin by mixing chem-

icals as directed—Kodak Dektol Developer (or equivalent) stock solution diluted 1:2 with water (or use 330cc [about 11 ounces] of developer to 660cc [about 22 ounces] of water). This goes in the left-hand tray.

Put about a litre of water in the second tray, and add 30cc of acetic acid, glacial (or use a quart of water and an ounce of acid). This is your stop bath.

Put a litre (about a quart) of fixing bath in the third tray, and you are ready to begin.

Position the safelight so it shines on the developer tray, at a distance of at least four feet, assuming it contains a 15-watt bulb and a Wratten Series OC or DuPont S-55-X filter. Also place a set of print tongs in each tray.

You have already chosen a negative, and it is in the enlarger; it is assumed you have also decided on the size print you intend to make, and the easel is properly adjusted for that size. Turn off the room lights, turn on the enlarger, and check the focus and centering of the image. Now stop the lens down to $f/8$, and turn off the enlarger.

Recheck all your chemicals with the darkroom thermometer, and adjust temperatures to 20 C (68 F) if necessary. This is not quite as critical as it is for film development, but don't let the temperatures vary much; 18 to 22 C (65 to 72 F) is about as much variation as can be tolerated.

TEST EXPOSURES

Nobody can tell you in advance what exposure your prints will need. To find out, there are several methods, the simplest of which is to make a test strip.

With white lights out and the safelight on, open your package of paper, take out one sheet, and cut or tear it into five strips, each about two inches wide and eight inches long. Return all but one strip to the package and close it. Now follow these steps:

1. Place the strip of paper on the easel, emulsion side up, and sort of catercornered, so it lies under the most important part of the image you intend to print. Recheck to ensure that the remaining paper has been returned to the package.

2. Make an exposure of exactly 15 seconds, using whatever timing device you own; what is important is that it must be *exactly* 15 seconds, so you can repeat it as necessary.

3. At the end of the exposure time, take the strip of paper from the easel, and slide it into the developer, face up. Take the print tongs, turn the strip face down, and move it around gently for about 30 seconds. Now turn it face up again.

4. At the end of one minute, and regardless of what the test looks like, take it from the developer and drop it in the stop bath. Put the tongs back in the developer tray, pick up the stop-bath tongs, move the strip around for a few seconds, then let it drain, and drop it into the fixing bath.

5. Put the stop-bath tongs back in its tray, pick up the fixing bath tongs, and move the strip around in the fixer for a few seconds. Recheck to be sure no sensitive paper is uncovered.

6. Turn on white light and examine the test.

Corrected Exposures

It is not too likely that the first test will be anywhere near right, but it will tell you the direction to go in making the next one. Obviously, if it is too dark, you will have to use less exposure; if it is too light, you will need more exposure time. Unless it is very nearly right, you will find it necessary to make fairly large changes; it is seldom of much use to change exposure by much less than double or half. Even when a test is nearly right, an addition or subtraction of much less than 50 per cent will not make very much of a change. It is not likely that this initial trial of 15 seconds at $f/8$ will be far overexposed; it is more likely to need more exposure than less. If your enlarger is very powerful, or if you are making

a small print rather than the 8″ × 10″ recommended, it might indeed be overexposed. In this case, it may be better to stop the lens down to $f/11$ or even to $f/16$ rather than to shorten the exposure time.

By the same token, if a print is very much underexposed, you may wish to open the lens to $f/5.6$, which automatically doubles the effective exposure. The point is, it is well to find some lens setting at which all your prints will be made at times between 15 and 30 seconds—it is hard to work with shorter exposures than 15 seconds, and exposures running to a minute or more can severely limit the number of prints you can make in an evening.

Having decided what correction in exposure is likely to be required, reset your enlarger timer to the new exposure time, and if necessary, change the lens diaphragm setting. Now turn out the white lights, take another strip of paper from the package, and repeat Steps 1 to 6 above. It is important to follow those steps exactly; if the developing time is not exactly one minute, then the test will not mean very much. Use your clock-timer, and recheck developer temperature now and then.

This second test should be nearly right; in many cases, it will be close enough so you can decide whether another few seconds more or less will make a perfect print. In that case, you may proceed to make a final print on a full sheet of paper. If you have any doubt whatever, it is better to make another test strip—the few minutes extra time will be compensated by the saving of an expensive sheet of paper. You will find, after a while, that you do get familiar with your enlarger and the general density of your negatives, and that you can pretty much guess the exposure a given negative will require. This does not mean that you should not make a test strip, even when you are very sure of yourself. What it does mean is that you should make one at the exposure you think will be right and develop it to make sure, before exposing a whole sheet of paper. It may be a good one each time, but more

often you may find that a final little adjustment of exposure will result in an even better print.

The important thing is that all tests must be done in the same way—they must be exposed correctly, according to a timer, and they must be developed for exactly one minute, regardless of whether you think a little more or less will make a better print. Any slight adjustment of developing time should be reserved for the final full-size print.

Kodak Projection Print Scale

There are, of course, other ways to determine the exposure for a print. One quick method utilizes the Kodak Projection Print Scale. This is a sheet of clear plastic imprinted with ten wedges of various densities, and each wedge is numbered. By exposing the test *through* this scale, you get the equivalent of ten test exposures on a single piece of paper, and almost always one of these will turn out to be the right one.

The Kodak Projection Print Scale is about 4″ × 5″ in size, so you will cut a sheet of 8″ × 10″ paper into quarters; return three of these to the package and close it up. Then follow the steps below.

1. Place the piece of paper, emulsion side up, in the middle of the easel, about where the most important part of the picture detail will fall.

2. Lay the Projection Print Scale, emulsion side down, on top of the paper.

3. With the enlarger lens set at, say, $f/8$, expose the paper for exactly one minute.

4. After exposure, remove the Projection Print Scale and put it aside, then develop the exposed paper exactly as recommended above for a test strip. Repeat: Development time must be exactly one minute, after which the test is stopped and fixed as usual.

When you turn on the white light, you will find that you have a print of your negative, exposed in ten pie-shaped wedges at ten different exposures. In each sector, you will note a number—2, 3, 4, 6, 8, 12, 16, 24, 32, or 48. All

KODAK PROJECTION PRINT SCALE

PLACE THE PROJECTION PRINT SCALE OVER THE SENSITIZED PAPER ON THE PAPER
BOARD. WITH A NEGATIVE IN THE ENLARGER, EXPOSE IN THE USUAL WAY FOR
ONE MINUTE. AFTER DEVELOPMENT, THE CORRECT EXPOSURE TIME IN SECONDS
CAN BE READ DIRECTLY FROM THE BEST APPEARING SECTOR ON THE ENLARGEMENT

Made by EASTMAN KODAK COMPANY, ROCHESTER, N.Y., U.S.A.

PATENTS: U.S.A. 2,226,167, CANADA. 1942 • T.M. REG. U.S. PAT. OFF.

you need do is decide which segment of the image has the correct exposure; the number of that segment is the exact number of seconds you will have to expose the final print. Thus if the best-looking sector is No. 16, then you will make your final print with a 16-second exposure.

It is just possible that none of the exposures is correct; the entire test may be too light or too dark. If the whole thing is too light, the best way to correct it is to open the lens by one or two stops and make another test. If the entire print is too dark, then stop the lens down one or two stops and make another test.

You can make changes like this even if you get a good test the first time. Suppose, for instance, your first test showed the correct exposure to be three seconds. This is a little short for convenience, and you may wish to try another test, with the lens stopped down one or two stops, to get a longer and more manageable exposure.

Another way to use the scale is to change the basic exposure time. For instance, if you are consistently getting fairly long exposures, you might try exposing the test through the scale for 30 seconds instead of one minute. When you decide which sector of the test print is the right one, you will also have to divide its time in half; thus if you exposed the scale for 30 seconds and your best test was 24, then you

A test exposure made through the Kodak Projection Print Scale. In this particular case, it appears that the correct print exposure will be 16 seconds.

will expose the final print for half that, or 12 seconds. Likewise, if exposures are too short, expose the test for two minutes, and then double the time found for the best segment.

PRINT EXPOSURE METERS

There are various measuring devices which are claimed to make it unnecessary to make any test strips at all; they read the projected image on the easel in much the same way that an exposure meter for camera use reads the light from the subject.

The amount of light available for measurement is much less than for a normal exposure meter, so enlarging meters have to be a good deal more sensitive than camera meters; the simpler ones use various methods to avoid this problem. The main difficulty with enlarging exposure meters is that the exposure of paper for a print has to be much more precise than exposure of film in a camera; papers have nearly no latitude.

This does not mean that such meters do not work; some of them work very well indeed. What it does mean is that you cannot simply look up a paper speed, set it on your meter, and proceed to read the correct exposure for a print. In nearly all cases, it is necessary, first of all, to make tests with a given paper and arrive at a meter setting for that paper. This meter setting, in turn, will be correct only for that paper, at that developing time, and usually only for that one batch of paper. There is an appreciable variation in sensitivity of papers from one batch to another.

Just the same, for those who make many prints, an enlarging exposure meter is a great convenience, and by buying paper in large quantities, you reduce the necessity of calibrating the meter at frequent intervals.

Enlarging exposure meters are available in a wide variety of types, ranging from simple devices selling for $20 and less, up to fairly complex computer-type meters selling for upwards of $500. The latter, of course, are in-

tended for commercial operations and the mass production of prints. The simpler units work fairly well, and you may want to buy one later on. But since most of them will have to be calibrated by the user, with one or more test strips, you may as well start out by making test strips by one of the methods described above.

MAKING THE FULL-SIZE PRINT

Once you have a good test, the rest is easy. Simply follow these steps:

1. Turn off white lights and safelight, and turn on enlarger. Recheck the position of the easel to make sure it was not accidentally moved out of place during the making of the test strips.

2. Turn off enlarger, and turn on safelight. Take a full sheet of paper from the package, and close the package carefully.

3. Raise the masking bands of the easel, and place the paper emulsion side up, against the corner guide, and square to it. Holding the paper in place, lower the masking bands to hold the paper in place.

4. Set enlarger timer to exposure time determined by the test strip.

5. Push button to make exposure. If you are not using a timer, then you will turn on the enlarger with its own switch or (preferably) a foot switch, time the exposure with the sweep-second clock or audible timer, and shut the light off precisely at the expiration of the proper time.

6. Raise the masking bands of the easel, and take out the paper.

7. Slide the paper, emulsion side up, into the developer tray.

8. Take the print tongs, turn the print face down, and move it around gently for about a half minute. Turn it face up again.

9. Given the correct exposure, the print should be fully developed in one minute exactly. If it is a bit light, development can be extended to about 1½ or at most 2 minutes.

This is rather hard to judge (see below), so if your test was OK at one minute, then the final print should likewise be correct in one minute.

10. When development is complete, lift the print from the developer with the tongs, let it drain for a few seconds, and then drop it, face up, into the stop-bath tray.

11. With the stop-bath tongs, turn the print over once or twice, pushing it under the surface of the solution each time. The time in the stop bath is not critical but should not exceed about a half minute ordinarily. If the print remains in the stop bath for as long as two or three minutes, however, no harm will be done.

12. Lift the print from the stop bath, let it drain for a few seconds, and drop it, face up, into the fixing bath. Return the stop-bath tongs to its tray.

13. Take the fixing-bath tongs, and turn the print over two or three times in the fixing-bath tray. Turn the print face up, and push it well below the surface of the solution.

14. Be sure no sensitive paper is uncovered. Turn on the white light and examine the print. It should be a good one, but you may decide that you would like it a little darker or lighter. In this case, simply change your exposure slightly, take a fresh sheet of paper, and repeat the steps above.

EVALUATING THE PRINT

There are two points to be noted here. Sometimes even with a perfect test, the final print will seem too light or too dark. This may be because the test strip did not cover the most important part of the image, or it may be that a large print sometimes does look different from a small piece of the same image.

Developing a Print: 1. Slide the exposed print into the developer tray, face up. Let go of it just before it is all the way in, so you don't wet your fingers.

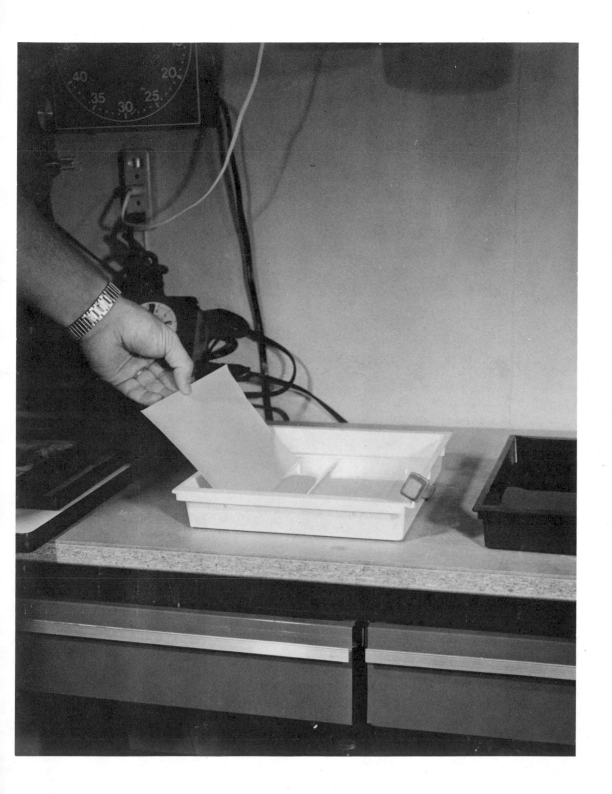

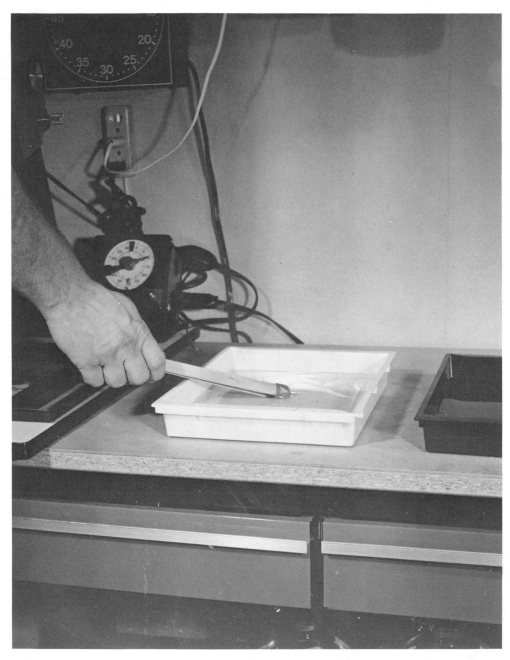

2. Press the paper under the surface of the developer with the print tongs, making sure it is completely covered.

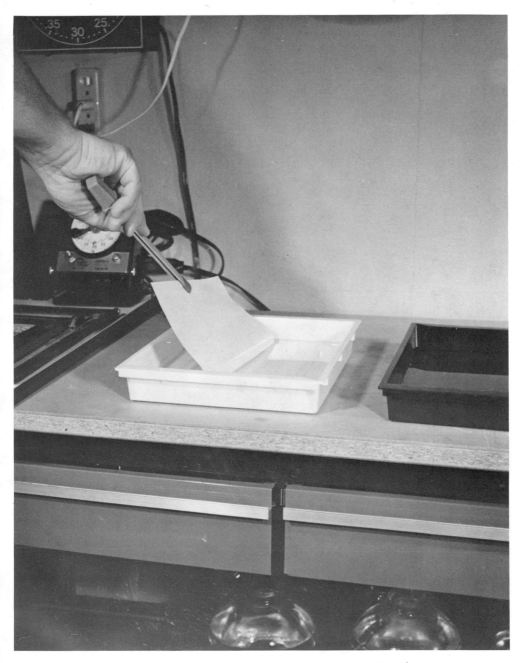

3. With the tongs, turn the paper face down in the developer. Agitate it gently, making sure it stays beneath the surface. Let it remain face down for 30 to 45 seconds.

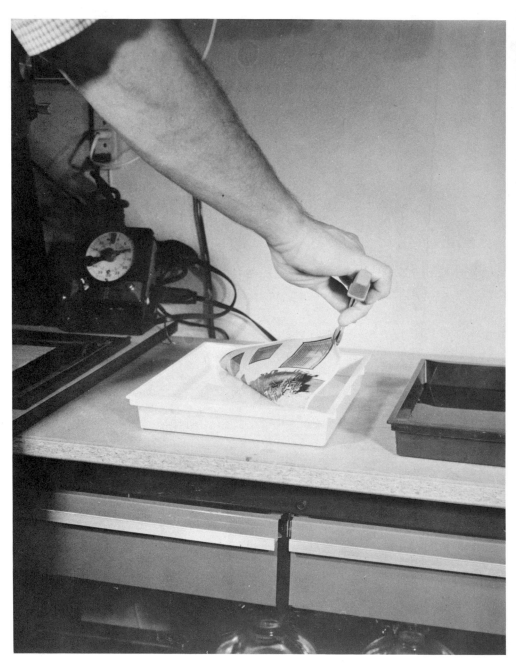

4. Turn the print face up again, and allow it to finish developing in this position. While normal developing time is from 1 to 1½ minutes, it may sometimes require a little more or less time; never less than 45 seconds, and never more than 2 minutes.

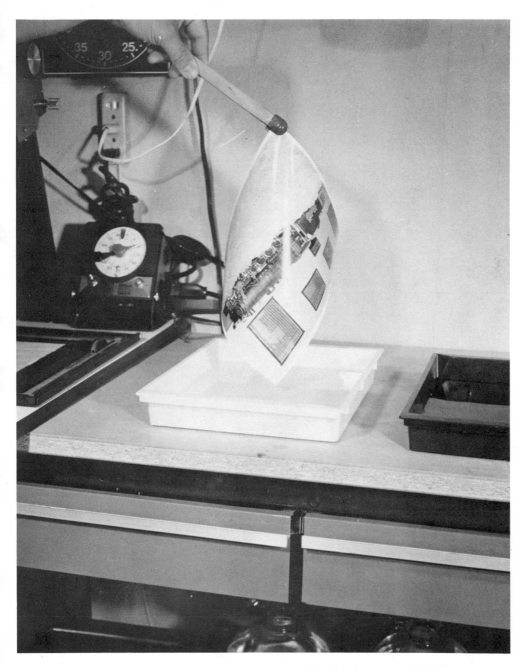

5. When the time is up, lift the print from the developer with the developer tongs, and allow
it to drain for a few seconds.

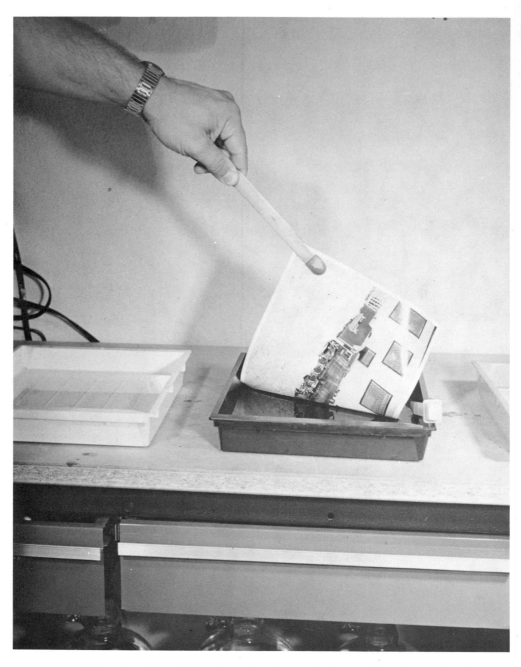

6. Now drop the print face down into the stop-bath tray without immersing the tongs. Return the developer tongs to its tray.

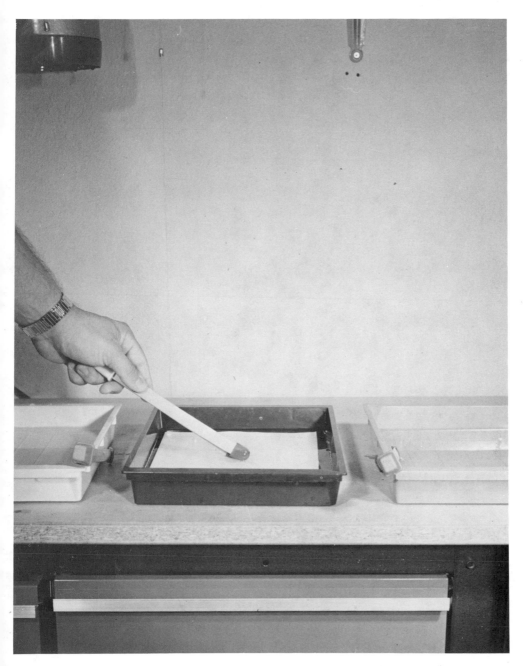

7. With the stop-bath tongs, press the print below the surface of the stop bath, and agitate gently for about 15 seconds.

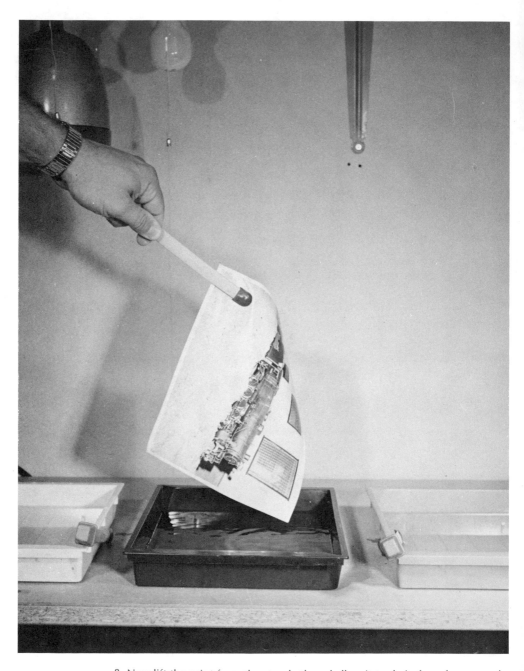

8. Now lift the print from the stop bath and allow it to drain for a few seconds.

9. Drop the print into the fixing bath, and return the stop-bath tongs to its tray. Press the print below the surface of the fixing bath with the fixing-bath tongs.

10. Turn the print face up in the fixing bath with the tongs.

11. Press the print below the surface of the fixing bath with the tongs and agitate gently for a few seconds. After about 30 seconds, you can turn on the white light to inspect the print.

Most of the time, though, you will find that a good test produces a good print.

The second point is this: We pointed out above that it is possible, if the print still seems a bit light in the developer, to carry development on for a total of 1½ to 2 minutes. This should only be done with caution, however. Most enlarging papers tend to have a whitish "veil" over the image during development; this makes the print look lighter than it actually is in the developer tray. The veil disappears in fixing, and the print then attains its full density. A few papers act oppositely; they lose some density in the fixer. For this reason, unless you are sure that the paper you are using does not act this way, or until you have learned to judge the amount the print will darken or lighten in the fixing bath, it is best to develop all prints for the exact one-minute developing time, regardless of how they look in the developer.

Once the prints are in the fixer, they look pretty much as they are going to, at least in the case of prints on glossy paper. Prints on matte papers do "dry down" to a small extent and tend to get slightly darker or duller-looking after drying. If you intend to make prints on such papers, you may have to get used to making the test strips just a bit lighter than you want your final print to be. In any case, it is a good idea to make several prints of a given negative, with exposures varying a small amount (say, about 25 per cent more or less than the one first chosen), just to see what they look like when dry. This sort of practice is important to gain skill in judging the quality to be expected of a given print, based on what the test strip looks like.

At any rate, having made as good a print as you can from your first negative, choose another and print it, going through the entire routine, step by step, of test strips and final print; always be sure that exposures are repeated exactly, that developing time remains exactly at one minute, and that you

recheck the temperature of your developer now and then.

Later, you will be able to take a set of negatives and group them by density before printing, so that all the negatives in a group will print at about the same exposure. Even then, it is well to make a test from each, just for the sake of minor corrections that will help you produce the best possible print.

Meanwhile, continue to make as many prints as you wish to make at this session. If you have been working more than 15 minutes or so, it is best not to let finished prints soak in the hypo too long; some papers tend to bleach slightly in the fixer after a while. It is not necessary to stop to wash the prints made earlier; simply take them from the fixing bath and put them into a tray filled with plain water. This is the holding bath, and prints can remain there for an hour or more if necessary.

FINISHING THE PRINTS

When you finish the printing session, some prints will probably be in the holding tray and a few still in the fixer. Since these latter should stay long enough to finish fixing, you can utilize the time here to empty the developer and stop-bath trays and to wash them and their tongs. By the time this is done, the last few prints will be fully fixed, and you may transfer them to the holding bath, while washing the fixing tray and its tongs.

Now empty the water from the holding tray, and refill it with fresh water. Take a print from the bottom of the pile, and put it on top. Take the next print from the bottom and put it on top, and continue this "leafing" of prints till you are back to the first one.

This being done, empty the water from the tray, fill it with fresh water and go through the same leafing procedure. If your prints are on one of the resin-coated papers, such as Kodabrome II RC, Luminos RD, or similar waterproof paper, five such changes of water

12. An inexpensive print washer. Water is sprayed on the prints from the perforated tube at left, and drains out of the tray through small holes at right. You must keep shuffling the prints in this type of washer, otherwise only the top print will be properly washed.

13. Lay the print face up on a towel, and remove surface moisture with a damp sponge.

14. Prints can dry face up on a few sheets of newspaper. Ordinary papers will curl rather strongly during drying, as shown here. Resin-coated (RC) papers scarcely curl at all.

15. A dry print will curl up. To flatten it, wipe the back of the print with a damp (NOT WET!) sponge. Be careful not to get any moisture on the face side.

16. Place the lightly dampened print between the pages of a telephone book to flatten out.

will produce a very satisfactory wash. If you are using a plain-base paper, such as Kodak Polycontrast, Kodabromide, Agfa Brovira, DuPont Velour Black, or Ilford Ilfobrom, it will take 10 to 15 changes of water for complete washing. In this latter case, some labor can be saved by using ten changes, but allowing the prints to remain in the tray at least three or four minutes for each change of water after one round of leafing.

Drying

When washing is complete, take the prints from the water, one by one, blot them as nearly dry as possible with a cellulose sponge, and lay them out, face up, on dry newspapers. Resin-coated papers will finish drying in a matter of minutes if all the surface water has been removed. Regular papers will take a bit longer, but the exact time will depend on the conditions—a warm room with dry air results in the fastest drying.

It appears that as time passes, more and more papers will be made with the "RC" (for *resin-coated*) base. The main advantage of these base materials is that they absorb almost no water, hence the drying of the final print requires only the drying of the thin emulsion layer.

Because the resin-coated base is impervious to water, these papers cannot be ferrotyped, nor can they be dried on a heated dryer in the ordinary way. The fact is, however, that none of these expedients is necessary with RC papers; they have a very high gloss in the "F" (or equivalent) surface and do not require ferrotyping. Only a very short time is required to dry the emulsion layer, so heated dryers are hardly necessary, except for mass-production printing.

For ordinary papers, the best thing is to wipe both sides as dry as possible, then dry them, face up, on newspapers. As long as the prints are not really wet, they will not pick up any contaminants from the newspaper pad,

which is cheaper and just as good as the usual print-drying blotters, especially after the latter have been used for a while. Blotter rolls, which comprise a long strip of blotter, covered on one side with muslin or cheesecloth, were popular at one time, but they have another problem aside from possible contamination; when tightly rolled up, the blotters allow moisture to escape only from the edges, and drying takes a long time. It may take as much as 24 hours to dry a few prints in a blotter roll, so most people have given them up.

Flattening

It is best to pick up the prints as soon as they are dry to the touch; allowing them to lie in a warm atmosphere after they are completely dry may cause them to curl. Regular papers can be flattened by wiping the back of each print with a damp sponge and placing the print under a weight or between the pages of a phone book. In the latter case, be careful not to get any water on the emulsion side of the print, or it may stick to the book pages.

Resin-coated papers are harder to flatten if they dry with much curl; it may be necessary to hold them in the current of steam from a teakettle for a few seconds and then put them in a book to flatten out. Normally, this is not necessary; most resin-coated papers dry almost perfectly flat.

JUDGING YOUR PRINTS

If your prints were correctly exposed and developed according to instructions, they ought to be sharp and crisp, with a good scale of tones from white to black. Now and then, though, you will find a negative that simply will not make a good print on No. 2 paper. Enlarging papers are made in several grades, to allow printing negatives of varying contrast.

How to judge the negative and choose a grade of paper that will make the best print will be the subject of the next lesson.

LESSON 4

Intermediate Enlarging

Up to this point, we have covered negative development, contact printing, and enlarging. It has been assumed that everything was more or less normal; given a normal exposure on average subject matter, normal development, and printing on normal paper, the result would be a normal and generally good print.

WHY VARY STANDARD PRINTING?

There are various reasons why this will not always be the case; it is not necessarily due to any fault of the photographer's. Occasionally, subject matter is too contrasty or too lacking in contrast for normal treatment. Then, too, an "average" print may not be exactly what is wanted; a given subject may call for a stronger treatment or a softer one.

A great deal of control is possible in the photographic process. It is possible to vary the development of the negative to produce softer or more contrasty results, but this is not always wise; one would not wish to risk a valuable exposure in the development. Now

and then, special development has to be given, but this is more often in the case of a known underexposure, where some "pushing" may produce a more printable negative. This matter will be covered in a later lesson.

Here we will discuss methods of controlling the quality of the print only, and we will continue to assume normal exposure and development of the negative. Before going into methods of control, though, it is well to recapitulate the development procedure used in printing and enlarging, to avoid needless repetition in the following pages.

Normal Procedure

Specifically, there is a fixed routine for developing black-and-white sensitized papers, and this routine should, by now, have become habit. It is as follows:

1. Slide the exposed paper into the developer tray, face up.

2. With the first set of tongs, pick up the print and turn it, face down, in the developer, submerge it, and move it around gently.

3. After about a half minute, turn the print face up again, using the tongs, and immerse it completely, moving it around gently.

4. At the end of one minute, lift the paper from the developer, let it drain into the tray for a few seconds, then drop it, face up, into the stop-bath tray.

5. Return the developer tongs to the developer tray.

6. Pick up the stop-bath tongs and turn the print over in the stop bath. Do this several times.

7. Lift the print from the stop bath, allow it to drain into the tray for a few seconds, then drop it, face up, into the fixer.

8. Return the stop-bath tongs to its tray.

9. Pick up the fixer tongs, turn the print over several times, ending with it face up in the tray. Push the print below the surface of the bath.

10. Make sure all sensitive paper is covered or in its envelope.

11. Turn on white light and examine print.

This routine, including all the apparently unimportant steps, such as returning each pair of tongs to its respective tray, must become a matter of habit. In fact, the return of the tongs to their respective trays is one of the most important steps in the procedure. The purpose of this step is to avoid any possibility of contamination. If the developer tongs get into the hypo, or worse yet, if the hypo tongs get into the developer, the result will almost certainly be severe staining of subsequent prints.

One step not mentioned above is to check the temperature of the developer. This is done, of course, while mixing it, but if room temperature is much higher than 20 C (68 F), the developer temperature should also be checked at intervals while working. Each time this is done, the thermometer should be washed and returned to its container. All of these little "housekeeping" steps are important, because contamination is the enemy of good print quality.

The reason we have put so much emphasis on the above procedure is simply that it will save further repetition; in the following pages, when instructions state: "Develop the print, stop, and fix," it means, "Follow Steps 1 through 11 above." Later on, you may be instructed to "develop the print for two minutes." This means that in Step 4 you will allow the print to remain in the developer tray for two minutes instead of the usual one minute. All the remaining steps remain exactly the same and are carried out as usual.

In this lesson, we will continue using the same chemicals as before, for a developing time of one minute. The developer is Kodak Dektol Developer (or equivalent) diluted one part of stock solution to two parts of water. The stop bath is 30cc of acetic acid, glacial, in a litre of water (one ounce of acetic acid, glacial, in a quart of water). The fixing bath is the same as you used for films.

CONTRAST CONTROL

So far, only the "No. 2," or "normal," grade of paper has been used. It has already been pointed out that paper grades actually refer, not to the contrast of the paper itself, but to the contrast of the negative to be printed on it.

(Above right) Flat lighting produces a flat picture. And while this picture could be printed on very hard paper to produce a bright-day effect, this would be false. (Right) By printing on paper that is one grade harder, and by using the same exposure, we keep the overcast effect while achieving better blacks in the lighthouse railing.

Contrast has been defined, as far as the negative is concerned, as the difference in density (or blackness) between the darkest and lightest tones. Papers, however, are almost always printed to produce the maximum black of which they are capable in the dark areas, and to produce the lightest gray, approaching pure white, in the light areas. In this sense, then, the contrast of a paper print is always the same—full black to nearly pure white.

Therefore, the term "contrast" in papers really means *exposure scale*. It refers to the amount of exposure required to produce a full black as compared with the exposure required to produce a just visible gray. Some papers require a great deal more exposure to produce their maximum black as against the exposure that just produces a visible gray; these are called "soft," or "No. 0" or "No. 1," papers and are used to make prints from very contrasty negatives. Other papers require only a little more exposure for a black than for a light gray; these are called "hard," or "No. 3" or "No. 4," papers and are used to print very soft or thin negatives. The "normal" papers fall between the two types.

Densitometers

It is possible, but as we shall see shortly, not necessary, to use some kind of measuring instrument to decide what the negative range actually is. Such instruments exist; they are called *densitometers*. They are used in certain advanced work in color; where very precise control of the process is needed, as in motion pictures; and in the manufacture of films. A simple densitometer could be made of an exposure meter and a small light source. If the strength of the light is fixed, all we have to do is measure the strength of the light, without a negative in place, then put the negative in the light beam, take another measurement, and decide from the difference what the light-stopping power of the negative is. Since, in effect, we are measuring transmission, such a gadget is called a *transmission meter*, but by a simple change of meter scale, it can be designed to read density instead.

Suppose, as a concrete example, we get a meter reading of ten "candles" with no negative in place and one "candle" with the darkest part of the negative in the light beam. Then, obviously, the negative is transmitting 1/10 of the incident light; we say it has a transmission of 10 per cent. To look at it as light-stopping power, simply invert the fraction, that is, instead of 1/10, we make it 10/1. We call this value *opacity*, and in this case, the negative area measured has an opacity of 10. In photography, opacity is not used; instead, the logarithm of the opacity is used and is called *density*. The reason for this is that density corresponds more closely, not to mere light-stopping power, but to the actual quantity or weight of silver in the image. This is important to emulsion makers, though not of much interest to photographers ordinarily.

In any case, it is not necessary to know anything at all about logarithms to use a densitometer; the meter scale is merely marked in density units and is read directly. What we need to know is not the actual density of a negative, but the density range, that is, the difference between the deepest black and lightest clear area. If, say, a given negative has an opacity of 15 at the darkest part and 1½ at the lightest, then its opacity ratio is 15 divided by 1½, which is 10 to 1. If we know the exposure ratio of the paper we wish to use, we can tell which grade of paper will make the best print from that negative.

(Above left) A print from an excessively contrasty negative on normal paper. (Left) No dodging or burning-in is needed in this case—just a straight print on extra-soft paper.

This picture, printed for the proper density on the left, is too light on the right-hand side. Burning-in is the proper correction.

If we had a regular densitometer, we would find that this negative would read, in density units, 1.2 at its darkest part and .2 at the lightest. With logarithmic scales, we do not have to divide—all that is necessary is to subtract the smaller from the larger, and so this negative has a density range of 1.2 − .2 = 1.0. And for those who know their logarithms, 1.0 is the logarithm of 10, so the two readings mean exactly the same thing. The main advantage of the logarithmic scale is that it is not necessary to multiply or divide—simple addition or subtraction is all that need be done.

As we said at the beginning, all this is nice to know, but not necessary in practical photography. If you could get a paper that came in a great many grades so you could match almost any negative exactly, then using a densitometer would make it possible to find the right paper without any tests or guesswork. But as it happens, papers are made only in a few widely spaced grades; at most, there are six available in a few papers. More commonly, papers come in four, three, two, and sometimes in only a single grade, in which case it is usually a No. 2 grade. The No. 2 grade in all papers has nearly the same contrast; the additional grades are harder or softer, as marked.

Taking Kodak papers as an example (most others are much the same), we find that there are, at most, six grades available, and they can be listed as follows. We give both name and type, as well as both exposure scale and density range; the latter both refer to the negative to be printed).

| | | NEGATIVE | |
Contrast Grade	Number	Exposure Scale	Density Range
Extra soft	0	50:1	1.7
Soft	1	30:1	1.5
Normal	2	20:1	1.3
Medium Hard	3	13:1	1.1
Hard	4	8:1	.9
Extra Hard	5	5:1	.7

JUDGING NEGATIVES

Now you see why we don't need a densitometer or other measuring instrument. With only a few grades of papers available, it takes only a little practice and experience to be able to judge a negative well enough to decide what grade of paper it will print on. After a while, you will be able to pick up a negative, and at a single glance say it will print on No. 2, or No. 4, or whatever grade it needs.

As an example, take the negative we were discussing above. With a 10:1 exposure scale, or 1.0 density range, it obviously does not exactly match any of the above paper grades; it falls pretty well between Grade Nos. 3 and 4. This does not pose any difficult choice; the

fact is, it will probably make a fairly good print on either grade of paper, and the choice depends mostly on whether you prefer a soft print or a snappy one. To some extent, that is dictated by the subject matter, and in any case, is a matter of taste. You could, easily enough, decide what grade to print that negative on by experience; density readings, falling right between two grades, would only serve to confuse you.

In the beginning, it is hardly necessary to consider more than the main four grades—Nos. 1 through 4—of paper. Grades 0 and 5 are really only for emergencies, to eke out a print from a really bad negative. The steps between Grades 1 and 4 are large and well defined, and that makes estimating easy.

To give you something concrete to start out with, we show, on the next page (p. 104) three negatives, corresponding to the three major

With the right side of the picture burned-in, the print is uniform in density and there is no evidence that any kind of correction has been applied.

Soft Negative. With Soft (No. 0) paper, you get a very soft print; with Normal (No. 2) paper, you get a soft print; with Hard (No. 4) paper, you get a normal print.

Normal Negative. With Soft (No. 0) paper, you get a soft print; with Normal (No. 2) paper, you get a normal print; with Hard (No. 4) paper, you get a hard print.

Contrasty Negative. With Soft (No. 0) paper, you get a normal print; with Normal (No. 2) paper, you get a hard print; with Hard (No. 4) paper, you get a very hard print.

density ranges. In the next three columns, we show all three negatives printed on three different grades of paper; thus we have all the possibilities. As you can see, there is one best grade of paper for each negative, and since you have only a few choices, it is easy to decide which to use. The use of Grades 1, 3, and 5 will be obvious; they fall between the steps in the illustration.

As a preliminary exercise, take whatever negatives you have on hand, and by comparison with the illustration, sort some of them into three groups corresponding to the three main types of negative shown. Try sorting the remainder of them without looking at the illustration, then check and see how closely you guessed the correct paper grade.

Contrast Subtlety

It is necessary to repeat an earlier statement here: The contrast of a negative depends on the difference between the lightest and darkest portions only; the middletones do not count,

(Below) Quaker State Refinery. Straight print on No. 2 paper is too contrasty. (Right) A straight print of the same scene on softer paper brings out the detail, but the tank on the right is too light and draws attention to itself. Moreover, smoke from the chimney is not visible enough. (Below right) The corrected print. The tank has been burned-in and the smoke dodged.

for the time being. Thus a negative of a night scene, which is mostly very light, except for a few dark areas corresponding to lights, windows, and so on, may at first strike you as being a thin negative, hence a soft one. If you think of contrast only, not overall density, you will realize that this negative is actually a contrasty one, and it will probably need to be printed on a soft grade of paper.

On the other hand, a thin negative that does *not* contain any small dark areas is considered soft, and so is a fairly dark negative containing no small light areas. To repeat—it is the density *difference* that counts, not the actual density.

There will be some borderline cases, of course—negatives that seem to fall between two classes. These should cause no difficulty; all it usually means is that such a negative will produce a pretty good print on either grade of paper, and the choice becomes one of subject matter and personal taste. Suppose, for instance, you have a negative of a child portrait, which looks like it would print about as well on either No. 2 or No. 3 paper. Since most people prefer portraits of children to be fairly soft, you would probably prefer to print this negative on a No. 2 paper. If you have another negative that also seems to fall between a No. 2 and No. 3 contrast but is a brilliant outdoor scene, you may prefer to print it on the No. 3 grade for a generally stronger effect.

TRIAL PRINTS

At this point, it will be a good idea to make a few prints from various negatives of different contrasts, to get the feel of the process and also to corroborate your judgment in deciding what paper each negative will need. For this reason, in the following steps, you will at first print all negatives on several grades of papers. (While it is possible to skip this whole sequence and go right to the section on variable-contrast papers, it is preferable to do these

first tests on a regular graded paper.)

These trial prints need not be 8″ × 10″ in size; you can learn just as much from smaller prints and at less expense, especially as you will need at least four packages of paper here. Therefore, it is best to supply yourself with one package each of Nos. 1, 2, 3, and 4 paper, in either 4″ × 5″ or 5″ × 7″ size.

The Normal Negative

It is a good idea to see what each grade of paper does with a normal negative. For this test, then, choose a negative from which you have already made a good print on No. 2 paper. Set up your trays with the chemicals in them, as in the previous lesson, with a pair of tongs in each tray; be sure the developer temperature is between 18 and 22 C (65 to 72 F).

You will have to make a test strip for each print, as in the previous lesson. It is important to remember that the different grades of paper are not equally fast, and exposures for No. 1 and No. 4 paper will differ a good deal. Later on, you will make it a habit to group your negatives so that all needing a given grade of paper can be printed at one time, thus minimizing the number of tests required. For the moment, however, make a test for each print.

Printing Procedure

For each negative in this series, follow this routine:

1. Make a test strip from your chosen negative on No. 2 paper, and develop it for one minute in the established way given at the beginning of this lesson.

2. If the exposure is not correct, make another test; if you are using the Kodak Projection Print Scale, choose the correct exposure from the scale image.

3. Make a final print from this negative on No. 2 paper, develop for one minute, stop, and fix.

4. Without changing the enlarger set-up,

make a test strip of the same negative on No. 1 paper.

5. When you have the correct exposure, make a complete print on No. 1 paper, develop for one minute, stop, and fix.

6. Make another test from the same negative, this time on No. 3 paper. Determine correct exposure as before.

7. Make a final, complete print on No. 3 paper, develop for one minute, stop, and fix.

Evaluating the Results

Now being sure all sensitive paper is covered, turn on the room lights. Take the three prints from the fixing bath, rinse them in a tray of plain water, and lay them out on a newspaper to catch the drippings. Now compare the three. If all was correct and the negative properly chosen, the print on No. 2 paper should be clearly the best. The one made on soft paper will be full of detail but lacking in blackness in the shadows. The one on hard paper will, on the other hand, have amply black shadows but will lack detail in the whites (or if enough exposure was given, it will have detail in the whites, but the blacks will be all clogged up and lacking in detail).

If this is not the case, then it means one of two things: Either you misjudged your negative, or the subject matter in question requires an off-standard rendition. An example of the latter case is a backlighted portrait; if "correctly" printed, that is, printed for detail in the highest lights, the face will be much too dark. Usually, such subjects are printed for best detail in the facial area; this causes the backlight on the hair to wash out into a glowing halo, which is the effect that is actually desired. Technically, though, such a print is underexposed.

To decide which is the case, take another negative, one which also made a good print on No. 2 paper, and make the three prints from it, as above. Again, rinse and judge them in white light.

It pays to spend some time and paper on this test, printing a number of negatives if necessary, to establish your knowledge of what a "normal" negative is. There is some slight variation in this concept, partly because certain enlargers tend to produce more contrasty prints than others. If, for instance, your enlarger uses a diffused light source, you may find that *your* negatives have to be fairly strong to print on No. 2 paper; if your enlarger has double condensers, you will find *your* normal negative to be a good bit softer. The purpose of these trials, then, is *to establish your own working conditions,* which will *not* necessarily be the same as anyone else's.

Hard and Soft Negatives

Once you have established what you consider to be a normal negative, the next step is to choose a negative that is *not* a normal one. For this trial, find a negative that, by comparison with those you have just printed, is noticeably soft or lacking in contrast. Repeating an earlier instruction: It does not matter whether this negative is thin and weak overall, or whether it is dense, the important thing is the *difference* in density between the highlights and shadow.

Having chosen a soft negative, repeat the above steps, making tests and final prints on each of three grades of paper; this time, however, use paper grades Nos. 2, 3, and 4. If your negative was only moderately soft, it will probably make its best print on the No. 3 paper; if it was very soft, then perhaps the print on No. 4 paper will be the best. The print on No. 2 paper will probably be gray and muddy in either case.

Repeat this trial with one or more additional negatives that you judge to be soft or flat. The purpose here is to decide whether a given negative is only moderately soft and needs No. 3 paper, or whether it is very flat and needs the No. 4. You will be able to make the distinction easily enough after a few prints.

Finally, choose one more negative, this one a contrasty, or hard, negative. Again, make a set of three prints on Nos. 1, 2, and 3 paper. Process normally—one minute in the developer, at 20 C (68 F), stop, and fix. This time, you should find your best print the one on No. 1 paper, while those on Nos. 2 and 3 will be harder than you would desire. If this is not the case, try another negative and repeat the whole process.

Once you have made all these tests (and it should not take too long to do so), you will find you are beginning to develop judgment of negative contrast. At this point, you may proceed to print a few more negatives, but now, instead of making three prints of each, try to decide in advance which paper will make the best print, and make a test and a final print on that one grade of paper only. In the beginning, you may decide that your choice was wrong, in which case simply make another print on harder or softer paper as you think necessary.

The whole thing is much easier to do than it sounds, and by the time you have made a dozen prints, you will be approaching the whole matter of paper grade choice with considerable confidence.

VARIABLE-CONTRAST PAPERS

If your negative development routine is an accurate one, most of your negatives will print on No. 2 paper. This being the case, you will only occasionally have need of a No. 1, No. 3, or No. 4 paper; very seldom indeed will you

(Above) White ice against black rock—a very contrasty subject. If printed on soft paper, the effect would not have the crispness associated with ice and rock. (Right) Shortening the exposure brings out detail in the rocks, while burning-in the ice gives it added tone and texture.

need No. 0 or No. 5. In the past, this has caused a problem of supply; one had to stock four or five grades of paper in any one surface. Often, one ran short of No. 2 paper in the middle of a printing session, while boxes of No. 5 stayed on the shelf till they spoiled.

With variable-contrast papers, you will have the equivalent of all grades from No. 0 to No. 4 in a single paper, so you only have to stock one grade instead of five. This has been accomplished in a very simple but effective way; just by placing a color filter on the enlarger lens, you can get various contrasts from the same paper.

There is nothing mysterious about this. Normally, printing papers are sensitive only to blue light; it is, however, possible to sensitize them to green or red if desired, just as films are sensitized to light of various colors.

So to make a variable-contrast paper, all that is necessary is to prepare two different batches of emulsion. The first is an ordinary enlarging emulsion, sensitive only to blue light and of quite high contrast, about the same as a No. 4 paper. The second batch of emulsion is sensitized to green and is made quite soft, much like a No. 1 paper. Then the two batches of emulsion are mixed together and coated on the paper in the ordinary way.

If this paper is exposed to blue light, it will produce a contrasty print, like any No. 4 paper. If it is exposed to green light, it will make a very soft print, about No. 1 gradation. And if half the exposure is given to blue light, and half to green, the result will be a normal print, about the same as would be made on a No. 2 paper.

VC Filters

As we said, the exposure to colored light is made by the use of filters placed either under the enlarger lens or in the lamphouse. Originally, the process was exactly as described above, and only two filters were supplied; the "hard" filter was a deep blue, and the "soft"

Variable-contrast filters. The No. 1 filter is yellow, No. 2 and No. 3 are pinkish, and No. 4 is a deep magenta. Some sets also include half steps, Nos. 1½, 2½, and 3½, while others provide one or two extra-soft steps, Nos. 0 and 00, which are deep yellow in color.

one was not green but yellow. (The reason is simply that green filters absorb an excessive amount of light, and yellow filters transmit both green and red light, quite freely. Since the paper is not sensitive to red, the result is exactly the same as if a pure green were used, but exposures are shorter.)

Making the exposure in two parts proved to be a bit inconvenient, especially when a number of duplicate prints had to be made. Later, manufacturers offered graded sets of filters, running through a variety of colors from blue, through various pinks and magenta colors, to yellow. Each filter produced a specific degree of contrast. In the beginning, filter sets had as many as ten filters in them, producing a con-

trast range from No. 0 to about a No. 4 grade of paper. This proved to be unnecessary, and current filter sets are usually made in sets of four as a minimum; these are designed to match the corresponding numbered grades of paper. Kodak also supplies three additional filters, comprising the half steps, No. 1½, 2½, and 3½. DuPont, in its set of variable-contrast filters, does not supply half steps, but does include two additional filters for even softer effects; these are numbered 0 and 00. There is no filter corresponding to a No. 5 contrast grade, and for such extreme contrasts, it is still necessary to have a separate paper.

Filters supplied by Kodak will also work with DuPont Varilour paper; likewise, DuPont filters will work with Kodak Polycontrast paper.

Because light is absorbed by the filters, exposures are longer than they are with the ordinary enlarging papers of the faster types. Also, as with graded papers, there is a difference in speed when printing a No. 1 and a No. 4 grade. In general, variable-contrast papers require from two to three times as much exposure as ordinary fast enlarging papers; this is only equivalent to opening the enlarger lens by 1 to 1½ stops.

If you are in a great hurry and have a batch of normal negatives to print, the variable-contrast papers *can* be used without a filter, which effectively doubles their speed; the contrast produced will be approximately that of a No. 2 paper.

Printing with VC Papers

Other than the use of filters to control contrast, variable-contrast papers are handled in exactly the same way as any enlarging paper. The developer is Kodak Dektol Developer diluted 1:2 as usual, and developing time is the same one minute, though one or two of these papers may produce slightly richer blacks if development is extended to 1½ minutes.

To get used to variable-contrast papers, it is well to make a complete series of prints, just as you did in the preceding exercise with graded papers. To begin, you will need a box of any one of the following papers:

> DuPont Varilour Paper
> Kodak Polycontrast Rapid Paper

You will also need a set of filters and the appropriate holder for your enlarger. Small filters can be used over the enlarger lens; filters to be used in this position must be made of optical quality gelatin and must be kept spotlessly clean. A single fingerprint on a filter can ruin both the sharpness and contrast of a print.

If your enlarger is a "color" type and has a filter drawer in the lamphouse, it is preferable to get filters large enough to fit in this position. These larger filters will not necessarily be much more expensive, because they are usually made of dyed cellulose plastic, not of optical quality. These filters, therefore, must never be used over the lens.

Having the paper, filters, and some negatives for trial, set up to make some prints as usual. The three trays contain, as always, Kodak Dektol Developer diluted 1:2, a stop bath of 3% acetic acid (acetic acid, glacial, 30cc in a litre of water, or one ounce of acetic acid in a quart of water), and the usual hypo fixing bath.

Printing Procedure

1. Choose a negative that made a good print on No. 2 paper. Insert it in the enlarger, adjust the size of the image, and focus. Stop the lens down, and attach the No. 2 filter to the lens (or insert it in the lamphouse).

2. Make a test strip at roughly twice the exposure you would have used for a normal graded paper. If you are using the Kodak Pro-

jection Print Scale, give the one-minute exposure, and determine the final exposure in the usual way. You may find it better to open the enlarger lens one stop more than you used in normal paper printing.

3. Develop the test for one minute, stop, and fix.

4. Examine the test and decide the final exposure. Expose and develop a full print.

5. Without changing anything, make another full-size print with the No. 1 filter. With most variable-contrast papers, the exposures with the No. 1 and the No. 2 filters are alike.

6. Develop this print normally for one minute, stop, and fix.

7. Now repeat Steps 2, 3, and 4 with the No. 3 filter. You will find the exposure required is rather longer.

8. You now have three prints of the same negative, and comparison of results should indicate much the same as your corresponding test with a normal negative and graded papers. That is, the print made with the No. 2 filter should be about right, the one made with the No. 1 filter, rather soft, and the one made with the No. 3 filter, a bit harder than desirable.

9. Choose another negative, this time a rather soft or flat one, and make a print, first with the No. 2 filter, then with the No. 3, making tests for each. In this case, the No. 3 print should be the good one, but if still too soft, another print should be made using the No. 4 filter. Here, again, another test will be needed, because the No. 4 filter absorbs a good deal of light. Exposure will be about three times that given through the No. 2 filter.

10. Now try one more negative, this time a fairly hard or contrasty one. Print it with the No. 2 and No. 1 filters; this time, only one test will be needed, because both these filters require the same exposure.

By the time you have completed these tests, you will have the feel of the whole thing, especially if you have already done the same thing with the ordinary graded papers. You may then pick out a few more negatives and try printing them, estimating by eye the filter required, but as usual, making a test first for exposure.

Of course, if you are printing negatives that you had previously printed, you will already have a fair idea of what filters are required and even a suggestion of the correct exposure. This is also the case if you made a contact sheet of all your negatives before enlarging them; the contact sheet gives you a rough idea of the contrast of the individual negatives and some hint of the probable increase or decrease of exposure for certain negatives. Even so, do not bypass the test strip or Projection Print Scale; trying to guess exposures will waste a lot of paper.

LOCAL CONTROL—DODGING AND BURNING-IN

While most negatives will produce good prints if you choose the proper grade of paper, there are some that need extra manipulation to make the best possible print. Some, for instance, have a single part of the scene where some detail was in a shadow: The rest of the print is fine, but one area is too dark. If this one detail could be given a little less exposure while making the print, it would improve the final picture greatly. Then there is the opposite case; everything in the print is fine except one detail, which is too light and washed out. A little extra exposure on just this one part would make the print very much better. Finally, there is the occasional subject that prints well enough on soft paper, but the end result is weak; it would be nice if we could compress the scale to some extent to permit printing on a harder grade of paper for more brilliance.

All of these things can be done with two simple techniques known as *dodging* and *burning-in*. Dodging consists of shading parts of the projected image while printing, to

produce a lighter tone; burning-in is the opposite—shading *all but* the single desired area, to make that one detail darker.

When to Dodge and Burn

Dodging is usually done during the exposure of the print; burning-in is generally done during an auxiliary exposure, after the overall exposure has been given. In either case, it is usually necessary to make not only the usual test strip but a full-size print as well. In most cases, it is this first full print which indicates that some extra treatment will be required.

Let us assume that you have made a full-size print, and that, by and large, it is a good one, with about the desired overall density. But there are one or two small areas that are a bit too dark. Making another print with less exposure would cure this, but then the rest of the print would be too light. The answer is dodging—shading the given area during printing so it gets a little less exposure, while the rest of the print is the same as before. The exact amount to dodge requires some experience; in general, it should not be overdone. Most of the time, from one half to as little as one quarter the exposure time is sufficient; in some cases, even less. Subtle changes are the best, because excessive dodging produces artificial effects which are mostly unpleasing.

On the other hand, should an area be too light when the rest of the print is satisfactory, it will require burning-in. The preliminary steps—making a full-size print and judging it—are the same. But burning-in, being an auxiliary exposure, has to be added to the main exposure, hence it is usually done as a separate step, after the main exposure has been given. The shading device is put in place, and the enlarger light is turned on again for the auxiliary exposure. Again, only subtle effects should be aimed for; however, the auxiliary exposure may be fairly long anyway, because we are printing through the densest part of the negative. Generally, though, the aim should be to put only a faint tone of gray over a washed-out area; much more is unnatural and unpleasant.

Tools for Dodging and Burning-In

You will need a set of dodging tools. These can be bought, but are easy enough to make. The dodging tools are pieces of black paper or cardboard of various shapes, fastened to long wire handles. A few old coat hangers will provide good pieces of stiff wire for the purpose. One end of the wire is bent into a round loop, for handling or hanging when not in use. The other end is bent into whatever shape will make it easiest to glue the paper dodger to it; generally, a short "U" bend is adequate. The thin wire handle does not throw much of a shadow, and so the shading is done entirely with the paper object on the end. To begin with, make a few of circular shape, varying in size from about an inch in diameter to about two or three inches; other shapes can be made as they are needed. In any case, only a few sizes are required, because the size of the shaded area is also controlled by the distance of the dodger from the paper.

Burning-in tools are sheets of black paper or cardboard with holes of various sizes and shapes in the middle. Only a few are needed—the smallest hole ought to be about a half inch, and then a middle-size one of about two

(Above left) Dodging tools, made of gray cardboard and fastened to handles made of coat-hanger wire with black Scotch tape. (Left) The dodging tools must be painted with dull black spray paint on both sides, including the handles, so that they do not reflect any light.

inches, and a large one about three inches in diameter. Again, you can make other shapes and sizes as you need them. Keep some black paper or cardboard in the darkroom, together with an X-Acto knife, to make dodgers and burn-in tools as needed.

The easiest way to fasten the dodging tools to their handles is with pieces of Scotch tape, preferably the black paper variety. If you don't have any black paper to make these, any paper will do; after the tool is finished, the whole thing, including the handle, is sprayed with matte black lacquer, such as the "Wrought Iron Black" sold in pressurized cans at most hardware stores. The same applies to the burning-in tools; they can, in a pinch, be made of ordinary thick cardboard,

such as the laundry inserts in shirts. After cutting the opening, spray both sides of the board with the same flat black paint.

Keep extra wire handles around for making additional dodgers, and never throw a dodger away once you have used it; eventually, you will have a whole set of dodgers that can be used in nearly every situation.

Preliminary Tests

Before making any dodged prints, it is a good idea to try a "dry run," just to get the feel of how these things work. Put a negative in the enlarger, focus it on a sheet of white paper on the easel, and turn off the room light. Now pick out a light area in the negative, which you would want to shade during exposure.

Burning-in tools are made of sheet cardboard with holes of varying shapes cut in them; again, both sides must be sprayed a dull black so as not to reflect light.

Dodging is done by holding the dodger under the lens of the enlarger, and keeping it in continual motion so that no sharp edges show where areas have been held back.

Choose a dodging tool that is a little smaller than the area you wish to shade, and hold it in the beam of light from the enlarger. You will find, as you move it up, its shadow gets bigger, and as you move it down, its shadow gets smaller. You can shade almost exactly the area you have in mind simply by moving the dodger up and down, just so it is somewhere near the right size. Note, though, that as you get closer to the paper, the edges of the shadow get sharper. This is not always desirable, and you should choose a smaller dodger and hold it farther away. In general, try not to get closer to the paper than about halfway between lens and easel, though there will be times when you may want to break this rule.

Try moving around to different areas, changing the height of the dodger so it just covers the part you want to shade. Note that even the soft shadow thrown by the dodger may be too evident in the final print. To avoid this, keep the dodger continually in motion during the exposure; its shadow should actually overlap the edges of the dodged area for the smoothest result. This steady movement also prevents any slight shadow of the wire handle from making a streak across the print.

Now try a dry run with the burning-in tools. For this, you can leave the same negative in the enlarger. This time, however, choose a dark area, and position a hole of about the right size at such a distance that the light spot

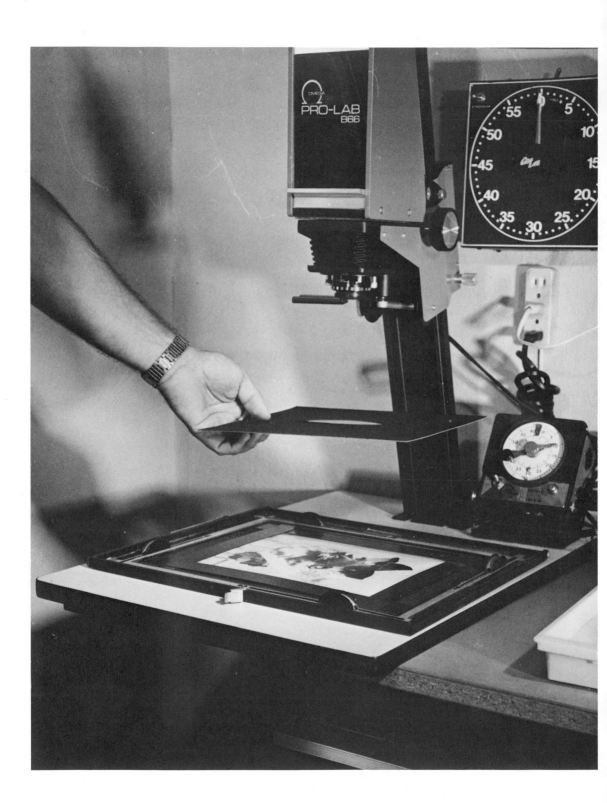

just covers the dark area. This is the opposite of dodging, so it is best not to let the burned-in area overlap the edges of the dark area very much (though it should not be much too small either—one way or the other, the result will be artificial and unpleasant). As in the case of dodging, keep the tool in motion continuously. And again, if you find a given negative has some odd-shaped area that needs treatment, simply make another tool with an irregularly shaped hole to fit the area in question. Always make the hole in the tool smaller than the area to be burned-in.

It will only take a little practice to get used to these various tools; 10 or 15 minutes of dry run will be adequate. Then set up for a printing session, and choose a few of your negatives that look as though they might make better prints from these treatments. The chemicals, of course, are the same, and you may use whatever paper you prefer, either graded or variable-contrast.

Dodging Procedure

1. Choose a negative with a dense area that caused a washed-out highlight on the first full print. Insert it in the enlarger, adjust for desired image size, focus, and stop the lens down to printing aperture.

2. Make a test strip, or use the Projection Print Scale.

3. Develop the test for one minute, stop, and fix.

4. Determine the exposure from your test. At this point, you may have to make a change in procedure. If the test indicates an exposure of less than ten seconds, make another test with the lens closed down one stop or more. Since dodging takes only part of the exposure time, if the total time is short, the dodging time will be much too short and hard to control. Aim for an exposure of 20 to 30 seconds.

5. Now set the timer for the exposure to be given, insert a sheet of paper in the easel, and have the chosen dodging tool in your hand. If in doubt, try the tool on the actual negative before putting sensitive paper on the easel; dry runs of this type are always a good idea, until you know exactly what each of your dodging tools will do. When the sensitive paper is in the easel, turn on the enlarger timer, and immediately start dodging the chosen area, noting the elapsed time from your timer if it shows it. Otherwise, count off seconds by one of the well-known tricks ("one chimpanzee, two chimpanzee," and so on).

6. When you have dodged for about half the exposure time, say, 10 seconds of a 20-second exposure, put the dodger aside, and let the timer complete the exposure.

7. Develop the print for the usual one minute, stop, and fix. Being sure all paper is covered, examine the print under white light.

Evaluating the Dodged Print

Now, we hope, this print is noticeably improved over the straight one. It is, of course, important that everything be done according to routine. If, say, you made a dodged print, but the exposure was not exactly the same as that given the undodged one, you will get a different and not necessarily better print. It is

Burning-in an area on a print. The tool must be kept in constant motion and at the right height from the enlarger easel to ensure coverage of just the area desired with a very small overlap.

A perfectly satisfactory print of a rural scene. However, the silo draws attention away from the barn, which is the center of activity.

By dodging the barn door to the same tone as the silo, a better balance of tones is secured.

a good rule that whenever you are trying any kind of new routine or variation, be doubly sure that nothing else has been changed, otherwise the result will simply be confusion.

It may be that the amount of dodging has been too little or too much. The cure, in either case, is obvious. In general, however, the rule is, don't overdo it. A spot that has been over-dodged generally has a foggy or ghostly look, which is not pleasant, though there may be an occasional subject where just such an eerie effect is wanted. This is a matter of creative judgment, not rule, and you are on your own in such a case.

Most of the time, though, dodging should take no more than half of the total exposure time, and generally less. Experienced workers find that they can often dodge two parts of a print during the normal exposure time simply by working on one area for a number of seconds, then moving smoothly to the next for whatever time it seems to require. Whatever time is left is given to the overall exposure by the enlarger timer.

The important thing here is, dodging is not a photographic necessity, but simply the result of a desire of the photographer to have one detail a little lighter than it normally appears. This being the case, there is nothing at all critical about it, and it should take only a few trials to give you the feel of the process. It is important to keep track of the dodging time as well as the total exposure, so a print can be repeated or a new one made with a definite increase or decrease of the dodging period. If you can't count seconds accurately and your timer hasn't got an elapsed time indicator, then maybe it would be a good idea to have an extra timer, such as a metronome, ticking off seconds audibly.

Lacking all of this, it is perfectly possible to give the exposure in sections. Suppose, for instance, you want to dodge for the first eight seconds of a 20-second exposure. Simply set your enlarger-timer to eight seconds and make an exposure, dodging for the entire time. Now without moving anything, reset the timer to 12 seconds and make the exposure for the overall print. While in theory two separate exposures do not always add up to the same thing as one continuous one, the difference with most print papers is very slight and probably not even noticeable. If there is any difference at all, it will usually be that the final print will need a few seconds more exposure than if it were all given at once. This varies with different papers, but you will find that most do not need any correction at all.

Burning-In Procedure

The same routine is followed for burning-in, except that the split-exposure procedure is used in all cases. For a trial, choose a negative that needs a little more density at some light area in the print.

1. Insert the negative in the enlarger, compose, and focus. Stop the lens down to an aperture that gives a relatively short exposure, say, about 10 to 15 seconds. Make the usual tests to be sure of the exposure.

2. With a piece of plain white paper in the easel, make a quick dry run to decide which burn-in tool will do the job.

3. Put a full sheet of paper in the easel, and give the exposure determined from the test.

4. Without moving anything, take your burn-in tool and hold it under the lens of the enlarger. Start the timer again, which turns on the enlarger light. Keep the tool in motion, and try to cover just the dark area you wish to

(Above left) A night scene. When the darker areas are correctly printed, the sign on the front of the building is washed out. (Left) Dodging the doorway and burning-in the sign produce a fairly natural rendition. Additional burning-in of the light area at the extreme right edge might have improved the print even more.

A straight print of a straight shot. It is a good record shot but has a great many picture elements, none of which stands out.

By printing the whole negative darker and then dodging the building in the middle,
emphasis is placed upon this one feature.

This freshly painted white house (note the ladders!) glares in the bright sunlight; reflected light from the walls can be seen in the grass.

Burning-in the center of the picture brings out detail in the clapboards of the house and also darkens the grass to match the foreground.

bring out. A little overlap is permissible, but try not to cover less than the full area, otherwise you may get an effect like a smudge in the middle of the burned-in area.

5. Note that we have given as much exposure to the burn-in as we did to the entire print. As mentioned, this is because the darkest areas of the negative transmit little light and require considerable extra exposure to produce any result at all.

6. At the end of the burning-in period, remove the paper from the easel, develop, stop, and fix. Examine under white light.

7. In most cases, there should be a noticeable improvement; judge whether more or less burning-in would produce an even better result. Generally speaking, it is best not to overdo it; a washed-out highlight is still a highlight and should not be darkened to a point where it looks like a middle gray. The effect wanted is simply that of a detailed white.

Once you have the feel of both dodging and burning-in, you may find some negatives where you can use both in a single print. This is merely a matter of experience and also of just what effect you want in your print. In any case, this kind of manipulation is purely photographic, hence esthetically legitimate. You can use it to enhance the naturalness of a picture or to produce eerie or other-worldly effects. The limit in this area is your own taste.

There are many possible variations to local control in the exposure of a paper. One, for instance, is to change the contrast of a given area, making a softer highlight and a snappier shadow in one print. This is done with variable-contrast papers by burning-in with different filters. You can explore these possibilities as you gain experience, but for the beginning, try some simple dodging and burning-in steps till you have the feel of the process.

LESSON 5

Print Toning

The natural color of a silver image is black. There are, however, many occasions when a warmer tone, from a sort of ivory-black through brown-blacks to deep-brown and sepia, is more appropriate for a given subject. If only a small warming-up of tone is required, it can be accomplished by proper choice of paper and developer. For more pronounced tones, an after-treatment of the finished print is required; this is known as *toning*.

Toning is normally used to produce browns and sepias; the process consists in converting the silver image into silver sulfide or silver selenide. If colors other than shades of brown are desired, it is done by replacing the silver image with some other metal. Alternatively, a colored dye image can be superimposed on the silver, or it can be made to replace the silver altogether. All of these possibilities will be covered in this lesson, insofar as they can be accomplished with readily available, ready-mixed chemicals.

To begin, we shall discuss, rather briefly, ways to produce brownish tones by direct development of the print. While there are developers that will produce true browns and even sepias directly, we must reserve discussion of these until later in the next course, because these developers are not available in ready-mixed form. With those papers and chemicals normally available, only warm-black and brown-black tones can be produced.

These tones are, however, very desirable in themselves, and most portrait photographers generally use the warm-toned papers and developers designed for them. More important is the fact that many of the toning processes to be described will only work on warm-toned prints; few toners have much effect on cold-toned images. Selenium toners, for instance, have almost no effect on cold-toned papers, such as Kodabromide or Kodak Velox.

WARM-TONED DEVELOPMENT

The color of a silver image depends upon the size of the silver grains that go to make it up. An image mainly composed of very large,

coarse grains will be blue-black in tone; if the grains are somewhat smaller, the tone will be neutral-black; and if the image is composed mostly of very fine grains, the image will be warm-black or even deep-brown.

Thus, to produce warm-toned prints, we have to do two things; we have to choose a warm-toned *paper,* that is, one whose emulsion is composed mainly of fine silver grains, and we have to develop it slowly, in a somewhat diluted and restrained *developer.*

The following papers are representative of warm-toned emulsions, when processed in the recommended developers:

Agfa Portriga Rapid Paper
DuPont Emprex Portrait Paper
DuPont Varilour Paper
Kodak Ektalure Paper

In addition, there are several papers which, while not primarily intended as warm-toned papers, will produce a variety of brown-blacks when used with the proper developer; among these are:

Kodak Medalist Paper
Kodak Polycontrast Rapid II RC Paper

All have ample speed for printing with the usual enlarger, though it will be found that they are somewhat slower than cold-toned papers. Some will require more exposure when processed in certain warm-toned developers. However, since exposure tests are made in every case, the difference in speed will make no difference in handling; simply give the exposure indicated by the test.

Chemicals
Developers for warm-toned papers are usually less concentrated than the usual paper developer; they are made up to different formulas and contain a good deal of restrainer, which makes them work more slowly. This will be covered at greater length in a subsequent

course; for the moment, we shall use one of the available warm-toned developers in packaged form. Any of the following will serve:

DuPont 55-D Developer
Kodak Selectol Developer

The stock solution is prepared according to the instructions on the package of chemicals. For use, this stock solution is diluted with water. In the case of the previously mentioned Kodak Selectol Developer, the stock solution is diluted with an equal part of water, that is, 500cc of developer stock solution and 500cc of water (or 16 ounces of developer stock and 16 ounces of water). DuPont 55-D Developer requires greater dilution; one part of stock solution to two parts of water, that is, 333cc of stock solution to 666cc of water (or 11 ounces of stock solution to 22 ounces of water).

The image tone produced by these developers depends, to some extent, upon both the exposure and development times. Normally, prints should be exposed to develop fully in two minutes in any of these developers at 20 C (68 F). If greater exposure is given and development shortened to one minute, the print tone will be considerably warmer; there will also be a very small decrease in print contrast. Oppositely, shortening exposure and developing for as much as four minutes will produce colder tones and a small increase in contrast.

The stop and fixing baths are the same as those used in previous lessons.

Preliminary Practice
To get a quick idea of the variations in image color that can be produced by warm-toned papers with the appropriate developer, a few preliminary tests and prints should be made. Here the Kodak Projection Print Scale will save a great deal of time otherwise used to make a succession of test strips for exposure. In fact, the tests made with the scale will

prove very instructive as far as color and contrast are concerned. We will, however, make a full-size print after each test; this will prove useful, because these prints may later be toned to show the variations possible in a given toning solution. If, however, you wish to learn the most about toning, it may be well to make several prints through the Projection Print Scale at the standard test exposure, then to fix and wash these prints and save them for use in testing toners later.

The processing steps are the same as those used in preceding lessons, except for developing times, which should be carefully noted. Fixing and washing are the same as in preceding lessons, but care should be taken to wash prints very thoroughly, especially if these prints are to be saved for subsequent toning.

Using a warm-toned material, such as Kodak Ektalure Paper, and Kodak Selectol Developer, diluted 1:1, begin by choosing a negative that has already produced a good print on No. 2 paper. Set up and focus the image on the easel.

Test No. 1: Normal Exposure

1. Take a 4″ × 5″ piece of paper, place it face up on the easel in the middle of the image area.

2. Place the Kodak Projection Print Scale on top of the paper, so that it covers an important part of the image, such as the face in a portrait.

3. With the lens stopped down to about the same aperture as was used previously, make an exposure of exactly one minute.

4. Develop the paper for exactly two minutes, turning it face down after immersion, then face up after a half minute.

5. At the end of two minutes, lift the paper from the tray with the tongs, drain, and immerse in the stop bath. Replace tongs in the developer tray, and with the stop-bath tongs, transfer the print to the fixing bath.

6. Being sure all unexposed paper is covered, turn on white light and examine print.

Determine the best exposure as usual.

7. Turn off light, place a full sheet of paper on the easel.

8. Expose, then develop this paper for two minutes. When it is in the fixing bath, cover all unexposed paper, and turn on white light.

9. Examine this print. If density and contrast are satisfactory, proceed to the next test. If not, make another full print with corrected exposure; do not change developing time.

Test No. 2: Short Developing Time

1. Place a piece of 4″ × 5″ paper on the easel as before, with the Projection Print Scale over it, and expose for one minute.

2. This time, develop the test for *one* minute exactly. Stop and fix, then check for the exposure that will produce a good print at this shorter developing time. It will probably require a longer exposure.

3. Expose a full sheet of paper for the time required by the test. Process it for exactly one minute, stop, and fix.

4. Examine this print in white light. If density and contrast are satisfactory, proceed to the next test; if not, make another print with appropriate exposure correction.

Test No. 3: Long Developing Time

1. Place a piece of 4″ × 5″ paper on the easel, with the Projection Print Scale over it. Expose for one minute.

2. Develop this test for *four* minutes.

3. From the result of this test, choose the proper exposure, and expose a full sheet of paper.

4. Process this print for four minutes, stop, and fix.

5. Allow this print to fix for about five minutes, then transfer all three prints to a tray of plain water.

Judging the Tests

What we now have is a set of three prints from the same negative, developed for one, two,

and four minutes, respectively. If exposures have been correctly chosen, all three prints should be nearly identical in density and only slightly different in contrast. The main difference between the three prints will be in image color.

You will find that the print developed for two minutes is pretty much a normal print, having a somewhat warm-black tone; that is, the black tends to be brownish but is still more black than brown. The print that was processed for only one minute may be slightly softer, but the main difference will be in tone; it should be quite warm, again a brown-black but noticeably browner than the two-minute print. And finally, the print that was developed for four minutes will be very nearly neutral-black in color, just noticeably warmer than a normal print on a plain enlarging paper processed in Kodak Dektol Developer.

This last print was made only to demonstrate that shorter exposure and longer development of a print produces less warmth of tone; normally, there is no reason to make prints this way, since neutral-blacks can be produced much more easily in a normal paper and Kodak Dektol Developer.

Therefore, it is suggested that you now make several more prints from different negatives, and these will be used later for tests of the various toners. In each case, make two prints from a given negative; develop one print for one minute, the other for two minutes (with the necessary correction of exposure so both prints will have the same density).

After-development

One precaution must be taken in making these warm-toned prints; they must not be overfixed. Because the image is composed of fine-grained silver emulsions, the image is slightly soluble in hypo and may bleach if left in the fixer too long. Even if no noticeable bleaching takes place, the hypo will dissolve some of the smaller silver grains first, and the result of overfixing is to produce a less-warm tone. If you are making a large number of prints, prepare a holding bath of plain water, and transfer prints to it after no more than five minutes in the fixing bath. Of course, if your darkroom has a large sink with running water in it, you can have your print washer set up and transfer prints right to the wash at frequent intervals.

If you do this, though, please note that each time you place prints in the washer, they will carry in some hypo, which will contaminate prints already in the tray. Thus total washing time must be figured from the time the last prints are placed in the washer.

This is important, because prints to be toned must be very thoroughly washed. It is probably best to use the holding bath, then wash all prints at once, either in a tray of water, changing the water at five-minute intervals for at least ten changes, or in a running-water type of washer. In the latter case, it is well to dump the entire washer every five minutes or so and let it fill up again; this produces a complete change of water and more efficient washing.

TONING PRINCIPLES

Toning consists in changing the material of which the image is made, from pure silver to silver sulfide, or in substituting some other metal for the silver—for example, brown tones can be produced by transforming the silver image into one of selenium, and blue tones can be produced by exchanging the silver for gold or iron.

The commonest and easiest method of toning is by the use of a *sulfide,* to convert the silver image into one made up of silver sulfide. A variety of tones is possible with the sulfide process, depending upon the toning formula used and also upon the type of print being toned. That is, just as a silver image made up of large grains is blue-black while one made of smaller grains is warm-black, so a sulfide-

toned image, if large-grained, will be a dark-brown, and if fine-grained, it will be anything from warm-brown to sepia, even to a yellow-brown. Thus a given toner will produce different tones on different papers, or even on the same paper, processed in different developers.

There is an additional factor to be considered. Silver images may be converted to silver sulfide either directly or indirectly. The direct method involves treatment of the print in a highly reactive sulfur compound. This method works best on fine-grained, warm-toned originals; many of these toners will not affect a cold-toned print at all. The indirect method utilizes a *bleach,* which converts the silver image into silver bromide which, in turn, is easily converted to a sulfide in almost any sulfide salt. This latter method can be used with cold-toned prints quite well but tends to produce excessively warm tones when used on prints that were fairly warm to begin with. In a few cases, the bleach-and-redevelop type of toner produces an unpleasant yellowish-brown color and should not be used on such papers.

Selenium toners are, in fact, really sulfide toners with some selenium metal added; the final image is probably a complex silver seleno-sulfide. Like direct sulfide toners, selenium toners work best on prints that are made on warm-toned papers. They have little effect on the coarser-grained papers, such as Koda-bromide and DuPont Velour Black. However, a few workers treat these latter papers in a selenium toner for a short time; they claim that while no actual brown toning takes place, the treatment produces better blacks by neutralizing a tendency such papers have to be greenish.

MAKING PRINTS FOR TONING

We have already outlined the way in which warm-toned prints are made; these should be suitable for treatment with any of the standard toners. If you have made prints previously on cold-toned papers and now wish to tone them, this can be done, but only in a bleach-and-redevelop type of toner.

One thing that cannot be overemphasized—since the color of the final toned print depends to a large extent on how long the original print was developed, for consistent color it is essential that all prints be processed for the same time. It is most important that no attempt be made to gain or reduce density in the original print by lengthening or shortening the time in the developer. If this is done, toned prints will vary in color, and no consistent results can be obtained. In general, prints that have been developed for shorter times will tone to warmer browns; those that have been developed longer will produce colder browns. A print that has been snatched from the developer, in an attempt tc salvage an overexposure, will tone to an unpleasant, foxy-yellow color.

Proper fixing is another important matter. Since the sulfide or selenium in the toner deposits upon any silver in the paper, it will also deposit upon unfixed silver bromide. Thus a print that has not been completely fixed may look satisfactory until it is placed in the toner; then brown stains will appear wherever unfixed silver halides remain (this is sometimes used as a test for completeness of fixing).

It is equally important not to overfix, because fixing baths tend to bleach the finer silver grains, and the toned print will be colder than one properly fixed. Fixing time should be held to between five and ten minutes in a fresh bath.

Most important of all, prints to be toned must be thoroughly washed. Traces of hypo in the print may cause either stains or bleaching of the image. The bleach-and-redevelop type of toner is especially critical in this regard; since the image is converted back to silver bromide in the first step, and since silver bro-

mide is soluble in hypo, it is obvious that traces of hypo left in the print can dissolve the silver bromide and cause loss of density, or in extreme cases, total loss of the image. Even tiny traces of hypo in the paper can cause loss of fine detail in the highlights.

TONING PROCEDURES

Toning is carried out in full light, and no darkroom is required. In fact, most of the procedures that follow should not be done in the photographic darkroom if any other place is available. The reason for this is that most toners contain sulfides, which have strong and very unpleasant odors; these fumes not only smell bad, they have a severe fogging effect on sensitized photographic materials. If toning must be done in the darkroom, be sure that you have installed ample ventilation, and do not store any sensitive materials there.

A fairly bright white light should be hung directly above the toning tray. This aids in judging the extent of toning, in the case of direct toners. Where the bleach-and-redevelop system is used, exposure to white light during bleaching and washing steps helps make the bleached image more reactive and produces deeper tones.

BROWN TONING

Kodak Brown Toner is a highly concentrated sulfide solution, which is to be diluted with water at ratios of up to 1 part of toner to 50 of water. Exact instructions for this product are given on the container.

This toner has little or no effect on coldtoned images; prints to be toned should be made on warm-toned papers and developed in a warm-toned developer for at least two minutes. As mentioned, prints should be thoroughly fixed and washed to avoid stains.

Preparing the Toner

The procedure requires three trays plus a print washer, or a separate large tray for washing the prints. In the first tray, place one litre of diluted toner; see instructions on the package for mixing. In the second tray, place a litre of diluted Kodak Hypo Clearing Agent; again, see package for instructions. There are several dilutions listed; use the one for prints. If Kodak Hypo Clearing Agent is not available, you may substitute a simple 3% solution of sodium bisulfite (30 grams of sodium bisulfite in a litre of water, or one ounce in a quart of water). In the third tray, place a litre of hardening bath, made by diluting Kodak Liquid Hardener with water at a ratio of 1:13 (say, 70cc of hardener to 930cc of water, or 2 ounces of hardener stock solution to 30 ounces of water. These quantities are not exactly equivalent, but the strength of this bath is not critical.).

Toning the Print

1. If all baths are at 20 C (68 F), toning will take from 15 to 20 minutes. Several prints can be immersed in the toner at one time, and they should be gently shuffled. This is done by slipping your fingers or tongs under the pile, pulling out the bottom print and placing it on top. It is preferable not to place your fingers in this bath; if you can't do the shuffle with tongs, then use rubber gloves.

2. When prints are completely toned, rinse each print for a few seconds in running water, then place each in the second tray containing the Kodak Hypo Clearing Agent or sodium bisulfite solution. Agitate prints gently in this bath for about one minute.

3. Transfer the prints to the last tray containing the Kodak Liquid Hardener. The time in this tray is not critical; prints may remain in it up to five minutes. If any sediment appears on the prints, they should be swabbed gently with a sponge or a wad of cotton.

4. Transfer prints to the washer and wash for 30 minutes in running water or wash

thoroughly in at least six changes of water.

5. Dry as usual.

This toner will work much faster if used at a higher temperature. If the bath is heated to 38 C (100 F), toning will take only three to four minutes, and in this case, prints may be toned one at a time. It is not necessary to heat the other baths; they may be used at room temperature, that is, anything around 20 C (68 F).

Sulfide baths have a severe softening effect on gelatin, especially at elevated temperatures. Be careful not to handle the prints any more than necessary until they are in the hardener bath; here they may be wiped with a sponge if necessary, before washing.

The color of prints toned by this process is a rich, deep-brown. They are suitable for use as they are, or they are especially well adapted to hand coloring.

As has been pointed out several times, this toner contains a powerful fogging agent. It is very important that all utensils—trays, tongs, and graduates—be thoroughly washed after use. Anything that may absorb chemicals should not be used with this toner; this especially refers to such things as bamboo print tongs, which are very difficult to wash free from chemicals. If they must be used, a separate pair should be reserved just for the toner and never used for anything else.

Likewise, all baths used in this procedure must be discarded after use; the Kodak Hypo Clearing Agent bath will be contaminated with sulfide and should not be saved for any other use.

SELENIUM TONING

The most popular toners currently in use are those based on selenium; for one thing, they have little or no odor and are thus pleasanter to use. These toners work only on warm-toned prints; and depending on the warmth of the original, the toned image will range from reddish to purplish-brown. Packaged selenium toners include Kodak Selenium Toner.

Preparing the Toner

Only a single tray is needed for selenium toning (plus a tray of plain water or a washing device). For normal tones, prepare the toner by diluting one part of the toner stock solution with three parts of water. Prepare only as much as you need; once diluted, the solution only keeps for about a day. Since one litre (or one quart) of the working toner will treat about one hundred 8″ × 10″ prints, you will probably need only about 200cc of toner (made by diluting 50cc of toner stock solution with 150cc of water) to do a dozen or so 8″ × 10″ prints. This quantity, about six ounces, is about the least that can safely be used in an 8″ × 10″ tray; and even so, it will require continual agitation to be sure the print is evenly covered.

Toning the Print

Toning is simple; immerse the well-washed print in the toner, and agitate to be sure the print is covered. Toning will take from two to eight minutes, depending upon the type of paper.

The advantage of this toner is that it works very evenly—there is no tendency to tone middletones more than shadows or highlights more than middletones (this effect is called "double-toning" and is noticed with certain other toners). In the absence of double-toning, it is possible to secure dark tones by toning a print only partially. This makes it possible to secure tones ranging from dark-brown to a barely warmed-up black. To make it easier to control, it is quite possible to dilute the toner more than normal, so that toning progresses more slowly and may be watched to secure the exact tone desired. Kodak Selenium Toner may be diluted up to 1:9. This extreme dilution is seldom necessary, though, and a good compromise is to dilute the toner stock solution 1:6, say, 100cc of toner stock

solution to 600cc of water (or 3 ounces of toner stock solution to 20 ounces of water). At this dilution, toning may take from three to ten minutes, depending upon the paper and the tone desired.

When toning is complete, prints must be washed for at least 30 minutes in running water; they are dried as usual. In the case of partial toning, note that toning continues for a short time in the wash, so treatment in the toner should be stopped just short of the desired tone. If it turns out that the tone is then not brown enough, the print can be returned to the toner for a further short treatment. Very precise control can be had this way.

POLY-TONING

Poly-toning is a hybrid process that partakes of the character of both the sulfide and selenium toners. Kodak Poly-Toner is a representative product of this type. It is supplied in stock solution form and produces various tones, depending upon the dilution used. When used at high concentration (dilution 1:4 to 1:6), toning takes only a minute or a little more, and the tones resulting are dark-browns, resembling those secured with selenium toners. At 1:50 to 1:60, the process takes about seven minutes, and the results are warm-browns, similar to those produced by sulfide toners. At intermediate dilutions, such as 1:25, toning takes about three minutes and the tones are in between those produced at the extreme dilutions.

Poly-toning is recommended mainly for warm-toned papers, such as Kodak Ektalure; it will, however, work on contact papers, such as Kodak Azo, but not on Kodak Velox. For deep-brown tones, prints should be developed normally. Where the toner is to be used at high dilution for very warm tones, it is best that the original print be processed a little longer than normal, say, about 2½ minutes in the de-

veloper (Kodak Selectol), to avoid a tendency to produce yellowish-browns in toning.

This process can be carried out in a single tray (plus the washing tray, of course). If, however, a rinse of sodium bisulfite is used after toning, washing can be reduced considerably.

Preparing the Toner

To prepare the toner, dilute the stock solution according to the following table:

Dilution	Stock Solution	Water
1:5	120cc (4 ounces)	600cc (20 ounces)
1:25	30cc (1 ounce)	750cc (25 ounces)
1:50	15cc (½ ounce)	750cc (25 ounces)

Place the mixed solution in the first tray. A second tray should be filled with plain water. The third tray should contain a sodium bisulfite solution made by dissolving 50 grams of sodium bisulfite in one litre of water (about 1½ ounces of sodium bisulfite in a quart of water —this is not exactly equivalent, but the strength of this solution is not critical).

Toning the Print

The toning process is as follows:

1. If the print has just been made and is still in the wash water, be sure washing is complete; it should be at least 30 minutes in running water for single-weight papers and one hour for double-weight papers. Even if a running-water wash is used, the water in the wash tray should be changed at least five to ten times during the wash time.

2. If the print has been dried before toning, it should be placed in the wash tray and rewashed, for 10 to 30 minutes, depending upon how thoroughly it was washed originally.

3. Drain the wet print, then immerse in the toner tray. Toning time varies with the dilution of the toner. The following is a sugges-

tion, but it can easily be seen when toning is complete.

Toner Dilution	Toning Time 21–24 C (70–75 F)
1:5	1 minute
1:25	3 minutes
1:50	7 minutes

4. At the end of the toning time, rinse the print shortly in the tray of plain water, then transfer to the tray of sodium bisulfite. Agitate in this solution for two minutes.

5. Wash the print for ten minutes, and dry as usual. If the sodium bisulfite rinse is not available, it may be omitted, in which case the print is transferred directly from the toner to the washing tray and washed for at least 30 minutes.

BLEACH-AND-REDEVELOP TONERS

Occasionally, it may be necessary to tone a print that has been made on a standard cold-toned bromide paper, such as Kodabromide, and others. These papers do not react to the toners already described, and a different method must be used.

In this method, the silver image is first converted to silver bromide in a bleach containing potassium ferricyanide and potassium bromide. The bleached print is then treated with a sulfide solution, which converts the silver bromide to a brown silver-sulfide image.

For best tones with this method, the original print should be made on a cold-toned paper and should be rather fully developed; an overexposed and underdeveloped print will produce yellowish tones. Prints on warm-toned papers also tend to produce yellowish tones and should not be toned by this method.

The most important thing to remember is that since silver bromide is soluble in hypo, even tiny traces of hypo left in the print before bleaching will cause some loss of image den-sity; if any really appreciable amount of hypo is left in the print, it may bleach out totally and not redevelop at all. Thus prints must be washed very thoroughly indeed before toning; prints that have already been dried should be rewashed for 30 minutes before toning.

Preparing the Chemicals

The bleach-and-redevelop toner usually available is Kodak Sepia Toner. It is supplied in two packets, each containing enough chemicals to make one litre (one quart) of solution. To prepare the solutions, first dissolve the contents of the packet marked "Bleach" in one litre (one quart) of water, and when they are completely dissolved, pour the solution into the first tray. Then dissolve the contents of the packet marked "Toner" in one litre (one quart) of water, and pour this into the third tray. The tray between the two should contain plain water for a rinse, but it may be better to have a running-water wash available.

Toning the Print

The toning procedure is simple; all steps go to completion, and it is not possible to produce intermediate tones by varying the time in either bath. The procedure is as follows:

1. Rewash prints for 30 minutes in running water, changing the entire trayful several times.

2. Drain excess water from a print, and immerse it in the bleach tray. Allow it to remain until the black silver image is completely bleached. A faint brownish image may still be visible, but this is unimportant; it is merely a trace of developer stain.

3. Rinse the bleached print several times until the greater part of the yellow color from the bleach bath is gone. This should take only a few minutes.

4. Drain the excess water from the print, and immerse it in the toner tray. The bleached image will develop quite rapidly, and redevelopment should be complete in from one to

three minutes. Toning is complete when the print does not get any darker.

5. Wash the toned print for 30 minutes, and dry as usual.

It is necessary to emphasize that this is a sulfide process; it should not be carried out in a room where ventilation is poor, or where sensitive materials are stored. After work is done, all utensils must be very thoroughly washed, to be sure that not even a tiny trace of sulfide remains on a tray, graduate, or tongs. Use only stainless steel or glass with this toner.

GOLD TONING

There is a variety of *gold-toning methods,* most of which produce warm-brown tones much like selenium tones. One, however, is rather special; it is a combination of a gold salt with sodium thiocyanate. If used directly on a print made on warm-toned paper, this toner produces a variety of interesting blue tones; if, on the other hand, it is tried on a cold-toned paper, it produces no effect whatever. If a cold-toned print is first toned in a sulfide toner, then treatment with the same gold bath will produce *red* tones. Other red tones are produced on warm-toned prints that have been toned with sulfide.

Gold toning is a very flexible process, because it is not necessary to tone the print completely; a large variety of intermediate effects can be produced by partially toning a print in a sulfide toner, then treating the incompletely toned print in the gold bath. This, however, does not work equally well with all sulfide toners; it is best done with the *hypo-alum toner* which, unfortunately, is not available in packaged form.

Preparing the Blue Toner

A toner that works like the gold toner is sold in packaged form as Kodak Blue Toner. All that is necessary to prepare it is to dissolve the chemicals in one litre (one quart) of water, according to the instructions on the package, and to place the mixed solution in a tray. The well-washed print, made on a warm-toned paper, such as Kodak Ektalure, is placed in the tray of toner, allowed to remain until the full blue tone is reached, and is then washed and dried.

Using the Blue Toner

For red tones, any kind of paper can be used, because the print must first be toned in the bleach-and-redevelop type of sepia toner. Three trays are needed plus a washing tray. The first tray contains the bleach bath of the Kodak Sepia Toner, the second tray contains the sulfide redeveloper, and the third tray contains the Kodak Blue Toner solution. As usual, prints must be developed fully, and they must be thoroughly washed before toning, otherwise loss of image may result in the bleach bath. With prints on hand, the procedure is as follows:

1. Place the well-washed print in the bleach bath, and leave it there until the black image is completely bleached; some faint trace of a brown stain image may remain.

2. Wash the bleached print thoroughly, until the yellow stain of the bleach bath is gone.

3. Place the print in the sulfide redeveloper, and leave it there, with gentle agitation, until the image has completely redeveloped.

4. Wash the print thoroughly, to eliminate all traces of sulfide.

5. Place the print in the Blue Toner bath; the image will slowly change from brown to red. This may take anywhere from 15 to 45 minutes. It is possible to tone several prints in the same tray at the same time. In this case, it is best to lift the bottom print out from under the pile, place it on top, then do the same with the next print. As each print reaches the desired red tone, it is removed and placed in the wash tray.

6. When all prints are in the wash tray,

continue washing for about 30 minutes, then dry as usual.

DYE TONING

With the exception of gold toning, all the procedures discussed to this point produce brown tones. There is not really very much in the way of subject matter that calls for prints in colors other than black or brown, yet there are times when a photographer may wish to produce a print in green, purple, or other color for some special reason.

One way in which an almost unlimited variety of colors can be produced is by the use of *dye toning*. This must not be confused with mere tinting, which simply puts a wash of color over the light areas of the print, leaving the shadows black. Dye toning consists in chemically transforming the silver image into what chemists call a *mordant,* which has the property of attracting dyes and making them insoluble. The dyes used are of a type that does not stain gelatin or paper and is easily washed out. Thus when a mordant is present, the dye attaches itself only to the mordant, forming a colored image, but washes out of the gelatin and paper, leaving the highlights white. There are various mordants, some of which attach themselves to the silver image, so the final image is composed of both silver and dye. Others are transparent and replace the silver image completely; in this case, the final image is a pure dye, bright and clear.

The currently available dye toners are produced by Edwal under the name of Edwal Color Toners, in a range of five colors: red, brown, yellow, green, and blue. Of these, however, only the first four are dye toners; the blue is a metal toner containing iron salts. It is possible to produce intermediate colors by treating the print partly in one toner and partly in another.

These toners are made with the mordant and dye in a single bath, and they work in a gradual fashion. At first, a small amount of mordant is formed, and the dye deposits on a black silver image. If toning is continued, the silver is gradually converted almost completely to the transparent mordant; thus the image becomes brighter and purer in color as toning continues.

The toners are supplied in 4-ounce bottles, each being diluted with enough water to make 64 ounces of solution. It is not, of course, necessary to use up the whole bottle at once; for most cases, diluting one ounce of the stock solution with 16 ounces of water will produce enough working solution for a number of prints in an 8″ × 10″ tray. In metric measure, dilute 25cc of stock solution with 475cc of water.

Prints to be toned should be made on warm-toned papers, such as Kodak Ektalure and DuPont Varilour. These must be processed in the recommended warm-toned developer, but development must not be forced. Traces of fog, which are too slight to be noticed in a normal print, will pick up dye and produce stained highlights in dye toning. Prints should be very thoroughly washed before toning; traces of hypo in the print may cause image bleaching or stains on the toned print.

Toning Procedure

1. Prepare the toner for the desired color as directed on the bottle.

2. Place the well-washed print in the toner tray, and agitate gently. Toning will take from four to ten minutes, depending on temperature and also upon the brightness of color desired.

3. When the desired color has been almost reached, transfer the print to a washing tray and wash in running water. The color will brighten somewhat during washing, so it may be worthwhile to make a few tests to determine the exact time needed to produce a given color.

4. If the color is not bright enough after a

short washing time, it is possible to return the print to the toner tray for further treatment.

5. Washing should be only long enough to remove the excess dye from the paper. Excessive washing may cause a loss of density in the toned print, but this may be of some help in lightening a print that was accidentally made too dark.

After-Treatment

There are some supplementary treatments that will assist in securing clean images. The green toner, for instance, is somewhat more difficult to clear out of the whites than the other colors. Clearing can be speeded up by rinsing in a 1% solution of sodium bisulfite (ten grams of sodium bisulfite in a litre of water or about ⅓-ounce of sodium bisulfite in a quart of water).

This clearing bath will work with all the colors except the blue which, as mentioned, is not a dye toner. In the case of the blue toner, clean whites can be obtained with a clearing bath composed of 1% sodium carbonate (ten grams of sodium carbonate in a litre of water or about ⅓-ounce of sodium carbonate in a quart of water).

If toning is considered slow, it may be speeded up by adding from ¼-ounce to ½-ounce of 28% acetic acid to each quart of toner; this is from 7½ to 15cc of 28% acetic acid to each litre. Again, this will work on the brown, green, yellow, and red toners, but will have no effect on the blue.

Local Toning With Edwal Color Toners

The *Edwal Color Toners* can be applied to a print with a brush; in this way, an image can be made in several colors. Since the print accepts color in proportion to the amount of silver image present, the process is not at all critical, and it is quite possible to produce colored prints from black-and-white originals, which look like actual color prints. Obviously, colors need not be natural, and some "far

out" effects can be secured in this way.

Brushes for this process should be those set in quills; metal-bound brushes may react with the toner and cause stains or other unwanted reactions. Larger areas can be toned with Q-tips or similar swabs.

COLOR DEVELOPMENT

One of the by-products of color film research is the so-called *chromogenic* developer. This is a developer that produces not only a silver image but a dye image along with it. For color films, such developers are designed to produce only magenta, cyan, and yellow images, but many other formulations are possible for a wide variety of colors.

Of course, you cannot merely use the color developer out of a color film processing kit; it produces colored images on color films, only because a color-forming component is included in each layer of the film, and this component reacts with the developer to produce the correct color in each layer. For producing colored images on ordinary films or papers, it is necessary to make a developer that contains both the color-coupling developing agent and the color-former for the particular color desired. Such a developer will produce the desired color on almost any type of film or paper.

Obviously, only one color can be produced this way, in any one print, but this is pretty much what we want in any case. The final image is a combination of dye and silver and is fairly dense; in some cases, this is desirable, and the print is left that way. For lighter and brighter colors, the silver image can be bleached out, leaving a pure dye image.

DEVELOCHROME

A color developer for papers is available commercially; it is known as *F-R Develochrome* and is available in a variety of colors.

The dyes produced by this developer are reasonably permanent, but they are somewhat sensitive to acids and also to the components of the ordinary acid-hardening–fixing bath. For this reason, no stop bath is used in processing with Develochrome, and only the special Develochrome Fixer can be used.

Develochrome reacts well with nearly any type of enlarging or contact paper; it is not necessary to use a warm-toned type of paper. There are, in fact, some warm-toned papers that require a good deal of overexposure to produce usable images with Develochrome.

Using Develochrome

The developer and fixing bath are mixed according to the instructions on the package. Ordinarily, the developer is supplied in a three-part package, and for use, parts A, B, and C are dissolved in order in 375cc (12 ounces) of water at 24 C (75 F). The fixer is a single powder, and the contents of the package dissolved in 375cc (12 ounces) of water.

The developer does not keep very well and should be mixed just before use. It cannot be saved after use. Some persons are sensitive to this developer; it may produce a mild skin irritation. To avoid this, keep fingers out of the bath altogether, handling prints entirely with tongs. If you are unusually sensitive to this chemical (few persons are) rubber gloves will provide complete protection.

Exposures for this process will have to be greater than those given to the same paper with a normal black-and-white developer. If the Kodak Projection Print Scale is used to determine the exposure, the difference will be taken care of automatically.

Developing Procedure

Set up three trays: In the first put the Develochrome Developer for the desired color; in the second, a plain water rinse; and in the third, the Develochrome Fixer. Repeat: *do not substitute any other fixer, and do not use an acid shortstop.*

1. Set up and focus enlarger for the desired image size. Place a 4″ × 5″ piece of paper on the easel and the Kodak Projection Print Scale on top of it. Make a trial exposure of one minute.

2. Develop this test for two to four minutes. The exact time will depend upon the particular paper being used, and it will be necessary to watch the print as it develops. Leave the print in the developer as long as it continues to gain density. When it seems to come to a stop, note the time; that will be the developing time for future prints on that paper.

3. Rinse the print in the water rinse, and place it in the fixing bath, agitating it for a few seconds.

4. Making sure all unexposed paper is covered, turn on the white light, and determine the exposure from the Projection Print Scale image in the usual way.

5. Expose a full print for this time.

6. Develop this print for the time determined in the first test.

7. Rinse and fix; fixation takes three to five minutes.

8. Wash prints for 15 minutes and dry as usual; prints may be ferrotyped if not on resin-coated paper.

Variations in the Develochrome Process

When less color is wanted, say, when a black image with only a tinge of color is desired, it is possible to produce an image containing more silver and less dye. This is done by setting up an extra developer tray containing Kodak Dektol Developer (or equivalent) rather diluted. For a trial, mix 200cc of Dektol Stock Solution with 800cc of water (6 ounces of Dektol Stock Solution to 24 ounces of water).

The exposed print is first placed in the Dektol tray and agitated gently for about a half minute. As soon as the image begins to appear, but before it has gained much density, rinse the print quickly, and transfer it to the Develochrome tray, where it may remain for up to four minutes. This will not add much

density to the image—development will practically stop when full density is reached anyway. At the end of the color development period, rinse and fix as usual.

This is a purely experimental method for expressive purposes, and you may find it desirable to dilute the Kodak Dektol Developer even more than suggested. Almost any combination of development times in the two trays will produce some kind of result; it is well to make notes of exactly what is done, so that results can be repeated later if you happen to secure a particularly desirable tone.

To Obtain Brighter Colors

The image produced by the Develochrome Developer is a combination of a colored dye image and a black silver image. It is possible to obtain brighter colors by removing the silver image, leaving only the dye. This is done by bleaching the print in a potassium ferricyanide solution containing hypo; this is essentially a strong Farmer's Reducer solution. Packaged Farmer's Reducer can be used for this purpose but may be a little weak; faster action can be obtained by using only half the normal amount of water to mix the reducer. This bath must be mixed immediately before use and discarded as soon as used; it does not keep for more than a very short time.

Another quicker bleach is that used with the Kodak Sepia Toner; since this does not contain hypo, its keeping qualities are better. However, since this bleach does not contain hypo, it does not actually remove the silver; it merely converts it to silver bromide. The silver bromide can then be removed by immersing the print in hypo; use only the Develochrome Fixer, though, because a hardening fixing bath may bleach the dye image.

Processing Procedure

1. Develop the print in the Develochrome Developer; rinse and fix in the Develochrome Fixer.

2. Wash the print for at least ten minutes to eliminate most of the hypo; this is only to avoid contaminating the bleach bath, and complete washing is not essential.

3. Place the print in the bleach (solution "A" of the Kodak Sepia Toner; do not use solution "B," and in fact, it is better if solution "B" is not even mixed or kept in the darkroom). Allow the print to remain in the bleach for two to five minutes; it will not bleach out completely, since the bleach only affects the silver image, not the dye. When no further change occurs, take the print from the bleach, and put it in the wash tray.

4. Wash the print until the yellow bleach stain is eliminated—usually for five to ten minutes.

5. Put the print in the Develochrome Fixer for not more than five minutes.

6. Wash and dry as usual.

Using the Develochrome Developer as a Toner

It is not necessary to use the Develochrome Color Developer only on freshly exposed paper. If you prefer, you may make your print in the normal way—straight black-and-white —using whatever paper you please, develop it in Kodak Dektol Developer, fix, wash, and dry it. Then at any time you choose, you can convert the black-and-white silver image into a dye image of any one of the Develochrome colors by using the Develochrome Developer as a toner.

The Develochrome Developer will not have any effect on a black-and-white print; the latter must first be converted back into silver bromide, after which it may be color-developed like any sensitive paper. Since the bromide exists only as an image, the development this time goes to completion and need not be done in darkness. All that is necessary is to bleach the print in a standard toning bleach, then wash and redevelop in the chosen Develochrome Color Developer. No fixing is necessary after this process; if you desire brighter

142

colors, the silver image may be bleached out and the print fixed, just as described above.

The bleach bath from the Kodak Sepia Toner will serve well for this purpose; it is prepared according to directions. Solution "B" of the Kodak Sepia Toner is not used; instead, after bleaching, the print is washed and redeveloped in the Develochrome Developer of the appropriate color.

The procedure is as follows:

1. In the first tray, place the bleach solution of the Kodak Sepia Toner; do not mix solution "B" at all.

2. In the second tray, place the Develochrome Developer of the desired color.

3. Wash the print for 15 to 30 minutes; as in sepia toning, it is essential that all traces of hypo be eliminated from the emulsion. Loss of image will occur if this is not done.

4. Bleach the print in the first tray until only a trace of brownish image remains.

5. Wash the bleached print thoroughly, until the yellow color of the bleach is entirely removed. This should be done in bright room light, preferably under a strong incandescent light. Sunlight must not be used, however, as it may cause staining.

6. Place the bleached print in the Develochrome Developer, and allow it to remain there, with gentle agitation, until the image has reached its full density.

7. Wash thoroughly, then dry as usual. Fixing is not required, though a short treatment in the Develochrome Fixer will do no harm and may result in a slightly brighter colored image.

There is a small but useful range of control possible in this process. As already mentioned, we can have dark colors, with an admixture of black, by leaving the silver image in the paper. We can have lighter but purer colors by removing the silver image with a bleach and hypo fix. Finally, some intermediate colors can be produced by mixing Develochrome Developers of two different colors. The whole field is a fertile one for those who like to experiment.

If you do experiment, it will pay to keep careful notes of everything you do as you do it. Then if you find a particularly desirable color effect, which you wish to repeat at a later date, you will know exactly what you did to get it.

One possibility for control, which has not been mentioned, is a sort of double-toning; in this process, the print is only partly bleached, leaving some silver in the deepest shadows. The image, after washing, is redeveloped in the appropriate color developer, producing neutral-black shadows and tinted middle-tones, with highlights remaining substantially white, as in all other uses of the Develochrome process. This method is of some experimental interest, but results are likely to be erratic; and in any case, leaving the silver image in the final print, after bleaching and redeveloping completely, will produce substantially the same effect. For this reason, the method is not recommended, at least for beginners.

SUMMARY OF LESSONS 1–5

At this point, we wish to review what has been learned in the first part of this course. So far, we have mastered the techniques of negative developing, contact printing, and enlarging to the extent that they can be carried out with easily available materials and without having to mix formulas from bulk chemicals.

This summary will also be useful as a quick reference. In it, we repeat the most important tables and recommendations, so if you need to find something in a hurry, it may be easier to locate it here than to go through the bulk of the lessons. Furthermore, now that the reader has learned the basic techniques, following all instructions implicitly, we can here point out where there are tolerances and where one can make personal alterations and corrections.

We must make one point very clear: We are not advocating any variation from the instructions we have given. Moreover, the basis of the whole course is that consistent results can only be obtained if the procedures are consistently carried out and done exactly the same way every time. On the other hand, no two people can agitate a developing tank exactly the same way or at the same rate; some varia-

tion in contrast must necessarily result. This variation is quite small, and a very small correction is all that is needed. Once the correction is applied and the desired result attained, this becomes your standard procedure which should be followed consistently in all future procedures. This applies to all corrective steps: It is essential to first determine that a correction really is needed, and if it is, to apply the correction uniformly from that time on.

LESSON 1: NEGATIVE DEVELOPMENT

Chemicals required are Kodak Developer D-76 or its equivalent in other brands (Du-Pont Developer 6-D, Ilford Developer ID-11, FR X-Trol 76 Film Developer) and the fixing bath—Kodak Fixer in powdered form or its equivalent in other brands.

To mix chemicals, put about three-quarters of the final amount of water in a plastic or enameled bucket. For the developer, the water may be at 50 C (120 F); for the fixer, it should not be warmer than 27 C (80 F). Slowly

145

pour the powdered chemical into the water while stirring steadily. When all is dissolved, pour the solution into a labeled jug and add cold water to fill the jug to the neck. Allow solutions to cool before using. The slight milkiness of the fixer will clear up if left to stand overnight.

To develop exposed film, wind it into the reel of the tank in total darkness. Stainless steel wire reels are the best, although some good plastic reels are available. An inexpensive tank, which uses an "apron" for separating the turns of film, is available for beginners who do not wish to invest much money at first. Automatic, or self-loading, tanks have very nearly disappeared from the market.

Developing times at 20 C (68 F) are as follows for commonly used films:

Ilford FP4 Films	6 minutes
Ilford HP-5 Films	7 minutes
Kodak Tri-X Panchromatic Films	8 minutes
Kodak Verichrome Pan Roll Films	7 minutes

These are normal developing times and should produce good negatives in all cases. However, there is a possibility of a small variation here. Development depends upon time, temperature, and agitation. The latter is most important, as a film developed without agitation will have much less density than the same film developed for the same time, in the same developer, at the same temperature, with constant, vigorous agitation. Another variation occurs because most inexpensive thermometers are not very precise; an ordinary Celsius thermometer may be off by a whole degree and a Fahrenheit one as much as two to three degrees.

We suggest strongly that you follow instructions exactly for your first roll of film. It is important that this roll contain accurately exposed pictures, because you can't judge the development of a negative if it is not correctly exposed. In all cases, you cannot try varying any one procedure unless all others are held constant.

Assuming that your film was correctly exposed and that you developed it strictly according to instructions, with agitation every minute and temperature at 20 C (68 F), the negatives you get should be very good indeed. If there is any error at all, it will be quite small and more a matter of personal preference than of pure correctness. For example, your taste may run to fairly soft negatives for finest grain and big enlargements; or you may prefer stronger negatives printed on a diffusion enlarger. In the first case, you may, if you like, decrease development by one or at most two minutes less than the listed time. In the second case, you may wish to increase development by one or at most two minutes. Greater changes than these are not desirable. If they seem to be necessary, check your exposures first, then make sure that you are following all instructions for processing implicitly.

If there is any doubt about exposures, then don't make any changes in developing time until you have developed one or two more rolls. Only if your negatives are *consistently* light or dark should you make any alteration in developing time.

After development and before fixing, give the negatives a short rinse in plain water. Simply empty the developer from the tank, fill it with plain water, agitate for about a minute, and empty the tank. Next pour in the fixing bath and agitate for a minute. Now you can remove the cover of the tank and continue agitation simply by rotating the reel with your fingertip or a stirring rod. From time to time, lift the reel out and inspect the film. The milkiness seen at first will disappear as fixing proceeds. When the film is entirely cleared, give it another two minutes in the fixer to be sure, then empty the fixer and wash the film.

The most efficient washing method involves filling the tank with water, agitating for a min-

ute or two, then emptying and refilling. Five such cycles of fill and empty will be ample for nearly all purposes. Ten fill-and-drain cycles will wash the film far better than any amount of time in running water.

Add a few drops of Kodak Photo-Flo, Agfa Agepon, or other wetting agent to the last wash. At the end of this cycle, you may hang the film to dry without wiping.

LESSON 2: CONTACT PRINTING

We ended Lesson 1 with a roll of developed and dried negatives. To discuss these further, we need a few words in our vocabulary. *Density* is the amount of silver deposited in any given area of a negative; colloquially, it is used not merely for quantity, but for light-stopping power or blackness. *Contrast* is the difference in density between the lightest and darkest parts of a negative (or the ratio of the light-stopping powers of these areas). The word is used in further work to refer to brightness ranges of subjects. *Highlights* are those areas of the *subject* which are brightest; they are represented in the negative by the blackest areas and in prints by the lightest arcas. *Shadows* are the darkest parts of the subject, the lightest parts of the negative, and the deepest blacks of the print. *Middletones* are all the tones lying between highlight and shadow.

It is important to remember that the terms *highlight, middletone,* and *shadow* all refer to areas of the subject. So although a shadow is black in the subject and transparent (light) in the negative, it remains a shadow always.

Printing papers are sensitized with different emulsions, depending upon whether they are intended for contact printing or enlarging. Contact-printing papers are less sensitive than enlarging papers; however, there is little difference otherwise, and many photographers make contact prints on enlarging papers simply by reducing the strength of the printing light or using the enlarger as a light source.

Papers are made in various surface textures, weights of paper base, and degrees of contrast. Here *contrast* refers not to the paper, but rather to the contrast of the negative to be printed upon it.

Paper emulsions need not be handled in total darkness because they are much slower than film emulsions, and because they are usually sensitized only to blue light, or in a few cases, to blue and green. Thus any light that contains neither blue nor green rays will be safe. The usual safelight filters are the Kodak Wratten Series OC or the DuPont Series S-55-X. Both are a brownish-orange color and are safe for any kind of paper, including the variable-contrast types.

Papers are developed in much stronger developers than those used for films; the ones most commonly used are Kodak Developer D-72 and Kodak Dektol Developer; or similar formulas of other makers. These are mixed to form a stock solution which is further diluted for use.

A plain water rinse will not serve for the strong print developer; always follow development with a rinse in a stop bath, made by diluting 30cc of 99% glacial acetic acid with 970cc of water to make a litre of stop bath. In American measure, that is 1 ounce of the acid and 29 ounces of water to make a scant quart.

The fixing bath is exactly the same as that used for films.

Always develop papers to completion; this takes from one to three minutes at 20 C (68 F). It is impossible to correct a badly exposed print by changing developing times, and in general, not much happens after the first minute. Therefore, for best quality on Kodak Kodabromide Paper or DuPont Velour Black Paper, we suggest that you try to time your exposures so print development is complete in exactly one minute. A print that is much too light or much too dark at the end of one minute developing time cannot be saved and should

be discarded at once. There is some small leeway, though, and for the papers mentioned, one may develop for as short as 45 seconds or as long as 1½ minutes.

There is, however, one problem with this: It is very hard to judge the density of a print while it is in the developer. With Kodabromide and Velour Black, there is always a grayish veil over the image, and the print becomes noticeably darker when placed in the fixer; this is not the final appearance of the print either, as prints tend to darken slightly upon drying. For this reason, develop Kodabromide or Velour Black papers for exactly one minute at 20 C (68 F) without any attempt at judging the quality of the print in the tray.

Handle prints in solutions with tongs made of bamboo or stainless steel. When you get the knack of handling these tongs, you will find that you can process a print completely without ever getting your hands wet. Each pair of tongs is used in one solution only and is never put into any tray but its own. To ensure that tongs are not mixed, they should be color coded to match the trays or marked, using black lacquer, with the letters D, S, and F, for Developer, Stop, and Fixer, respectively.

Make exposure adjustments in fairly large steps; if a print is not dark enough at 10 seconds, try another with a 20-second exposure. Smaller adjustments are effective only when you are very close to the final result.

We repeat: Make all adjustments of print density by varying the exposure of the paper, keeping the development time constant at one minute. Only after you have attained considerable experience can you try to make corrections in the developer tray, and even then, only very small alterations of density can be made. But if you keep varying both exposure and development, you will *never* attain consistently good results.

When making only a few prints, you can leave them in the fixer until the session is over and then wash them at once. If the print-making session is a long one, then allow prints to remain in the fixer for ten minutes or less, then transfer them to a holding bath of plain water until you can wash them thoroughly. The prints can stay in the holding bath for several hours if necessary.

Prints on ordinary papers should be dried face up on blotters or newspaper. When dry, they curl rather badly and have to be flattened. Do so by dampening only the back of the dry print and placing it in a heavy book for about a half hour to flatten out.

The RC ("resin-coated") papers dry very fast and curl very little; usually no flattening treatment is required.

In any case, never dry prints face down on paper or blotters; they will pick up contaminants from the newspaper, and in extreme cases may stick to it. In the case of resin-coated papers, face-down drying extends the drying time considerably; almost all the moisture is on the face, or emulsion side, and cannot easily escape through the back.

LESSON 3: BASIC ENLARGING

Enlarging papers come in a variety of surface texture and weights of paper base. Most come in two thicknesses: "single-weight," the moderately thin paper base used for small snapshot prints and large prints that are to be mounted; and "double-weight," a heavy base for large prints not intended for mounting. Resin-coated ("RC") papers usually come in only one weight, an intermediate one between single and double, called "medium-weight." In addition, one or two papers come in an extra-thin base for prints that are to be air-mailed and other purposes.

Enlarging papers, like contact papers, are available in a variety of *contrast* grades, or exposure scales, or with variable-contrast emulsions that produce a variety of exposure

scales in a single paper. With these latter, the contrast of the paper is adjusted to the negative by printing through a colored filter; in addition, the papers can be used without a filter to produce results roughly equal to an ordinary No. 2 paper.

Develop enlarging papers in exactly the same way as contact papers, using Kodak Dektol Developer or equivalent developer diluted 1:2 with water and developing for one minute. The stop bath and fixer are likewise the same as those used for contact papers. Variable-contrast papers react somewhat differently than ordinary enlarging papers. For instance, Kodak Polycontrast Rapid RC Paper does not acquire the grayish veil over the image while in the developer, and the print tends to lose a little density in the fixer. For this reason, it is not easy to judge the progress of development visually.

During development of variable-contrast papers, the image gets quite dark in the developer, and at the end of the normal development time, the print appears overexposed. When the print has been in the fixer for about a minute, however, it becomes noticeably lighter and will probably be correct. This means that you must develop entirely by time; do not attempt to judge the progress of the print in the developer or to make corrections of exposure by adjusting the time of development.

One other recommendation for Kodak Polycontrast Rapid: While excellent prints are possible with the recommended one-minute developing time, this paper will produce slightly richer blacks if development is extended to 1½ minutes. Actually, you will see little gain in density after the first minute, but the added 30 seconds seems to "set" the image and reduce the loss in density in the fixing bath. The leeway in processing Kodak Polycontrast Rapid RC Paper is that development may be carried as long as three minutes or shortened to 45 seconds if necessary, but the best print quality

comes from processing for 1½ minutes.

One major factor in making high-quality enlargements is the enlarger lens. A poor-quality lens can badly degrade the sharpness and contrast of the print, and you can purchase an excellent enlarger lens for far less than a high-quality camera lens. This is because an enlarger lens does not need to be of great speed —most are $f/3.5$, and the best even slower; furthermore, enlarger lenses do not need complicated and expensive focusing mounts and automatic diaphragm mechanisms. A word of caution: Do not try to use your camera lens in the enlarger. While some of the slower, say, $f/3.5$ maximum-aperture lenses, are capable of making pretty good prints, the cemented elements of such lenses may be damaged by heat in some enlargers. Fast lenses—$f/1.8$ and $f/1.5$—should not be used for enlarging at all; they are not properly corrected for close ranges and some have severe field curvature, making it impossible to get a print sharp to the corners.

You can determine enlargement exposures by making test strips or by using the Kodak Projection Print Scale, which produces a whole set of tests with a single exposure. There are also print exposure meters, some of them very good and not too expensive, but these must be calibrated by the user; there is no system of paper speeds that corresponds to the speeds used for films with camera exposure meters.

Also in enlarging, you can stop down the enlarger lens to an aperture that produces the most convenient exposure times with average negatives. For instance, if you are making small prints, you may stop down to $f/16$ to get exposures in the range of 10 to 20 seconds. For large prints, you may open the lens to $f/11$ or even $f/8$ so that the exposure remains in the same range. In all cases, the lens is opened wide for focusing then stopped down just before exposing.

After making a good test, expose a whole sheet of paper and develop exactly as in pre-

vious lessons. It is essential that developing times be maintained exactly for both test and print, otherwise consistent results cannot be obtained. In the beginning, at least, you should make a test for every print; later on, you will learn to judge negatives in advance and group them into sets, each of which can be printed on the same exposure for all negatives in the group.

LESSON 4: INTERMEDIATE ENLARGING

Up to this point, we have avoided any discussion of what to do when negatives are not normal, that is, when they are excessively dense or excessively thin, or when they are too contrasty or too soft. The reason is, we wished to establish a tight routine for exposing and developing the print first. Once you have made it a habit of developing all prints exactly alike and making all corrections in the exposure of the paper, then you can go ahead with corrective measures for off-standard negatives.

Contrast in the negative is the range of density from light to dark; in papers, it is the difference between an exposure that produces a barely visible image and one that produces the maximum black of which the paper is capable. As an example, if the negative has a highlight that is 30 times as black as its thinnest shadow, you need a paper with a 30:1 exposure scale to print this negative.

There is nothing very critical about this, though. For one thing, it is hard to tell the difference when a few black tones go beyond maximum black or when the light areas of the print are a bit grayer than normal. Therefore, papers come only in a few contrast grades, and it is simply a matter of choosing the one nearest right for the negative in question. The nominal ranges of the usual papers are: "extra soft," about 50:1; "soft," about 30:1; "normal," about 20:1; "medium hard," about

13:1; "hard," about 8:1; and "extra hard," about 5:1.

This being the case, a negative with a 25:1 range, for instance, will fall between two grades of paper. This poses no problem whatever; all it means is that a good print can be made on either grade. Which grade you select is a matter of personal preference. Those who like snappy prints will choose the harder paper; others who prefer softer ones will choose the lower of the two grades. Sometimes subject matter is the controlling factor, so in general, you will probably print portraits on softer paper than you would for industrial negatives.

It is necessary to repeat that the contrast of a negative depends upon the density of the highest light and deepest shadow and not at all upon the proportion of each in the picture. Thus while a night scene may seem to be a thin negative because it is mostly clear film, you will find the highlights pretty dense and so must classify the negative as a contrasty one.

If a thin negative contains *no* black areas, then it is, indeed, a soft negative, but so is a dense negative containing no white areas. In short, contrast is "density range," not average density.

All of the recommendations given here are approximate, one reason being that the enlarger has some effect upon the contrast of the image of the negative as it reaches the paper. A triple condenser enlarger will produce a noticeable increase in contrast of the projected image, sometimes as much as the difference between two adjacent paper grades. A diffusion enlarger, on the other hand, adds little or no contrast to the projected image, and the print will be similar to a contact print from the same negative. However, since you probably have only one enlarger, it is simply a matter of getting used to it.

You get used to an enlarger by printing a number of negatives on it and making a test for each negative before printing a full-size sheet.

Choosing the correct contrast grade of paper is easy because there are only a few contrast grades, and there is nothing very critical about the choice anyway.

Most papers are available in one to four grades, ranging from No. 1, "soft," to No. 4, "hard." Some papers have one or two additional grades, such as a No. 0, "extra soft," or a No. 5, "extra hard," but these are seldom used, except to salvage otherwise unprintable negatives.

Since the extreme paper grades are seldom used, one often finds that packages of No. 0 and No. 5 paper remain on the shelf till they spoil while several packages of No. 2 and No. 3 paper are used up. By exposing through filters, variable-contrast papers solve this problem by producing any degree of contrast except the most extreme. Yellow filters produce soft prints while magenta or blue filters produce contrasty ones. The deepest filter in the contrasty range produces the equivalent of a No. 4 paper; it is not possible to secure the effect of a No. 5 with these papers. In addition, there are yellow filters that produce softer results than any graded No. 0 paper.

Kodak Polycontrast Filters contain "in-between" grades, Nos. 1½, 2½, and 3½. DuPont's filters do not contain the half steps but do supply two very soft filters, a No. 0 and a No. 00.

Other than exposing with filters, these papers require no special handling; they are developed in Kodak Dektol in the same way as other papers. The only difference is that Kodak Polycontrast Rapid RC Paper produces better tones if developed for a full 1½ minutes instead of one minute. If you watch development proceed, you will note that very little increase in density results during the final 30 seconds.

If your enlarger does not have a filter tray in the lamphouse, you will have to place the filters under the lens; in this case, filters must be of optical-quality gelatin and must be kept spotlessly clean and free from fingerprints and smudges. If your enlarger does come with a filter tray in the lamphouse, then you may use less expensive colored plastic filters; however, these should still be kept clean and free from smudges and dust.

There is another method of controlling contrast in a print. Sometimes you find that a given negative, which prints easily on a soft paper, looks better on a harder grade, but then a few highlights are washed out or a shadow or two are too black. In this case, it is possible to hold back the exposure of the offending shadows by *dodging* or to add density to certain highlights by *burning-in*.

Dodging is done during the main exposure, because it generally requires only a small part of the total exposure time; if, say, a negative requires 30 seconds to print, it is seldom that any area will have to be held back more than about 10 seconds. Burning-in, on the other hand, is usually done after the main exposure has been given. Since burning-in is only required in the highlights—the densest parts of the negative—the additional exposure required will be considerable in order to get any effect through this density. For a first trial, burn-in a print for about the same time as the main exposure. The final print may need still more, but seldom any less.

Neither of these tricks should be overdone; the effect of excessive burning-in or dodging is always highly artificial and gives itself away at once. When subtly done, however, dodging and burning-in are the two most powerful techniques in the photographer's craft.

Once you have mastered simple dodging and burning-in, there will be little difficulty in handling negatives that require both. In this case, dodge the print during the initial exposure, then give it an auxiliary exposure for burning-in. It is essential that you first make a straight print to determine which areas will need dodging or burning-in and the amount of

each that will be required during exposure.

There are many advanced tricks that can be utilized when these photographic techniques are mastered. For instance, you may find that a given highlight is not only denser than the rest of the negative, but is also more contrasty; if so, burning-in may only exaggerate the problem. With variable-contrast papers, it is possible to make the main exposure, say, through a No. 3 filter, then to change to a soft, say, No. 1½ filter for the burning-in of a contrasty highlight. If you use this approach, less burning-in will be needed and the final result will look more natural, or at least more subtle.

These tricks must be considered very special ones, to be used only when all else fails. When properly done, they can produce excellent results; wrongly used, they produce distorted tone renditions that are unnatural and unpleasant.

LESSON 5: PRINT TONING

The natural color of a silver image is black. There are many "shades" of black, however —cold blue-blacks, warm ivory-blacks, brown-blacks, and others. There are times when you may not want a black-toned print; for a portrait, you may sometimes prefer a warm-brown or sepia. Some odd and interesting effects can be produced if a print is made in tones of blue, green, or red.

If you require only a small variation of tone, ranging from warm-black to brown-black, you can obtain it by using a warm-toned paper in the appropriate developer. Not much variation in tone can be obtained with ordinary papers with any useful developer formula; to secure really warm tones requires a paper designed for this effect, and variation in developer can produce useful differences in tone from warm-black to deep-brown.

Some of these papers will produce warm-blacks even in a normal developer like Kodak

Dektol, but for more marked effects, a different formula, such as Kodak Selectol, is required.

Beyond various blacks, you can produce other tones only by after-treatment of the print in a toning bath. This is a chemical bath which may: (1) replace the silver with some other metal, such as iron, for a blue tone; (2) deposit a metal, usually gold, upon the silver for blues and reds; or (3) convert the silver image into silver sulfide or silver seleno-sulfide to produce various browns and sepias. Another way to produce a colored image is by depositing a dye upon the silver image; this is called dye toning and does not stain the paper as a simple tint would. Finally, a method of producing colored images by direct development calls for the use of a *chromogenic* developer similar to those used in processing color films. This developer produces a combined dye image and silver image; brighter results can be obtained by removing the silver with a bleach, leaving only the dye image for light, pure colors. The colors obtainable this way are very varied and range from blue, magenta, and yellow through greens and pinks and lavenders.

For the moment, you will use only the commercial toners that are available in packages and require no weighing or mixing of chemicals. These are ample to introduce you to the method of toning; later, you will come to mixing your own toners.

Warm-toned developers can only be used on warm-toned papers; they have little effect on normal and cold-toned emulsions. There are quite a number of warm-toned papers available, some of which produce much warmer tones than others; thus, for instance, Kodak Ektalure Paper produces very warm-brown tones whereas DuPont Varilour Paper is only capable of warm-blacks and deep brown-blacks in most developers. The following papers are typical of warm-toned emulsions:

Agfa Portriga Rapid Paper

DuPont Emprex Portrait Paper
DuPont Varilour Paper
Kodak Ektalure Paper

For best results, all of these must be developed in a warm-toned developer, such as Kodak Selectol, and DuPont 55-D. As usual, the stock solution is diluted for use, but in most cases only at 1:1 instead of the 1:2 used with Kodak Dektol. The tone produced depends upon both the exposure and developing times—long exposures and short development produce the warmest tones.

Nonetheless, a fixed development time is essential for consistency in tone and color. Therefore, you must first run tests with different exposures, developing the prints for one, two, and four minutes, respectively. When you have decided upon the tone you prefer, then you "freeze" the developing time for all subsequent prints and adjust only the exposure to secure proper density at that one developing time.

Toning consists in converting the silver image to silver sulfide. With the so-called "direct" toners, this is done by using a reactive sulfide salt, which works directly upon the silver image. "Indirect" toning is done by first bleaching the print in a bath, which converts the silver image back to silver bromide, then "redeveloping" it in a sulfide bath, which produces an image varying in tone from brown to sepia. Prints to be toned must be thoroughly fixed and even more thoroughly washed. Insufficient fixing may result in stains upon the toned print, while insufficient washing, especially before a bleach-and-redevelop toner, may cause partial or total loss of image.

Equally important, prints to be toned must be uniformly developed; different developing times produce different colors after toning. An underdeveloped print will usually result in toned prints that vary from light-sepia to a foxy yellow-brown when toned in a bleach-and-redevelop type of toner. Moderate overdevelopment does no harm, but extreme forcing of a print in the developer may cause stains if the print is subsequently toned.

Among packaged toners, Kodak Brown Toner is a single-solution, direct-type toner and is used in highly diluted form on warm-toned prints only; it has little or no effect on cold-toned papers.

Kodak Selenium Toner produces brown tones directly on warm-toned prints and has little or no effect upon cold-toned papers, though some workers claim that a short treatment in selenium improves the blacks of a cold-toned print.

Hybrid toners, such as Kodak Poly-Toner seem to be mixtures of sulfide and selenium toners. The tone produced depends upon the dilution: highly concentrated baths produce deep-browns like pure selenium tones; weak baths produce warm-browns like the usual sulfide toner. Many intermediate effects are possible.

The bleach-and-redevelop toners are the only ones that will work on cold-toned papers, as the latter do not react to direct toning. In this case, the print must be very fully developed; underdeveloped prints produce yellowish sepias.

Gold toning, on the other hand, works only on warm-toned papers. If the gold solution is applied directly to the print, it produces blue tones; if the print is first treated with a sulfide toner and then toned with a gold toner, the resulting tones are not blue but red. Both effects are useful.

Dye toning and chromogenic developers are both available commercially. Dye toners are marketed by Edwal under the name of Edwal Color Toners; a chromogenic developer is known as F-R Develochrome. Numerous creative tricks are possible with both procedures.

GROUP 2—
Advanced Black and White

LESSON 6

Mixing Chemicals;
Special Negative Developers

Until now, we have used only those chemicals which can be obtained ready-mixed, in liquid or powder form. Most professionals find this the best way to work when a few formulas are used in fairly large quantities. The saving in the cost of ingredients when you mix your own is overbalanced by the cost of the labor of mixing. This, to the professional, is usually the deciding factor. The casual photographer, likewise, will probably find it preferable to use the common formulas, such as Kodak Dektol Developer, Kodak Developer D-76, and the ordinary acid hardening fixer, available ready-mixed or dry-packaged; the time saved can be devoted to more productive pursuits.

When should you mix your own chemicals? When you desire a specific effect that cannot be produced by readily available packaged products. This is seldom the case with negative developers as there is little demonstrable difference in final results no matter what developer is used. But for paper developers, there are numerous special formulas that do

have value. There are paper developers that will produce a variety of brown to sepia tones by direct development; these formulas are not available in packaged form and must be mixed by the user. The same applies for toning baths; the most popular toners, such as the hypo-alum toner used by many professional photographers, are not available in packaged form. Finally, there are various after-treatments, such as reduction and intensification, and only a few of these can be had in packages.

CHEMICALS

Purchase all chemicals from a photographic supply store, not from the local druggist, unless he understands the type of chemicals needed and can order them if necessary. For example, most photographic formulas call for sodium sulfite, desiccated ("dried") or anhydrous ("water-free"). Many druggists stock this chemical only in the form of large crystals; these crystals contain almost 50 per cent water and thus are only half as strong as

Inexpensive scale for weighing chemicals. This Kodak scale is no longer available, but a similar one made by Pelouze is carried by most dealers.

they should be. In a pinch, crystal sodium sulfite can be used if no other form can be obtained, but in this case you must use exactly twice as much as the formula requires.

A similar situation occurs with sodium carbonate, except that it is supplied in one of three forms: crystal, monohydrated, and anhydrous (or desiccated). Of the three, the most stable form is the monohydrated, and it is always specified for photographic purposes. If crystal is the only form obtainable, however, you will have to use 57 per cent *more* crystals than the amount of monohydrated carbonate called for in the formula. If only

desiccated (or anhydrous) sodium carbonate is available, then you must use 15 per cent *less* than is called for in the formula. These calculations are a nuisance, and it is best to have the correct grade of chemicals in the first place.

CHEMICAL MIXING EQUIPMENT

You already have most of the equipment you need to prepare your own solutions—in earlier lessons you used mixing cups and graduates for liquids, a plastic bucket or two for making up larger quantities of fixing bath, and the

A swinging pointer is attached to the arm of the scale in order to indicate an exact balance. The scale should not rest in this position, but should remain moving until the pointer moves an equal distance to each side of the balance point.

necessary stirrers, spoons, and thermometer. All you will need in addition to these is a fairly good scale for weighing chemicals.

Scales

The most popular type of scale used by photographers is the so-called "studio balance." This is a simple two-pan balance, with separate weights for larger quantities and a sliding weight on a graduated beam for small amounts. This scale will accommodate about 125 grams, or about 4 ounces, of most chemicals, which is ample for most developer formulas in the usual quantities. For large amounts of chemical, such as hypo, where you often need as much as a kilogram, or about two pounds, of material, a simple spring scale, such as is usually found in the kitchen, will prove adequate.

While most books give formulas in both U.S. Customary (known commonly as "avoirdupois") and metric measures, we strongly urge that you do your chemical mixing in the metric system. This poses no difficulty whatever—you do *not* have to remember any equivalents or memorize any tables. If your scale has metric weights, then you use the metric figures given in the formulas; it is

no more difficult to weigh out 50 grams on a metric scale than two ounces on an avoirdupois balance.

This being the case, it may be hard to see why there is any advantage to weighing in metric measure. The reason is simply that for most work, only two units are used, the gram and the kilogram, the latter being equal to 1000 grams and used only for large quantities. Thus when you prepare the average photographic formula, all quantities are given in grams and tenths, and there is no need to do any arithmetic of any kind.

In the U.S. Customary system, on the other hand, there are 16 ounces to a pound, and 437½ grains to an ounce. This latter is a formidable and intractable figure; it cannot be divided by four or any other number. If you have a scale with a sliding weight on a beam of up to 50 grains, and your separate weights are ⅛, ¼, ½, 1, and 2 ounces, you will really have a nasty problem when you come, say, to weigh out 1 ounce 145 grains, a quantity that appears quite frequently in photographic formulas. The best you can do is to figure that ¼ ounce is about 109 grains, and then subtract this from 145, leaving 36 grains to be set on the beam.

The same quantity in a metric formula is 50.0 grams; all you have to do is to put two 20-gram weights and one 10-gram weight on the pan, and no calculations of any kind are required. If your scale does not accept large weights, you still have no problem; most kitchen scales today are marked in both metric and U.S. weights, and if yours is not, you need only remember that a kilogram is about 34 ounces; no greater accuracy than this is required for mixing hypo and such chemicals.

Litre Bottles

The only problem arises with liquid measures: While graduates in metric measure are available, bottles in one- and four-litre sizes are not usually found, except at chemical supply houses. However, if you use a quart bottle for a litre of solution, and a gallon jug for four litres, the error is only about three per cent, which is unimportant in almost all photographic cases.

NOTE: METRIC AND AVOIRDUPOIS CONVERSIONS

If you have a metric scale you don't have to do any converting between systems; merely use the metric quantities given in the formulas. Nevertheless, a few readers may have noticed what seems to be a discrepancy in these formulas. A quantity may be given as, say,

Sodium Sulfite 30.0 grams 1 ounce

and this may seem incorrect because conversion tables give the metric quantity corresponding to 1 ounce as about 28 grams, not 30. However, the two columns do not make equal quantities of solution: The metric column makes a litre, which is about 33 ounces, whereas the U.S. column makes a quart, or 32 ounces. Thus all the quantities in the metric column are slightly larger, and the result is a final solution that is a little greater in total amount but of exactly the same strength.

PERCENTAGE SOLUTIONS

Chemicals are sometimes kept in stock solutions. Some dispute has prevailed as to the exact meaning of "x per cent solution," but in photographic practice it means x parts in 100 parts of the total bulk of the solution. As most chemicals are sold by the avoirdupois ounce of 437.5 grains, and liquids are measured by the ounce of 480 minims, some confusion has arisen. The following tables show: (a) the accurate quantities of solids to be dissolved in sufficient liquid to make a total bulk of 100 parts for the various percentages.

Per cent		Grains	Per cent		Grains
1	=	4.375	6	=	26.25
2	=	8.75	7	=	30.625
3	=	13.125	8	=	35.0
4	=	17.50	9	=	39.375
5	=	21.875	10	=	43.75

(b) The number of grains of a solid which must be dissolved in sufficient liquid to make one fluid ounce for the various percentages:

Per cent		Grains	Per cent		Grains
1	=	4.8	6	=	28.8
2	=	9.6	7	=	33.6
3	=	14.4	8	=	38.4
4	=	19.2	9	=	43.2
5	=	24.0	10	=	48.0

These tables are sufficient to calculate any percentage or volume, by merely multiplying or adding. Example: to make a 15% solution, how many grains are required?

$$
\begin{aligned}
10 \text{ per cent} &= 43.75 \\
5 \text{ per cent} &= \underline{21.875} \\
&\ 65.625 \text{ grains}
\end{aligned}
$$

To make 16 ounces of 10% solution, how many grains are required?

$$48 \times 16 = 568 \text{ grains}$$

A table listing the factors to use in making up an aqueous solution of any percentage strength, weight to volume, is published by Merck & Co. These factors are based on the value: 1 fluid ounce = 480 minims, the weight of which is 455 grains. Thus for 10 ounces (of 10% solution) the figure to use is 455 grains. For 16 ounces, $455 \times 16 = 728$ grains. For one ounce, 45.5 grains of solid make a 10% solution, for a 5% solution, take half of the 10 per cent values, for 30% take three times the 10 per cent values, and so on.

The foregoing provides one of the most powerful arguments for adopting the metric system. All the confusion and ambiguity disappear when a percentage solution is made in metric measure. For instance, to make a 10% solution, one need merely dissolve 10 grams of chemical in enough water to make a final volume of 100.0ml. Since the chemical takes up some room in solution, the procedure is simply to dissolve 10.0 grams of chemical in about 90.0ml of water and after it is fully dissolved, add enough water to bring the total volume up to 100.0ml. Obviously, if 100.0ml of solution are to be made, the number of grams of chemical is exactly the same as the percentage desired, and no calculations are necessary.

When a percentage solution is to be made of a liquid, the problem is a bit different; of course, if the liquid is 100% in strength or substantially so, then it is merely necessary to dilute it with the required amount of water. But many liquids used in photography are already diluted. Formalin, for example, is a 40% solution of formaldehyde. If it is to be further diluted, a special method is required to determine the quantities required to produce a final solution of a given strength. The "criss-cross" method given below is probably the most convenient and has been used for many years. It is reproduced from *Photographic Facts and Formulas* by Wall and Jordan, John S. Carroll, Editor (Amphoto 1975).

Percentage strength that is to be diluted

Percentage strength of diluting solution

At A write the percentage strength of the solution that is to be diluted.

At B write the percentage of the diluting solution. Use 0 for water.

At C write the percentage strength desired. Subtract C from A and write the result at Y. Subtract B from C and write the result at X.

Then if X parts of A are diluted with Y parts of B, the result will be a solution of C percentage.

For example, if it is desired to make a 30% solution of hypo from a 50% stock solution, write 50 at A, 0 at B, and 30 at C. Subtracting

30 from 50, write 20 at Y. Subtracting 0 from 30, write 30 at X. Reading the result, if 30 parts of 50% hypo is diluted with 20 parts of water, the result will be a 30% solution of hypo.

HOW TO WEIGH CHEMICALS

Most of the chemicals used in photography are in the form of powders or fine crystals. The best way to handle these is to dip them out of their containers with small plastic spoons, such as the picnic spoons sold at supermarkets in packets of a dozen or more. These spoons can be left in the container of chemical, thus avoiding contamination and saving the labor of washing.

Using Scales

The basic rule for cleanliness is: *Never pour chemicals directly on the scale pan.* Always weigh chemicals on a piece of paper placed on the pan; another piece of paper on the opposite pan serves to counterbalance it. Before weighing chemicals, cut up several sheets of ordinary writing paper into squares of, say, four to five inches, and keep a quantity of these on hand at all times. You may crease the paper on the left-hand pan crossways in

both directions to make a shallow dish, but leave the one on the right flat, and place the scale weights directly on it.

Most inexpensive scales have some friction in the bearings; and all scales have inertia in the pans and moving beam. Thus you will find that by the time you have added enough chemical to the pan to start the scale moving, you already have too much, and the balance is overweighted. To avoid this, hold the spoon in your right hand, and shake the chemical out of it and onto the scale pan a little at a time; with your left hand, meanwhile, keep tapping the scale pan lightly. As you approach the correct quantity, the pan will begin to bounce gently; and when you attain the correct amount, the pan will descend farther and probably will not return all the way.

A pointer attached to the moving beam of the scale runs over a short graduated arc; the center of the arc is marked to indicate the balance point. It is *not* intended that the pointer come to a dead rest at the midpoint. The most accurate way to weigh chemicals is to keep the scale moving at all times, and to note the swing of the pointer to right and left. If, say, it moves five graduations to the right and only three to the left, either add or remove some chemical (depending upon how the scale pointer is pivoted) until, with the beam moving freely, the pointer swings an equal number of spaces to left and right. The exact number of spaces it covers is not important; what is important is that the pointer cover the same number of spaces in both directions.

ADDING CHEMICALS TO WATER

The mixing vessel should contain warm water, at about 52 C or 125 F, unless otherwise directed in the formula. As explained already, the chemicals take up some room in solution, so the amount of warm water in the mixing cup should be less than the final amount of solution desired. Usually, about three-

quarters of the final amount of water will suffice, though a different amount may be specified in some formulas. In general, if you are mixing a litre of developer, start with approximately 750.0 ml of warm water; if mixing a quart, start with 24 ounces. There is, of course, nothing critical about this.

Pick up the paper containing the weighed-out chemical from the scale pan, and pour the chemical into the water while stirring rapidly with your other hand. Do not tap the paper against the side of the mixing cup; this may shake some chemical into the air, which could settle out and contaminate other materials. Instead, let the chemical slide off the paper into the water; then dip the paper into the water to dissolve any remaining chemical, and discard the paper into a waterproof wastebasket. Take a fresh piece of paper for the next chemical.

This procedure not only avoids having chemical dust in the air, it also makes for accuracy in preparing chemicals, as the last traces of chemical are transferred to the water. In addition, the use of a fresh piece of paper for each chemical avoids contamination. Even for a single formula, where all the chemicals are going into the same bath anyway, using fresh papers for each avoids error in weighing that could result from traces of the preceding chemical remaining on the paper. And because some ingredients, such as potassium bromide, are used in very small amounts, such an error could be quite considerable.

Finally, in mixing developers and fixing baths from a published formula, always weigh out and dissolve the chemicals in the order in which they are listed in the formula. The reason for this rule will be given later; for the moment, just remember that some formulas will be ruined totally if mixed in the wrong order. Always note any special mixing directions on a published formula; occasionally, one ingredient may have to be dissolved or diluted separately before adding it to the main bath.

THE INGREDIENTS OF A DEVELOPER

Practically all developers are made up of the same few ingredients in varying quantities. Each ingredient has a job to do, and it is seldom that any is omitted. On the other hand, there is seldom any duplication of function among the ingredients; the exception to this rule is the developing agents, which are often used in combination to secure results that cannot be attained with either one alone.

A practical developer usually contains at least four components:

1. The developing agent.
2. The preservative.
3. The accelerator.
4. The restrainer.

The purposes of these four components are more or less obvious from their names. The developing agent is a reducing agent, or de-oxidizer; it has a natural affinity for oxygen and will take it up from any source, including the atmosphere. Thus it tends to oxidize rapidly, and, unless protected, would quickly become useless. For that reason, we add a preservative, usually a sulfite or bisulfite, which also has an affinity for oxygen, and which can preferentially attract atmospheric oxygen, leaving the reducing agent free to do its work on the silver halides in the film emulsion.

Most reducing agents are active only in an alkaline solution; therefore, some chemical is needed to establish a level of alkalinity high enough to produce the desired developer activity. Finally, the restrainer is added, not to counteract the action of the alkali, or accelerator, but rather to prevent the developing agent acting upon unexposed silver halide; in this sense, it is not really a restrainer but an antifoggant. The most common restrainer is a soluble bromide, usually of potassium, and in most modern developers it actually does not

slow down the action to any measurable extent. Where the intention is to extend the time of development, the accepted method is to reduce the alkalinity of the bath either by simple dilution, the use of less active alkalis, or the addition of a *buffer*.

The Developing Agent

Over the past 50 years or more, many developing agents have been discovered, and at one time or another, almost miraculous properties have been attributed to nearly all of them. Gradually, it is being realized that the developing agent serves only to reduce silver halide to metallic silver, and that there is little to choose from among the many chemicals that are capable of performing this function. Essentially, what is required is merely a high degree of selectivity; that is, the developing agent must reduce *exposed* silver halide to metallic silver as completely as possible while affecting unexposed silver halide as little as possible.

Out of the 50 or more proposed and marketed in the past half century, fewer than a dozen developing agents are still in use today. Of these, perhaps four are of any real value; the rest are more or less specialized, producing, in some cases, special effects on papers but affording no real benefit in processing films. The four agents currently in use are:

1. Metol, Elon, Rhodol, and other names for a salt of mono-methyl-para-aminophenol.
2. Hydroquinone, chemically dihydroxybenzene.
3. Phenidone, Ilford's trademark for 1-phenyl-3-pyrazolidone.
4. Para-aminophenol and its salts, usually the sulfate, hydrochloride, or oxalate.

Metol (Elon or Rhodol) is a rapid-working developing agent that brings up shadow detail early in the process but produces density only with difficulty. For this reason, it is seldom used alone, except where low contrast is desired; most often it is combined with another developing agent, usually hydroquinone.

Hydroquinone is quite the opposite of Metol; it can produce considerable density but is slow to bring out shadow detail.

Phenidone is similar to Metol but is even more active. It is used in both film and paper developers, almost always in combination with hydroquinone, and is preferred by people who are susceptible to skin irritation from Metol.

Para-aminophenol was formerly used by people who were susceptible to Metol dermatitis, and also in tropical developers; in most cases, its place has now been taken by Phenidone. However, para-aminophenol has one interesting property: In combination with caustic alkalis, it forms paraminophenolates, which are very powerful developers that can be used at dilutions up to 1:100 and even higher. This is the basis of such developers as Rodinal, which can be obtained only in commercial form. It cannot be prepared by the user because a special technique is required to form a stable solution of the developing agent.

The overwhelming majority of today's developers is compounded with combinations of Metol and hydroquinone or Phenidone and hydroquinone. These have certain advantages over the use of the individual developing agents alone, and the results are not merely an average or compromise between the characteristics of the separate types. When Metol and hydroquinone are combined in alkaline solution, they form a new developing agent, more active than either alone. It appears that the Metol has the power to activate hydroquinone and give it more energy than it possesses alone. This property is called *superadditivity* and is the reason most modern developers utilize this combination of developing agents. Phenidone has the same property

to an even greater degree; whereas a given weight of hydroquinone requires about ¼ its weight of Metol to form a superadditive combination, the same amount of hydroquinone requires only $1/_{40}$ its weight of Phenidone. Thus most developers in which Phenidone is substituted for Metol generally contain only about $1/_{10}$ as much of the former developing agent.

A less well-known property of the Metol-hydroquinone combination is the preservative action of hydroquinone on Metol. In these developers, the hydroquinone is oxidized more rapidly than the Metol. This occurs because some of the hydroquinone is used up in reducing exposed silver halide to metallic silver, and some of it is used up in reducing oxidized Metol back to its normal state.

This is the real reason for the presence of hydroquinone in low-alkalinity, low-activity developers. For example, in the Kodak Developer D-76, the alkali used is borax. It is generally known that hydroquinone is practically inactive at this level of alkalinity; in fact, if hydroquinone is omitted from the D-76 formula, the developer will act almost exactly the same as it does with it. On the other hand, omitting the Metol and preparing the developer with hydroquinone alone will result in a bath that is practically inactive. It is evident from this that hydroquinone plays little part in the developing action of Kodak Developer D-76. If hydroquinone is omitted from the D-76 bath though, the resultant developer will appear to work properly for a short time, but will oxidize rapidly and become totally inactive quite soon. With hydroquinone present, Kodak Developer D-76 is one of the most stable and long-lasting of all developers.

The two effects are separate and distinct; that is, the superadditivity of Metol and hydroquinone is not in any way related to the regenerative ability of hydroquinone on Metol. The combination of the two separate properties is what makes the combination of Metol

and hydroquinone so valuable that it has practically displaced all other developing agents. However, the recently introduced Phenidone not only has a greater degree of superadditivity than Metol, it also has a stronger regenerative effect on hydroquinone. For this reason, we may expect to see the Phenidone-hydroquinone combination become more popular in the future.

The Preservative

Since the developing agent is, in effect, a strong deoxidizing agent, it will combine quite easily with the oxygen in the air as well as with any dissolved oxygen in the water used for mixing. To avoid this, sodium sulfite is usually added to the developing agent and acts as a preservative.

Once it was thought that the action of the sulfite was to absorb the oxygen (which changes it to sodium sulfate) before it had a chance to act on the developing agent. However, it seems that it doesn't actually work that way; how it does work is not clearly understood. The best explanation so far is that sodium sulfite combines with hydroquinone to form a new compound, which is more resistant to oxygen than either of its components. This is a matter of little interest to the photographer; the fact is, it does work, and that is all that matters.

Sodium sulfite is somewhat alkaline when dissolved in water, and a workable developer can be made with nothing more than some Metol and sodium sulfite. A formula of this type has certain interesting properties, as we shall see later in this lesson.

The Accelerator

The activity of a developer depends mostly on the alkalinity of the solution. Chemists express alkalinity in a scale known as pH, or hydrogen-ion-concentration numbers. The exact significance of this need not concern the photographer; all that is necessary is to know

that pH is expressed as a scale of numbers. Values from 0 to 7 are acid, 7 to 14 are alkaline. The neutral point—the reading produced, say, by distilled water—will be exactly 7. As the numbers go below 7, the acidity increases, reaching a maximum at 0. Above 7, the solution becomes steadily more alkaline, reaching a maximum at pH = 14. So all you need to remember is that as the pH increases, so does the alkalinity, and that the term "high pH" means "high alkalinity."

All developers must contain some alkali, whose function it is to establish a pH level suitable for the desired activity. Merely establishing a given pH is not enough; when in use, the developer must keep a constant level of activity for a reasonable length of time without the constant addition of alkali. Sodium hydroxide, for instance, is a very alkaline salt, and a tiny amount will produce a very high pH. But this tiny amount will be exhausted rapidly when the developer is used. Adding an excess of sodium hydroxide at the beginning will not solve the problem; the initial pH will then be too high.

Since various alkalis (and acids, in the case of fixing baths) have a more or less definite pH range, it is not always possible to substitute one alkali for another. For instance, you can't make a paper developer like D-72 with borax as the alkali because the required pH cannot be attained with even a large quantity of borax. Here is a table showing approximate pH ranges of a few common acids and alkalis.

Substance	Approximate pH in solution
Acid, sulfuric	0.3–2.0
Acid, acetic	2.4–3.4
Acid, boric	5.2-5.5
Distilled water	7.0 (neutral)
Borax	9.0–9.5
Sodium metaborate	10.0–11.0
Sodium carbonate	11.0–11.5
Sodium phosphate, tribasic	12.0–12.5
Sodium hydroxide	12.0–14.0

These are approximate because the pH depends upon concentration to some extent, and also upon other chemicals in a given formula. What is needed is a chemical that will release its alkali a little at a time, to maintain a moderate pH level over an extended period of use. Such a chemical is called a *buffer* and does exactly what its name implies—it protects, or buffers, the solution against changes in alkalinity.

One of the most interesting things about buffers is that there is a fairly large number of them, and each one has a certain pH level that is maintained over a fairly broad range of concentrations. Some of these salts cannot be used in photography for other reasons. Those most commonly used are sodium carbonate, which has a fairly high pH and is used in developers of high activity; borax, which has a much lower pH range; and sodium metaborate, which is somewhere between the two.

Sodium metaborate and the proprietary Kodalk Balanced Alkali, which is similar to it (Kodalk is available through Kodak), have one special property: with these chemicals, it is possible to vary the pH level of the solution by adjusting the amount of the chemical used. This property was once considered rather important; currently, it is not much utilized, and sodium metaborate may simply be considered another alkali with properties intermediate between those of sodium carbonate and borax.

The sole purpose of the accelerator, then, is simply to establish a pH value in the developer for the desired activity level. There is no other noticeable difference between alkalis, and there is no reason to believe that any one alkali will produce results superior in graininess, detail, or gradation to any other alkali used at the same pH level.

What is important is that the type of alkali used is dependent upon the desired alkalinity. For instance, it is not possible to produce a slower developer by reducing the amount of sodium carbonate in a more active type of

bath. Because of the buffer action of the carbonate, the pH will remain the same as the concentration is reduced, until a point is reached where there is so little alkali present that the developer will be rapidly exhausted. To produce a less active developer, use a less active alkali—sodium metaborate or borax.

The Restrainer

It may seem contradictory to add a restrainer to a bath that has just had the addition of an accelerator, but actually the term "restrainer" is a misnomer. The bromide added to a developer is not intended to "restrain" the action of the developing agents, but rather to improve their selectivity. That is, it is intended to prevent the developer from reducing unexposed silver grains to metallic silver while leaving it free to produce a silver image from the exposed grains.

This action of a bromide is only relative: any developer will eventually turn a film black all over if allowed to act long enough. All the bromide can do is hold back the formation of fog for the time required to produce an image of the desired contrast. Thus high-activity developers (that is, developers of high pH) require more bromide than low-activity formulas. A high-activity developer does not necessarily produce the maximum emulsion speed of which a given film is capable; the term "activity" refers more to *contrast level* attainable.

Developers of very low activity, such as Kodak Developer D-76, produce the maximum emulsion speed, measured as shadow detail, mainly because they contain no bromide or other restrainer. That is, bromides not only restrain the production of fog, they also hold back the development of minimally exposed grains, which contain the shadow detail in the image.

A developer that is free of bromide when mixed does not remain so in use. Development reduces the silver bromide to metallic silver; this sets free the bromide ion, which combines with the alkali to form sodium bromide. The amount is small but increases with the amount of film processed; thus a developer in continual use tends to lose shadow detail and film speed. This effect is greatest with developers such as Kodak Developer D-76, which contain no bromide at all when first mixed.

More active developers require the addition of some bromide in the original formula. This is not only to reduce fog, it also serves to reduce the effect of further additions of bromide from the film from developing. Thus the initial bromide addition mainly serves to stabilize the developer throughout its useful life.

The commonest restrainer is potassium bromide; it is most effective with developers containing large amounts of Metol, which is quite sensitive to bromide. Hydroquinone is much less sensitive, and it takes large quantities of bromide to stabilize a high-contrast hydroquinone developer. Paper developers use larger amounts of bromide because fog is less tolerable in paper prints than in negatives. But try to avoid excess bromide in a paper developer because it adversely affects the tone or color of the image, making the blacks greenish or brownish. Some formulas do, however, use large amounts of bromide in a highly diluted developer to produce brown and sepia tones on direct development.

Other antifoggants used in modern developers are complex organic chemicals, such as benzotriazole and 6-nitrobenzimidazole nitrate. These control fog very effectively in tiny amounts but affect emulsion speed in the same way as does bromide. In paper developers, the organic antifoggants not only control fog, they also improve image color, leaning toward bluish blacks.

Phenidone-hydroquinone developers of high activity tend to produce more fog than

Metol-hydroquinone formulas. This particular type of fog cannot be eliminated by the addition of bromide, and organic antifoggants must be used in these formulas. Low pH developers, such as Phenidone-hydroquinone-borax negative developers, do not usually have this problem.

Combinations of both restrainers are sometimes used—the organic compound mainly to restrain fog production, and the bromide to stabilize the developer against the further addition of bromides from the processed film.

ORDER OF MIXING DEVELOPERS

Each ingredient in a developer has some function to perform; what is not quite so obvious is that each ingredient has some effect upon the others. For example, if the alkali were dissolved first, then the developing agent, the result would be almost instant oxidation of the developing agent, which would turn it brown and ruin it. Thus it would appear that the best order for compounding a developer would be: first the preservative, then the developing agents, followed by the alkali, and then any remaining ingredients.

This is a good order for some developers, but it presents some difficulties. For instance, Metol will not dissolve in a strong sodium sulfite solution; thus in developers containing Metol and a large quantity of sodium sulfite, such as Kodak Developer D-76, you have to dissolve the Metol first, then add the sulfite. When the latter is dissolved, add the hydroquinone, then the carbonate or borax. Some persons make it a habit to dissolve just a pinch of sulfite first, before dissolving the Metol, then to add the remainder of the sulfite. This is a nicety which does ensure total freedom from oxidation, but there is little evidence that it is really necessary.

One other variation: Phenidone is not soluble in a sulfite solution nor in plain water. In mixing developers containing Phenidone, you must add the Phenidone after the sulfite and alkali have both been dissolved.

You probably have noticed that packaged developers have all the ingredients in a single batch; the entire thing is dissolved at once. This is safe only where the powdered ingredients have been mixed together completely, usually by machines. While some workers like to weigh out all ingredients before dissolving them, with each ingredient on a separate piece of paper, this is done only to avoid omitting any. Always dissolve each ingredient in succession, and in the order given.

Start by taking about ¾ the final volume of warm water, say, 750.0 ml for a litre of developer, or 24 ounces for a quart. This should not be too hot; 52 C or 125 F is about right, but the exact temperature is not critical.

The reason for starting with less than the final amount of water was explained earlier but to reiterate, the chemicals take up some room in the solution, and if you started with a litre of water, you would end up with more than a litre of developer, which would not be of full strength. By the time all the chemicals have been dissolved, the solution will have cooled somewhat; at this point, add cold water to bring the solution to its final amount. It will probably still be too warm for use and will have to be cooled to 20 C (68 F).

MIXING A DEVELOPER

As an example of how to mix an actual developer, let's prepare a litre of paper developer stock solution. While the formula for Kodak Dektol Developer is not available, the well-known Kodak Developer D-72 is quite similar and produces approximately the same results when used in the same way. The difference between the two is mainly in the addition to the commercial product of certain preservatives and water-softening agents to avoid sludging during use. This formula is a highly popular one for papers of all manufacturers,

and developers of similar, but not identical, composition are offered as Ansco Developer 125, DuPont Developer 53-D, Gevaert Developer G.251, and Ilford Developer ID-36. The Kodak version of the formula is as follows:

Kodak Developer D-72

Warm water (52 C or 125 F)	750.0cc	24 ounces
Metol (Elon, Rhodol, Pictol)	3.0 grams	45 grains
Sodium sulfite, desiccated	45.0 grams	1½ ounces
Hydroquinone	12.0 grams	175 grains
Sodium carbonate, monohydrated	80.0 grams	2 ounces 290 grains
Potassium bromide	2.0 grams	30 grains
Add cold water to make	1.0 litre	32 ounces

Step-by-Step Procedure

Begin mixing by placing 750.0cc (24 ounces) of warm water in the mixing vessel; check the thermometer.

1. Weigh out 3.0 grams (45 grains) of Metol on a piece of paper, placed on the scale pans as usual. Pick up the paper with the chemical and pour the chemical into the water while stirring. Dip the paper into the water to wash off any remaining traces of chemical and discard the paper into a watertight wastebasket. Stir until dissolved.

2. Weigh out 45.0 grams (1½ ounces) of sodium sulfite. Start stirring the solution with one hand as you pour the chemical into it with the other. If you don't do this, there is danger of the sulfite forming a hard cake, which is very difficult to dissolve. Again, rinse the paper in the solution and discard.

3. Weigh out 12.0 grams (175 grains) of hydroquinone, pour into the solution, and stir. Rinse and discard the paper as before.

4. Weigh out 80.0 grams (2 ounces 290 grains) of sodium carbonate. Again there is danger of caking, so add slowly while stirring the solution steadily. Rinse and discard paper.

5. Weigh out 2.0 grams (30 grains) of potassium bromide, add to solution, and stir till dissolved. Rinse and discard paper.

6. When all chemicals are dissolved, add cold water to the solution to make exactly 1.0 litre (32 ounces). Pour the finished solution into the stock bottle and mark this "Kodak D-72 Stock Solution." This will be used exactly the same way as the solution of Kodak Dektol Developer in earlier lessons.

Formulas for warm-toned paper developers will be given in Lesson 8. Many other formulas for both negative and print developers are found in currently available books; see the list of reference books for titles and publishers.

FIXING BATHS

A plain solution of sodium thiosulfate (commonly known as *hypo*) will dissolve silver halides and accomplish the primary purpose of fixation. However, plain hypo does not make a satisfactory fixing bath for other reasons.

A certain amount of developer is always carried over into the fixer—on the surface of the film, or absorbed in the gelatin coating. In a neutral hypo bath, this carried-over developer will oxidize rapidly and may cause stains on the film being developed or subsequent films. In addition, developer remaining in the gelatin may continue to act while fixation is taking place, and this may cause image streaks. For these reasons, it is preferable to have the fixing bath in an acid condition, which will immediately neutralize any carried-over developer. This can be accomplished easily by adding some salt of sulfurous acid, such as sodium bisulfite or potassium metabisulfite. These will not react with the hypo itself, but will make the bath sufficiently acid to keep it clear and to neutralize developer carry-over.

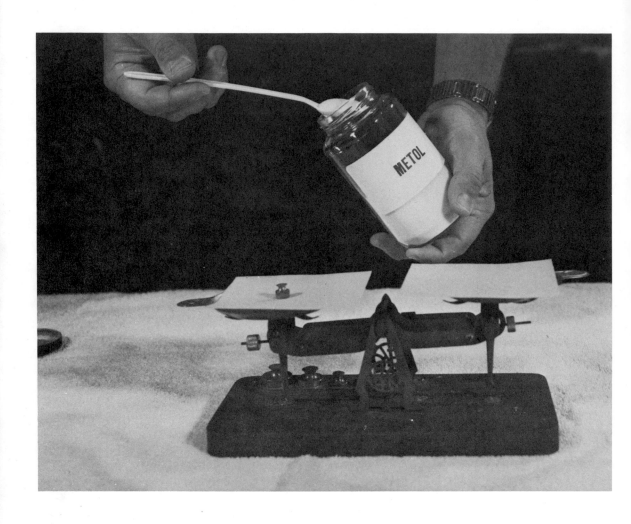

Always dip chemicals out of the bottle with a clean plastic spoon. Never try to pour directly from the bottle onto the scale pans.

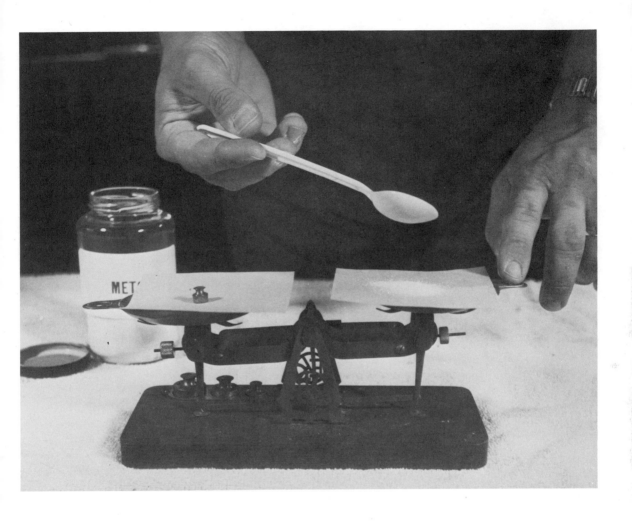

Drop the chemical in small amounts on the paper in the scale pan. While doing so, gently tap the pan with the other hand to overcome the scale bearings' friction.

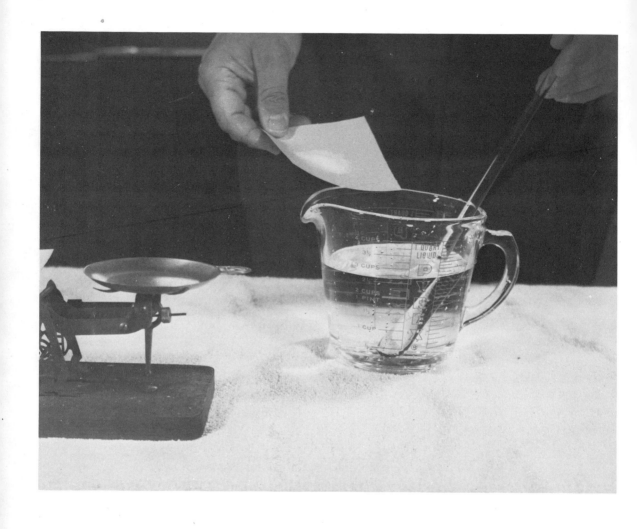

Slowly pour chemical into the warm water while stirring with the other hand to avoid caking.

Dip paper into the solution to wash off any chemical traces. Then discard the paper into a wastebasket.

Be sure to stir solution until the chemical is completely dissolved before adding the next ingredient.

Such a bath is satisfactory for papers, and even for films in places where temperatures do not rise much above 20 C (68 F). But under warmer conditions, there is danger of swelling the gelatin and damaging the image. Usually, a hardener is added to the fixing bath to prevent this softening; the usual hardener is an aluminum salt, such as potassium alum, or, occasionally, a chromium salt, such as potassium chrome alum.

Alum cannot be added directly to hypo because it will react with the sodium thiosulfate to form a thick sludge of aluminum sulfite. The hypo must be acid to prevent this reaction. Sodium bisulfite will provide some acidity, but not enough to maintain the bath in good condition over its working life. Stronger acids cannot be added to hypo either; they will react to produce free sulfur, ruining the bath.

As in the case of developers, the answer is a

buffer, but this time, one to maintain a low pH, or acidic condition. In this instance, we use acetic acid buffered with sodium sulfite, this liberates sulfurous acid in the bath at just the right rate to keep it acid, but not enough to cause unwanted reactions. As the acid is used up in neutralizing carried-over developer, the combination of acetic acid and sodium sulfite liberates more sulfurous acid, maintaining the acidity of the solution at almost constant level.

A practical fixing bath should contain hypo, sodium sulfite, acetic acid, and potassium alum, and the bath must be mixed in that order. Having dissolved the hypo, you cannot add either acid or alum to it without causing a reaction and producing a sludge. So you must add first the sulfite to protect the hypo from the acid, then the acid to protect it from the alum. Finally, add the alum.

The foregoing was the classic fixing bath for many years; it worked well but tended sometimes to sludge before it was completely exhausted. This, it appeared, was because the acetic acid/sodium sulfite combination did not contain sufficient reserve acidity, while adding more acetic acid made the bath excessively acid. Modern fixing baths contain an additional buffer—a quantity of boric acid as a source of reserve acid. Boric acid fixing baths remain clear and usable until they are exhausted completely.

For tropical work, hardening fixing baths containing potassium chrome alum, a deep-violet-colored salt, are used; these have a more powerful hardening action but are difficult to prepare and do not keep very well. Modern films are hardened to a great extent in manufacture, and the normal boric acid fixing bath is satisfactory for almost all cases; few people bother with chrome alum anymore.

One other possible hardener is formaldehyde; this hardens only in an alkaline solution and so is never used in black-and-white work, except as a prebath, and then only for a few very special processes.

How to Prepare a Fixing Bath

As mentioned, the most generally useful fixer is one containing hypo, acetic acid, boric acid, and alum, with sodium sulfite as preservative. This bath is recommended by most manufacturers and is known, variously, as Kodak Fixing Bath F-5, Ansco Fixing Bath 104, DuPont Fixing Bath 1-F, and Ilford Bath IF-15. The formula is as follows:

Warm water (52 C or 125 F)	600.0cc	20 ounces
Hypo (sodium thiosulfate)	240.0 grams	8 ounces
Sodium sulfite, desiccated	15.0 grams	½ ounce
*Acetic acid, 28%	48.0cc	1½ fluid ounces
†Boric acid, crystals	7.5 grams	¼ ounce
Potassium alum	15.0 grams	½ ounce
Add cold water to make	1.0 litre	32 ounces

Mixing a fixer is done in much the same way as mixing a developer, and the rule to add ingredients in the order given in the published formula still holds. The major difficulty is that mixing in water that is too hot can cause trouble through decomposition of some ingredients. On the other hand, it is very difficult to dissolve sodium thiosulfate in cold water because the dissolving of this particular chemical absorbs a great deal of heat from the water, thus chilling the solution. Therefore, the method given on the next page should be followed closely.

*If you have only acetic acid, glacial, 99%, you may prepare 28% acetic acid from it. In metric measure, mix 30.0cc of acid with 80.0cc of water. Or, if you wish, in mixing the above formula, simply use 13.0cc (3¼ fluid drams) of glacial acid in place of the marked amounts of 28% acid. In U.S. measure, take three ounces of glacial acid, add eight ounces of water, and put this in a bottle marked "Acetic Acid, 28%."

†Crystal boric acid is preferred because it is easier to dissolve; the powdered boric acid sold in drugstores tends to float on the solution, and dissolving it is much more difficult.

Step-by-Step Procedure

1. Start with 600.0cc (20 ounces) of water at 52 C (125 F), but no hotter. Weigh out 240.0 grams (8 ounces) of sodium thiosulfate and pour it into the water, slowly, stirring continually. By the time the hypo has dissolved, the water will have cooled considerably, but continue stirring until the chemical is all dissolved.

2. Now check the temperature of the bath; if it is above 30 C (85 F), allow it to cool below this point before continuing.

3. Weigh out 15.0 grams (½ ounce) of sodium sulfite and add it slowly to the solution, stirring steadily to avoid caking. Rinse and discard paper.

4. Measure out 48.0cc (1½ fluid ounces) of 28% acetic acid and slowly pour it into the bath, stirring steadily. If only glacial acetic acid is available, it should first be diluted, as mentioned above.

5. Weigh out 7.5 grams (¼ ounce) of boric acid crystals and add to the solution with constant stirring. Do not use powdered boric acid unless no other kind is available; it is very difficult to dissolve.

6. Weigh out 15.0 grams (½ ounce) of potassium alum and add it to the solution while stirring steadily. Do not attempt to use ordinary household alum; this latter is an ammonium salt and can cause fog on paper or negatives.

7. When all the chemicals are dissolved, the solution should be clear and colorless; any large amount of milkiness indicates an error in mixing. A slight opalescence will usually clear up if left to stand.

8. Add enough cold water to make the total quantity 1 litre (32 ounces) and pour into a bottle.

Some manufacturers provide a similar formula in two parts, to be mixed separately and combined. In this case, each half may be mixed in warm water (not over 52 C or 125 F); allow both parts to cool before combining.

Other fixing-bath formulas are available in various books*. By and large, all work pretty much the same; the formulas using potassium alum and acetic acid, but without the boric acid buffer, may be considered obsolete today. Chrome alum fixers have some small application in tropical work but are seldom used because of their instability and a tendency to stain. The only other type of fixing bath that is attaining any popularity is the rapid fixer, which utilizes ammonium salts. One such formula is given below.

Kodak Fixing Bath F-7

This bath is recommended for fast fixing of films; it may be used for papers but has limited advantages, and there is some danger of fogging or overfixation.

Warm water (52 C or 125 F)	600.0cc	20 ounces
Sodium thiosulfate (hypo)	360.0 grams	12 ounces
Ammonium chloride	50.0 grams	1 ounce 290 grains
Sodium sulfite, desiccated	15.0 grams	½ ounce
Acetic acid, 28%	47.0cc	1½ ounces
Boric acid, crystals	7.5 grams	¼ ounce
Potassium alum	15.0 grams	½ ounce
Add cold water to make	1.0 litre	32 ounces

This formula is mixed in exactly the same way as the Kodak Fixing Bath F-5 described above. Note particularly the order of mixing. The ammonium chloride must be added im-

*John S. Carroll, *Photographic Lab Handbook* (5th ed.; Garden City, N.Y.: Amphoto, 1979).

Wall, Jordon, and Carroll, *Photographic Facts and Formulas*, (4th ed.; Garden City, N.Y.: Amphoto, 1975).

mediately after dissolving the hypo; if it is added to a completely mixed fixing bath, it may cause sludging.

SPECIAL NEGATIVE DEVELOPERS

Many different formulas for negative developers have been offered over the years; it is only fair to state that most of these simply represent different ways to arrive at the same result. Most contain the same four or five ingredients, differing only in proportions. Since the only function of a developer is to reduce exposed silver bromide to a silver image, different formulations can result only in shorter or longer times to produce the same density and contrast.

There are, nonetheless, a few variations on developer formulas, which have some useful properties. One of these is the simple Metol-sulfite developer, originally recommended by Windisch. This formula represents the ultimate simplification of a developer; it contains only Metol as developing agent, and sodium sulfite as combined preservative and alkali. Because of its low activity, this developer requires no restrainer; in fact, the addition of a bromide would eliminate the most interesting property of the formula—its compensating power. The formula is as follows:

Metol Compensating Developer

Warm water (52 C or 125 F) 750.0cc		24 ounces
Metol	2.5 grams	37 grains
Sodium sulfite, desiccated	25.0 grams	365 grains
Add cold water to make	1.0 litre	32 ounces

Developing time will have to be found by test; depending upon the type of film, it may be anywhere from 10 to 20 minutes at 20 C (68 F). This developer must be used just once and then discarded. The solution keeps well without use, but once used, it deteriorates rapidly, with or without further use.

The virtue of this particular formula, aside from its simplicity, stems from its low activity and lack of restrainer. Developers of this type are very sensitive to bromides, and a very tiny amount of bromide exerts considerable restraining action. In development, reduction of silver bromide to image silver results in the release of soluble bromides from the emulsion into the solution. The more silver reduced, the more bromide released, so the maximum amount of bromide is released in the vicinity of the image highlights. If the film is not agitated to any great extent while it is in the solution, these bromides will not wash out into the bath, but will remain in the emulsion where they will exert a restraining effect upon the developer. The result will be that highlight density will be restrained while shadow areas will be free to develop fully.

In effect, this is a sort of "compensating" developer; it is particularly useful for subject matter of wide brightness range, limiting the contrast of the resultant negative without loss of shadow detail. This is particularly valuable in the case of flash exposures, which often tend to "burn up" highlights if development is extended sufficiently to secure full shadow detail.

The compensating action depends upon the amount of agitation during development; if the film is agitated continually, little compensation will occur because the soluble bromides will be washed out into the solution instead of remaining in contact with the highlight areas. On the other hand, if no agitation occurs, the result will be streaks and edge effects. The best way to work with this developer is to immerse the reel of film in the solution and agitate vigorously for about one minute. Let the reel remain in the solution without agitation for at least two minutes, then apply a little gentle agitation. Repeat this procedure at two- to four-minute intervals for the total time of development. Rinse and fix the film in the usual way.

Kodak Developer D-23 is similar to the

above formula but is about three times as strong; it is a good soft-working developer for portraits, but because of its higher alkalinity, it has less compensating action.

Kodak Developer D-23

Warm water (52 C or 125 F)	750.0cc	24 ounces
Metol	7.5 grams	¼ ounce
Sodium sulfite, desiccated grains	100.0 grams	3 ounces 145 grains
Add cold water to make	1.0 litre	32 ounces

Developing times for most films will be between five and eight minutes at 20 C (68 F). Use normal agitation techniques, rinse, fix, and wash as usual.

TWO-BATH DEVELOPMENT

Two-bath development is an interesting technique that has at least two useful properties. For one, it is not as sensitive to temperature as a normal developer and so is a useful emergency procedure when negatives must be developed in the field and temperature controls are not available. For another, because the process is more or less self-limiting, it can be used with very strong developers for exceedingly short processing times, without danger of accidental overdevelopment.

The method is simply to prepare a developer in two parts. The first part contains the developing agent and preservative; the second contains the accelerator and restrainer. The film is immersed, first in one bath, then in the other.

While the film is in the first bath, no development takes place because no alkali is present. The film emulsion absorbs the solution to a certain extent but nothing more occurs. In the second bath, the alkali activates the developing agents in the emulsion and development proceeds. However, since only a limited quantity of developing agents has been absorbed,

development can continue only until this is used up, and then the action ceases. It is thus impossible to overdevelop; furthermore, the total degree of development will be the same regardless of temperature, though the process will take longer if the solution is cold.

Almost any developer can be split into two parts and used this way. For instance, you can make a simple Metol-sulfite developer, like Kodak Developer D-23, and use it as the first part of a two-bath developer. For the second bath, a simple borax solution will suffice. The first bath alone could develop an image if sufficient time is allowed, but in this case, the film remains in the bath only three to six minutes. Development is completed in the second bath in about three minutes. The formula is as follows:

Bath No. 1

Warm water (52 C or 125 F)	750.0cc	24 ounces
Metol	5.0 grams	75 grains
Sodium sulfite, desiccated	100.0 grams	3 ounces 145 grains
Add cold water to make	1.0 litre	32 ounces

Bath No. 2

Borax	10.0 grams	145 grains
Water	1.0 litre	32 ounces

For use, treat films in Bath No. 1 as follows:

Slow films	3 minutes
Medium-speed films	4 minutes
Fast films	6 minutes

At the end of this time, transfer the film, without rinsing, to Bath No. 2 for three minutes, then rinse and fix as usual.

There is little saving in time with this two-bath developer; in fact, the first bath could be used alone if you developed the film for about ten minutes. The two-bath method simply is less critical; in addition, it has some fairly

marked compensating action because the absorbed developer is used up more rapidly in the highlight areas than in the shadows.

A more practical two-bath developer is designed for rapid development of press negatives; it is a real time-saver over normal methods, especially when used in connection with a rapid fixing bath. The formula is as follows:

Bath No. 1

Warm water		
(52 C or 125 F)	750.0cc	24 ounces
Metol	5.0 grams	75 grains
Sodium sulfite,		
anhydrous	30.0 grams	1 ounce
Hydroquinone	10.0 grams	145 grains
Add cold water		
to make	1.0 litre	32 ounces

Bath No. 2

Warm water		
(52 C or 125 F)	750.0 cc	24 ounces
Sodium carbonate,		
monohydrated	100.0 grams	3 ounces 145 grains
Add cold water		
to make	1.0 litre	32 ounces

At normal temperature (between 18 and 21 C or 65 and 70 F), immerse the film in Bath No. 1 for one minute; without rinsing, transfer to Bath No. 2 for one minute, then rinse and fix as usual. For further time saving, use the rapid fixer bath Kodak Fixing Bath F-7.

The above formula is affected somewhat by temperature. If temperature is between 15 and 18 C (60 and 65 F), increase processing time to 1½ minutes in each bath; if it is between 21 and 24 C (70 and 75 F), decrease time to 45 seconds in each bath.

Development is not completed in Bath No. 2, and you can obtain some increase in contrast by increasing the time in this bath.

After a water rinse, transfer the film to the Kodak Fixing Bath F-7, and let it remain there just long enough for complete clearing. This fixer has a slight tendency to bleach silver images if negatives remain in it for any great length of time.

You can also save time further by washing the film, after fixing, for only two or three minutes in running water, followed by force-drying with heated air (as from a small hair dryer). The resultant negative will not be permanent, though it will keep for some months in this condition. If you intend to use it for permanent filing, you can rewash the negative after the required prints have been made from it. For best results, place the dry negative in a fixing bath for a few minutes; a regular Kodak Fixing Bath F-5 is preferable. After refixing, the negative should then be washed fully, as recommended in earlier lessons, and dried in the normal way.

LESSON 7

Enlargers and Creative Enlarging

For the earlier lessons, we assumed you were using a small camera, either a 35mm single-lens reflex (SLR) or a 2¼" × 2¼" twin-lens reflex (TLR), and that you had some kind of usable enlarger in your darkroom. Practically any enlarger will serve well enough while you are learning, so we did not go into the differences between types of enlargers.

By now you are probably planning to go on to more advanced work, and may be considering the purchase of a fairly advanced enlarger to match. Hence some information about the different types of enlargers should prove helpful.

CALLIER EFFECT

If you have ever made both contact prints and enlargements from the same negative, and especially if you used the same paper for both, you probably noticed that your enlargements seemed to have a little more contrast than the contact prints from the same negative. This is not an illusion, but comes about through a property of the silver image itself, first described by André Callier and known as the Callier Effect.

The Callier Effect is the result of the granular structure of the silver image; if the image were perfectly homogeneous, this effect would not occur. What happens is that the individual grains of silver block some light while most of the remaining light passes between the grains. That is, the individual grains are opaque, and the differences in light transmission in the image result from the amount of light blocked by the grains as compared with the amount of light that passes between them. Even this would not matter were it not for a further occurrence. Some of the light rays that strike the edge of a grain are deflected from their normal paths and go off at odd angles; the total effect of the various deflected light rays is called *scattering*, and it is this scattering which causes the Callier Effect.

The scattering is least where there is little silver deposit, and most where there is the most silver. The deflection of the light is small

The head of a condenser enlarger has a large opal bulb with double condensers below it. This model utilizes a third condenser, which is added when a short focus lens is used, to concentrate the light through the smaller negative.

but becomes significant in the case of a projected image. In an enlarger, much of the scattered light is deflected sufficiently to miss the lens altogether; if this occurred uniformly in all negative areas, it would make little or no difference, but the amount of deflection actually depends upon the way in which an enlarger is built.

ENLARGERS

The earliest enlargers were built like slide projectors; they had small, highly concentrated light sources and large lenses, called *condensers*, to direct the light through all areas of the negative and then to the enlarger lens. In the absence of a negative, the light rays traveled in straight lines from lamp to lens to paper. A system like this was highly efficient but difficult to adjust; every time you focused the lens, the lamp and condensers had to be adjusted also.

Another type of enlarger did away with the condensers altogether; instead, it used a sheet of highly diffusing material, such as opal glass, to assure uniform illumination. The problem with this system was that the opal glass absorbed a good deal of light, hence powerful lamps were needed or else exposures were inconveniently long.

These are the two extreme types of enlargers and are known as *condenser* enlargers

and *diffusion* enlargers. A hybrid type of enlarger is used by most workers today—it contains condensers for better light efficiency but uses a large opal-glass lamp bulb. Thus we have some diffusion right at the source, then the light is picked up and directed through the negative by the condensers in the normal way. This improves the efficiency as compared with a pure diffusion-type enlarger, while eliminating any need to adjust the lamp and condensers once they have been set up at the factory.

Each type of enlarger has a different effect on the contrast of the enlarged print as compared with a contact print from the same negative. In the case of the contact print, there being no appreciable distance between negative and paper, any light scattered by the silver grains of the negative reaches the paper before it has departed from its proper area. Thus all the printing light reaches the paper except the amount absorbed by the silver grains of the negative, and the print has the same contrast as the negative.

Condenser and Diffusion Enlargers

The condenser enlarger represents the opposite extreme (see accompanying diagram). Where there is little silver in the negative, as in shadow areas, light rays from the condensers travel in a straight line directly to the enlarger lens. In the middletones, only those rays which pass directly between grains can travel to the lens undeflected; any light scattered by the image never reaches the lens. In the highlights, there is more silver, more scattering, and an even larger proportion of light fails to reach the lens.

Summing up, light from the shadows reaches the lens *in toto*; some of the light from the middletones is lost by scattering; and still more light is scattered and lost from the highlights. Thus the projected image has a definitely higher contrast than the negative itself.

In a diffusion enlarger, the scattering still takes place in the negative, but there is also some random scattering in the diffuser. This does not change the situation in the middletones and highlights, where scattering still takes place as before; it does, however, result in some loss of light due to scattering in the shadows, where little silver image is present. There is still more loss in the highlights and middletones than in the shadows, so the projected image will have some increase in contrast, but the increase will not be as great as with the condenser enlarger.

These are the extremes; the enlarger that uses an opal-glass bulb combined with condensers will show some gain in contrast— more than a diffusion enlarger, but less than a true condenser enlarger. There is little to choose between the totally diffusing machines and those which use a diffused light source with condensers. The general belief that condenser enlargers produce grainier images is not really true, though the increase in contrast may sometimes cause graininess to appear a little more evident. This is easily proved by

Condenser enlarger (left) and diffusion enlarger (right).

making a print on softer paper; you will notice that it is no grainier than a print made on harder paper using a diffusion enlarger.

Newer Diffusion Enlargers

As mentioned, the main fault with older diffusion-type enlargers is the great loss of light in the opal-glass diffusing medium. A newer type of diffusion enlarger is becoming popular now, in which diffusion is accomplished by reflecting the light back and forth from the walls of the lamphouse. As a result of multiple random reflections, most of the light eventually finds its way through the negative and lens, and there is far less loss of illumination.

The chief advantage of this system is that several light sources of different colors may be used; the diffusion housing acts as a mixing chamber, resulting in highly uniform illumination and complete color control. Modern color lamphouses of this sort utilize dichroic filters, which do not fade under heat; a single light source and three variable filters allow complete color-correction capability.

FILTERS

Such a lamphouse can also be used for black-and-white printing on variable-contrast papers; proper adjustment of the built-in filters approximates the variable-contrast filtering to some extent. With the built-in filters, however, it is not possible to secure the entire range of contrast possible with papers such as Kodak Polycontrast Paper; the magenta filter in the dichroic lamphouse is not strong enough. The built-in filtering can be used unless the maximum contrast is required, and the following table gives suggested settings for the Chromega B lamphouse. Other lamphouses may require different settings.*

Chromega B Setting	Polycontrast Filter Equivalent
35M-24Y	1
42M-20Y	1½
50M-16Y	2
100M- 8Y	2½
150M- 0Y	3

If either the No. 3½ or No. 4 contrast is required, the ordinary Polycontrast filters can be used, setting the lamphouse filters back to zero.

Thus if you wish to buy the best at the beginning, you may install a color enlarger, since it will be equally useful for black-and-white

*The Eastman Kodak Company suggests somewhat different figures for the substitution of CC filters for the Polycontrast ones. However, they are referring to actual CC filters, not to their equivalent settings on a dichroic head. For comparison, the Kodak figures are as follows:

Kodak Polycontrast (PC) Filters	Color-Printing (CP) Filters
1	30Y
1½	10Y
2	20M
2½	40M
3	70M
3½	150M
4	300M

This suggests that even softer results could be obtained by using stronger yellow filters, and the author has determined by trial that this is actually the case; contrasts corresponding to a No. 0, and even a No. 00 (if such a thing existed), are obtainable by using filters up to CP-150Y and stronger. The point that should be emphasized here is that these recommended filter substitutions are only a guide, and you will have to try this out to see what works best for you.

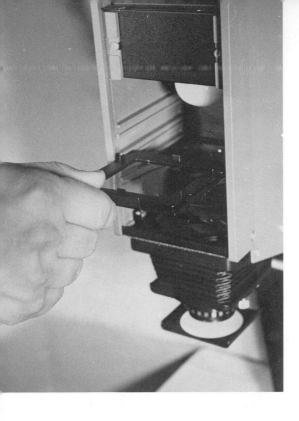

printing. On other grounds, there is little to choose between diffusion and condenser lamphouses of different makes; they produce minor differences in image contrast, but if a good enlarger lens is used, prints will be equally sharp with any of them. The graininess question is trivial.

FILTER HOLDERS

Almost all modern enlargers have a filter holder or drawer in the lamphouse; this is useful for both color-compensating and variable-contrast filters. When filters are used in this position, they need not be of optical quality, and stray fingermarks or dust on their surfaces will not affect the quality of the print. It is important, though, that the filter drawer be placed underneath the heat-absorbing glass if one is present; this will extend the life of the filters, although they will fade eventually anyway. Filters used in the lamphouse should be checked frequently.

Where a filter drawer is not available, use variable-contrast filters under the lens; accessory filter holders are available for most lenses. Filters used in this position must be of optical-quality gelatin, not plastic, and they must be kept spotlessly clean.

VIEWING FILTERS

Most enlargers are fitted with a red filter on a swinging arm just under the lens. These were

(Above) Filters are placed in the enlarger head's filter drawer for contrast control with variable-contrast black-and-white papers. This drawer can also be used with acetate CP (color printing) filters when making prints from color negatives or transparencies.

(Left) If the enlarger does not have a filter drawer, optical-quality gelatin filters must be used below the lens. In this case, it is important to use as few as possible to prevent degrading the print's sharpness and contrast.

A diffusion enlarger's lamphouse that has built-in variable filtration can be used to adjust contrast by rotating the knobs as shown.

originally intended to permit placing the paper directly on the baseboard of the enlarger when the proper size easel was not available. All you do is project the image on the baseboard, swing the filter under the lens, and you can see enough of the image in a deep-red color to be able to place the paper in position without fogging it.

The red filter is designed for absolute safety with all papers except those used for color printing; the only trouble is that with the lens stopped down and a fairly dense negative, the resultant image is difficult to see. For some of the techniques to be described later in this lesson, it is necessary that you be able to see the projected image before exposure begins. To

make this more convenient, a lighter filter is preferable; a Kodak Wratten Series 21 Gelatin Filter costs about a dollar and will serve for most enlarging papers if the light does not remain on too long. The fast variable-contrast papers may need a deeper-red filter, and a Kodak Wratten Series 23 is safe for nearly all of these papers; it is lighter and brighter than the deep-red plastic filter supplied with most enlargers.

ENLARGER LENSES

A good lens is essential for high-quality prints. Lenses made especially for enlarging are almost always superior to camera lenses for this purpose. One reason is that any lens works best at the distance for which it was designed; most camera lenses are designed for use at distances of six feet to infinity, whereas enlarger lenses are designed for use at distances of two feet and less. Another factor is color correction; chromatic correction of camera lenses differs from that of enlarging lenses, even where both are intended for use with color films and papers. The difference can be of great importance for black-and-white as well as for color printing.

Enlarger lenses are corrected for best performance at close ranges, specifically, for magnifications between 1:2 and 1:15. This suggests that a *macro* lens would also make a good enlarger lens, and in fact, this is true. However, a macro lens is more expensive than a good enlarger lens, one reason being the cost of the long focusing mount needed with a macro lens on a camera. With an enlarger, the extension is built into the machine, and the lens is mounted on a simple barrel.

Color Correction of Lenses

Color correction of lenses, in general, and enlarger lenses, in particular, requires compensation for two different types of chromatic aberration: ordinary, or longitudinal, chromatic aberration, and lateral chromatic aberra-

tion, or lateral color. Ordinary chromatic aberration causes the violet to focus nearer the lens than the red. Different correction methods have been employed: Older lenses brought blue and green to a single focal point, while modern lenses for color work cause the blue and red to coincide. In either case, other colors are slightly out of focus. With shorter focal-length lenses, the error is small and usually unimportant. With the longer focal lengths, however, lenses are sometimes made to bring three colors to a single focus; these are called *apochromats* and usually are quite costly. Apochromatic correction in an enlarger lens would not produce sufficiently improved results to justify the cost.

With lateral chromatic aberration, even though two colors are brought to the same focus, there is a difference of magnification between them, so the blue image is either larger or smaller than the red. As a result, a sharp image is surrounded with color fringes. This did not matter much when enlarger lenses were used only with plain black-and-white papers, sensitive only to blue light, as the red image did not affect these papers at all. But you will find often that an old enlarging lens that makes quite satisfactory prints on ordinary papers produces unsharp pictures not only with color prints, but even for black-and-white printing on variable-contrast papers (which are sensitive to both blue and green).

So if you are setting up a new darkroom, or improving an old one, along with your enlarger you should buy the best lens you can afford. It will cost less than a camera lens of equal quality because it does not need to be of large aperture and because it does not have to be mounted in a complicated focusing mount.

Lens Focal Lengths

The focal length of the enlarger lens should be matched to the size of the negative to be printed. In some cases, you will need more than one lens for different negative sizes; a 50mm lens will not cover a 2¼" × 2¾" nega-

tive, while the four-inch lens needed for the latter negative will produce only a limited range of print sizes with a smaller negative.

In general, focal lengths of enlarger lenses can be shorter than those used on cameras for the same negative size because an enlarger lens is usually used at a longer bellows extension; still, for good definition right to the corners of the negative, it is better not to cut the focus too short. You can choose an appropriate focal length from the following table:

Subminiature (Minox, Size 110)	25mm
Single-frame 35mm, Robot, and Instamatic Size 126	35mm
Double-frame 35mm	50mm
4 × 4 cm to 6 × 6 cm	75mm
6 × 7 cm to 6 × 9 cm	90–105mm
3¼″ × 4¼″ to 4″ × 5″	135–150mm

If you use a number of the above sizes, there are obvious compromises, as it is certainly not necessary to have one lens for each film format. Unless you are making enormous enlargements from very small negatives, the 50mm lens will take care of everything from Minox to full double-frame 35mm. A 105mm lens will take care of everything from 4 × 4 cm to 2¼″ × 3¼″. If you use only 35mm and 2¼″ × 2¼″, then a 50mm and an 80mm or a 50mm and a 75mm lens will cover both formats. If, on occasion, you have to make a large print from a small section of a 2¼″ × 2¼″ negative, the 50mm lens will provide the extra magnification needed.

TILTING NEGATIVE CARRIERS

Some advanced enlargers are made with a mechanism to tilt the negative carrier and sometimes tilt the lens board as well. If only the negative can be tilted, then you need a device for tilting the paper easel too. With this capability, a negative that shows perspective distortion due to camera tilt can be rectified in printing by tilting some part of the enlarger system. If only the negative carrier, or only the easel, is tilted, you cannot attain sharp focus over the entire picture area.

Where only a modest degree of correction is required, you may tilt either the negative or the paper easel, and then take advantage of the depth of field of the lens by stopping it down to a small aperture. This means longer exposures in printing. Where extreme correction is required, or where you do not wish to make long exposures, it is possible to secure sharp focus over a tilted negative or paper plane by also tilting the lens board. Or, where the lens board cannot be tilted, you may tilt the negative and the paper easel. In short, with the three elements in an enlarger setup—negative plane, lens plane, and paper plane—you should be able to tilt *any two* of the three to secure both perspective correction and uniform focus at the same time.

To understand how this works, remember, first of all, that as the distance from lens to paper increases, so does the size of the image; secondly, that as the distance from lens to paper increases, the distance from lens to negative must decrease to secure sharp focus. Consider the diagram below:

Tilting the enlarger easel can correct perspective distortion. See page 42 for details.

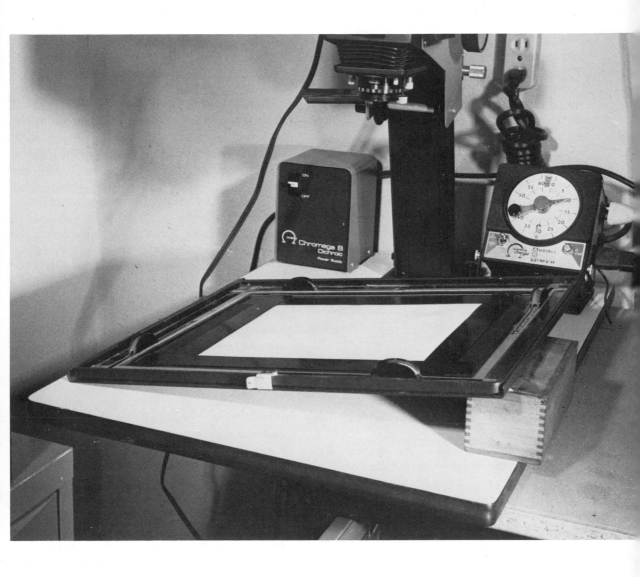

Moderate amounts of correction can be obtained by tilting the easel with a block under one end. If the enlarger provides no negative or lens stage tilts, then the lens must be stopped down to insure adequate overall print sharpness. All the following examples were made in this simple manner.

What we are doing, in effect, is making the part of the image at the right of the easel larger than the part at the left. This is accomplished by making distance B longer than distance A. And by tilting the negative in the opposite direction, we focus B by making C shorter, while we focus A by making D longer. Thus since the extreme ends are in focus, and the middle is also in focus, the entire negative is in focus, but the magnification is considerably greater on one edge than on the other.

If you have an enlarger with a tilting negative stage, it will be very instructive for you to make this setup and see how it works. Starting with the easel and negative stage both level, insert a negative in the carrier and proceed as follows:

Step-by-Step Procedure

1. Raise the enlarger head until the desired image size is reached.

2. Focus the image on a sheet of white paper on the easel.

3. Tilt the easel to a position such as the one shown in the above diagram—with the left side higher than the right.

4. The image will now be out of focus. Refocus so that the image is sharp in the center of the easel. Both edges will be out of focus.

5. Tilt the negative carrier in the direction shown—opposite to the tilt of the easel. Watch the image while tilting; if it goes out of focus, stop and refocus it again for the middle.

6. When the correct angle is reached, the image will be sharp not only in the middle, but all the way across its width. A slight touch-up of focus may be needed at this point, but if the angle is right, the focusing should result in uniform sharpness from one side to the other.

While you will have to find the final setting by careful trial, it is not necessary to guess which way the easel and negative must be tilted if you watch the projected image. Let's assume you have a picture of a building that was made with the camera tilted upward. This will produce the usual distortion, with the top

of the building narrower than the base. If you put the negative in the enlarger with its top to the left, and tilt the easel exactly as shown, then the right side *of the image* will be bigger than the left; that is, the top of the building will have more enlargement than the bottom, and this will correct the distortion. A few trials will lead to a setting that results in the building being depicted as perfectly straight, up and down.

Now tilt the negative to secure exact focus; this is in the opposite direction to the easel tilt. We have pointed out that the same result can be secured by tilting the lens board. Here you are no longer working with the distances alone; when you tilt the lens board, a different optical principal comes into play, and to decide how much tilt is required, and in what direction, we take advantage of a rule sometimes known as the *Scheimpflug Principle*.

THE SCHEIMPFLUG PRINCIPLE

In any optical system—camera, enlarger, or whatever—the plane of the object, the lens, and the film must all be parallel if uniform focus is to be obtained over the entire image area.

If any *one* of these planes is tilted with respect to the others, overall focus cannot be obtained.

But if *two* planes are tilted, then it is possible to secure focus over the entire image area.

The rule states, simply, that when the planes of all three elements are extended in either direction, and all three planes meet in a single point, then the condition for focus exists. (For those conversant with advanced geometry, when three planes are parallel, they will meet at infinity, and so the parallel situation is merely a special case of the Scheimpflug Principle.)

The only essential fact is that the three planes meet in one point; where this point is, and which planes are tilted, is immaterial. With an enlarger, you may tilt the easel and

This diagram illustrates the Scheimpflug principle.

the film plane, or the easel and the lens board, or the film plane and the lens board. What matters is that *two* of the three elements be adjustable.

For example, it would be fine if the easel could remain flat on the baseboard of the enlarger; in this case, you would have to tilt both negative carrier and lens board for perspective control. Unfortunately, very few enlargers are built this way; those which have any control at all usually have it in the form of a tilting negative stage. Thus for both perspective control and focus, you have to tilt the easel as well. While various ball-joint arrangements are

made for this purpose, it is almost as easy to prop one edge of the easel on a thin book or some similar object. If you have any woodworking facilities available, you can make a set of wooden blocks of various thicknesses and keep them near the enlarger for use when needed.

EXPOSURE COMPENSATION

When printing with tilted negative and easel, one end of the image will be bigger than the other; as in any enlargement, the bigger image requires the greater exposure. And if you

make the print without compensation, the larger end of the image will be underexposed.

The correction is simply a matter of dodging. The easiest way to do it is to make the exposure test at the larger end of the image; if this is correct, then the smaller end will be getting too much exposure but can be held back easily with a straight dodger during the exposure.

For most precise results, it may be best if you make a separate exposure test at each end of the image. If it turns out that the larger end needs 20 seconds, and the smaller end 13 seconds, all you need do is dodge the smaller end of the image for 7 seconds while making the exposure.

Since the change in exposure is uniform from one end to the other, it would seem necessary to dodge progressively, with the most holdback at the smaller end, and then gradually less and less across the print area. This can be done without too much trouble, but in most instances it won't be necessary; if the smaller end of the image is dodged for the proper time, no great or sudden change in density will be noted at the transition point, especially if the dodger is kept in motion as is always recommended.

Most photographers find it possible to make the exposure correction by freehand dodging, without any special tests. In this, as in other areas, practice makes perfect, and it pays to print the same negative several times, with different amounts of dodging.

DELIBERATE DISTORTION

Once you have mastered the use of the enlarger tilts, you will begin to see other possibilities in their use. You probably noticed that when you tilted the easel to correct a tilt in an original image, other things happened at the same time.

Take the classic case of the building that was shot with the camera pointing upward. When you corrected this by tilting the easel, and the top and bottom of the building were equal in width, you probably noticed that the height of the building had increased at the same time. What happened is that when you tilted the camera up, you not only caused the image to converge, but also to foreshorten at the same time; in correcting the tilt, you also corrected the foreshortening.

However, this compensation is not automatically correct; it is correct only when the extension of the enlarger lens is the same as that of the camera lens when the picture was taken. If the enlarger lens happens to be of the same focal length as the camera lens, and is extended the same amount, it will produce a print the same size as the original building, which is impractical. But if the enlarger lens has a slightly shorter focus than the camera lens, then when it is extended for a reasonable size enlargement, it will also produce the proper size correction when used with a tilted negative and easel.

As a numerical example: If a building is photographed at a fairly large distance with a four-inch lens, a three-inch enlarger lens at $3\times$ enlargement will produce correct proportions, as will a 3½-inch lens at $7\times$, and so on. If the image of a building is rectilinear, few persons will notice that the height of the image is incorrect. But the general principle has other uses: In general, if the enlarger lens has a longer focus than the camera lens, the image will be somewhat stretched; if it has a shorter focus than the camera lens, the image will be shortened.

You can utilize this principle to make prints that are deliberately extended or compressed. In fashion photography, for instance, a favorite trick is to photograph the model from a low angle, then to rectify the image in an enlarger with a long-focus lens and a tilted easel; the resultant image makes the model appear taller and thinner than she actually is.

Since the method works just as well sideways, this trick is often used in photographing automobiles; instead of making a picture

square to the side of the car, it is photographed at an angle, generally in front. The converging image is then straightened out in an enlarger with a long-focus lens and a tilting mechanism, and the end result makes the car appear considerably longer. It is safe to say that practically every advertising photograph of an automobile has been treated in this way. Obviously, the possibilities of this type of deliberate distortion are limitless.

CURVING THE PAPER

Another way to produce "far-out" images is to project on paper held in a warped shape; it may be cupped, convex, or twisted. The effect is somewhat similar to that seen in the twisted mirrors in amusement parks. Since the paper is no longer a plane surface, no method comparable to the Scheimpflug Principle can be found to secure sharp focus overall; you may use only moderate amounts of distortion, and you have to stop the lens down as far as it will go to secure reasonable sharpness. Luckily, unsharp effects are usually acceptable in such cases; an image that is sharp in some areas and blurred in others, corresponding to the degree of bending of the image, is to be expected and usually is considered a normal effect.

This is a process for which no exact rules or directions can be given; we suggest that you try projecting the negative on pieces of plain white paper, bent and twisted as you please, while watching the effect closely. If you see anything that looks promising, you may substitute a piece of sensitive paper and make a print. As a creative trick, it depends entirely on your own taste and desires. It is an easy trick to learn; you can get the hang of it in a few trials and decide if the whole idea interests you.

Some parts of the image may need more exposure than others, as in the case of the tilted negative. This, again, is done by dodging, and the only way to find out where, and how much, is to make a full-sized test print; test strips are not likely to be of much assistance.

COMBINATION PRINTING

With a good enlarger setup, making combination prints from two or more negatives is not a difficult task. Most books describe this procedure mainly for adding clouds to landscapes, but it has other uses. Combination printing can be used to add foregrounds, to frame an image with tree branches or a window outline, or, commercially, to insert lettering or other artwork in a photograph.

Since the landscape-plus-clouds picture is the easiest to do, we will use it to demonstrate the method; understand that the procedure for combining negatives is exactly the same regardless of subject. Basically, the method consists in printing part of one image while protecting the unexposed paper areas with a mask of some kind, then printing the second image, using a complementary-shaped mask to protect the area already printed.

For this first trial, take two negatives—one of a landscape with a fairly large area of blank sky, the other, a sky picture with good strong clouds. This latter may have a foreground in it, but we can eliminate this as we go along. By the same token, it is not necessary that the horizon in both negatives be in the same place, nor even that both negatives be of the same size; all these matters can be adjusted in the enlarger.

All you need, other than your usual enlarging equipment, is a few sheets of thin but opaque cardboard, preferably light-colored or white, which should be a little larger than the print you are going to make; a soft black pencil, such as a Grade BBBB drawing pencil or one of the Ebony pencils used by editors; and a few pieces of black masking tape. Set up your enlarger and processing trays in the usual manner.

To begin, take your negative of the foreground scene and insert it in the enlarger. Put a piece of plain white typewriter paper in the easel, project the image of the negative on it, focus, and compose as you wish.

In this photo a sharp, upward camera angle causes sharp convergence of vertical lines.

The corrected print has not only straightened vertical lines, but the whole building now appears taller and narrower than it did in the straight print.

In this photo of a compact car, the angle used makes the car appear even shorter and stubbier.

Now take your soft pencil and mark in the horizon line and the positions of a few foreground details. This will make it easier to return the enlarger to this setting later. Stop down the lens and make a test strip for the foreground exposure; ignore the sky area.

Next substitute the sky negative for the foreground negative. Focus it on the same

Using the same correction as in the church photo, the car's front and rear wheels are now almost the same size which would be the case if the car were photographed broadside, yet both windshield and radiator grille are still visible. The perspective change causes the car to look noticeably lower and longer than in the straight print. This trick is often used in commercial automobile illustrations.

piece of white paper already marked with the foreground details. This will give you an idea of how the cloud area should be composed. You may have to move the easel to get the sky placed just right; this will cause no difficulty because you have the marked paper to show you the composition and to make it easy to return to it.

If you have to change magnification for the cloud negative, then you must mark the height of the enlarger. Stick a piece of tape to the enlarger column to mark it; place the tape above or below the position of the head, depending upon which way you are going to move.

Once this is done, set the head to the right height for the cloud negative; when this is decided, mark a few cloud outlines on the focusing paper to enable you to return to this setting later. Again stop down the lens and make a test strip for the cloud exposure. This can be a little deceiving; the correct cloud exposure will be less than the test suggests. If the highest light in the clouds is pure white, that should be about right. Clouds that are gray all over make a scene look gloomy and dull.

When you have a good test, make a note of the exposure. Put another piece of tape on the enlarger column, to indicate the height for the cloud negative. Now put the foreground negative back in the enlarger and return the enlarger to the original setting. Focus sharply, and move the easel around, as needed, to make the foreground details and horizon fall right on the pencil marks made the first time.

Take the sheet of thin cardboard, place it on the easel, and mark the horizon line on it. Below the line, write "foreground mask"; above the line, write "sky mask." With scissors, cut the cardboard into two pieces along the horizon line. With this done, you are ready to make the actual combined print. Proceed as follows:

Step-by-Step Procedure

1. Stop the enlarger lens down to the aperture used for making the foreground test.

2. Swing the red viewing filter into place under the lens. Shut off the enlarger.

3. Put a sheet of enlarging paper in the easel.

4. Hold the sky mask over the easel, a few inches above the paper. The red filter is still in place.

5. Turn on the enlarger light and move the sky mask around till it just covers the sky area, down to the horizon.

6. Swing the red filter aside and expose the paper for the time determined by the first test. Keep the mask moving so that it does not make a sharp line at the horizon; small orbital motions are the best.

7. When the exposure is complete, shut off the enlarger, and put the mask aside. Put the viewing filter over the lens again, turn on the enlarger, and following the projected image, put a few dots of soft pencil right on the emulsion side of the paper to indicate the approximate course of the horizon line. These must be placed just slightly inside the exposed area so that they will not cause marks on the final print.

8. Shut off the enlarger and put the paper in the paper-safe. Place the pencil sketch of the picture back on the easel.

9. Insert the sky negative in the enlarger, and return the enlarger head to the marked spot on the column for this negative. Focus sharply and move the easel until the cloud outlines fall into the right position on the pencil sketch.

10. Put the red filter over the lens, remove the pencil sketch, and replace the partly exposed sheet of paper on the easel.

11. Hold the foreground mask over the paper so that it just barely covers the pencil dots made on the emulsion of the paper after the first exposure.

12. Swing the red filter aside and make the cloud exposure, keeping the foreground mask about an inch above the paper and in continual motion. The two images should actually overlap a bit, but since the sky is usually lightest at the horizon, a tiny gap at this point will not look unnatural. If the clouds are heavy, though, this should not be done; it is far better to have the clouds actually lap over the foreground. They will not produce any noticeable cloud image over foreground objects.

13. When the exposure is complete, shut

off the enlarger and remove the paper from the easel. Slide it face up into the developer, and immediately with a fingertip, rub off the pencil dots along the horizon line.

14. Develop the paper for the usual time (from 1 to 1½ minutes), stop, and fix.

If everything went well, you should have a perfect combination print. Almost always you can see where a little shift of one or the other negative, or a slight change of one or the other exposure, will improve the final result. There is nothing difficult about this whole procedure, but it does take some practice before you can predict what the combination of any two negatives will look like.

If the only change needed is in the exposure, or if change is needed only in the sky area, then the sketch and mask you made the first time will be suitable for a second print. Otherwise, you may need new sketches and masks.

It sometimes turns out that the result looks unnatural; this usually comes about when the light on the clouds comes from a different direction than that on the foreground. In cases where the foreground is frontlit and the clouds backlit, nothing can be done except to find another cloud negative. If the landscape is lit from the left, and the clouds from the right, the cloud negative can be flipped over in the enlarger to produce a more natural result.

Another problem that may arise is a difference of contrast in foreground and cloud negatives. Sometimes having a cloud negative more contrasty than the foreground produces a more dramatic effect. On the other hand, if the cloud negative is softer than the scene, the composite seldom looks right. If you print on a variable-contrast paper, the cure is easy; simply print the cloud negative through a more contrasty filter to secure a balance of contrast overall.

Sometimes this last trick is worth trying even where the two negatives are substantially alike in contrast. A slight increase in contrast in the sky area can often enhance the dramatic

quality of the composite. If you use this double-printing system to make commercial illustrations later on, you will find that contrast control will be an important part of the procedure.

For example, if you intend to print lettering over the white area of a picture, you will obtain the best results by printing the lettering negative at maximum contrast; sometimes the effect is further enhanced by printing the continuous-tone image softer than normal.

Once you have mastered the art of combining two negatives, you will find it equally easy to combine as many as three or even four. As an example of a three-negative print, you may have a scene in one negative, clouds in another, and some foreground tree branches on a third. The resultant picture may well be one that could not possibly have been made as a single shot. Esthetically, it is quite legitimate since all steps are purely photographic; there is no handwork, drawing, or image fakery involved.

VIGNETTING

Vignetting is dodging carried to the extreme; with this technique, certain areas of the print are shaded during exposure not for just part of the time, but for the entire period. Thus the shaded areas remain pure white after the print is developed. This is a popular effect in portraits when you wish to subdue or eliminate an unwanted background.

Vignetting is considered slightly old-fashioned today, but it still has its uses; in portraits of children or young women, it produces a light and airy effect in connection with an image composed mainly of white and light-gray tones. Such an image is called a "high-key" image.

Image Key

The "key" of an image is the predominance of one particular tone over the remainder. Thus a *high-key* print is one that is mostly whites or

This country church on a bright sunny day has clouds, but the hazy, white sky renders the clouds nearly invisible.

The church's sky area is masked out.

A cloud negative with the foreground masked out.

The combination print with a new sky.

light-grays; a *low-key* print is one that is mostly blacks and dark-grays. A *medium-key* image, if there is such a thing, is simply a normal photograph.

There is some misunderstanding of just what a high-key or low-key image is. You cannot make a high-key picture of a dark-haired girl in black clothing by making a lighter-than-normal print; the result is simply an underexposed print. By the same token, a heavily overprinted picture of a blonde in white clothing is not a low-key picture; it is merely an overexposed print. It *is* possible, using advanced lighting techniques, to make low- or high-key pictures of such subject matter, but this is not something that can be done in the darkroom.

What is important to realize is that a high-key print is not *all* whites and light-grays, nor is a low-key print *all* blacks and dark-grays; either image must have a complete scale. The important thing in keying an image is merely the predominance of one group of tones; that is, a high-key subject may be 80 per cent white and light-gray, but there must be a few small areas of dark-gray and black in it. The portrait of a blonde girl in white clothing requires these small dark accents—a few spots of dark-gray and black. These could be the eyes, small hair ornaments, or some jewelry, perhaps. The scale must be completed with a small amount of dark-gray and black, otherwise the print looks washed out.

Once image key is understood, then vignetting can be appreciated; often you have an excellent high-key portrait spoiled by a dark chair, a doorway, or some other background object. By vignetting, you can eliminate these unwanted accents and fade out the picture to a pure white all around.

Vignetters

A vignetter is like a dodger; it is a piece of black paper or cardboard with an irregular hole cut in it. Since the effect desired is a gradual fadeout of the image to the edges of the picture, the vignetter must produce a much softer edge than a dodger; usually, the edges of the hole are serrated, like saw-teeth, and the hole itself is quite small. The vignetter can be held closer to the enlarger lens than a dodger, and the result is a very gradual effect.

To avoid any possibility of the saw-toothed edge of the vignetter causing a rough outline on the print, keep the vignetter in motion during the exposure, just like a dodger; a small orbital motion is the best.

To find the exact position for a vignetter, first project the image on the easel, with the enlarger lens wide open. Try the vignetter at various heights until you find a position that will project the face and hair of the subject through the aperture. When you have located the approximate position, stop down the lens and put a sheet of sensitive paper on the easel.

Put the red viewing filter in place, turn on the enlarger, and hold the vignetter in position, as determined by the test. When you have the position, swing the filter aside and make the exposure, remembering to keep the vignetter in motion.

One variation in the method is to start with the vignetter fairly close to the paper, so that only the extreme center of the image is exposed; then during the exposure, raise the vignetter to the lens position. This exposes the paper progressively from center to edges and produces a very smooth gradation of tone from the middle out.

Where the negative has been made against a pure white background, you may need to vignette only the bottom of the image. In this case, the vignetter is simply a piece of cardboard with a crescent-shaped notch cut in one edge; this may be serrated for smoother results. It is used in exactly the same way as a complete vignetter.

Where a serrated edge is used, it should not be too coarse; the saw-teeth ought to be about ½-inch wide and a little deeper. Since it takes only a few minutes to make one, you should make several, with holes of different sizes and

different serrations. You can try them all and find out which one produces the effect you prefer. With a serrated edge, it is even more important than usual to keep the vignetter moving smoothly, to produce an even gradation of tone.

FLASHING

The opposite of vignetting is *flashing*— exposing the edges of the image longer than the middle, so that the image fades to a dark-gray or black at the edges. This, however, cannot be done merely by dodging or burning-in the edges of the enlargement with the negative in the carrier. The reasons are twofold: First, the negative image prevents the attainment of a full black with any reasonable exposure. Second, what is wanted is not only a darkening, but a lowering of contrast at the outer areas. In a way this is the same as vignetting, in which the image not only fades out, but becomes less contrasty as it does so.

One way of fading out the image to a black in the margins is to use a vignetter in front of the camera; this will produce the desired effect of progressive darkening and lowering of contrast at the same time.

If you want to get the same effect in printing, it must be done by superimposing an exposure to white light on the image exposure. This will produce the necessary black margins and will also lower the contrast in the flashed areas.

How this comes about can be demonstrated with some simple arithmetic. Say, for example, your negative has a contrast range of 9:1 (the shadows transmit nine times as much light as the highlights). If you expose the paper through this negative, then the shadows will get nine units of light, the highlights one unit.*

Suppose you give the paper an overall exposure of three units of light. The highlights have now received 1 + 3 units = 4 units of light; the shadows have received 9 + 3 units = 12 units of light. So your image contrast is now 12:4, or 3:1, compared to the 9:1 of the negative alone. This is a very marked reduction in contrast.

Flashing Methods

At first thought, it might seem that the easiest way to flash a print would be simply to remove the negative from the enlarger and make the added exposure with the enlarger light, using dodgers of various shapes to put the light just where it is wanted. Without a negative, though, the enlarger light is too strong and requires exceedingly short flashing exposures, which are hard to control. You could stop down the enlarger lens, and if you are making only a single print, this works; but making several prints in succession involves stopping the lens down again, opening it again, and so on, with multiplying chances for error.

Another suggestion is to use a pocket flashlight and move it around the borders of the print, thus putting the extra light just where it is wanted. A few people have mastered this technique; however, most find it too difficult, except for occasional use just to put a little spot of light in an inconvenient place. Again the problem is one of control; it is very difficult, when exposing various parts of the print in succession, to ensure that all will get exactly the same exposure.

The most controllable way to flash is to set up a space alongside the enlarger, to which you can shift the easel after the print exposure has been given. Above this space, install a socket with a tiny incandescent bulb, suspended on a bracket that puts it just above the center of the easel at a predetermined dis-

*For simplicity, we are ignoring the Callier Effect in this example.

tance. Connect this lamp to a separate foot-switch.

For normal enlarging papers, only a very small bulb is needed if the light is hung at least three feet above the table. Even the little globe-shaped 7½-watt white bulbs may be too strong for the faster papers, but they can be made usable by partly covering them with black masking tape, leaving a small uncovered area for light to emerge.

For a better way to flash, and to provide some control for different papers, you need a little cardboard or wooden box with the socket glued into a hole in one side using epoxy glue. In the cover, which is removable for bulb replacement, insert a hole, to cut down the light to the desired degree. Make black cardboard masks with different-size holes in them, and place these inside the box to adjust for different paper speeds. Only a few tests, to be made as described below, will be needed to tell you what size aperture is required.

The beauty of this setup is that for any particular enlarging paper, once the exposure has been determined, it remains constant, regardless of the exposure given to the negative.

Exposure Tests

For a first estimate, the Kodak Projection Print Scale may be used to make a test. Put the scale and a 4″ × 5″ piece of paper (the *same* batch of paper from which you intend to make your enlargement) on the board under the exposing light and make a first test, exposing for one minute exactly, as you do when making a print test. Develop this test for your normal developing time. The result should be a series of gray steps, with full black somewhere in the middle of the scale.

If the entire scale is black, then the light is too strong. If you are using a bare bulb, cover part of it with black masking tape. If you have made an exposing lamphouse, then put a diaphragm with a smaller hole in the bottom. If, on the other hand, none of the steps is fully black, the light is not strong enough; remove tape from the bulbs if you have used it, or put a larger aperture in the lamphousing.

The ideal to work for is a 16-second step that is just barely black, the 24-, 32-, and 48-second steps that are fully black, with the rest all tones of gray; then your flashing exposure

(Left) These are easily obtainable flashing lights. On the left is a simple night-light fixture and on the right is a 7½ watt white bulb masked with black tape leaving a small opening. The size of the opening is found by testing for a convenient exposure time.

will be 15 to 20 seconds, depending upon how much dodging you are doing, and how much of an image you are printing over. There is nothing critical about this; the only purpose of the test is to be sure you can get a good black flash with a convenient exposure time—that is, between 15 and 20 seconds.

For a first test, choose a negative in which most of the subject matter is in the middle; the aim here is to have the image fade out equally to black on all sides. You will also need an ordinary dodging tool, roughly oval in shape, on the end of a wire handle. The steps are as follows:

Step-by-Step Procedure

1. Insert the negative in the enlarger, focus, and compose. Stop the lens down to a normal printing aperture.

2. Make an exposure test using the Kodak Projection Print Scale or your usual test-strip procedure. Set the enlarger timer to this exposure.

3. Place a full sheet of paper on the easel and make the exposure. Any routine dodging, burning-in, or holding back, is done at this stage, as when making a straight print.

4. At the end of the exposure, move the easel to the working position under the flashing lamp. Take the dodging tool, hold it just under the flashing lamp, and turn on the lamp.

5. As soon as the lamp is lit, start to lower the dodger slowly, while continuing to move it in the little orbital motions necessary to avoid printing a sharp outline. Watch the way the light hits the paper: it should illuminate the outer edges evenly, should fade inward about halfway, but no white light should reach the middle area of the paper. It will help if, before you make an actual print, you practice this shading technique until you can put the dodger at the right height almost instantly (though there is really no great hurry) to get an even ring of light around the outer areas of the paper.

6. At the end of 15 to 20 seconds, shut off the flashing lamp, develop, stop, and fix the paper.

If everything is right, the image should be clean and bright in the middle of the paper, gradually diminishing in contrast and getting darker toward the margins, and ending up pure black at the extreme edges of the image area.

If the edges are not dark enough, then more flashing exposure is needed. If, on the other hand, the black area extends too far into the picture, then either give the print less exposure or use a larger dodger. Like everything else, practice makes the whole process easy and quick. Dry runs are useful for a preliminary trial, just to get used to the method. In any case, make a number of prints, preferably from the same negative, varying the flashing time, the distance of the dodger, and the amount it is moved around during the exposure.

Once you get the hang of this, you will find it possible to use the same technique for more subtle effects. Using a much dimmer lamp, or a shorter flash exposure, you can put just a trace of darkening around the edges of the picture. This should be far less than you'd need to produce a complete black outer rim; it should just barely darken the outer parts of the image and will enhance the picture by directing the eye to the important detail in the middle.

The method can be used for other purposes. One thing that often happens is a glaring white

(Right) The flashing lamp is mounted on a wall with a socket that has it's own switch. For greater accuracy, an extra enlarger timer can be used.

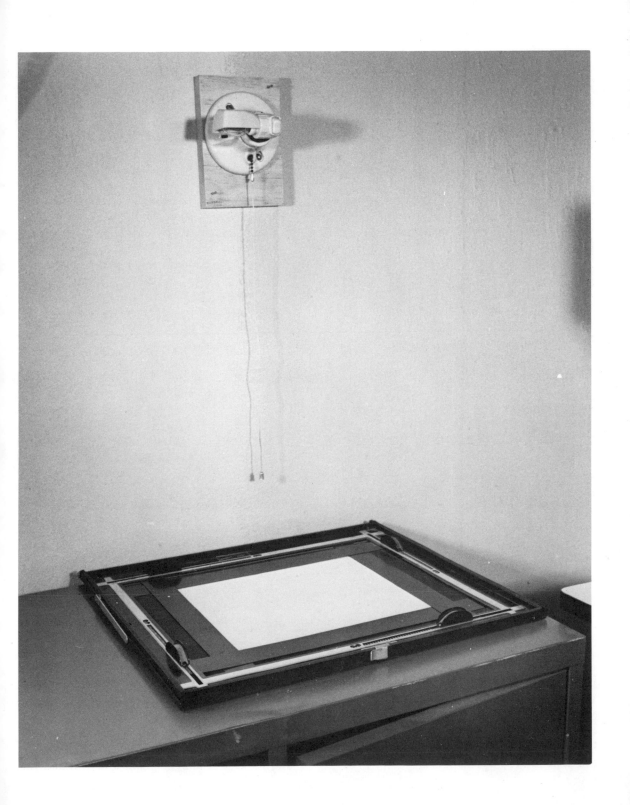

Black borders can be made by using a mask in contact with the paper during an exposure (before or after the enlarging exposure) to the flashing lamp.

highlight, outside the important subject area, which draws attention away from the subject. Such an area can be flashed to make it less obtrusive. Here a regular dodging tool with a hole in the middle is used to direct the light to the area and to flash-in details.

You will need some way to find the spot that is to be flashed-in. The best way is to make the image exposure as usual, then before moving the easel to the flash area, put the red filter under the enlarger lens, turn the light on again, and make a few light pencil dots around the

area to be flashed. Now move the easel to the flashing area, and use the dodger to put the light just inside the dots. Rub off the pencil marks with the ball of your finger as soon as you put the paper into the developer.

The same technique may be used to darken a washed-out foreground in a landscape, or to darken sky areas instead of printing-in clouds. There are times when a clouded sky does not look right in a given scene, yet a blank white sky is equally wrong. In this case, careful and subtle flashing is a good idea. Take a piece of cardboard with a straight edge, put it under the flashing lamp, then slowly move it down toward the horizon, but not quite to it, during the 15-second (or shorter) flash exposure. The thing to aim for here is a medium-gray at the extreme top edge of the image, shading down to white at the horizon. This, in fact, is exactly what a landscape looks like on a clear day, and the effect is both natural and emphatic.

DARK BORDERS

While the great majority of prints are made with the time-honored white margin, produced by the masking bands of the enlarger easel, there are subjects for which some other treatment is more appropriate. One such treatment is the borderless print, but this has limited value except where it is to be mounted on a larger white or light-colored background. Numerous easels and other devices are available to make borderless prints, but none of them is really necessary. All you have to do to make a borderless print is set the easel for the narrowest practical margin, and then trim this white margin off the finished print. It is seldom that an exact 8″ × 10″ print has any real necessity as compared with, say, one 7½″ × 9½″.

Another possibility is a print with a dark or even black border. These are often quite attractive, especially with high-key prints that are to be mounted on white or light-colored boards. With the flashing-lamp setup already described, making a dark border is an easy additional step in the exposure of a print.

All you need to form the width of the border desired is a piece of black cardboard, cut smaller than the paper to be used. Thus, say, for a ¼-inch margin on an 8″ × 10″ print, you need a piece of black cardboard 7½″ × 9½″ in dimensions. Place this over the paper, which has already had the image exposure, and give the additional exposure with the flashing lamp. If you have made a preliminary test with the Kodak Projection Print Scale, it will be easy to make the outline any desired tone of gray.

If you prefer a gray rather than black border, the edges of the paper must not be exposed before the border is flashed. In this instance, use the usual enlarging easel, set to almost exactly the same dimensions, when making the image exposure. To avoid an unsightly white line on one or more sides, make sure the black masking card is somewhat smaller than the unexposed white border because a little bit of overlapping image will not be very noticeable.

Assuming you intend to make an 8″ × 10″ print with a ¼-inch gray border around it, set the enlarger easel to produce a ³/₁₆-inch white border. The masking card will be exactly 7½″ × 9½″, but the easel opening will be 7⅝″ × 9⅝″ to produce the necessary overlap. The procedure is as follows:

Step-by-Step Procedure

1. Compose the image on the easel and make an exposure test.

2. On a separate piece of paper, make an exposure test under the flashing lamp to determine the exposure required for a given tone of gray. Develop both tests.

3. On a full sheet of paper in the easel, make the image exposure determined by the test. Any necessary dodging or burning-in is done at this stage.

4. Remove the paper from the easel and place it under the flashing lamp.

5. On top of the paper, place the masking card and adjust its position carefully to get an even margin all around.

6. Now give the flash exposure for the desired tone of gray.

7. Develop, stop, and fix the print.

If a subject requires black outlines, then any flashing exposure long enough to produce the maximum black of the paper may be given. It is possible to make black borders of shapes other than rectangular by using a card that is oval, round, or any other shape. If you want a black border, you don't have to mask the print during the image exposure; the mask flashing will simply burn out the image exposure in the border area.

LESSON 8

Advanced Paper Processing

In *Basic Black and White,* we described a number of ways of processing papers and toning papers to different image colors, all as far as they could be done using only readily available packaged formulas. This lesson will expand on the subject of paper development and toning, with formulas for those who can prepare their own solutions and have sources of supply for the various chemicals needed.

It is important to understand what can, and cannot, be accomplished by varying the composition of a paper developer. As we have pointed out already, papers are pretty rigid things as far as their exposure scale and image contrast are concerned. Papers develop very rapidly and reach their maximum contrast and density in one minute or so; it is not possible to influence the contrast of a print to any degree by varying either the development time or the composition of the developer formula.

GRAIN AND COLOR

Development does, however, have considerable influence upon the physical structure of the image, especially the size of the silver grains that make it up. The size of these grains, though far below that of negative images, has a large influence upon the *color* of the image. Images made up of large silver grains are blue-black in color; slightly finer-grained images are neutral-black; and still finer-grained images have colors ranging from warm-black through brown-black to brown and even olive colors. Like films, the grain of a paper emulsion is more or less built-in by the manufacturer; but unlike films, paper developers can have some noticeable influence upon grain structure, and some very warm-toned effects can be produced by using highly diluted, heavily bromided paper developers.

Even so, really warm tones (implying a fine-grained image) can only be produced on papers that have fine-grained emulsions to begin with. Cold-toned papers, such as Kodabromide, have a coarse grain structure and are not much affected by variations in developer composition; if you desire brown or

This scale is of high quality and is very accurate. It uses no loose weights, except for the hanging weight on the right which allows the scale to weigh an additional 1000 grams. The sliding weights on the three calibrated beams read: 0-10 grams, 0-100 grams, 0-1000 grams.

The balance indicator of this scale is of the more precise, calibrated type. The most accurate way to use it is to keep the balance moving until the pointer swings an equal number of spaces in both directions.

sepia tones on such papers, they must be produced by toning. Warm-toned papers, such as Kodak Ektalure, produce fairly warm-black tones even with ordinary paper developers and, with some developer formulas to be given later in this lesson, can produce browns, olive, and sepia tones quite comparable to those secured by toning. All of these developers must be prepared from bulk chemicals by the user; none is available in ready-mixed form.

As with negative developers, nearly all these formulas contain the same four or five ingredients, but in widely varying proportions and various overall dilutions. One or two formulas require such different developing agents as Amidol, Glycin, and Adurol (chlorhydroquinone). Before we discuss these formulas, let's first review the technique of mixing a developer.

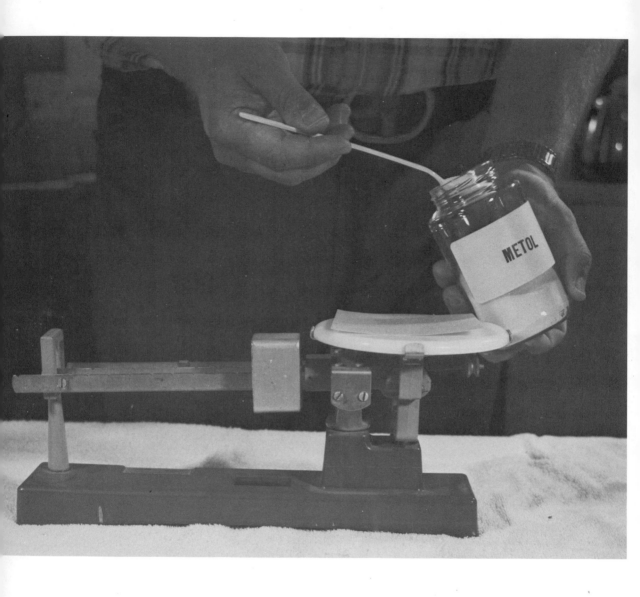

Paper is used on the scale pan and the weighing of the chemicals is done with a spoon in the same way as with the simpler scale.

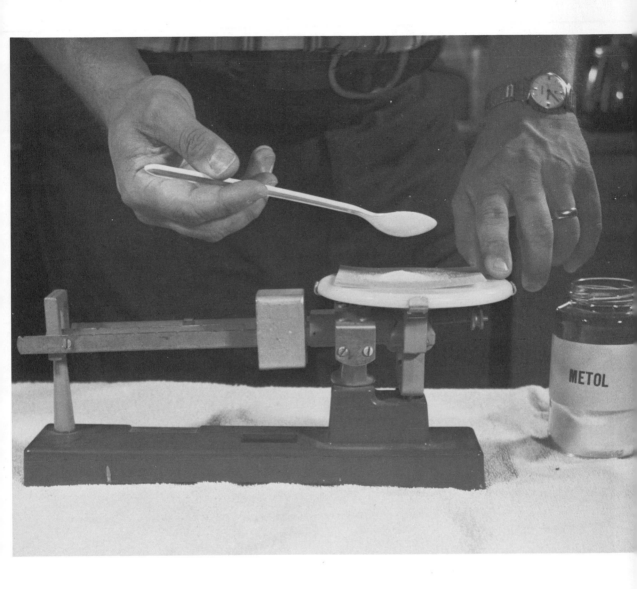

Since even high-quality scales have some bearing friction, one must tape the scale pan gently while adding small amounts of chemical to the pan.

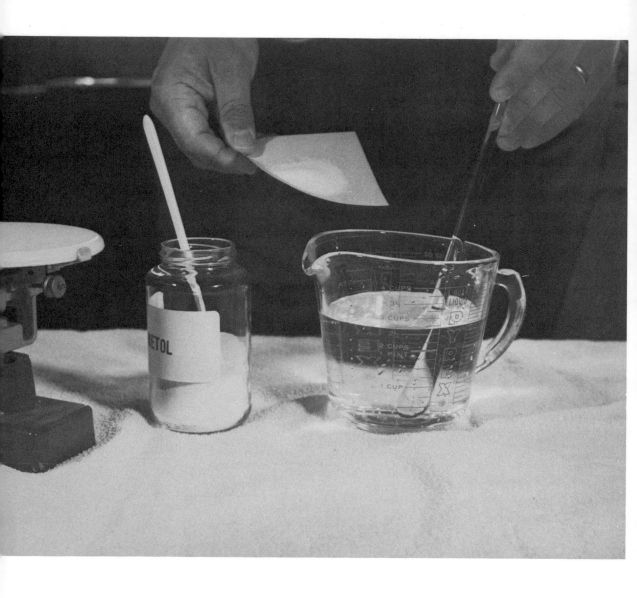

Pour the chemical into the water while stirring with the other hand.

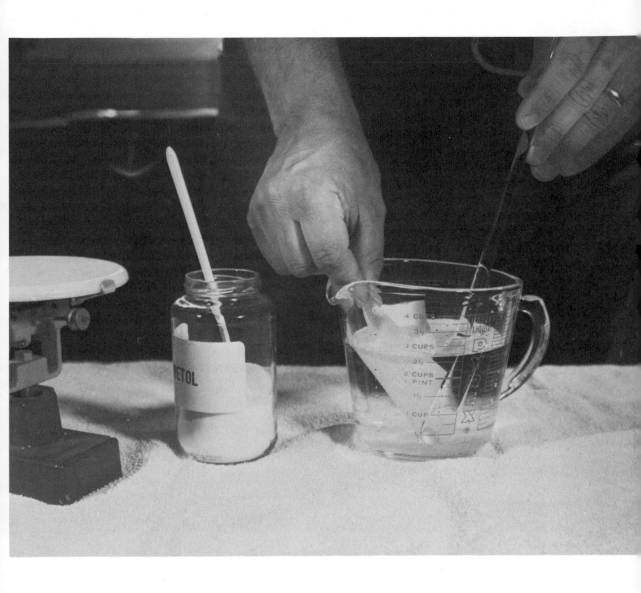

Rinse off the paper in the mixing vessel and discard the paper.

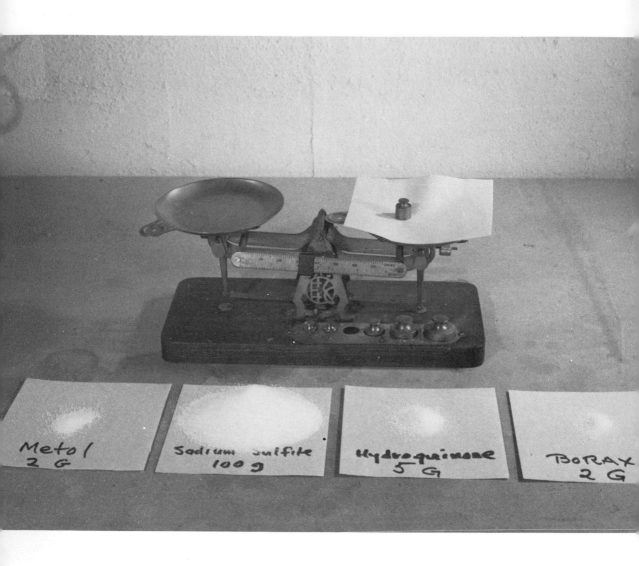

Metol
2 G

Sodium sulfite
100 g

Hydroquinone
5 G

BORAX
2 G

A recommended method of preparing formulas is to weigh out all the chemicals on marked papers before starting to dissolve any of them. This avoids the danger of omitting, or adding twice, a component which may happen if you are interrupted while working.

MIXING PAPER DEVELOPERS

A paper developer is mixed in exactly the same way as a film developer; that is, the developing agents are dissolved first, followed by the preservative, the alkali, and, finally, the restrainer. Because the chemicals take up some room in the solution, you begin with less than the full amount of water; and because chemicals dissolve more readily in warm water than in cold, you always begin with about ¾ the final volume of water at a temperature of about 52 C (125 F). Specifically, if mixing a litre of developer, begin with 750.0cc of warm water; if a quart, begin with 24 ounces; and for a gallon, begin with three quarts.

One important piece of advice, which is not at first obvious: *Never* try to memorize a formula nor to mix developers from memory. One slip can produce a disaster. The following procedure is recommended:

Since you always weigh out chemicals onto pieces of paper, not directly on the scale pans, the best method is to take as many pieces of paper as there are chemicals in the formula. Write the name and weight of each chemical on one of the pieces of paper. Then weigh out all the ingredients, each on its own marked piece of paper, before starting to dissolve them. This is particularly good when mixing a gallon of developer from a formula for a litre—you multiply each amount by four, write the figure on the paper, and double-check before starting to weigh chemicals. This way, there is less risk of accidentally including only one quarter the correct amount of a chemical.

Having weighed out all the chemicals, each on its own piece of paper, lay them out in a row, in the order of mixing (which is always the order given in the printed formula). You can see at a glance that you have all the chemicals needed for a given developer, and there is no danger of accidentally omitting one if you are interrupted while working.

Finally, as you begin dissolving the chemicals in the warm water, remember to start stirring before pouring in the chemicals, to continue stirring until all the materials are dissolved, and to rinse the pieces of paper in the solution to wash off the last traces of chemical. Discard each piece of paper in the wastebasket after rinsing, and make sure all the chemical is dissolved before adding the next ingredient. If you dump the chemical from the paper into the mixing vessel, it may form a hard cake, which is difficult to dissolve.

As a useful exercise, let's prepare a "Universal Paper Developer." This formula is known as Kodak Developer D-72 and is similar to, but not identical with Ansco Developer 125, DuPont Developer 53-D, Gevaert Developer G.251, and Ilford Developer ID-36, and packaged developers such as Kodak Dektol Developer.

Universal Paper Developer
(Kodak Developer D-72)

Warm water (52 C or 125 F)	750.0cc	24 ounces
Metol (Elon, Rhodol, Pictol, etc.)	3.0 grams	45 grains
Sodium sulfite, desiccated	45.0 grams	1½ ounces
Hydroquinone	12.0 grams	175 grains
Sodium carbonate, monohydrated	80.0 grams	2 ounces 290 grains
Potassium bromide	2.0 grams	30 grains
Add cold water to make	1.0 litre	32 ounces

This makes a stock solution, which is diluted, of one part stock solution to two parts water, for use with all ordinary enlarging papers; development time will be about one minute, just as with the Kodak Dektol Developer, which you used in the elementary part of this course.

Step-by-Step Procedure

To mix this formula, take five pieces of paper, weigh out the five ingredients, one on each piece of paper, marking the name of the ingredient and the amount on its respective paper.

1. Place in your mixing container 750.0cc (24 ounces) of water, mixing cold and warm water to get a temperature of 52 C (125 F). Use your thermometer; do not guess.

2. With your left hand, start stirring the water, and with your right hand, slowly pour the Metol into the water, continuing to stir until it is all dissolved. Dip the piece of paper on which the Metol was weighed into the solution and discard it in the wastebasket.

3. Continuing to stir, pick up the paper of sodium sulfite and slowly sift it into the solution; when it is all in the water, rinse and discard the paper as before. Continue stirring until the sodium sulfite is completely dissolved.

4. While still stirring, pick up the paper of hydroquinone, add this chemical to the solution, rinse and discard the paper. Continue stirring.

5. Do the same with the sodium carbonate. Be particularly careful to add it slowly and smoothly as sodium carbonate has a strong tendency to cake if poured into the water too fast. Rinse and discard the paper.

6. Now add the potassium bromide, and continue stirring until everything is dissolved and you have a clear solution. Rinse and discard the paper as usual.

7. Pour the mixed solution into a one-litre bottle (or a one-quart bottle if you have been working in avoirdupois measure). Add cold water to the bottle to fill it to the neck, cork tightly, invert a few times to mix the solution but do not shake vigorously. Label the bottle "Universal Paper Developer Stock Solution" and put it aside. Rinse out all utensils and put them away.

The above procedure assumes that you will be mixing one litre (or one quart) of solution.

If you need a gallon, though, mix it exactly the same way, but multiply all the quantities in the formula by four, and write only the new quantity on the pieces of paper. In metric measure, you will have five pieces of paper, marked, respectively, "Metol, 12.0 grams," "Sodium sulfite, 180.0 grams," "Hydroquinone, 48.0 grams," "Sodium carbonate, 320.0 grams," and "Potassium bromide, 8.0 grams." If you do this, and double-check against the formula before starting to weigh out the chemicals, then there is nearly no chance of making a mistake and forgetting to multiply one or more quantities by four.

There is another small point to remember, which we mentioned in earlier lessons. If you multiply by four, using metric quantities, you will end up with four litres of stock solution. Four litres is a little more than four quarts, and if you have only a gallon jug in which to keep the solution, you may do one of two things. The logical thing to do is to finish the mixing in your large plastic bucket, adding enough cold water to make four litres; then when you pour the solution into the jug, you will have four or five ounces of solution left over. You may discard this, or put it in a small bottle to be diluted and used for a few small prints. Alternatively, you may pour the mixed solution into the jug before adding the cold water, then fill the jug to the neck with cold water. You will have exactly a gallon of solution, slightly more concentrated than normal. The error is only about three per cent and will be quite unnoticeable in the use of the developer.

Developers can oxidize easily when allowed to stand in partially-full bottles that contain a great deal of air. This solution was reddish brown, with a marked blue fluorescence, and obviously incapable of developing. Storing a gallon of developer in several smaller bottles that are filled to the neck and tightly sealed will provide good solutions for several months.

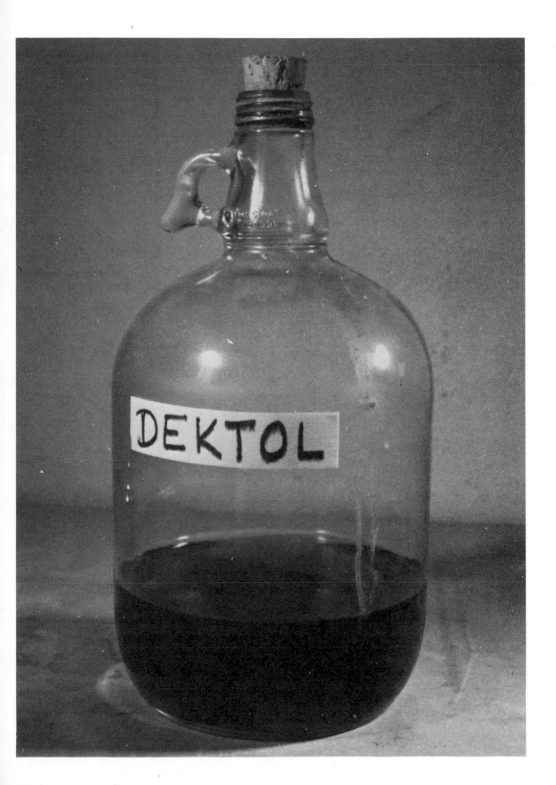

You now have a bottle of stock solution of a paper developer, which can be used exactly the same way you used the Kodak Dektol Developer solution in earlier lessons. By and large, if you buy your bulk chemicals in small quantities, you will find there is little or no monetary saving in mixing your own developers as compared with using the packaged variety, while the use of the latter definitely saves time.

The main reason, then, for mixing your own formulas from bulk chemicals is not to save money; it is to enable you to prepare a variety of special developers that you cannot buy in ready-to-use form. We will discuss some of these special developers in the following pages. You will, in all cases, mix them just as you did above—marking the quantities on the pieces of paper, weighing out all chemicals before mixing, and rinsing each piece of paper before discarding it. This being understood, we will not repeat the step-by-step mixing directions for each formula; the directions under each "mix chemicals in the order given" means that you follow these steps:

1. Weigh out all chemicals before starting to dissolve them.
2. Stir the solution steadily while adding chemicals slowly.
3. Be sure each chemical is dissolved before adding the next one.
4. Rinse the weighing paper in the solution to remove the last traces of chemical, and discard.

HOW PAPER DEVELOPERS WORK

We have already explained how a developer works on films. In sum, the "developing agent" reduces the silver bromide, which has been exposed to light, to metallic silver, forming the image. The other ingredients are: "preservative," which protects the developing agent from the oxygen of the air; "accelerator," which establishes the alkalinity of the bath for the desired speed or activity; and "restrainer," which prevents the reduction of *unexposed* silver bromide, thus acting as an antifoggant.

There is a major difference, however, between film and paper developers, and this difference is what makes the variety of paper developers useful as well as possible. With films, the specific developing agent used has little effect upon the quality of the final negative image; likewise, the old-time "bromide" papers, which were actually coated with slow film emulsions, were relatively unaffected by the composition of the developer.

But modern papers, coated with mixtures of silver bromide and silver chloride, are noticeably affected by changes of developing agent as well as by other alterations in the developer formula. This depends upon the proportion of silver bromide and silver chloride in any given paper coating. The fastest papers are mostly silver bromide; they produce cold to neutral-black tones in almost any developer, and for such emulsions, the Universal Paper Developer given above, or its packaged equivalents, is probably the best for securing normal results in the shortest possible time.

When the paper emulsion is high in silver chloride and low in silver bromide, it has a naturally warm tone, and this tone can be made even warmer by your choice of the developing agent and by other changes in the developer formula. Developing agents, even the usual Metol and hydroquinone, have a noticeable effect upon image tone—developers high in Metol tend to blue-black and neutral-black tones, whereas developers having a large proportion of hydroquinone produce brownish tones. The less common developing agents, such as Glycin and Adurol, produce even warmer tones in properly mixed formulas. On the other hand, the once-popular Amidol produces rich blue-black tones but only on papers that tend to neutral-blacks

anyway; papers high in silver chloride do not work well with Amidol and tend to greenish-blacks.

There are other influences upon print color besides the developing agent. The concentration of the developer is one such factor—strong developers produce neutral tones, highly diluted developers tend to warm-blacks and browns. The amount of restrainer in the formula also affects the tone; large amounts of potassium bromide produce warmer tones. If, for instance, you use more bromide than is needed merely to control fog, the action of the developer will become noticeably slower. And if, instead of extending the time of development, the print exposure is increased and development times remain short, you get colors ranging from brown to olive. This applies only to potassium bromide; the use of organic restrainers, such as Kodak Anti-Fog No. 2, slows the developer but does not warm the image tone noticeably, and, in some cases, actually shifts the image tone to blue-black.

These two effects are not independent; potassium bromide has considerable effect upon some developing agents, little or none on others. Developer formulas that are high in Metol, low in hydroquinone, will not produce very warm tones, even with a great deal of potassium bromide. Conversely, developers high in hydroquinone, combined with a large amount of potassium bromide, will produce very warm-brown tones on papers that are high in silver chloride. The faster papers, which are mostly silver bromide, are almost unaffected by all these variations.

CLASSES OF PAPER

Papers thus fall into three classes:

Class I: Fast papers, high in silver bromide. These produce cold-black to neutral-black tones and are almost un-affected by variations in the developer formula.

Class II: Medium-speed papers, about equal in bromide and chloride content. These produce warm-blacks in warm-toned developers, neutral-blacks in normal developers.

Class III: Slow papers, high in silver chloride. These produce warm-blacks in normal developers, and brown-blacks, browns, and olive tones in warm-toned developers.

Currently available papers in these classes are listed on the next page.

COLD-TONED DEVELOPERS

Most of the papers of Class I produce neutral-black tones; the exception is Kodak Velox Paper, which produces a definitely blue-black color with normal development. There are times when this very cold-black tone is appropriate to specific subject matter—commercial and theatrical photographers often prefer cold blue-black image tones. It is rather difficult to secure such tones on papers whose normal image color is rather warm, and a number of developers have been suggested for this purpose. They are all intended for contact-printing papers, earlier types of which tended to greenish-blacks. They may work on enlarging papers but will probably not have very much effect. The following formulas are given here mainly for trial; you can decide for yourself if they are of any use.

Cold-Toned Paper Developer
(DuPont Developer 54-D)

Warm water (52 C or 125 F)	750.0cc	24 ounces
Metol (Elon, Rhodol, Pictol)	2.7 grams	36 grains
Sodium sulfite, desiccated	40.0 grams	1 ounce 146 grains
Hydroquinone	10.6 grams	155 grains
Sodium carbonate, monohydrated	87.5 grams	2¾ ounces 75 grains
Potassium bromide	0.8 gram	12 grains
Add cold water to make	1.0 litre	32 ounces

This is a stock solution; for use, take one part of stock solution and two parts of water, and develop for about 1½ minutes at 20 C (68 F). Less exposure and longer development produce colder tones, but there is a danger of fog; if more bromide is added to prevent fog, it will make the tone warmer.

A much stronger developer is recommended by Gevaert for blue-black tones; it appears less concentrated on paper, but is intended to be used without dilution, thus it is really almost three times as strong as the formula above.

Cold-Toned Paper Developer
(Gevaert Developer G.252)

Warm water (52 C or 125 F)	750.0cc	24 ounces
Metol	2.5 grams	37½ grains
Sodium sulfite, desiccated	25.0 grams	365 grains
Hydroquinone	6.0 grams	88 grains
Sodium carbonate, monohydrated	45.0 grams	1½ ounces
Potassium bromide	0.5 gram	7½ grains
Add cold water to make	1.0 litre	32 ounces

Use full strength; develop papers for one minute at 20 C (68 F).

WARM-TONED DEVELOPERS

The papers of Classes II and III above will produce a wide variety of tones, ranging from neutral to slightly warm-blacks in a normal paper developer. Class II papers produce warm-blacks and brown-blacks in warm-toned developers, the results varying with the paper; as an example, Agfa Portriga Rapid is capable of yielding considerably warmer tones than, say, DuPont Varilour. In general, however, Class II papers are intended either for simple warm-black tones by direct development, or to produce browns and sepias by using various toning baths. These papers, if developed in a warm-toned developer, will also yield blue tones when toned with a gold toning bath.

There are many warm-toned developer formulas, and they produce a variety of tones. One very popular formula is the DuPont Developer 55-D, which is only a little warmer than a normal paper developer; it produces slightly brownish-blacks and, in some cases, even pure blacks. This latter tone is produced upon papers that have a tendency to be greenish with the Universal Paper Developer. For this reason, DuPont Developer 55-D was recommended for a number of early chlorobromide enlarging papers, but this reason for its use no longer exists. It is an excellent developer for prints that are to be sepia-toned in the various sulfide baths.

Warm-Black Paper Developer
(DuPont Developer 55-D)

Warm water (52 C or 125 F)	750.0cc	24 ounces
Metol (Elon, Rhodol, Pictol)	2.5 grams	36 grains
Sodium sulfite, anhydrous	37.5 grams	1¼ ounces
Hydroquinone	10.0 grams	146 grains
Sodium carbonate, monohydrated	45.0 grams	1½ ounces
Potassium bromide	5.0 grams	73 grains
Add cold water to make	1.0 litre	32 ounces

Paper Classifications

	Contact	*Enlarging*

Class I
Fast, cold-toned

Ilford CS Ilfoprint (stabilization)
Kodak Resisto (resin-coated)
Kodak Resisto Rapid Pan
 (resin-coated for printing
 color negatives)

Agfa Brovira
DuPont Velour Black
Ilford Ilfobrom
Ilford Ilfospeed (resin-coated)
Ilford LR Ilfoprint (stabilization)
Kodak Kodabrome II RC (resin-coated)
Kodak Kodabromide

Class II
Medium-speed, warm-toned

Kodak Azo

Agfa Portriga Rapid
DuPont Mural
DuPont Varilour
Kodak Ektamatic SC (stabilization)
Kodak Medalist
Kodak Mural
Kodak Panalure II RC (for printing
 color negatives)
Kodak Polycontrast
Kodak Polycontrast Rapid
Kodak Polycontrast Rapid II RC (resin-coated)

Class III
Slow, warm-toned

DuPont Emprex
Kodak Ektalure
Kodak Panalure Portrait (for printing
 color negatives)

This is a stock solution; for use, dilute one part of developer with two parts of water, and develop DuPont Varilour or DuPont Velour Black for one to two minutes at 20 C (68 F). The amount of potassium bromide in this formula may be increased to as much as 13.0 grams per litre (190 grains per quart) of stock solution. If additional exposure is given, prints still develop completely in about 1½ minutes, and somewhat warmer tones will be obtained.

For still warmer tones, there is a particularly popular formula, Kodak Developer D-52, which is similar to, but not identical with Ansco Developer 135, DuPont Developer 51-D, among others. The packaged Kodak Selectol Developer is also similar to this formula but is not exactly the same; it is, however, used in the same way.

Warm-Toned Paper Developer
(Kodak Developer D-52)

Warm water (52 C or 125 F) 750.0cc		24 ounces
Metol (Elon, Pictol, Rhodol)	1.5 grams	22 grains
Sodium sulfite, anhydrous	22.5 grams	¾ ounce
Hydroquinone	6.0 grams	90 grains
Sodium carbonate, monohydrated	17.0 grams	250 grains
Potassium bromide	1.5 grams	22 grains
Add cold water to make	1.0 litre	32 ounces

This is a stock solution; for use, dilute one part of developer solution with one part of water. Expose prints so they develop fully in about two minutes at 20 C (68 F). Additional exposure and shorter development times will produce somewhat warmer tones. Also the quantity of potassium bromide in this formula may be increased to double or even triple the listed amount; prints will then require even more exposure to develop fully in the normal time, and tones will be correspondingly warmer.

This formula is also good for processing Class III papers when further treatment, such as gold or selenium toning, is intended. With these latter papers, tones will be warm, approaching a brown, after development and before toning.

DIRECT BROWN DEVELOPERS

Where brown tones are desired in a single step, without toning or other after-treatment, there are a number of direct brown developers that will prove useful; the results depend to a large extent upon the particular paper you use. Do not assume that any Class III paper will respond to these formulas; on the other hand, Agfa Portriga Rapid, a Class II paper, responds well to one of the simplest direct brown developers, Ansco Developer 110. This developer utilizes only hydroquinone as a developing agent and is used, highly diluted, for development times up to seven minutes. The final image color depends upon the exposure given, the time of development, and, as mentioned, the type of paper used; some papers produce rich browns, others yield sepia and olive tones. No specific instruction can be given for the use of this developer; you simply have to try it on a few small (say, 4″ × 5″) prints, testing different exposures and development times, then fix, wash, and dry the tests to be sure of the final tone.

Direct Brown Developer
(Ansco Developer 110)

Warm water (52 C or 125 F)	750.0cc	24 ounces	
Hydroquinone	22.5 grams	¾ ounce	
Sodium sulfite, desiccated	57.0 grams	1¾ ounces	50 grains
Sodium carbonate, monohydrated	75.0 grams	2½ ounces	
Potassium bromide	2.75 grams	40 grains	
Add cold water to make	1.0 litre	32 ounces	

This is a stock solution; for use, dilute one part of developer with five parts of water. Give prints three to four times normal exposure, and develop five to seven minutes at 20 C (68 F). On some papers, this developer will produce, at this dilution, sepia tones closely resembling those produced by sulfide-toning an ordinary print. There is considerable control possible with this formula, and it should be possible, by a few tests, to arrive at a dilution and development time for any paper in Class III and some Class II papers as well.

Image tone in this developer is controlled by (a) dilution of the developer and (b) exposure and development times. Thus diluting the developer further, from 1:6 to as high as 1:8, and increasing exposure so as to maintain development time at five to seven minutes, will produce even warmer tones. The opposite— using a stronger developer, and developing for a shorter time, will produce less warm results, tending to deep-browns and brown-blacks.

The best way to test this formula for a variety of results is to mix a quantity of the stock solution. Then in a small tray, dilute about two ounces of stock solution with ten ounces of water, and try developing one or two 4″ × 5″ prints. Next dilute another two ounces of stock solution, this time with seven ounces of water, and again make one or two 4″ × 5″ prints. Other tests, at other dilutions, or with different development times, will suggest themselves. It is a good idea to write the developer dilution and development time on the back of the print with a soft pencil before developing it. After the prints are developed, fixed, washed, and dried, paste them into a notebook, first transferring the dilution and development time data to the notebook page, directly under the print. Such a notebook of sample prints will be very valuable later on if you wish to make prints of a certain definite color. Of course, if the tests are made on different types of paper, the names of the paper should also be entered in the notebook.

Many formulas similar to the above are offered by other manufacturers; they are all pretty much alike, differing usually only in dilution. One interesting variation is found in the Gevaert Developer G.262; here the alkali used is potassium carbonate instead of sodium carbonate. While ordinarily the alkali in a given developer has little or no influence upon its action, in this instance the higher alkalinity of potassium carbonate, as compared with sodium carbonate, allows greater dilution of the developer, producing even warmer tones without excessively long developing times.

Warm-Toned Paper Developer
(Gevaert Developer G.262)

Warm water (52 C or 125 F)	750.0cc	24 ounces
Sodium sulfite, desiccated	70.0 grams	2 ounces 145 grains
Hydroquinone	25.0 grams	365 grains
Potassium carbonate	90.0 grams	3 ounces
Potassium bromide	2.0 grams	30 grains
Add cold water to make	1.0 litre	32 ounces

This is a highly concentrated stock solution, intended for dilution at one part of stock to six parts of water. If exposure is adjusted to produce complete development in about six minutes, brown and even red tones may be produced depending upon the particular paper being used. The developer may be used stronger, diluting with as little as two parts of water to one of developer stock, and development time shortened to two minutes for rich-black and brown-black tones. Other tones, intermediate between the above extremes, can be produced by diluting accordingly—dark-browns, from, say, dilution with four parts of water and development for four minutes, and so on.

It pays to experiment a good deal with this developer, trying it at different dilutions, for different development times, with a variety of papers. The warmest tones will be produced upon papers of Class III, but some Class II papers may also react well to it. As recommended, keep a notebook on the trials and the results.

OTHER DEVELOPING AGENTS

Unlike films, which produce pretty much the same results regardless of the developing agents used, papers are noticeably affected by the choice of developing agent. Years ago a developer called Amidol was very popular for the production of rich purple-black tones on bromide papers. However, papers with a silver chloride content in the emulsion produced inferior tones with Amidol; it also had other disadvantages and is seldom used today.

Other agents, such as Glycin* and Adurol (the latter is also called chlor-hydroquinone), are still useful with modern papers; they produce tones ranging from rich-browns to sepias and even reds. The only difficulty with these compounds is getting them; few dealers stock them anymore. If you have a cooperative camera-shop proprietor who can get these chemicals for you, the following formulas will prove interesting.

Glycin Developers

Glycin produces pure black tones on papers of Class I, brown and sepia tones on papers of Classes II and III.

Glycin Developer

Warm water			
(52 C or 125 F)	750.0cc	24 ounces	
Sodium sulfite	100.0 grams	3 ounces	145 grains
Trisodium phosphate	125.0 grams	4 ounces	75 grains
Glycin	25.0 grams	365 grains	
Add cold water			
to make	1.0 litre	32 ounces	

Dilute one part of this stock solution with three parts of water, and develop for about two to three minutes. Longer development or greater dilution produce warmer tones.

Glycin may be used in combination with hydroquinone to produce very warm browns and even reddish tones.

Glycin-Hydroquinone Developer
(Ansco Developer 115)

Warm water (52 C or 125 F) 750.0cc		24 ounces
Sodium sulfite, desiccated	90.0 grams	3 ounces
Sodium carbonate,		
monohydrated	150.0 grams	5 ounces
Glycin	30.0 grams	1 ounce
Hydroquinone	9.5 grams	135 grains
Potassium bromide	4.0 grams	60 grains
Add cold water to make	1.0 litre	32 ounces

Note the order in which the ingredients are given; they *must* be mixed in this order, which is different from that usually given. The reason is that Glycin is difficult to dissolve except in an alkaline solution.

For warm tones, dilute one part of this stock solution with three parts of water, and develop for about three minutes at 20 C (68 F). For very warm tones on Agfa Portriga Rapid Paper, dilute one part of stock solution with six parts of water, increase exposure

*CAUTION: Do not ask for Glycin at the drugstore. Pharmacists have a medicinal known as Glycine (note the final "e"), also called Glycocoll; this is not the same as photographic Glycin and will not work in the formulas below.

three or four times normal, and develop from 2½ to five minutes. At this greater dilution, the solution will develop only a few prints and will need frequent replacement.

Another and quite different Glycin-Hydroquinone formula comes from Gevaert.

Glycin-Hydroquinone Developer
(Gevaert Developer G.261)

Warm water		
(52 C or 125 F)	750.0cc	24 ounces
Sodium sulfite,		
desiccated	40.0 grams	1 ounce 145 grains
Glycin	6.0 grams	88 grains
Hydroquinone	6.0 grams	88 grains
Sodium carbonate,		
monohydrated	35.0 grams	1 ounce 70 grains
Potassium bromide	2.0 grams	30 grains
Add cold water		
to make	1.0 litre	32 ounces

This solution may be used full strength or diluted. At full strength, it produces brown-black tones, developing two minutes at 20 C (68 F). Diluting one part of stock solution with two parts of water, and developing four to eight minutes, results in a brown tone. Diluting one part of stock solution with four parts of water, and developing 8 to 15 minutes produces red-brown tones. Diluting one part of stock solution with six parts of water, and developing 15 to 25 minutes results in red tones on some papers. If still warmer tones are desired, dilute 1:6 and add 10.0 grams (145 grains) of sodium bicarbonate (baking soda) to each litre (or quart) of the diluted developer. Development time will be very long; it may be a half hour or more.

Adurol (Chlor-hydroquinone) Developers

Adurol is considerably more active than hydroquinone and is less influenced by the addition of potassium bromide. Like the hydroquinone warm-toned developers, it gives warm tones ranging from brown-black through brown to sepia tones by varying the exposure of the paper and the dilution of the developer.

Chlor-hydroquinone Developer
(DuPont Developer 58-D)

Warm water		
(52 C or 125 F)	750.0cc	24 ounces
Sodium sulfite,		
desiccated	16.0 grams	232 grains
Chlor-hydroquinone		
(Adurol)	4.0 grams	58 grains
Sodium carbonate,		
monohydrated	18.7 grams	½ ounce 60 grains
Potassium bromide	0.5 gram	7½ grains
Add cold water		
to make	1.0 litre	32 ounces

Dissolve chemicals in the order given. Dilute one part of stock solution with one part of water; develop four minutes at 20 C (68 F) for warm-black tones.

At the same dilution, increased exposure and shorter development will produce somewhat warmer tones; if these prints are subsequently toned, they will yield warmer results than prints developed initially in DuPont Developer 55-D.

Contrast-Control Developers

We have already pointed out that the contrast of a print can be affected only very little by any variation in the way the paper is developed. The reason is this: With negatives, a soft negative is one that has tones ranging only from clear film to a light-gray, or from a middle-gray to black; with a print, however, you always want a complete scale of tones from white to black.

Thus since you have to secure the entire scale of the paper in any print, whether from soft or contrasty negatives, papers are almost always developed to the maximum possible contrast. You may have noticed this when you

first developed a print; the paper first started to darken rapidly, then came to an almost complete stop by the end of 1 to 1½ minutes. Evidently, the word "contrast," as applied to a paper, is really the exposure scale required to utilize the entire range of the paper emulsion, and this cannot be influenced to any great extent by the developer.

Any attempt to soften a print by shortening the development will merely result in grayish-blacks; also, since print development times are very short, shortening them much further will usually produce streaks and poor tones. Trying to do the opposite—to increase contrast by forcing development—accomplishes even less because the paper reaches its maximum contrast in the normal time and after that, not much more can happen.

Accepting this as a fact, you can see where there may be cases where you need only very small control over the contrast of a print; if the limits are understood, you can indeed produce some variation in print contrast by controlling development. This control is almost always on the soft side; it is not possible to *raise* the contrast of most papers by any manipulation—neither by increasing the time of development nor by using a stronger developer.

But if some loss of maximum black is acceptable, as it often is in portraiture, then some control is possible. This will seldom exceed the difference between two adjacent grades of paper. Thus given a No. 2, or normal paper, you can soften it, perhaps to the equivalent of a No. 1 paper, but you cannot increase it to equal a No. 3 grade.

If this small amount of control is sufficient, there is at least one commercial paper developer that will reduce contrast to some extent on certain papers—Kodak Selectol-Soft Developer. Instructions for use are found on the package and will not be repeated here.

If you mix your own chemicals, there is at least one interesting formula; it is similar to Kodak Selectol-Soft Developer, but is not the same thing. The formula is known variously as Ansco Developer 120 or Gevaert Developer G.253; these appear different in the published versions, but when diluted as recommended, they are similar. The interesting feature of these developers is that although they contain only Metol as developing agent, they produce a moderately warm image tone and a small but useful reduction in print contrast. This makes them particularly useful for developing portrait prints.

Soft Portrait Developers
(Gevaert Developer G.253)

Warm water		
(52 C or 125 F)	750.0cc	24 ounces
Metol	3.0 grams	45 grains
Sodium sulfite,		
desiccated	20.0 grams	292 grains
Sodium carbonate,		
monohydrated	23.0 grams	¾ ounce
Potassium bromide	1.0 gram	15 grains
Add cold water		
to make	1.0 litre	32 ounces

(Ansco Developer 120)

Warm water		
(52 C or 125 F)	750.0cc	24 ounces
Metol	12.3 grams	¼ ounce 70 grains
Sodium sulfite,		
desiccated	36.0 grams	1 ounce 88 grains
Sodium carbonate,		
monohydrated	36.0 grams	1 ounce 88 grains
Potassium bromide	1.8 grams	27 grains
Add cold water		
to make	1.0 litre	32 ounces

This solution may be used full strength or diluted with one part of water for slower development. Warmer tones may be obtained by increasing the amount of potassium bromide. Develop prints for one to three minutes at 20 C (68 F).

Many years ago, Kodak published a formula known as Kodak Developer D-64, which was, in fact, two developers, one soft, the other contrasty. By mixing the two developers in different proportions, it was supposed to be possible to secure four or more degrees of contrast with the same paper. This, however, was intended only for the true bromide-type enlarging paper, which was generally made in only one contrast grade, and which was, to some extent, susceptible to some variation in contrast in development. When the newer chlorobromide papers were introduced, and bromide papers became obsolete, the formula was withdrawn by Kodak; they stated that it would produce little or no useful variation in contrast with the newer types of papers. It is probable that even with the old bromide papers, the amount of contrast variation possible was scarcely more than the difference between two adjacent grades of modern papers.

Another variable-contrast paper developer has been recommended by certain eminent photographic teachers; this formula was first proposed by Dr. Roland F. Beers. It is possible that some small degree of control can be attained with it, especially with negatives having a longer-than-normal scale of tones and thus requiring reduction of the maximum black. Both the Kodak Developer D-64 and the Dr. Beers Variable-Contrast Developer formulas are hardly more than curiosities, and the composition of these developers will not be given here; those who wish to experiment with them can find the formulas in the literature.*

FIXING PAPERS

Usually papers are fixed in the same fixing baths as films. (But *never* fix papers in a bath that has already been used for films; stains may result.) The Kodak Fixing Bath F-5, or the packaged Kodak Fixer, are equally good for this purpose and should be used full strength if points are to be toned or dried on heated dryers. This is to secure maximum hardening of the gelatin coating of the paper.

These full-strength fixers are likely to be too strong for some types of paper, especially the warm-toned variety, where some bleaching of the image may occur. This effect is particularly noticeable with the very warm-toned papers of Class III; first it affects the finest grains of the emulsion, which are responsible for the warmth of tone. Therefore, overfixing of these papers, or use of too strong a fixer, may result in both a slight loss of density and a somewhat colder tone in the print.

The easiest way to avoid this problem is to dilute the Kodak Fixing Bath F-5 with an equal quantity of water for use with warm-toned papers. Remember that at this dilution there is only half as much hypo in the fixer, so it must not be overworked; its capacity is about forty 8″ × 10″ prints as against 80 prints for the full-strength fixer in each gallon of working bath.

An alternative method of avoiding bleaching is to use a plain 20% hypo bath, with the addition of sodium bisulfite to acidify it sufficiently to avoid stains. This acidity is not very high, and such baths would be neutralized rapidly unless a stop bath (3% acetic acid)

*Wall, Jordan, and Carroll, *Photographic Facts and Formulas* (4th ed.; Garden City, N.Y.: Amphoto, 1975).

were used between development and fixing. This is the same stop bath recommended in the earlier lessons in this course.

Nonhardening Fixer

Warm water (52 C or 125 F)	750.0cc	24 ounces
Sodium thiosulfate (hypo)	200.0 grams	6½ ounces
Sodium bisulfite	25.0 grams	365 grains
Add cold water to make	1.0 litre	32 ounces

Dissolve the hypo in the warm water, then allow the solution to cool to about 28 C (80 F) before adding the sodium bisulfite. When the chemicals are completely dissolved, add the cold water to make the final quantity.

One further caution: Avoid using the so-called "rapid fixing baths" for prints. These baths contain ammonium salts and can severely bleach the silver image of the paper emulsion unless fixing times are kept to the minimum; there is also danger of staining and fog. Paper emulsions fix very rapidly; there is rarely any advantage to the use of a rapid fixer.

Two-Bath Fixing

The thin, fine-grained emulsion of a print paper is fixed very rapidly; in a fresh hypo bath, it takes no more than a minute or two for complete fixing. However, in a fixing bath that is approaching exhaustion, fixing will not be complete in any length of time.

The way it works is this: in dissolving out the unexposed silver halides, the fixing bath first converts them to complex silver-sodium-thiosulfate compounds. These are not soluble in water but will dissolve in fresh hypo; in practice, their removal takes place at the same time as their formation in a fresh fixing bath. However, when a certain concentration of these complexes exists in the fixing bath, the bath becomes saturated with them and will not dissolve any more of them from the paper emulsion. If the print is washed at this stage, it will still contain large quantities of silver and thiosulfate salts, which are not soluble in water and are not removed by the washing. It is this retained silver salt which is responsible for eventual staining on prints kept for a long time.

However, if the print is not allowed to stay in the partly exhausted hypo bath for too long, the silver-sodium-thiosulfate complex is still soluble in *fresh* hypo; this is the basis of the two-bath system of fixing.

For this method, you need four trays—developer, stop bath, first fixing bath and second fixing bath (both fixing trays contain F-5 or similar fixers). The first bath removes most of the silver halides; the second bath will accumulate little silver and can easily dispose of what is left in the paper plus the difficult-to-dissolve complexes. The two baths are good for as many as two hundred 8″ × 10″ prints for a gallon of each; when that many prints have been fixed, discard the first bath, transfer the second bath to the first tray, and mix a new second bath. The combination is again good for 200 prints. You may repeat this procedure for three additional changes, after which both baths must be discarded and the process started up again with two fresh baths. If fewer prints are being made, you should discard both baths at the end of a week, even if they have not run the full five cycles.

Allow prints to remain in each fixing bath for two minutes, then transfer them to the wash; do not allow them to soak in the second fixer. If they cannot be washed immediately, transfer them to a *holding bath* of plain water, where they may remain until they can be washed.

WASHING

Washing prints is more difficult than washing

negatives because the paper fibers tend to hold the hypo and silver complexes quite tenaciously. Prints on double-weight papers may require up to three hours of washing if real permanency is desired; excessively cold water extends the washing time still more.

Washing time can be shortened appreciably by using a bath such as Kodak Hypo Clearing Agent. Prints go from hypo to the clearing agent bath without rinsing; they remain in this bath for one to two minutes and are then washed as usual. With this treatment, washing time for double-weight prints is reduced to about 30 minutes.

With RC (Resin-Coated) papers, the situation is quite different; because the paper base is practically waterproof, it absorbs no hypo, and only the emulsion needs to be washed. This takes only a few minutes. Five minutes of washing is ample for most RC papers, and even less time is recommended for such materials as Ilford Ilfospeed.

STABILIZATION PROCESSING

We will not give much space to stabilization processing for several reasons; one of the most important is that since some RC papers, notably Ilford Ilfospeed, can produce a fixed and thoroughly washed print in less than five minutes, there is no longer any real advantage to stabilization processing.

In short, stabilization consists in developing a print, then treating it in a bath that does not remove the unexposed silver halide but merely converts it into a form that is not light-sensitive. To speed up the process still further, the paper used for this process carries the developing agents in the emulsion; thus only an alkaline activator and the stabilizer bath are needed. Stabilized prints may last for six months or so under the best storage conditions, but they sometimes stain and turn

brown much sooner. They are used mainly for newspaper work, where they are needed only long enough for engravings to be made, after which they are discarded.

Because the stabilizer is a thiosulfate, stabilized prints must not be dried on any dryer that is also used for regular prints because the chemicals in the stabilized prints will seriously contaminate the machine; likewise, stabilized prints must not be filed in folders along with regular prints as they will cause the latter to stain and fade.

If a stabilized print is to be filed for permanent record, you can make it permanent by the following procedure. (It is important not to wash the stabilized print before this treatment; serious damage will result if this is done.) Take the stabilized print and immerse it directly in a regular fixing bath—Kodak Fixing Bath F-5 or a solution made from the packaged Kodak Fixer. Allow the print to remain in this bath for five to ten minutes, with gentle agitation. After this fixing, wash the print for at least 30 minutes, then dry as usual.

Do not use this trayful of fixer for any other purpose after stabilized prints have been treated in it; discard it as soon as you are through with it.

TONING

Image tones available by direct development on most papers are limited to a few shades of black and brown. If a wider range of tones is desired, it can be secured by using a toning bath after processing. These baths either change the silver image to one of silver sulfide, or they substitute another metal for the silver. Sulfide toning produces a range of brown and sepia tones. Metal toning produces a wider variety of colors, depending upon the metal in question: gold toners produce blues, reds, and browns; iron toners produce blues,

or, in combination with a sulfide treatment, greens.

The type of paper used has considerable influence upon the color of the final image too. For instance, a gold toner applied directly to a print made on a Class I paper will have nearly no effect; the same toner applied to a very warm-toned print made on a Class III paper will produce a bright blue color. If the image were first toned in a sulfide bath, then the same gold toner would produce not a blue, but a red tone. There are, however, other gold toners, such as the well-known Nelson Formula, which yield brown and sepia tones directly, without preliminary sulfide treatment.

Sulfide toners usually proceed rapidly to a final, definite image color that is more or less constant for a given type of paper. On the other hand, gold toners, such as the Nelson Formula, have a progressive action and produce a succession of colors in a given order. In such a case, you can attain the tone desired by control of the time of treatment in the toning bath.

Sulfide Toning

Most toning is done in sulfide-type toners since they are simplest, and the brown tones produced are considered very pleasing. Several methods are used: hypo-alum toning, which is done in a heated bath; the bleach-and-redevelop toner, which is a two-stage process worked cold; and the so-called direct toner, which utilizes a polysulfide bath that may be worked hot or cold.

The hypo-alum toner has one advantage: since it contains hypo, there is no need to wash the prints before toning; a short rinse between fixing and toning is all that is necessary. Full washing *after toning* is, of course, required.

Bleach-and-redevelop toning consists in first converting the silver image to silver bromide in a bath containing potassium bromide and potassium ferricyanide. The bleached image is then treated in a sulfide bath, which converts it into silver sulfide. Resultant tones may vary from yellow-brown through sepia to deep, rich-browns, depending upon the type of paper used; the best one, a deep-brown, is produced on cold-toned papers of Class I, such as Kodak Kodabromide, DuPont Velour Black, and so on. The most important thing to remember about this process is that prints must be well washed before bleaching; the silver bromide produced by the bleach is soluble in hypo, and any traces of hypo left in the print will cause partial or total loss of image density.

The third method employs a polysulfide salt that is applied directly to the print without bleaching. The print must be washed thoroughly before toning, otherwise stains will occur. This method works best on papers of Classes II and III; it has little effect on most cold-toned papers.

Gold Toning

Gold toning is used mainly as a modifier of tones produced by sulfide toners; it produces richer, redder browns than sulfide toning alone. Gold tones applied directly to a warm-toned print that has not been sulfide-toned produces a rich-blue color, which is sometimes desirable for water scenes, winter landscapes, night scenes, and the like. Gold toners applied directly to a cold-toned print, such as one made on Kodak Kodabromide or DuPont Velour Black papers, have little or no effect; they work best on warm-toned prints made on Class III papers, and the warmer the original print, the richer the blue tone will be. The maximum effect is attained by using a warm-toned paper and developing it in a very warm-toned developer, such as one containing Glycin or Adurol.

Selenium Toning

One other toning method is currently popular; this is toning with selenium. Selenium toners are almost always purchased in ready-to-use form (Kodak Rapid Selenium Toner, GAF Flemish Toner, and others). Although formulas are available* by which you can prepare your own selenium toners, they all involve the handling of selenium in powdered metal form. *This is dangerous* as selenium metal is highly poisonous. The toning bath is actually a sodium seleno-sulfide, or a selenium sulfide, depending upon how it is prepared. The toned image is a complex silver seleno-sulfide. The image is deep-brown and very permanent.

Selenium toners work best on papers having naturally warm tones; they produce little change of color on cold-toned prints. The change in tone is progressive; it can be watched while toning, and the treatment stopped when a desired color is reached. Selenium toning is used on cold-toned prints to eliminate a slightly greenish tone sometimes found on these papers. Toning is done for a very short time, and no change of image color results other than a neutralization of the greenish color. The slightly toned images are also more permanent.

Hypo-Alum Toning

The only inconvenience connected with the use of the hypo-alum toner is having to heat the bath; it works at a temperature of 49 C (120 F). On the other hand, there are several advantages: prints need no washing before toning; a short rinse after fixing is all that is needed. The hypo-alum toner is probably the only photographic solution that actually improves with age and use; it is not necessary to replenish it; merely add a little water now and then to make up for the amount lost by evaporation. Even though the solution gets rather muddy with use, it should not be filtered or decanted; just stir it up, and if any of the sludge deposits on the print that is being toned, just wipe it off with a soft sponge.

The hypo-alum toner is especially good on warm-toned papers, which tend to produce yellowish-brown tones with the usual bleach-and-redevelop type of toner. Depending upon the type of paper, hypo-alum toning produces colors ranging from a rich sepia through various deep-browns to a purplish-brown reminiscent of the old-time gold-toned printing-out papers. The exact tone with any given paper will vary with the time of treatment; keep a record of the time of toning for the first few tests so that you can repeat a given effect at a later date.

Hypo-Alum Toner
(Kodak Toner T-1a)

This bath must be mixed in a series of steps. Begin by mixing a plain hypo solution, as follows:

Cold water	2800.0cc	90 ounces
Hypo (sodium thiosulfate)	480.0 grams	16 ounces

Dissolve the hypo completely. In a separate container, mix the following:

Hot water		
(about 70 C or 160 F)	640.0cc	20 ounces
Potassium alum	120.0 grams	4 ounces

Add this solution to the thoroughly dissolved hypo solution. Now prepare the following in a small cup:

Cold water	64.0cc	2 ounces
Silver nitrate, crystals	4.2 grams	60 grains
Sodium chloride (table salt)	4.2 grams	60 grains
(table salt)	4.2 grams	60 grains

*Wall, Jordan, and Carroll, *Photographic Facts and Formulas* (4th ed.; Garden City, N.Y.: Amphoto, 1975).

239

When the sodium chloride is added to the silver nitrate, a thick, heavy white cloud of silver chloride will be precipitated; do not filter this off, but add the entire mixture, including the precipitate, slowly to the hypo bath, while stirring rapidly. The cloud of silver chloride will dissolve as it is added to the hypo-alum solution; some black material may be precipitated, but this does no harm whatever, and it should be left in the bath. After combining the above solutions, and stirring well, add enough water to make four litres, or one gallon.

For use, pour the solution, or as much of it as you need, into a glass, stainless steel, or enameled tray; plastic may not be able to stand the heating. Put the tray into a larger tray of hot water, and heat the whole setup until the temperature of the toner is 49 C (120 F).

Prints to be toned should have been exposed and developed a little darker than normal, as the toner bleaches the print slightly. If prints have been previously washed and dried, first soak them in cold water until limp. Prints that have just been made merely need a rinse in water before toning.

Toning Procedure

1. With the toner at the right temperature (49 C or 120 F), immerse the prints one at a time; shuffle them around, making sure they are separated a few times, to allow the toner to get to the entire surface of the print.

2. Continue toning until the desired tone is reached; the print will go through brown-black, brown, warm-brown to sepia tones. In any case, toning is complete in 20 minutes at 49 C (120 F) and should not be carried any further. Excessively long toning times, or excessively high temperatures, may cause blisters and stains.

3. When toning is complete, wipe the prints carefully with a soft sponge to remove any sediment that may have deposited on the surface. Then place them in a tray of cold water for a few minutes to cool down.

4. Finally wash the prints in cold running water (or in a number of changes of water, as for normal prints). In running water, washing will take as much as an hour for double-weight papers.

Polysulfide Toning

The polysulfide toner produces dark-brown tones on warm-toned papers (Classes II and III); it will not work to any extent upon cold-toned papers, such as Kodak Kodabromide, DuPont Velour Black, and similar types. The tones produced are darker than those produced by the bleach-and-redevelop type of toner. Its advantage over the hypo-alum toner is that it does not need heating, although it *can* be heated if desired. At 38 C (100 F), the time of toning in the polysulfide toner is only three minutes. Mixing is straightforward.

Water, cold or warm	750.0cc	24 ounces
Liver of Sulfur (crude potassium sulfide or potassium polysulfide)	7.5 grams	¼ ounce
Sodium carbonate, monohydrated	2.4 grams	35 grains
Add cold water to make	1.0 litre	32 ounces

Toning Procedure

Dissolve chemicals in the order given.

1. Prints must be well washed before toning.

2. Immerse the well-washed prints in the toning bath and tone for 15 to 20 minutes at 20 C (68 F). If desired, the bath may be heated to 38 C (100 F). In this case, time of toning is three minutes.

3. If any sediment settles upon the surface of the print, wipe it with a soft sponge.

4. Wash the print for at least 30 minutes for single-weight papers, and up to an hour for double-weight. Dry as usual.

The approximate life of this bath is about 150 prints—8″ × 10″ size—per gallon. If the bath becomes cloudy, add another portion of sodium carbonate (that is, 2.4 grams per litre of toning bath or 35 grains per quart). Discard the bath when it has toned 150 prints per gallon, whether or not it has been revived with the sodium carbonate.

Bleach-and-Redevelop Toning

The only way a good sepia tone can be obtained on cold-toned papers, such as Agfa Brovira, Kodabromide, and DuPont Velour Black, is by the bleach-and-redevelop method. A typical toner of this sort is the Kodak formula T-7a, given below. An auxiliary hardener is needed with this process because the sulfide bath has a strong softening action upon the gelatin of the print.

Bleach Stock Solution
(Kodak Toner T-7a)

Warm water		
(52 C or 125 F)	750.0cc	24 ounces
Potassium ferricyanide	37.5 grams	1¼ ounces
Potassium bromide	37.5 grams	1¼ ounces
Potassium oxalate	97.5 grams	3¼ ounces
Acetic acid (28%*)	20.0cc	5 fluid drams
Add cold water to make	1.0 litre	32 ounces

*To make 28% acetic acid, dilute three parts of acetic acid, glacial, 99% with eight parts of water.

Toner Stock Solution

Sodium sulfide (not sulfite),		
desiccated	90.0 grams	3 ounces
Cold water to make	1.0 litre	32 ounces

This toner must be used in plastic or glass trays; if enameled trays are used, they must not have any chips or bare metal spots, otherwise blue stains may occur.

Toning Procedure

1. Prepare the working bleach by diluting one part of the bleach stock solution with one part of water. Put this in tray No. 1.

2. Prepare the working toner by diluting one part of toner stock solution with seven parts of water. Put this in tray No. 2.

3. The print to be toned should first be washed thoroughly; if there is any doubt as to how well it was washed, rewash it for a full 30 minutes for single-weight paper, or an hour for double-weight.

4. Immerse the print in tray No. 1, the bleach bath, and allow it to remain until only faint traces of the image are left (a faint brown image composed of developer stain usually remains after bleaching). This should take only about one minute.

5. Wash the bleached print to remove all traces of the yellow color of the bleach.

6. Redevelop the print in tray No. 2, which contains the diluted toner bath. Full detail will return in 30 seconds.

7. Rinse the print in water for a minute or two, then harden in the following hardener bath.

Hardener Bath
(Kodak Hardener F-1a)

Warm water		
(52 C or 125 F)	500.0cc	16 ounces
Sodium sulfite,		
desiccated	60.0 grams	2 ounces
Acetic acid		
(28%*)	190.0cc	6 fluid ounces
Potassium alum	60.0 grams	2 ounces
Add cold water		
to make	1.0 litre	32 ounces

*To make 28% acetic acid from acetic acid, glacial, 99%, dilute three parts of glacial acetic acid with eight parts of water.

Mix the above solution in the order given, and be sure that each chemical is fully dissolved before adding the next.

Allow the toned print to remain in the hardener bath for 5 minutes, then wash for 30 minutes to an hour, depending upon the weight of the paper base.

The hardener will have no effect upon the density or color of the toned image; its only function is to toughen the gelatin coating of the paper so that it will not be damaged in washing and drying.

Gold Toning

A variety of gold toning formulas is available, each of which is used in different ways to secure tones that may be blue, red, or brown. The following formula is very similar to that recommended for many years by Adolf Fassbender; applied to a print on a warm-toned paper, it produces deep, rich-blue tones suitable for night scenes, snow scenes, seascapes, and others.

Gold Toner
(Ilford Toner IT-5)

Stock Solution A

| Thiocarbamide | 14.0 grams | 225 grains |
| Cold water to make | 1.0 litre | 32 ounces |

Stock Solution B

| Citric acid crystals | 14.0 grams | 225 grains |
| Cold water to make | 1.0 litre | 32 ounces |

Stock Solution C

| Gold chloride | 6.0 grams | 88 grains |
| Cold water to make | 1.0 litre | 32 ounces |

For use, take one part Solution A, one part Solution B, one part Solution C, and add ten parts of water.

Toning Procedure

1. Place the well-washed print in the mixed toner and agitate gently until the desired tone is reached. Warm-toned prints will tone in about five minutes, producing rich-blue tones.

2. When toning is complete, wash the print for about 30 minutes, and dry as usual.

3. Blue-toned prints on glossy papers can be ferrotyped if a very high gloss is desired.

According to Ilford, this toner will work on plain enlarging papers such as Ilfobrom, but toning may take from 15 to 30 minutes, depending upon the tone desired.

Direct gold toning can also produce rich reddish-browns or golden-browns on prints made on warm-toned papers. The best known of the direct brown toners that use gold is the Nelson Formula (U.S. Patent 1,849,245). The patent is in the public domain, and free use may be made of the formula.

Nelson Gold Toner

Stock Solution A

Warm water (52 C or 125 F)	4.0 litres	1 gallon
Sodium thiosulfate (hypo)	960.0 grams	2 pounds
Potassium persulfate	120.0 grams	4 ounces

Dissolve the hypo completely before adding the potassium persulfate. The bath should turn milky when the latter is added; if it does not, heat it slightly until it does. Now prepare the following silver solution:

Cold water	64.0cc	2 ounces
Silver nitrate	5.2 grams	75 grains
Sodium chloride (table salt)	5.2 grams	75 grains

Be sure the silver nitrate is dissolved completely before adding the sodium chloride. A thick milky precipitate will form when the latter is added. Be sure the hypo solution is cool, then add the silver solution to it, milky precipitate and all. Stir thoroughly.

Stock Solution B

Warm water (52 C or 125 F)	250.0 cc	8 ounces
Gold chloride	1.0 gram	15 grains

To prepare the toner for use, take 125.0cc (4 ounces) of Solution B and add it to the entire volume of Solution A, which already has had the silver solution added. Allow the mixed solution to cool. A sediment will form and settle at the bottom of the bottle; carefully pour off the clear liquid for use and avoid stirring up the black sediment.

Place the clear solution in a tray which, in turn, is standing in a larger tray containing hot water. Heat to 43 C (110 F) maximum; working temperature may be between 38 and 43 C (100 and 110 F).

Toning Procedure

1. Be sure the print to be toned is well washed. If it is dry, soak it in water for about five minutes.

2. Immerse the print in the warm toning bath and agitate it while watching. The image will progress from black to brown to reddish-brown as toning proceeds; the time will vary from 5 to 20 minutes.

3. When the desired tone is reached, rinse the print in cold water. Prints may be allowed to accumulate in the water tray until all have been toned.

4. Refix prints in a regular fixing bath (Kodak Fixing Bath F-5, the packaged Kodak Fixer, or equivalent) for five minutes.

5. Wash for one hour, and dry as usual.

The above bath will tone about fifty 8″ × 10″ prints in the gallon of solution. At this point, add 4.0cc of the gold solution (Stock Solution B), which will revive the bath for another 50 prints. Gold solution may again be added for another batch of 50 prints, and this may be continued almost indefinitely. You may keep an additional stock of toner on hand and add it to the working bath to keep the volume up; some solution is lost when the toned prints are transferred from the bath, and if this loss is made good, the bath may be used almost indefinitely.

Two-Bath Gold Toning

A gold toner may also be applied to a print that has already been toned in a sulfide bath; the result is a variety of rich tones from brown to deep-red. The advantage of this method is that it can be applied to prints made on any kind of paper. If the original print was made on a warm-toned paper, then it may be toned in a direct sulfide toner, such as the hypo-alum or polysulfide formulas. If, on the other hand, the print was made on a cold-toned paper, it may be toned in the bleach-and-redevelop toner. The print may be gold-toned immediately after the sulfide treatment, or it may be dried after sulfiding and toned later. The gold-toning bath is a typical gold-thiocyanate solution, such as the following:

Gold Toner
(Ilford Toner IT-4)

Warm water (52 C or 125 F)	750.0cc	24 ounces
Ammonium thiocyanate	20.0 grams	292 grains
Gold chloride	1.0 gram	15 grains
Add cold water to make	1.0 litre	32 ounces

Toning Procedure

1. Tone the black-and-white print in the appropriate sulfide formula to produce a deep-brown or sepia tone.

2. Wash the print for five to ten minutes, then immerse in the above gold toner. In this bath, the print will change color from sepia to reddish-brown and finally to red. Time of ton-

ing to reach a red tone is about ten minutes, but this varies with different papers.

3. Prepare a 10% solution of hypo (dissolve 100.0 grams of sodium thiosulfate in a litre of water, or about 3¼ ounces of hypo in a quart of water).

4. After toning, refix the print in the 10% hypo solution for five to ten minutes.

5. Wash thoroughly for 30 minutes to an hour in running water, and dry as usual.

WASHING TONED PRINTS

The various toning baths recommend washing in running water for up to an hour. The method of washing in six to ten changes of water, recommended for prints in the earlier lessons in this course, is just as practical for toned prints and may be used to save water while providing adequate washing.

The Paterson major auto print washer is 12″ × 15″ and accommodates 12 large-size prints (8″ × 10″ to 12″ × 15″) or 24 smaller prints at one time. It thoroughly washes prints on both sides and eliminates the danger of the prints clumping together. A unique feature of this print washer is its automatic syphon-action drainer for when the wash is complete. The washer comes with hoses and tap adapter from Braun North America.

LESSON 9

Copying, Reversal, and High-Contrast Processing

COPYING

There are many occasions where a duplicate negative is required: either the original negative has been lost or damaged; or a negative of a different size is required, the original negative being available for duplication. Different methods are used for making new negatives, and these will be discussed separately.

Let's assume you have a print for which you do not have the negative, and you need a new negative to make further prints. It would appear that the obvious thing to do would be to set up your camera and photograph this print in the normal way, thus procuring a new negative in one step. While this *is* simple enough in principle, there are certain problems that prevent the results from ever being quite as good as the original negative. We will discuss these problems first, for a better understanding of the whole copying process, then we will outline several methods for securing the best possible results in given circumstances.

Although we are concerned with the darkroom aspects of copying, before we get into that area, we must point out a few things about the optics of copying.

It is generally believed that the average camera lens is fully corrected for all aberrations and should produce perfect results if the image is correctly focused and exposed. However, this is not the case. A camera lens is completely corrected only for a small range of subject-to-camera distances, and since most pictures are taken at fairly long distances, from, say, six feet to infinity, correction is generally carried out for such distances. In most cases, the lens will perform fairly well at shorter distances too, but there is likely to be some curvature of field at extremely close ranges. This means that if the center of the image is sharply focused, the edges may be somewhat out of focus.

The remedy, of course, is to stop the lens down to a relatively small aperture. But then you run into another problem: Lenses generally do not resolve fine detail well at very small openings. This latter problem ordinarily is not annoying at apertures around $f/11$ to

$f/16$, so try to shoot copy negatives at these openings.

Try to focus at the aperture you intend to use; if you focus wide open and then stop down, some residual aberrations, mainly traces of spherical aberration, may cause the focus to shift. Luckily, copying is usually done with pretty bright lights, and it is easy to see the image well enough to focus, even stopped down to $f/11$. When focusing the image, always check both the center and the edges of the image; if it is difficult to secure overall focus from center to edges, even at small apertures, then try to split the difference by focusing at a point about halfway from the center to the corner.

All this difficulty could be eliminated by using a lens that has been corrected specifically for close-up photography. Such a lens is called a *macro* lens, and if you do much copying, it pays to have one. A good substitute for a macro lens is a high-quality enlarger lens, preferably one designed for color printing; such a lens will have its corrections optimized for close ranges and will also have color correction equal to a good camera lens. Enlarger lenses do not come in focusing mounts, and they have to be used in a bellows attachment with 35mm cameras. On larger cameras, there is no problem at all.

COPYING SETUPS

For an occasional copy, all you have to do is set the camera on a tripod and tack the original to a wall. Place a lamp to each side of the copy so that the light falls from about 45 degrees, then photograph the original. The exact angle of the light is not critical and may have to be varied for very large originals. The biggest problem with this entire arrangement is to ensure that the camera is parallel to the picture being copied; if it isn't, not only will the image be distorted for shape, but one end or the other will be out of focus.

For more frequent copy-making, a vertical stand is better; such stands are inexpensive and consist of nothing but the column and baseboard of an enlarger. The easiest way to set up such a stand is to obtain a small spirit level. Then begin by making sure the baseboard of the stand is level, raising a corner or an end with a small block, if necessary, until the level shows that the base is level, both side to side and front to back. Now place the level on the back of the camera (or in the film channel, if your camera does not have a flat back) and make sure that the camera is level side to side also (front-to-back level will usually be set once and for all by the construction of the camera carrying arm).

This done, now drop a plumb bob from the center of the lens to locate the center of the field; this will only be necessary if you are using a rangefinder-type camera. With a SLR, you simply locate the copy in the viewfinder.

The lights should be at approximately a 45-degree angle to the center of the copyboard. But this may need adjusting if there are any unwanted reflections or hot spots in the image.

This simple copying setup uses two lights placed at 45 degree angles to the subject and aimed at the exact center. The camera is carefully lined up parallel to the picture frame by checking in the groundglass.

249

Use a spirit level to be sure copy and camera are exactly parallel. Level the copyboard first and then transfer the spirit level to the camera and adjust it's alignment to be exactly level also. Two spirit levels can make this task a little quicker to do.

The two lamps require exactly set angles and distance in relation to the copy print. A simple test is to stand a pencil upright on the copy board and adjust the lamps until the shadows are equal in length and point in exactly opposite directions.

Determining the exposure is much the same as for any other type of photography; if your camera has a built-in meter, it works just as well for copying as for anything else, though an adjustment may have to be made for very light or very dark originals. For instance, copies of thin line drawings on white paper may require up to five times the exposure indicated by the meter. In such a case, it may be well to substitute an 18% Gray Card for the copy and take an exposure reading on it.

If your camera does not have a built-in meter, you may use any ordinary exposure meter to determine the exposure. In this case, you will not only have to compensate for the type of copy by using a gray card, but you will also have to allow for lens extension, which can require as much as four times the indicated exposure for a same-size (1:1) copy. An exposure-compensation calculator for lens extension and a gray card can both be found in the *Kodak Master Photoguide*, available from your dealer or from Amphoto, 750 Zeckendorf Blvd., Garden City, N.Y. 11530.

PHOTOGRAPHIC PROBLEMS IN COPYING

If you have made the proper setup, and have copied an ordinary photograph on one of the usual black-and-white films, such as Kodak Plus-X Panchromatic Film or Kodak Tri-X Panchromatic Film, you may be somewhat disappointed with the results when you make a print from the copy negative. The new negative will be too contrasty with blocked-up highlights; attempts to print them by dodging and burning-in merely produce a foggy, gray tone over the whites, but no significant detail. This effect is typical of copy negatives, and the fault is not in the copy negative, but in the original print being copied.

The problem is that when a print is made for viewing, it has highlights that are virtually the color of the enlarging paper; the detail in these highlights is very faint and of low contrast. So when such a print is copied, the contrast in the highlights is much less than in the middletones, and the result is the flat, washed-out highlight areas.

If you have the original negative and are making a copy for some other reason, then the logical thing to do is to prepare a print especially for copying. This print should be made much darker than a print intended for viewing only, and there should be a definite gray tone over the highest highlights. If you do this, though, the shadows may end up an inky black, which would cause trouble in making a copy negative if shadow detail is required.

Thus for the best possible copy, the print should be made both darker *and* softer than normal. Use a glossy paper to avoid problems with surface texture, and the paper grade should be the softest available. Make the print so that the deepest shadow is a dark-gray, not black, and the highest light is a medium-gray tone. The print will look too flat and too dark, but the copy negative from it will be better in quality than one from a normal print; the slight lack of contrast is easily made up in developing the copy negative, or in making the final prints, or both.

KODAK PROFESSIONAL COPY SHEET FILM 4125

Unfortunately, most of the time the original negative is not available, and a copy has to be made of whatever print is handy. A special film, Kodak Professional Copy Sheet Film 4125, is available for this purpose. Its main characteristic, as compared with ordinary films, is that it has higher-than-normal contrast in the highlight areas, while the middletones and shadows maintain normal or slightly soft gradation.

This material is a professional-type film and is available only in sheet-film form. To secure the best possible results with it requires the

use of a densitometer, and this is beyond the scope of this lesson. Nonetheless, even if it is handled like ordinary film, considerable improvement is possible as against attempting to copy on such emulsions as Kodak Ektapan Sheet Film 4162 and similar medium-speed films.

Kodak Professional Copy Sheet Film 4125 is a relatively slow film, having an ASA rating to tungsten light of 12. It is sensitive only to blue and green (*orthochromatic*) and could therefore be developed by the light of a red safelight; this is not really necessary, though, and development can be done in darkness, as with *panchromatic* films. If a safelight is used, it should have a Kodak Wratten Series No. 2 Safelight Filter (dark-red) with the usual 15-watt bulb, and should be kept at least four feet from the film at all times.

You may make a preliminary exposure test, using a regular exposure meter setting of 12. Do not forget to allow for the bellows-extension factor when copying closeups; an adjustment of two full stops additional is required for copying full size.

Develop the test negative for six minutes in a tray, or eight minutes in a tank, using Kodak Developer DK-50 diluted 1:1 with water. Kodak Polydol Developer is also satisfactory; development time will be 4¼ minutes in a tray, or 5½ minutes in a tank, always at 20 C (68 F).

The first test should produce a fairly contrasty negative, in which there is a definite gray tone over the shadows; there should be no clear film visible anywhere. The highest lights should be dark-gray, not black, and there should be detail visible in both highlight and shadow. If this is not the case, adjust the exposure accordingly: reduce exposure if the highlights are too dark or shadows a heavy gray; increase exposure if the shadows are nearly clear film. Do not make changes in development time, at least not in the beginning; make all adjustments in the exposure.

The resultant negative will be rather contrasty, and it will produce a good print on a No. 1 (soft) paper. This is necessary to secure best gradation in the highlights; if development is shortened to produce a softer negative, the highlight quality will suffer. Some small adjustment of development is possible but should be reserved for making corrections for variations in development technique only.

Copying Routine with Kodak Professional Copy Sheet Film 4125

The step-by-step procedure for copying a print with Kodak Professional Copy Sheet Film 4125 is as follows:

1. Set up and focus camera, with original photo evenly illuminated from both sides (45-degree lighting).

2. Take exposure reading; compensate for bellows extension (a two-stop increase for a 1:1 copy). Expose film.

3. Develop film in Kodak Developer DK-50, diluted 1:1, for six minutes in a tray with continuous agitation, or for eight minutes in a tank with the usual five-second agitation every minute (temperature 20 C or 68 F).

4. Fix, wash, and dry as usual. Negative should be rather contrasty, suitable for printing on a No. 1 (soft) grade of paper, but showing good detail in both highlights and shadows.

DUPLICATING NEGATIVES

Where the original negative is available, the situation is somewhat different. The major reason for making a duplicate is either to provide a larger or smaller negative than the original, or else to protect a valuable original by making a duplicate for routine printing. There are several ways to make a duplicate negative that will have nearly all the quality of an original.

Two principal methods exist for making a duplicate negative. With the first, you make a positive transparency on film and then print the duplicate negative from this transparency,

either by contact or by projection. The latter is usually the case where an enlarged negative is required. A second, and sometimes better, way is to make the duplicate negative directly from the original, in a single step, by using a film that produces a positive from a positive (or a negative from a negative). For the latter method, several special films are available, which can produce direct duplicate negatives without special processing. The film is made so that if *unexposed*, it will develop to a full black in an ordinary developer; exposed areas become lighter in development, and so on. When these special films are not available, it is possible to produce a negative from a negative by using an ordinary negative film (such as Kodak Panatomic-X Film) and processing it in a reversal procedure. This method is also useful for making direct-positive black-and-white transparencies, and is explained at length later in this lesson.

When making duplicate negatives by a two-step procedure, you will obtain best results if you remember that some loss of sharpness and increase in graininess always occurs in a contact-printing stage.

Note: It may not seem correct but it is; a contact print is actually less sharp than a projection print. This is not immediately obvious, because most people only make contact prints in large sizes. But the fact is, some loss of sharpness *will* occur in a contact-printing stage due to imperfect contact and spreading of the light beam. Photoengravers always do their contact printing in a vacuum frame for tightest possible contact, and, in addition, use a point-source light, such as a carbon arc, to print with. Anyone who has done much duplicate negative-making in movies, where images are very small, knows the above to be true, and the procedure—always make the contact print at the largest stage—comes directly from movie practice.

For this reason, contact printing should be done at that stage of the process where the image is largest. For instance, if you want a 35mm negative from a 4″ × 5″ original, make the positive transparency by contact-printing from the 4″ × 5″ negative; then make the 35mm negative by photographing or projecting down to size. Where you want a 4″ × 5″ negative from a 35mm original, first make the transparency by projection, then contact-print the 4″ × 5″ negative from it.

While the positive image is similar to a projection transparency, it should be made especially for the purpose, for best gradation in the highlights, and the usual high-contrast transparency or "lantern-slide" films or plates should not be used. Such materials produce images that project well but are nearly clear film in the highlights and very black in the shadows. What you want is a rather soft positive with a fairly deep-gray tone over the highest lights; the shadows should be no more than a dark-gray, never black. Such a positive would look overexposed, and is much too dark for projection upon a screen, but it will produce an excellent copy negative.

Inasmuch as we are working entirely in black-and-white, a panchromatic film is not necessary, and the best material is a relatively slow, not too contrasty, sheet film, such as Kodak Commercial Film or another brand. This film is sensitive to blue light only and can be handled in a bright-red safelight. "Positive" films, such as Kodak Fine Grain Release Positive Film, Type 7302, should *not* be used; they are too contrasty for this work, and trying to reduce the contrast by short development in a diluted developer will produce inferior highlight gradation.

Commercial Film has an ASA rating of 50 to daylight but only 8 to tungsten light. This is not a great deal faster than a fast enlarging paper, and exposures can be made with the enlarger. One or two tests will indicate the approximate exposure required for the transparency and for the negative to be made from it. The exact exposure is not critical at all;

there is more leeway than in making a black-and-white print on paper.

Development should be somewhat longer than that recommended for the same film used in the camera. For minimum graininess, the transparency should be developed for the longer time, the duplicate negative made from it for a shorter time. Begin by trying Kodak Developer DK-50 for about five minutes at 20 C (68 F) for the transparency, and about four minutes for the negative. You may want to reduce or increase both development times if the final negative is not of the desired contrast.

Exact directions cannot be given for this procedure, but the method is simple enough, and a few trials should give you the exact times for your conditions.

As a guide, the positive transparency should be darker than would be considered a good projection slide. There should be a fairly marked gray tone over the highest highlights, while the shadows should be very dark-gray but not black. It may pay to practice making several transparencies of different densities when first trying out this procedure.

From each transparency, an exposure should be made on another sheet of Commercial Film and developed. The final result should be a negative that is just slightly darker than the original negative but of almost identical contrast. In effect, the only difference should be that the duplicate negative does not have any clear film areas, even if the original does; the duplicate should show a very light-gray in the shadows, but the remaining tones should all be much the same as the original negative. Moreover, the highlight areas ought to be very nearly identical to those of the original.

If the highlights are normally dense, but the shadows do not have a gray tone over them, the duplicate negative has been *underexposed*; some additional exposure will bring up the shadow detail while having little or no effect on the density of the highlights. If the shadows are correct but the highlights lack density, the duplicate negative is *underdeveloped*; make another at the same exposure, but increase the development time. Conversely, if the shadows are correct but the highlights are too dense, then the duplicate negative is *overdeveloped*; make another with the same exposure, but develop it for a shorter time.

It appears from the foregoing that it is unnecessary to worry too much about the density or contrast of the transparency; provided it has a complete scale, with no solid black or clear film areas, a good negative can be made from it by adjustment of exposure and development.

Duplicating Procedure

The procedure is as follows:

1. If you are duplicating a 4″ × 5″ negative, then make the positive transparency by contact. This is done exactly as described in the elementary part of this course: Place a sheet of Commercial Film in contact with the negative in a printing frame, and make the exposure on the baseboard of the enlarger. You can make a test for exposure by placing a strip of the Commercial Film across the most important parts of the negative.

2. Other negative sizes should be handled as described above; that is, if you are making a 4″ × 5″ negative from a 35mm negative, make a 4″ × 5″ positive in the enlarger, then contact-print the duplicate negative from this. If you are duplicating a 35mm negative or even a 2¼″ × 2¼″ negative in the same size, probably the best way is to do both steps by contact.

3. Develop the positive for approximately five minutes in Kodak Developer DK-50 at 20 C (68 F). Fix and wash as usual.

4. Judge exposure and development as follows: The positive should have a medium-gray tone over the highest lights and a deep-gray in the shadows. If the highlights are clear film,

the positive is *underexposed*. If the highlights are a light-gray but the shadows are too black, it is *overdeveloped*. If the shadows are only a medium-gray but there is a good tone over the highlights, then the positive is *underdeveloped*. Make another test with the appropriate corrections.

5. When you have the desired result, make a note of both exposure and development times in a notebook. Now expose a full sheet at the proper exposure, develop, fix, wash, and dry.

6. If the new negative is to be the same size as the original, then it, too, should be made by contact. In this case, put a strip of Commercial Film in the printing frame, along with the positive transparency, make a test exposure, and proceed to develop the strip for four minutes at 20 C (68 F) in Kodak Developer DK-50. Fix and wash briefly.

7. The test strip showing the duplicate negative image should be substantially the same for density and contrast as the original negative, the only difference being that the duplicate negative will have a slight gray tone over the deepest shadows, even if the original had clear film at these points. Otherwise, highlight density and contrast should be about the same as the original. If not, then make the following corrections: If the shadows do not have a slight tone over them, then the negative is *underexposed*; make another test with increased exposure. If the highlights are too dense, the negative is *overdeveloped* (this is the same as saying the contrast of the new negative is higher than the original); try a shorter developing time. If the contrast is lower, make another test with more development.

8. Expose a full sheet, develop, fix, wash, and dry as before.

If you have a 4″ × 5″ positive, and wish to make a 35mm negative from it, set up a camera and place the positive over an illuminator of some sort. If your enlarger is capable of reducing, which means a fairly long bellows extension, it is possible to make the 35mm negative by reduction from the 4″ × 5″ positive. This can be done on a sheet of 4″ × 5″ Commercial Film, then trim the negative to size after it has been developed, fixed, washed, and dried. Most of the time this is the way it is done, anyway, because there is no film corresponding to Commercial Film in the 35mm size. If a 35mm camera must be used, then use a slow, fine-grained film, such as Kodak Panatomic-X Film, and adjust exposure and development accordingly. This is entirely a matter of trial and error, and no specific instructions can be given; however, if your 35mm camera has automatic-exposure control, this will usually give you a result that is very nearly correct at the first trial.

DIRECT DUPLICATION

Where you have the original negative and need a copy, it is especially convenient to have a material that can make a negative from a negative without the intervention of a positive transparency. Two such materials are available, based on a phenomenon called *solarization* (not to be confused with the effect produced by fogging a partially developed negative or print). In true solarization, an emulsion that has already been fogged to such a degree that it will produce complete blackness on development will actually produce less density if further exposed. Thus it is possible to make a film that is fogged in manufacture; if developed without further exposure, the film turns black all over. If this film is further exposed, density decreases, and if it is exposed to a negative, and developed, the result will be another negative.

Another way to attain the same end is to use an ordinary negative film and process it by reversal. This latter process consists in first developing a negative image, then re-exposing the underlying layers of the emulsion, bleaching the negative, and developing the remaining

halides to form a positive image. This procedure has a number of uses aside from making duplicate negatives and is explained at length later in this lesson.

The direct-duplicating material available is Kodak Professional Direct Duplicating Film SO-015. This film has approximately the same speed as that of a fast enlarging paper, and so can be used for making enlarged copy negatives with the usual enlarger; by using the enlarger as a light source, it can be used for contact duplicates also. It can also be used in cameras for making copy negatives if a sheet-film camera is available.

Since there is no intermediate positive step, exposure is more critical with this material and may require several tests to attain the correct exposure level. There is one other problem: if the copy negative is made by contact, with the emulsion sides of the two films facing each other, then the duplicate negative will be reversed left for right. This poses no great problem; just remember, when making enlargements from it, to put the negative in the enlarger with the emulsion side facing the lamp, rather than the lens, as is the normal position. If you are making duplicate negatives with this film, and are using an enlarger or camera to make an enlarged or reduced negative, then the original may be placed with its *base* side facing the camera (or facing the lens of the enlarger); this will produce a duplicate negative with the same orientation as the original.

Exposure tests are made in the usual way, and the judgment is exactly the same as that of duplicate negatives made from an intermediate positive. That is, the negative should have roughly the same tonal scale as the original but should not have any clear film showing, even in the shadows; a light-gray tone over the shadows is essential to preserve the shadow detail.

Since the material is a direct positive, corrections must be made in reverse; that is, if the duplicate negative is too light, *decrease* the exposure; if too dark, *increase* it. However, development affects this film in the same way as it does any normal emulsion; to increase contrast, increase processing time, and vice versa.

Safelight

Kodak Safelight Filter No. 1A (light red) or equivalent in a suitable safelight lamp with a 15-watt bulb. Safelight should be kept at least four feet from the film.

Manual Processing

1. Develop at 70 F (21 C). Deep tank (agitation at 1-minute intervals): Kodak Developer DK-50 (full strength)—7 minutes.
Tray continuous agitation: Kodak Dektol Developer (1:1)—2 minutes. Development times may be adjusted to obtain desired contrast.

2. Rinse at 65 to 75 F (18-24 C) with agitation. Kodak Indicator Stop Bath—30 seconds or Kodak Stop Bath SB-5—30 seconds.

3. Fix at 65 to 75 F (18-24 C) with frequent agitation (continuous for first 15 seconds). Kodak Fixer—5 to 10 minutes or Kodak Fixing Bath F-5—5 to 10 minutes or Kodak Rapid Fixer—2 to 4 minutes.

4. Wash for 20 to 30 minutes in running water at 65 to 75 F (18-24 C). To minimize drying marks, treat in Kodak Photo-Flo Solution after washing. To save time and conserve water, use Kodak Hypo Clearing Agent.

5. Dry in a dust-free place.

REVERSAL PROCESSING

It is possible to develop a regular negative film directly to a positive image by a process known as reversal. This is useful for making duplicate negatives in one step but is good for other things too; you can make black-and-

white slides for projection this way, or develop 8mm or 16mm black-and-white movie film. The process will work on almost any type of negative film, but the formulas have to be varied for the different films.

Kodak supplies a film especially for reversal processing called Kodak Direct Positive Panchromatic Film, which is sold in 100-foot bulk rolls of 35mm film. The processing kit supplied for this film will work just as well with Kodak Panatomic-X Film, which is available in 35mm cartridges and also in size 120 roll film and sheet films. For those who prefer to prepare their own chemicals, some formulas are given at the end of this section, and they work the same as the Kodak Direct Positive Film Developing Outfit.

The principle of reversal processing is simple enough; the film is first developed to a negative in a modified developer of fairly high contrast. Then the remaining unexposed halides in the film, instead of being fixed out, are used to make the positive image. This is done by bleaching the negative image just produced, then exposing the remaining halides to white light, and developing the newly formed positive image. In some cases, a fogging developer is used at this point, and no exposure to white light is needed; this is convenient when a closed tank is used.

If a good-quality image is to be obtained by reversal processing, certain factors must be taken into account. Because it is difficult to judge the density of the negative after the first development stage (it is very dense and contrasty, much more so than the normally developed negative), you cannot control the exposure of the positive to any useful degree. This being the case, all current reversal procedures control only the first development stage; the remaining steps run to completion.

This means that a special first developer is required. All emulsions contain a small number of silver grains that are almost totally insensitive to light. These cannot be made to develop completely in the first developer stage but will turn black in final development of the positive; the result is a dense, foggy image.

This problem is solved by adding a silver solvent to the first developer. Because the insensitive grains are very small, only a small amount of solvent is required, and it has no effect upon the larger, more sensitive grains. The usual solvent is sodium or potassium thiocyanate, and the quantity is about 0.2% of the total amount of developer—roughly two grams per litre of developer. You can make a good reversal first developer by adding two grams of potassium thiocyanate to each litre of Kodak Developer D-19. The addition not only clears the highlights, it also seems to raise the speed of the emulsion in some cases. Some, but not all, emulsions have nearly twice the speed as reversal films as they do when processed as negatives.

After the negative image has been developed, the film is washed, and then placed in the bleach which removes the silver image but has no effect on the unexposed and undeveloped halides. This requires an oxidizing type of bleach; this is different from the usual toning bleach in that it removes the silver image completely. If it merely turned the silver image into silver bromide or chloride, then this would redevelop in the final stage and the film would turn black all over.

The bleach leaves a heavy yellow stain and some silver salts in the film; it must be rinsed first, and then treated in a clearing bath, which serves two purposes: first, it eliminates all stain and soluble silver left by the bleach, and second, it restores the sensitivity of the remaining, unexposed and undeveloped halides, so they can be re-exposed for final development. The clearing bath is a simple solution of sodium bisulfite, and is freshly prepared and discarded after use; it becomes contaminated with bleach and should not be saved.

The film is then exposed to light (unnecessary if a fogging second developer is used) and developed in a strong black-and-white developer similar to the first developer but without the silver solvent.

After development, there should be little or no unexposed and undeveloped silver halide remaining in the emulsion, and fixing would seem to be unnecessary. However, some silver halide does escape the action of both developers, and you will obtain a brighter image if the film is fixed in a normal acid hardening fixing bath. This process also hardens the gelatin of the emulsion. This gelatin has been swollen to a considerable extent by two development treatments and a vigorous bleach; normal washing and drying complete the process.

Since the re-exposure step is not controlled, and is intended only to make all the remaining silver developable, it is possible to eliminate re-exposure to light altogether by adding a fogging agent to the second developer. This is done in the Kodak Direct Positive Film Developing Outfit and allows carrying out the entire process in a normal developing tank. Fogging developers usually tend to produce brownish images, but a special blue-black agent is incorporated in the fogging second developer. If you prefer to mix your own, formulas are given on page 268.

The following instructions are for processing either Kodak Direct Positive Panchromatic Film or Kodak Panatomic-X Film. For this purpose, both are rated at the same speed: ASA 80 to daylight, ASA 60 to tungsten light. These instructions apply only to Kodak Panatomic-X Film in the 35mm size. The sheet and roll films have different emulsions, which may also work, but which will require some preliminary testing.

Processing Reversal Films

Develop the film in the usual spiral reel tanks; agitate for the first 30 seconds after the tank is filled, then 5 seconds every minute thereafter. All operations should be carried out in total darkness (or with the tank cover on) for all steps until bleaching is complete. After this, a safelight with a Kodak Wratten Series OA Filter may be used until final fixing. Do not examine film by white light until the fixing stage.

The temperature for all baths is 20 C (68 F). It is possible to work at higher temperatures, but this will require shortened first development, according to the following table:

First Development Time

20 C (68 F)	8 minutes
23 C (73 F)	7 minutes
26 C (78 F)	6 minutes
29 C (83 F)	5 minutes

The remaining baths should also be used for shorter times, roughly proportional to the above, but exact times will have to be determined by trial. Since these steps may be watched, it is easy to tell when they are complete.

Step-by-Step Procedure

1. *First Development.* Develop the film for eight minutes at 20 C (68 F), with agitation as recommended. The contrast of the final positive cannot be changed appreciably by varying the time of development. Overdevelopment produces an effect similar to overexposure—a general loss of density and highlight detail. Underdevelopment produces dark highlights and a general effect similar to underexposure.

2. *Rinse.* Empty the developer from the tank; rinse for two to five minutes in running water, or in several changes of water, at 20 C (68 F).

3. *Bleach.* Drain the film for 10 to 15 seconds after rinsing, then pour the bleach into the tank and bleach for one minute at 20 C (68 F). At the end of the step, you may re-

move the cover of the tank, but do not turn on the white light; proceed under a safelight with a Kodak Wratten Series OA Filter. Empty the bleach from the tank and rinse once in water. This rinse step is not essential but advisable.

4. *Clearing*. Pour in clearing bath and agitate gently for two minutes at 20 C (68 F). Do not leave the film in this bath longer than two minutes, or some loss of final density may result.

5. *Redevelopment*. Use the fogging redeveloper supplied with the kit, or mixed from the formula for Kodak Fogging Developer FD-70, which appears on page 118. Redevelop for eight minutes at 20 C (68 F). Don't let traces of this developer contaminate other baths or anything else in the darkroom; the fogging agent is extremely powerful and can cause spots on sensitized materials, even if only a bit of the dust is allowed to get into the air. Mix the solution outside the darkroom, and always wash your hands and all utensils after handling this formula. All containers, graduates, tanks, stirring rods, and other items that have come in contact with it must be washed thoroughly.

6. *Rinse*. Rinse the film for one minute in running water at 20 C (68 F).

7. *Fix*. There is little residual silver halide in the film at this stage. However, continue fixing for at least five minutes to secure maximum hardening of the gelatin. Use any standard fixing bath. The Kodak Fixer used for films and papers in earlier lessons is quite satisfactory; if you mix your own, use the regular Kodak Fixing Bath F-5 formula.

8. *Wash and Dry*. The wash after fixing is exactly the same as that used after negative development. The film may be washed in running water at 20 C (68 F) for 20 to 30 minutes, or five to ten changes of water may be given, as recommended in earlier lessons. For final rinse, use Kodak Photo-Flo to minimize water-spotting. Then hang the film to dry in a clean, dust-free area.

If maximum permanence is desired, use a fixing bath that has been freshly mixed and has not been used for any purpose before, then wash for double the normal time.

Preparing Reversal Baths

Reversal baths are mixed exactly like any other formula. Unless otherwise specified, start with about ¾ the final volume of warm water and dilute to volume with cold water after all chemicals are dissolved. As usual, dissolve each chemical completely before adding the next, and always mix in the order given in the formula.

Reversal First Developer
(Kodak Developer D-67)

Warm water (52 C or 125 F)	750.0cc	24 ounces
Elon developing agent	2.0 grams	30 grains
Sodium sulfite, desiccated	90.0 grams	3 ounces
Hydroquinone	8.0 grams	115 grains
Sodium carbonate	52.5 grams	1¾ ounces
Potassium bromide	5.0 grams	75 grains
Potassium thiocyanate	2.0 grams	30 grains
Add cold water to make	1.0 litre	32 ounces

Those of you who are familiar with developer formulas will recognize that this formula is substantially the same as the standard Kodak Developer D-19, with the addition of potassium thiocyanate. Thus this developer can be prepared simply by taking a can of Kodak Developer D-19 and dissolving it as usual, then adding 2.0 grams (30 grains) of potassium thiocyanate to each litre (quart) of mixed developer (8.0 grams or 120 grains per gallon).

A. The first developer is poured into the tank and agitated for the required time.

B. At the end of the first development, the developer is poured out and the film rinsed under the faucet.

C. Pour bleach into the tank and agitate. This, and all remaining steps, may now be carried out with the tank lid off, but it is easier to agitate with the lid on the tank.

D. After emptying the bleach, rinse the tank with plain water, then pour the clearing bath into the tank.

E. Expose film thoroughly to white light if a fogging developer is not being used. If the fogging developer is used, (it is part of the Kodak Direct Positive Pan Processing kit), then this step may be omitted.

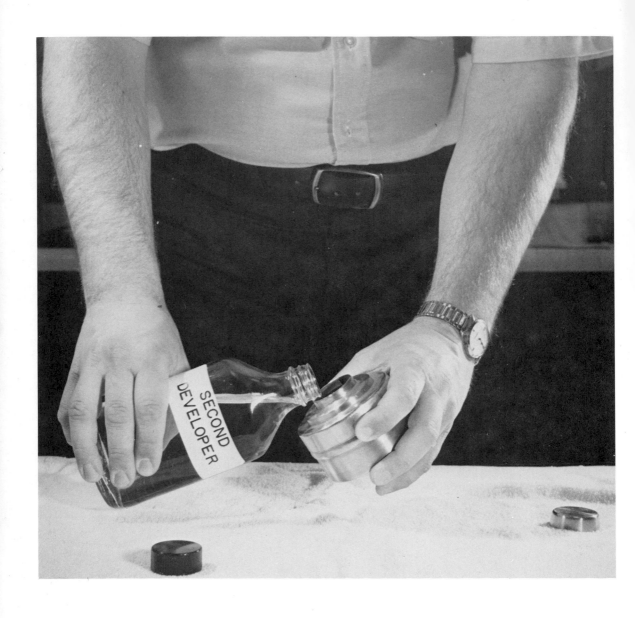

F. After the clearing bath, and re-exposure, pour in the second developer, and agitate for the prescribed time. If the fogging developer is used at this point, the previous step (Step E) is omitted.

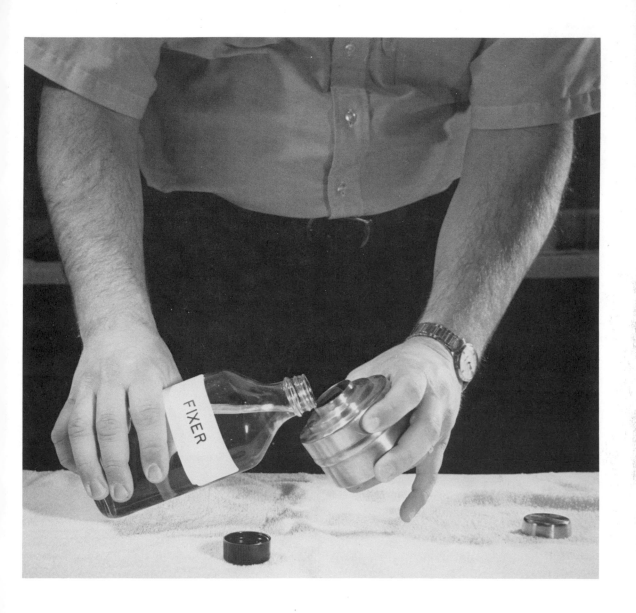

G. Empty the second developer and rinse. Then pour in the fixer. After this, wash and dry the film in the usual way.

Bleach Bath
(Kodak Bleach Bath R-9)

Cold water	750.0cc	24 ounces
Potassium dichromate	9.5 grams	140 grains
*Sulfuric acid, concentrated	12.0cc	3 drams
Add cold water to make	1.0 litre	32 ounces

*Concentrated sulfuric acid must always be added to the water, never vice versa; keep stirring steadily while adding the acid. There is little danger of spattering this small amount, but make it a habit always, when handling sulfuric acid, to add it to water slowly while stirring rapidly.

If you do not like to handle concentrated sulfuric acid, there is Kodak Bleach for Kodak Direct Positive Paper, a packaged bleach containing only dry powdered chemicals. The formula for this is not available for publication, but it can be used in place of the above formula, or you may use the bleach supplied in the kit for developing Direct Positive Panchromatic Film.

Clearing Bath
(Kodak Clearing Bath CB-1)

Warm water (52 C or 125 F)	750.0cc	24 ounces
Sodium sulfite, desiccated	90.0 grams	3 ounces
Add cold water to make	1.0 litre	32 ounces

The fogging redeveloper can be mixed much like any other developer. The problem is merely one of availability of the chemicals as well as the need for extreme care in handling the fogging agent. This latter is exceedingly powerful and can do severe damage to photographic films or papers if even a small amount is allowed to get into the air or is spilled on the table or floor.

The fogging agent is sodium dithionite, which is not usually sold in camera stores or even in professional photographic supply houses; it must be obtained from a dealer in laboratory supplies. You must purchase at least 500 grams (a pound) as a minimum. Furthermore, the chemical is a highly flammable solid and may ignite if allowed to become damp; it must be stored in a tightly sealed bottle and in a cool, dry place.

The other special reagent is called 2-thiobarbituric acid; its function is to produce a blue-black tone in the final image. It is not a common chemical and is not available in photographic supply houses.

If these special chemicals are available, the fogging developer can be prepared as follows:

Kodak Fogging Developer
(Kodak Fogging Developer FD-70)

Part A		
Sodium dithionite	5.0 grams	75 grains

Part B		
Warm water (52 C or 125 F)	750.0cc	24 ounces
Sodium metaborate	10.0 grams	145 grains
2-Thiobarbituric acid	0.5 gram	7½ grains
Add cold water to make	1.0 litre	32 ounces

Just before use, add the sodium dithionite to the mixed Part B; stir well, and use within two hours. Discard the developer after one use; it does not keep. Be sure to wash all utensils very thoroughly after using this formula.

Alternative Second Developer for Re-exposure

If the chemicals for the fogging developer are not available, or if you prefer not to use them, there is an alternative method for completing the reversal process. In this method, the process is carried out exactly as directed up to the clearing-bath stage. At this point, the film must be exposed on both sides to a strong white light, such as the light of a No. 2 (500-watt) photoflood bulb, at about two feet. (You will have to find the exact amount of re-exposure by trial, but this is not a critical step.) Expose thoroughly; overexposure is preferable to underexposure, but excessive re-exposure may cause a slight increase in highlight density.

After re-exposure, develop the film in Kodak Developer D-19 or Kodak First Developer D-67, *with the thiocyanate omitted*, for about four minutes at 20 C (68 F).

After redevelopment, fix the film in Kodak Fixer or Kodak Fixing Bath F-5 for five minutes, then wash and dry as usual.

HIGH-CONTRAST PROCESSING
FOR LINE COPY

It is often necessary to copy a piece of printed or written matter in such a way to secure an image that is white and black, with no middletones at all. There is a group of materials made especially for this purpose, known as *photomechanical* or *graphic arts* films or, more commonly, as *litho* films. Unlike ordinary films, these develop very rapidly to enormous contrasts with practically no fog. In effect, these films are nearly insensitive up to a certain exposure level; above this level, a small increase in exposure produces the maximum black of which the film is capable, and further exposure produces no additional density.

If a litho film in the camera is exposed to a normal subject rather than to line copy, the effect will be to enormously exaggerate the contrast of the resultant negative. What usually happens is that all the dark tones merge into a single black, all the light tones merge to white, and one, or at most two, middletones appear as some tone of gray. This effect can be used to produce silhouettes and, by using both negative and positive images, to produce bas-reliefs and tone-line images. These are beyond the scope of this course, but we suggest you try the simple copying procedures given at the beginning of this lesson; when you become accustomed to handling the high-contrast films, you can use them for creative photography as well. Instructions for these procedures will be found in several books available from Amphoto or from your dealer.*

Using Litho Films in the Camera

A typical litho film is supplied by Eastman Kodak Company under the name of Kodalith Ortho Films, Type 3. This film can be purchased in sheet-film sizes, $4'' \times 5''$, and larger; it is also available in 35mm, in 100-foot rolls.

This film is sensitive to blue and green but not to red, hence it may be handled by the light of a safelight with a Kodak Wratten Series 1A (light-red) Filter, fitted with a 15-watt lamp, and used at not less than four feet from the film. This is a fairly bright light, and development is done by inspection.

Exposure for very high-contrast films must be found by test; a preliminary test may be made with a meter but will almost certainly require correction. There is one additional problem: When photographing white paper with black printing on it, the meter reading will be too high, resulting in underexposure. For this reason, take exposure readings either with an incident-light meter or a reflected-light meter using a Kodak Gray Card substituted for the subject matter. High-contrast films, such as Kodalith Ortho Films, Type 3, are quite slow; for a first test in tungsten light, try a meter setting of ASA 6.

If neither an incident-light meter nor a gray card is available, a reading may be taken from a sheet of clean white paper or cardboard. Since this reflects about five times as much light as the gray card, an exposure correction is necessary. If, for example, you get a reading indicating an exposure of one second at $f/16$, you will actually have to give five times this exposure; that is, expose for *five* seconds at $f/16$. This, we repeat, is a test; you may find that more or less exposure is actually required.

*Otto Litzel, *Darkroom Magic* (2nd ed.; Garden City, N.Y.: Amphoto, 1975).

Eastman Kodak Co., *Creative Darkroom Techniques* (Rochester, N.Y.: Eastman Kodak, 1973).

Edwin Smith, *All the Photo Tricks* (Focal Press/Amphoto, 1974).

Joanne and Philip Ruggles, *Darkroom Graphics* (Garden City, N.Y.: Amphoto, 1975).

(Left) This is an example of a photograph with normal tones of black, gray, and white.
(Above) Reversal processing of the negative was used to produce this version of the photograph on the opposite page.

(Left) This is an example of a photograph with normal tones of black, gray, and white. (Above) This same subject was shot using high-contrast film. In the resulting photo, all dark tones have merged to black and all light tones have merged to white.

Developing Litho Films

If the litho film negative is required only for making a paper print, the maximum contrast is not really necessary, and a good line copy can be made by developing the film in any fairly strong black-and-white developer. Kodak Developer D-19 will produce good results, but you can use your regular paper developer (Kodak Developer D-72 or Kodak Dektol Developer).

In this case, do not dilute the stock solution but use it full strength for maximum energy. At full strength, Kodak Dektol Developer will produce a good high-contrast negative on Kodalith Ortho Film in three minutes at 20 C (68 F). You may watch development under the red safelight; you will note that the image comes up very fast, then gains density slowly, and comes to a full stop in about three to four minutes. Extending development time does not increase contrast very much; it merely adds density (similar to the effect of added exposure). Thus some slight correction for errors in exposure can be made in the development stage.

When development is complete, rinse the film in plain water (do *not* use an acid stop bath; it may blister the emulsion). Then fix in the usual fixing bath (Kodak Fixer or Kodak Fixing Bath F-5) for about five minutes.

The resultant negative should be almost opaque in the highlights and clear film in the shadows. There should be few, if any, gray areas. If density is not sufficient, try another test at double the exposure, at least. If, on the other hand, the lines or lettering seem to fill in, give less exposure and more development.

Maximum Contrast Processing of Litho Films

Photoengravers and others in the graphic arts who use litho films require maximum contrast; their negatives must be completely opaque in the highlights and absolutely clear and free from fog in the shadows. To accomplish this, a special "litho" developer is used.

Litho developers contain hydroquinone as developing agent; no Metol is used at all. As an accelerator, they contain paraformaldehyde; this gives the developer the ability to produce great contrast by adding to the highlight density, while at the same time removing traces of density, such as fog, from the shadows.

Litho developer is available in prepared form; Kodalith Developer is made by Kodak and supplied in both powder and liquid forms. A similar developer is available from several other manufacturers; any one of them will work equally well on litho film of any make.

With the regular litho developer, development of exposed film takes about 2½ minutes at 20 C (68 F). If required, development may be reduced to two minutes or increased to about 3½ minutes for correction of minor exposure errors.

Following development, rinse the film in plain water, fix and wash as usual.

Litho films have very thin emulsion, and washing is quite rapid; in most cases, five to ten minutes in running water is ample.

Mixing Litho Developers

If you wish to mix your own developer, a more or less standard formula for a litho developer is given below; it is essentially the same as the commercial product and is known variously as Kodak Developer D-85, DuPont Developer 7-D, Ansco Developer 79, Haloid Developer D-3, and so on.

Litho Film Developer

Warm water			
(not over 32 C or 90 F)	500.0cc	16	ounces
Sodium sulfite, desiccated	30.0 grams	1	ounce
Paraformaldehyde	7.5 grams	¼	ounce
Sodium bisulfite	2.2 grams	32	grains
*Boric acid, crystalline	7.5 grams	¼	ounce
Hydroquinone	22.5 grams	¾	ounce
Potassium bromide	1.6 grams	22.5	grains
Add cold water to make	1.0 litre	32	ounces

*Use only crystalline boric acid; the powdered variety is very difficult to dissolve.

Litho films are developed in this formula, used full strength, for between 1½ and three minutes; two minutes is a good average. Since the developer contains no sodium carbonate, there is no danger of blistering, and an acid stop bath (the usual 3% acetic acid bath) may be used; this will extend the life of the fixing bath. Fixing is very rapid; three to five minutes is as much as will be required in a fresh bath. As mentioned, washing is also rapid, and ten minutes will be ample; even less washing may be given if the negatives are not to be kept permanently.

Contact-Printing on Litho Films

On occasion, you may wish a line positive rather than a negative; in this case, simply make a contact print onto another sheet of litho film. The enlarger may be used as a light source, exactly as was done in contact-printing from ordinary negatives.

Since the material is of such high contrast, the printing step on another sheet of the same film will have the effect of increasing the contrast even further. Thus if there are some grayish or foggy spots in the negative, they will print either black or white, depending upon the exposure given.

You can take advantage of this to make such things as silhouettes from continuous-tone images. Starting with a continuous-tone negative, make a contact print on a sheet of litho film; then make a negative by contact-printing from this print. The result will eliminate all but the highlights from the original image.

This procedure may be used, with varying exposures, to produce negatives that have a series of flat tones; the process is called *posterization* and is explained at length in the books previously recommended. Given a negative and a positive of high contrast, outline and bas-relief effects can be produced also. It pays to practice using litho film before trying the various procedures recommended in the books mentioned.

(Left) This is an example of a photograph with normal tones of black, gray, and white.
(Above) This is the same subject rephotographed using litho film.

LESSON 10

Miscellaneous

There are certain operations in photography that may be classified as "salvage" operations; these include reduction, intensification, and a few others. Retouching and spotting are sometimes necessitated by accidents to the negative, and as such are likewise salvage operations, though retouching also has other uses.

If the earlier lessons in this course have been mastered thoroughly, and followed meticulously, there should seldom be any need for either reduction or intensification. Using fresh developer and hypo every time, checking temperature, and watching the clock should assure perfect negatives every time. So the moral is: Follow instructions and you will never have to resort to after-treatment to salvage a spoiled negative. Well, hardly ever.

Accidents happen sometimes in exposure, but it is seldom that any after-treatment can really save a grossly over- or underexposed negative. The best you can hope for is to get some kind of print from it, which might serve some kind of purpose, say, in the case of a valuable news picture that cannot be retaken. But with modern cameras with built-in exposure meters or automatic control, this, too, should be unnecessary.

Note that we have said nothing about salvaging a bad print. The reason is that it is always easier to make a new print than to attempt to save a bad one. Furthermore, intensifiers and reducers have little useful effect upon paper emulsions. The most you should ever have to do to a print is to touch up a few spots, or a scratch or two, and even the latter is mainly the result of a damaged negative; paper emulsions are hardly ever damaged in processing.

We must emphasize that intensification and reduction are strictly salvage operations; the result will never be as good as a print from a properly exposed and developed negative. Another point is that these techniques should be tried on unimportant work before attempting to salvage valuable pictures. On extremely valuable work, it is wise to make a duplicate negative as insurance against a mishap.

Take reduction. First, a grossly overexposed negative will lack contrast in the highlights, and while reduction will lower the density to where the negative can be printed with a convenient exposure, highlight gradation will still be poor and the whites of the print either washed out or muddy. On the other hand, a normally exposed negative that has been overdeveloped will have excessive contrast; reduction can reduce the density, but the contrast is likely to remain excessive. (There is one special reducer that can make some improvement in this case, but it is not easy to use. We will discuss it at length later.)

With intensification, the situation is much the same. If a negative is underexposed and normally developed, no amount of intensification can do any good because no intensifier can put into a negative detail that was not recorded in the original exposure. A correctly exposed negative that has been underdeveloped is slightly better—at least it is full of detail and lacking only contrast. Intensification can raise contrast in much the same way as continued development would do, but there are minor side effects, which are annoying if not serious. One is a marked increase in graininess in an intensified negative. Another is a tendency for negatives intensified in certain formulas to become stained and, in some cases, to fade in a short time.

But there are times when a salvage operation is absolutely essential and you might as well know how it is done.

TYPES OF REDUCERS

Reducers fall into three classes: cutting reducers, proportional reducers, and superproportional reducers. *Cutting reducers* remove density equally overall; because there is much less silver in the shadows of the negative, these are reduced markedly while little effect occurs in the middletones and highlights. *Proportional reducers* remove silver in proportion to the amount already present; that

is, they remove silver from the shadows, more from the middletones, and still more from the highlights, in proportion to the amount that is present at the start. *Superproportional reducers* attack the highlights most strongly while having little effect upon the small amount of silver in the shadows.

Each of these types of reducer has its own uses. The cutting (or subtractive) type of reducer is most valuable on overexposed negatives. Reducing the shadows more than the highlights tends to increase the contrast of the negative, which, in the case of an overexposed negative, is always lower than normal.

The proportional reducer is used mainly for negatives that have been overdeveloped but are fully exposed and have ample shadow detail. The effect of the proportional reducer is the opposite of the developer, as it tends to "undo" the developing action, thereby reducing both density and contrast.

The superproportional reducer is a special case; since it reduces highlights more than shadows, it, too, reduces contrast. Its main use is saving a negative that has been forced in development in an attempt to correct an underexposure. Such a negative will be very dense in the highlights, but shadow detail will be faint, if present at all. The superproportional reducer lowers the density of the highlights without destroying the faint shadow detail.

These three types of reducers are not mutually exclusive. For example, the common Farmer's Reducer is normally classed as a cutting reducer when mixed in a single bath of normal strength. If it is diluted and used in a weak bath, it has less cutting effect, and if it is used as two separate solutions, applied to the film in succession, it approaches the action of a proportional reducer. Thus this type of reducer is exceedingly flexible, and we will discuss it at considerable length.

Farmer's Reducer

This formula owes its name to Ernest Howard

Farmer who first described it in 1883. Numerous variations have been suggested since that time, but they are all changes in proportions of the two ingredients, namely, potassium ferricyanide and sodium thiosulfate (ordinary hypo). The bath is always mixed as two stock solutions. The potassium ferricyanide solution must be kept in a brown bottle as it is decomposed by light. Generally, infrequent use of potassium ferricyanide requires that you mix a fresh solution for immediate use, as it has poor keeping qualities in solution. The hypo solution keeps indefinitely in any kind of bottle. The two solutions are not combined until needed, as the mixed bath decomposes rapidly; its life is measured in minutes in some cases.

Since the reducer contains hypo, it is not essential that the negative to be treated be washed thoroughly before reduction; after treatment, though, washing must be very thorough.

The common versions of the Farmer's Reducer are known as Kodak Reducer R-4a and also as Ansco Reducer 310. Other manufacturers give different formulas, but all seem to end up about the same when diluted for use. Since all contain the same two ingredients, we will give only the Kodak version here; it will work on negatives made on films of any make.

Farmer's Reducer
(Kodak Reducer R-4a)

Stock Solution A

Potassium ferricyanide	37.5 grams	1¼ ounces
Add cold water to make	500.0cc	16 ounces

Stock Solution B

Sodium thiosulfate (hypo)	480.0 grams	16 ounces
Add cold water to make	2.0 litres	64 ounces

Mix each solution separately in a *clean* mixing vessel; store in tightly corked bottles. The bottle for the ferricyanide solution must be of brown glass or plastic. If only a clear glass bottle is available, cover it with brown paper.

For use in metric measure, take 30.0cc of Solution A, 120.0cc of Solution B, mix, and add water to make 1.0 litre. Or, in avoirdupois measure, take 1 ounce of Solution A, 4 ounces of Solution B, mix, and add water to make 32 ounces.

Place the negative to be treated in a white enameled or plastic tray, and immediately pour the mixed solution over it. Watch the action of the reducer closely. You should have a tray of plain water at hand, and when the negative is nearly light enough for your purposes, quickly transfer it to the plain-water tray and agitate it rapidly, then wash in running water or several changes of water, exactly as you do a negative that has just been developed.

The action of the reducer does not stop instantly, which is why we advise you to transfer it to the plain water when it is nearly light enough. This will slow down the action of the small amount of reducer still remaining in the emulsion of the film. If the negative is still too dense, you can return it to the reducer tray for further treatment. The whole process is quite easy to control, and there is little danger of going too far, especially as the bath begins to deteriorate as soon as it is mixed, and in some extreme cases, it ceases to reduce before the negative has been lightened sufficiently. In this case, merely mix a fresh trayful of reducer and continue reducing until the result suits you. The whole thing is a matter of taste, but do not allow reduction to go too far, or you may lose some detail in the deepest shadows.

When a negative needs only a small amount of reduction, it may be better to use a weaker bath. You make this by taking 15.0cc of Solution A, 60.0cc of Solution B, and 1.0 litre of water (or ½ ounce of Solution A, 2 ounces of Solution B, and 32 ounces of water). This weaker bath will have an even shorter tray life than the full-strength bath, and there is almost no danger of reducing the negative too far. The weaker bath will have less cutting action

than the full-strength one, and the danger of losing shadow detail is less, while overall reduction will be nearly the same.

On the other hand, a stronger solution will have more of a cutting action, working almost entirely in the shadows, or thinner parts of the negative. This is useful, occasionally, particularly with a negative that was normally exposed and developed but was fogged accidentally. If the fog is not too heavy, it can be removed almost completely without any great effect upon the image detail you want by preparing a strong solution and treating the negative for only a short time. This is dangerous, and there is a preferable method, explained below.

Two-Solution Farmer's Reducer
(Kodak Reducer R-4b)

Solution A

Potassium ferricyanide	7.5 grams	¼ ounce
Add cold water to make	1.0 litre	32 ounces

Solution B

Sodium thiosulfate (hypo)	200.0 grams	6¾ ounces
Add cold water to make	1.0 litre	32 ounces

These are not stock solutions and are intended for use in separate trays at full strength.

Immerse the negative in Solution A for one to four minutes at about 20 C (68 F), watching the reduction carefully. Since a slight milkiness is produced during this stage, do not carry the treatment too far at first. When the reduction is almost as much as you desire, transfer the negative to the hypo solution (Solution B), agitating rapidly. This will lighten the negative more while stopping the reducing action completely. If the reduction is sufficient, simply wash the negative in the usual way and dry.

If reduction is not sufficient, the negative may be returned to the ferricyanide (Solution A) for further treatment, followed again by stopping the action with the hypo bath. The action seems to speed up as it continues, so be

careful not to overdo subsequent treatments.

When used in this way, Farmer's Reducer has less of a cutting action, approaching the proportional. If you wish to use it as a fog remover, however, the trick is to *weaken* the ferricyanide solution; the usual method is to dilute the ferricyanide solution with an equal amount of water. This restores the cutting action, and it is possible to remove most of the fog without affecting the image very much.

If the ferricyanide solution is not contaminated with hypo, it will keep quite well in a brown bottle. But if you have been transferring the negative back and forth between the ferricyanide and hypo baths, and some hypo is carried back into the ferricyanide bath, then the keeping power of the latter will be much less, and it will, in fact, deteriorate with or without further use.

For this reason, it is best to use a small tray, just big enough for the negative being treated, and to use small portions of the ferricyanide bath and discard after use. The hypo may be used in a large tray; small amounts of ferricyanide carried over into the hypo merely decompose but do no harm other than to tint the bath a pale yellow.

Superproportional Reducers

We will for the moment, skip the subject of proportional reducers, for reasons that will be explained later. As mentioned, the superproportional reducer attacks the densest parts of the image first, and has little effect on the thinner parts; thus it is of value in reducing correctly exposed negatives that have been overdeveloped. It reduces contrast quite markedly without losing important but faint shadow detail.

There is only one known superproportional reducer—one containing a persulfate salt. The traditional formulas called for ammonium persulfate, but this salt is unstable and in most cases contains impurities that make its action

erratic. Much of the complaint that the persulfate reducers did not work as claimed were due either to stale ammonium persulfate or to impure chemical. The current formula uses potassium persulfate and appears to be more stable and more reliable. It is as follows:

Superproportional Reducer
(Kodak Reducer R-15)

Stock Solution A

Water	1.0 litre	32 ounces
Potassium persulfate	30.0 grams	1 ounce

Stock Solution B

Water	250.0cc	8 ounces
Sulfuric acid (10% solution)	15.0cc	½ ounce
Add cold water to make	500.0cc	16 ounces

If you can get 10% sulfuric acid, this formula is easy to mix and much safer than if you have to mix it from concentrated sulfuric acid. Perhaps you can get your druggist to prepare 10% sulfuric acid for you; if not, you can prepare it yourself, as follows:

Place 270.0cc (9 ounces) of cold water in a graduate. Now carefully measure out 30.0cc (1 ounce) of concentrated sulfuric acid in a small graduate. Begin stirring the cold water, then while stirring, slowly pour the sulfuric acid into the water. The result should be 300.0cc (10 ounces) of 10% sulfuric acid.

Warning: Never reverse the procedure; if water is poured into concentrated sulfuric acid, it may boil with explosive violence and spatter, causing considerable damage and possible personal injury.

For use, take two parts of Solution A, and one part of Solution B. Use only a clean glass, hard rubber, or plastic tray; use no metal of any kind.

First harden the negative to be reduced in a strong hardener; Kodak Special Hardener SH-1 is recommended.

Special Hardener
(Kodak Special Hardener SH-1)

Cold water	750.0cc	24 ounces
Formalin (40% solution)	10.0cc	2½ fluid drams
Sodium carbonate, monohydrated	6.0 grams	88 grains
Add cold water to make	1.0 litre	32 ounces

Immerse the negative in this hardener and agitate it gently for three minutes, then wash thoroughly. Now place the negative in a tray of the reducer and agitate continuously. It is not possible to specify the exact time of reduction, so you must keep inspecting the negative at frequent intervals. When it is *nearly* light enough, transfer it quickly to an acid fixing bath (same kind you use for films and papers). A small amount of reduction will take place in this bath, which is why you should stop reducing before the negative is quite light enough. After three minutes in the fixer, remove the negative and wash thoroughly before drying.

Don't try to save the used reducer; it does not keep. However, the stock solutions keep fairly well; the life of Stock Solution A is about two months at not more than 24 C (75 F), while Stock Solution B will keep indefinitely.

Proportional Reducers

Strictly speaking, there is no such thing as a proportional reducer; most single baths are either cutting reducers or superproportional ones. Still, it is possible to combine a cutting reducer with a superproportional reducer to secure an *approximately* proportional action. (There is one rather complicated formula, called Belitzki's Reducer, which is nearly proportional; we do not give it here, but you can find it in most formularies.) The usual proportional reducer consists of a mixture of a persulfate reducer for the superproportional

action and the permanganate reducer for the cutting part. A popular formula is as follows:

Proportional Reducer
(Kodak Reducer R-5)

Stock Solution A

Potassium permanganate	0.3 gram	4 grains
Sulfuric acid (10% solution)	16.0cc	½ ounce
Water to make	1.0 litre	32 ounces

Stock Solution B

Potassium persulfate	90.0 grams	3 ounces
Water to make	3.0 litres	96 ounces

See instructions on page 133 for preparing the 10% solution of sulfuric acid.

For use, take one part of Stock Solution A to three parts of Stock Solution B. Agitate the negative thoroughly in the solution, watching the progress of reduction very carefully. When sufficient reduction has been secured, quickly transfer the negative to a 1%* solution of sodium bisulfite, which will clear the permanganate stain. Wash the negative thoroughly and dry.

The two solutions of Kodak Reducer R-5 should be mixed immediately before use, and the mixed solution discarded as soon as it has been used; it does not keep. The stock solutions keep fairly well, but it is best to mix no more than you can use up in a few weeks.

INTENSIFICATION

As a salvage operation, intensification is generally less satisfactory than reduction simply because no intensifier can put detail where the original exposure did not register it. Thus intensification is of little use on underexposed negatives. It works fairly well on negatives that have been underdeveloped, but in most cases such negatives can be printed almost as easily on hard or extra-hard papers.

There are several special intensifiers that add hugely to the existing densities, but these are useful mainly for line work in the photomechanical industries. They have several disadvantages, such as extremely poisonous ingredients and instability of the final image, which make them undesirable for ordinary photographic use.

Basically, there are two ways of intensifying a negative. With the first method, you add some other metal to the silver image, thus adding density more or less in proportion to that already existing. With the second method, you change the color of the image to one that is more opaque to blue and violet light; thus the image is not visually intensified, but as far as the printing paper is concerned, it has much higher density to those colors to which the paper is sensitive. This latter arrangement, known as *color intensification*, is quite simple; it consists in treating the image with a toner, exactly as in changing the color of a print. Some commercial intensifiers, such as the Copper Intensifier, formerly sold by Agfa, work on this principle.

Where only a modest amount of intensification is required, you need only treat the negative in a bleach-and-redevelop type of sepia toner, as explained in Lesson 1.

To do this, first be sure that the negative is fully and thoroughly washed; traces of hypo in the emulsion will cause a loss of image density. If in doubt, rewash for at least a half hour.

The usual commercial bleach-and-redevelop toners, such as Kodak Sepia Toner or the equivalent of other manufacturers, may be used. Direct sepia toners of either the polysulfide or selenium types will not affect a negative image to any great extent.

*To prepare a 1% solution of sodium bisulfite, dissolve 10.0 grams of sodium bisulfite in enough water to make a litre of final solution (or 145 grains of sodium bisulfite in a quart of water).

Dissolve the contents of the two packets as directed on the package (or prepare the solutions from bulk chemicals as explained in Lesson 1).

Immerse the well-washed negative in the bleach; agitate until the image is an opaque white color and all traces of black silver are gone.

Then wash shortly in water and immerse in the sulfiding or toning bath. The image will turn brown or brown-black rapidly; keep the film in the bath until no trace of white silver remains and it is toned completely. This should take no more than five minutes. Now wash in cold water for 15 to 20 minutes at 18 C (65 F) or lower; the sulfide bath tends to soften the emulsion rather badly, and it will be very delicate at this stage. Give a final rinse in Kodak Photo-Flo and hang to dry in a cool place.

The redeveloped negative will not appear to be much denser than it was before the treatment, but it will print with considerably more contrast, at least on ordinary enlarging papers. The effect may be somewhat less with variable-contrast papers, but these latter do not come in the extreme contrast grades that are usually needed for printing these negatives.

Chromium Intensification

The method just described simply turns the image back into silver bromide and then, in turn, to silver sulfide. If a different bleach is used, it is possible to convert the image to a mixture of silver chloride and a chromium salt. If the bleached image is then treated in any strong black-and-white developer, the original silver image is restored and, in addition, some metallic chromium is also deposited upon the image in proportion to the silver already present. Thus the image is made visibly denser but is not changed in color.

The amount of added density produced by this method is not very great, but it has a peculiar property; namely, if the intensified image is bleached again, the chromium already deposited is not removed by the bleach, and a new chromium layer is added when the film is redeveloped a second time. Thus it is possible to increase density in several steps by repeating the bleach and redevelopment.

The chemicals needed for this procedure are the chromium bleach, and a strong developer, such as Kodak Dektol Developer, as used for paper development. For this purpose, the Kodak Dektol Developer should be diluted about 1:3, but it is not critical. Also have the Kodak Special Hardener SH-1 on hand because this procedure is fairly rough on the film emulsion and tends to soften it.

If you wish to prepare your own solutions, the formula for the Special Hardener SH-1 appears on page 133. You probably also have the Kodak Dektol Developer or its equivalent, Kodak Developer D-72, in your darkroom. (Do not use negative developer Kodak Developer D-76; it tends to bleach the image.)

To prepare the chromium bleach, proceed as follows:

Chromium Intensifier Bleach
(Kodak Intensifier In-4)

Stock Solution

Water	750.0cc	24 ounces
Potassium bichromate	90.0 grams	3 ounces
Hydrochloric acid, C. P.	64.0cc	2 ounces
Add cold water to make	1.0 litre	32 ounces

Note that unlike sulfuric acid, hydrochloric acid does not give off heat when diluted with water and is thus easier and safer to handle. Nonetheless, be careful since it is quite corrosive, and do not inhale the fumes it gives off. Add the acid to the solution slowly while stirring rapidly.

For use, take one part of the stock solution and dilute it with ten parts of water.

This negative is normally exposed but accidentally underdeveloped. It lacks density and contrast, but since there is reasonably good detail, intensification will improve it.

The intensified negative has better printing density, and should make an excellent print on normal paper.

This negative was overexposed and correctly developed. It is dense but lacks contrast. What is needed is a "Cutting" (subtractive) reducer. This will clear out the shadows without affecting the highlight density significantly, and therefore increase the contrast range.

After treatment with Farmer's reducer, the negative is contrasty enough to print well on normal paper.

This negative was correctly exposed but overdeveloped which makes it too contrasty. A super-proportional reducer, using a persulfate salt, will lower the highlight density without much loss of shadow detail.

The super-proportional reducer decreases the contrast to get a good print on normal paper.

This overexposed and overdeveloped negative is much too heavy and contrasty. A proportional reducer will remove density from both highlights and shadows.

The proportional reducer has lowered both density and contrast to get a negative that will print on normal paper.

Be sure the negative has been washed well; if any traces of hypo remain in the emulsion, it will cause bleaching of the image. If in doubt, rewash for a half hour. Then immerse the washed negative in a tray of Kodak Special Hardener SH-1 and agitate well for about three minutes. Rinse in running water before transferring to the bleach bath.

Now immerse the negative in the above chromium bleach bath and agitate gently until the image is completely bleached to a more or less white color overall. When it is completely bleached, wash for five minutes to eliminate the yellow bichromate stain, then redevelop in Kodak Dektol Developer, diluted 1:3 for about five minutes. This procedure can be carried out in full room light but not in direct sunlight, which sometimes causes stains.

When the negative is fully redeveloped and no trace of white remains, wash thoroughly and dry as usual. Thorough redevelopment is essential. Fixing is unnecessary, and if any trace of white remains in the image, fixing will cause loss of density.

If the intensification is not sufficient, wash for five to ten minutes after development and return to the bleach bath. After complete bleaching, develop as before; the result should be a noticeable increase of density as compared with a single treatment.

There is a similar treatment in which the bleach contains a salt of mercury instead of the chromium salt; the procedure is exactly the same, except that the final image consists of a mixture of silver and mercury instead of silver and chromium. While it is possible to secure somewhat greater additions of density by this method, the resultant image is rather unstable and tends to fade and stain with time.

For this reason, it is not recommended for normal use. If you wish to experiment with it, formulas are available in any good formulary.*

LOCAL CONTROL

Now and then you get a negative that is just about right for contrast and density, yet some areas print too light or too dark. In Lesson 4, we showed you how to dodge and burn-in parts of the image during printing. Often this is the only thing that can be done, and where you need only one or two prints, it is all that need be done.

But there are times when you have a negative from which you want many prints, all of which must be exactly alike. In this case, some handwork on the negative may make it possible to print the entire image with a single exposure.

This procedure is exceedingly difficult on very small negatives, such as 35mm, and if it must be done, it may be worthwhile to make an enlarged duplicate negative and work on this. This has another advantage in that the original negative is not touched, and if the duplicate is damaged, nothing is lost.

Basically, there are two things you can do to a negative, which correspond to dodging and burning-in, respectively. To hold back an area and make it print lighter, as in dodging, you simply apply a light-pink or red dye to those areas in the negative which need to be held back. To increase the density of a given area of a print requires lightening the negative at the corresponding point, which is done by local application of a weak Farmer's Reducer. Both techniques may be applied to the same negative, but in this case, do the local reduc-

*See, for example, Wall, Jordan, and Carroll, *Photographic Facts and Formulas* (4th ed.; Garden City, N.Y.: Amphoto, 1975).

294

tion before applying dyes to the negative.

Two other procedures are sometimes used, either separately or in combination with the above. One is the use of an abrasive to actually "sandpaper" the negative and lighten certain areas mechanically rather than chemically. In some cases, this is safer than applying Farmer's Reducer, especially to small areas where a liquid reducer would be hard to control. On the other hand, the reduced area tends to show the abrasion and gets "grainy," so the method is not recommended for very small negatives.

The other procedure is called "opaquing" and is used to remove a background completely, leaving it as pure white paper. This is used mainly by commercial photographers to make catalog illustrations, but it also has certain creative uses, where you may want to remove an existing background and then double-print one from another negative.

Holding Back with Dyes

Where a small area is to be held back by dye-dodging, the material used is a reddish dye called New Coccine (chemically, this is a dye called Crocein Scarlet). This dye is, as the name suggests, orange-red in color and blocks off, very strongly, the blue and green light to which photographic printing papers are sensitive. Because of the color, it is difficult to judge just how much dodging actually needs to be done; the effect in printing is much stronger than its visual appearance. Therefore, start by using a diluted form of the dye, and put only a faint pink wash over the areas to be held back.

It is virtually essential that you make test prints to judge the amount of dodging required; the old-time photographers used to make "sun-proofs" while dodging, to judge the progress of their work. If you apply the dye with an almost dry brush, it dries fast enough so you can make a proof almost immediately. If you are proofing in your enlarger, however, using a glassless negative carrier makes it pos-

sible to proof without waiting for the emulsion to dry completely.

If you find it too hard to judge the effect of red dye-dodging, there is a material called Dyene, which is available at many photo stores; Dyene comes in red and black, but both colors have the same effect. Thin the black dye to the density you want, and work from light to dark, checking the progress as you go. To do this, dilute a drop of dye with a few drops of water in a shallow dish, and try it. It will take only a few trials to learn how much water and how much dye to use for a given tone. The red version of Dyene is used exactly the same way as New Coccine.

Several other brands of retouching dyes are available, including Spotone and the special K. West Retouching Dye, which is sold in some areas.

The whole process is very forgiving, simply because the dye itself is water-soluble. Thus if you apply too much, you can wash it out easily with water, blot the negative nearly dry with a chamois or sponge, and try again.

Graphite Dodging

Another very simple way to dodge small areas is to darken them with graphite—ordinary pencil lead. The trick is to shave some graphite powder from the pencil lead with a piece of very fine sandpaper, then apply this graphite to the negative with a Q-Tip or a small tuft of absorbent cotton (used absolutely dry!).

You may find it preferable to do your retouching on a separate piece of gel-coated film, attached to the negative with Scotch tape. If you make a bad mistake, simply remove the overlay and discard it, and try again on a new one. Gelatin-coated film is obtainable from some dealers, or you can make your own. Take a piece of unexposed and undeveloped film and fix it in a normal hypo bath until it is clear, then wash thoroughly and dry as usual.

This picture of a Praxinoscope model is acceptable, but the background is uninteresting , and for a catalog illustration it should be removed.

For reproduction purposes, all that is needed is for the background to be opaqued in the area directly outlining the subject. The engraver can remove the remaining background.

For regular prints, the entire area is opaqued out. Alternatively, the partial-opaque technique is used and the remainder is covered with a paper mask.

When working on the film itself, it is best to do your retouching on the back side of the film, not the emulsion side. This is possible only with size 120 and sheet-film negatives, which have a gelatin coating on the back side. The 35mm film has no back coating, and dyes will not "take" on the celluloid side of the film.

This method is similar to pencil retouching but much easier. The negative surface will not hold much graphite, so it is almost impossible to overdo it; in any case, if too much should be applied, it can be rubbed off with a dry Q-Tip or, if it is to be removed completely, some benzine or cleaning fluid on a soft cloth will take it off entirely without leaving a mark on the negative.

Pencil Retouching

Pencil retouching is a professional technique. It can be learned only by practice and, preferably, from a good teacher who can demonstrate the various strokes. There is one thing that can be of assistance in connection with pencil retouching, and that is *doping*, or the preliminary preparation of the negative.

The surface of a normal negative will scarcely accept pencil marks at all; however, this is remedied by applying a tiny amount of a special varnish known as Retouching Fluid, which gives the surface sufficient "tooth" to accept pencil marks.

Retouching Fluid is available at any camera store and is used as follows: Apply a small amount of the fluid to the area of the negative to be worked on. With a tuft of clean, absorbent cotton, immediately rub it all off again, polishing with a gentle circular motion until the surface of the negative is dry; this takes only a few seconds. The negative will now accept pencil lead, if applied gently.

This process will also make the negative ac-cept a heavier dose of powdered graphite and is a useful adjunct to local dodging with graphite. If you wish to try retouching with pencils, first read a good book on the subject.*

Pencil retouching is not very practical on small negatives, and certainly not on 35mm, where every pencil mark shows up like a sore thumb on the enlargement. If you wish to try it, begin with a portrait on a 2¼″ × 3¼″ negative at least, one that was made close enough so the head is at least 1½ to two inches high on the film.

Local Reduction

This is a rather tricky procedure, and you can expect to ruin some negatives while learning how to do it. The basic method is quite simple; it is the manual skill and judgment that are difficult to attain.

We presume you have prepared the Farmer's Reducer as directed on page 131. The best way to handle it is to put a small quantity of Stock Solution A in a small bottle that has a dropper in the cork. In a second bottle, put some of Solution B, and you are ready to begin. Mix the solution in drops in a small dish; the reason is that once the two solutions are mixed, they lose energy very rapidly, so the best way to get consistent results is to mix only a few drops at a time, as needed.

Work over a light so that you may watch what is happening; you may improvise with a piece of heavy plate glass placed over a box with a small bulb inside, and a sheet of opal or groundglass in between to diffuse the light. If you expect to do much of this, however, you may want to build a stand for the purpose; the glass should be sloped slightly and a tray placed underneath to catch drippings and water.

First soak the negative to be treated in

*Kitty West, *Modern Retouching Manual* (2nd ed.; Garden City, N.Y.: Amphoto, 1973).

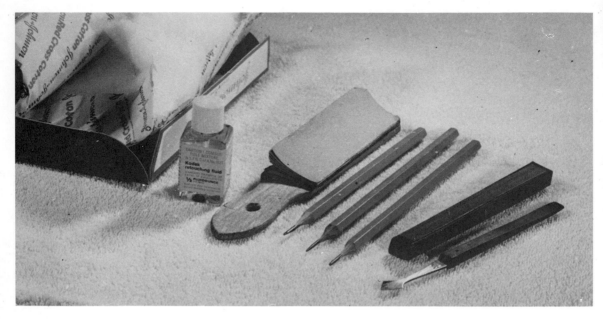

These materials are used in pencil retouching. The retouching fluid is applied with the cotton. The pencils are sharpened with the sandpaper paddle shown here. An etching knife is used to scrape small areas of the negative. An emery cloth on the knife case helps keep the edge sharp.

water for five to ten minutes; then place it on the glass and wipe it as dry as possible with a sponge or absorbent cotton.

Now you will need either brushes or Q-Tips to apply the reducer; if brushes are used, they must not have metal ferrules. Watercolor brushes made in a quill are probably the best kind. You should also have a tray of clean water or acid hypo right next to the stand; if it is necessary to stop the action of the reducer quickly, immersing the negative in hypo will do it.

Having decided just where the negative needs reduction, quickly put a few drops of each of the two solutions of the Farmer's Reducer in a tray, dip the Q-Tip or brush in the mixture, press out the surplus against the side of the dish, and wipe the mixture onto the negative. Apply only a very thin layer; this way the reducer will decompose within a minute or so, and the action will not go too far. If you do not get enough reduction the first time, repeat the application. After a few applications, you will have to mix more reducer in the dish.

When you have reduced the desired area as far as necessary, immerse the whole negative in the tray of hypo for a few minutes, then wash and dry as usual.

This procedure is very flexible—it is possible to lighten skies, bring out clouds and other large areas, and, in general, to perform a variety of creative tricks.*

Abrasive Reduction

A simple and considerably safer way to re-

*See also O. R. Croy, *Retouching* (Focal Press/Amphoto, 1964).

duce the density of small areas is to use an abrasive and rub to decrease the density. These materials are sold under various brand names; Kodak Abrasive Reducer is probably most easily available.

These materials do not contain any water and thus leave the negative dry and clean; all you need to do is wipe off the abrasive with a clean cloth and, perhaps, a drop or two of cleaning fluid, benzine, or Carbona.

For large areas, apply the abrasive with a cloth or chamois. Simply dip the cloth in the jar of abrasive and apply to negative with a gentle rubbing motion. Do not bear down too hard; the speed of reduction depends upon the pressure applied, and there is some danger of rubbing through the image if you apply too much force. It is easy to repeat the rubbing in selected areas until they are lightened to the desired degree.

For smaller areas, apply the reducer with little paper rolls called "stumps." You can get these at any art goods store, where they are sold by the dozen. You will need a fair quantity of them because they wear down pretty fast; use the worn ones on larger areas, and fresh ones with good points for small spots.

Another way of applying the abrasive is with Q-Tips, for areas slightly larger than the stumps can handle, and almost any kind of improvised applicator for small details. For the tiniest possible areas, you may use a bit of abrasive on the end of a soft wooden stick or toothpick. Just be careful not to dig into the negative.

Professional retouchers occasionally do mechanical reduction with a small knife known as an etching knife. This takes a good deal of skill and practice and is not recommended for beginners; knife work is nearly impossible on small negatives as it always shows in the print. What is difficult about knife etching is that it is not a scraping or gouging process; the knife must have a perfect edge so that it actually shaves off the emulsion in layers. This is exceedingly tricky and can only be learned from a good teacher or a great deal of practice. The method is shown in various books, and you may refer to these for further instruction.*

Opaquing

Occasionally, you may want to remove a background completely; this is useful in commercial work and sometimes even in landscapes, where painting-out a bad sky will enable printing-in a better one in subsequent darkroom procedures.

The material used for this work is a liquid watercolor paint called Opaque. The older type of opaque was a deep-red in color, and many photographers still prefer it. The newer type is black and seems to contain finely ground graphite as a pigment; it goes on in a much thinner coat, which is sometimes important in contact-printing but makes little difference otherwise. Black opaque is used mainly by lithographers to fill in pinholes in their high-contrast negatives.

Opaque is easy to use; all you need are some fine camel's hair brushes. To begin, stir the jar of opaque thoroughly because the pigment tends to settle to the bottom. Stir until it is smooth and creamy with no lumps.

Now with a fine-pointed brush, dip out a small quantity of the opaque and try it on a spoiled negative or a piece of paper. If it is difficult to brush, use a small dish or tray (a small porcelain coaster or a little ashtray will do fine) and add a few drops of water to the portion you have dipped out.

The negative to be opaqued must be supported on a sheet of glass with a light underneath so you can see the detail clearly. Now

*See books already mentioned. Also, Wayne Ford, *How to Retouch and Spot Negatives and Prints* (2nd ed.; Garden City, N.Y.: Amphoto, 1968).

Mechanical reduction of small areas is best done with abrasive reducer applied with cotton swabs. Very small details are reduced with an etching knife, but this requires skill.

take the finest brush in your kit and carefully and very slowly outline the image, bringing the opaque right to the edges of the image. Once you have gone completely around the image, take the next size brush and make a band about ¼-inch wide around the whole image, including the fine line you have already painted; that is, simply widen your outline to ¼-inch.

On a large negative, many professional photographers stop at this point. If they want the picture for reproduction by halftone or offset, the outline serves as a guide for the engraver or lithographer, who will remove the remainder of the background while making the printing plate. However, if they want the negative for normal printing, the rest of the background must also be eliminated. On large negatives, simply cut a paper mask out of thin black paper, to fit over the painted-out part of the negative.

On small negatives, it is just as easy to paint-out the entire background with opaque. After outlining the subject with a ¼-inch band, take a large brush and quickly brush a thin coat of opaque over the remainder of the background.

Allow this to dry, then examine it over a strong light. If you see any pinholes, put a dab of opaque over them and let these dry. The negative is then ready for printing.

The opaque may be applied to either side of the negative; usually, it is painted on the back side rather than the emulsion side. This is satisfactory with ordinary roll film and sheet films, both of which have a gelatin coating on the back to prevent curling. However, with 35mm negatives, there is no gelatin coat on the clear side of the film, and the watercolor pigment may refuse to "take" on the clear cellulose-ester base. In this case, opaquing must be done on the emulsion side.

Opaque is used to totally block out areas for outlining. Croecin Scarlet (New Coccine) is used to lighten details. A variety of brushes are used to apply these materials.

Summary of Lessons **6–10**

Now is a good time to check and see what we have learned in this advanced part of the Darkroom Course. For this purpose, we offer a summary of the lessons just completed. We suggest you read this through, then if anything seems to have been missed, go back to the lesson in question and read the full instructions therein. Therefore, this summary is only a memory jogger; do not use it as a substitute for the complete instructions in the lessons themselves.

LESSON 6
MIXING CHEMICALS; SPECIAL NEGATIVE DEVELOPERS

It is usually not necessary, nor even desirable, to mix developers from bulk chemicals; the monetary saving is often very small because chemicals always cost more in small quantities. Furthermore, there is less advantage in using different negative developers as compared to using special paper developers when variation in tone is required.

A simple studio scale is good enough for photographic chemical mixture because great precision is not required. It is better, when starting from scratch, to buy a metric scale. They require much less calculation in use and will reduce the chance of error.

For liquid measure, you will need graduates for 100.0ml and 1.0 litre quantities and also a plastic bucket holding 4 litres (or approximately a gallon). The bucket will serve as a mixing vessel and may already be on hand from the first part of this course.

Chemicals are always weighed out on slips of paper placed on the scale pans, never on the pans themselves. When dissolving the chemicals, first pour the powder from the paper into the water in the mixing vessel, then immerse the paper itself to rinse off any remaining traces of chemical. While weighing, tap the scale pans gently to keep them in motion to overcome the possibility of error caused by friction in the scale pivots. The balance point is found when the scale pointer swings an equal distance on each side of the index mark, not when it comes to rest at the mark.

A developer usually contains a developing agent, a preservative, an accelerator and a restrainer (or antifoggant). As far as negative development is concerned, there is little to choose from between currently available developing agents. One or two formulas—such as D-76 for small negatives, and DK-50 or D-61a for large negatives—are all that are ever really needed.

In mixing developer from a formula, it is essential that the chemicals be added to the water in exactly the order they are listed in the formula. There are some minor variations from this practice which are discussed in the lesson. As an example, the routine for mixing Kodak Developer D-72 is given in the lesson pages. This is followed by a routine for preparing fixing baths, and again, the main point to remember is to mix in the order given.

A few special negative developers are given; one of interest is the Windisch Metol-Sulfite formula, which is useful with high-contrast subject matter. The mechanism of the so-called "compensating developer" is used in this formula. The low alkalinity and lack of a restrainer make this developer very sensitive to bromides released from the film during development, and this in turn holds back development of heavily exposed areas while allowing shadow detail to build up.

The Kodak D-23 developer is a similar for-

mula, working in much the same way, but it has less compensating action. It is best used for subjects with a long scale, for soft, fine-grain effects.

Two-bath development is a technique which many photographers find valuable, especially where negatives must be processed without proper temperature control or where a very active developer is needed, but the danger of overdeveloping must be avoided. Two formulas are given for two-bath developers; one a soft-working one for general use, and the other a very active variation for press work.

LESSON 7
ENLARGERS AND CREATIVE ENLARGING

Because of the Callier Effect, which is the result of the granular structure of the silver image, enlargers with different types of illumination produce different contrasts on prints from the same negative using the same paper. Enlargers using condenser lamphouses have the highest contrast and those using diffusion systems have the lowest.

The newest type of diffusion enlarger utilizes a mixing chamber in which light bounces back and forth from one wall to another until it finally escapes through the negative. This produces a thoroughly diffused and very even type of illumination. But more important, it can be built with several filters of different colors for color printing. Such lamphouses can also be used for black-and-white work by simply setting all three filters to zero. In addition, the built-in filters can be used for contrast control with variable-contrast papers. While the amount of contrast control is not as great as with the filters usually used with these papers, it is adequate for most work.

Most modern enlargers using condensers provide means for holding filters in the lamphouses for contrast control, and also for color balance when printing with color papers.

A good lens is essential for optimum results in enlarging; it makes little sense to produce negatives with highly corrected camera lenses and then to destroy the definition with a poor enlarging lens. A good camera lens can be used in an enlarger, but it will not perform at its best because camera lenses are made to work at greater distances, and tend to exhibit a curved field at close ranges.

Since an enlarging lens does not need a focusing mount, it will be less expensive than a camera lens. Great speed is not needed either. A good enlarging lens need not be faster than $f/4.5$. Under these circumstances, an excellent enlarging lens will cost far less than a camera lens, making it false economy to skimp in this area.

It is possible to correct perspective distortion in the enlarger if it is equipped with a tilting negative carrier and lens board. Some limited correction can be accomplished merely by tilting the easel and stopping the lens down to a very small aperture. Likewise, the adjustments of the enlarger or tilting of the easel can be used to produce deliberate distortion for pictorial or expressive effects. Other types of distortion can be produced by curving or twisting the paper.

When printing with a tilted easel, the image will be bigger, therefore less bright, at one end, and some dodging will be necessary to produce an evenly exposed print. Tests should be made to determine the exposure at each end of the paper.

Perspective correction in enlarging usually results in a change of the image proportions, unless certain optical rules are followed. This effect can sometimes be used to produce images which are deliberately shortened or lengthened for advertising or other purposes.

Another type of print manipulation is to make a print of two negatives combined on a single sheet of paper. The simplest example of this is the landscape with clouds printed in from another negative. Once the method is

mastered, very complicated montages can be produced, some for pseudo-natural effects, others for deliberate distortion. Extensive directions are given in this lesson.

The masking methods used for this type of combination printing are also applicable to the making of vignetted prints. These can be made to fade out to white by simple dodging, or burned-in to black by flashing with white light. A sharp-edged mask can be used with flashing to produce a black border around a print.

LESSON 8
ADVANCED PAPER PROCESSING

It is important to emphasize that the only thing that can be varied by changing paper developers is the tone or color of the image; the contrast or exposure scale of the paper is built into the emulsion and is influenced only slightly, if at all, by changes in the composition of the developer.

Even the change of image color with development is a limited one. Cold-toned papers such as Kodabromide have a fairly coarse grain structure and a neutral-black tone that warm-toned developers have little effect upon. Likewise, naturally warm-toned papers have a fine-grain structure that will produce warm tones with almost any developer. All that can be accomplished by changes in developer formulation is to vary the tone from brown-black to warm brown. Some papers, such as Kodak Ektalure, can produce brown tones quite similar to a sepia-toned print, by direct development. A formula for this purpose is given in this lesson.

Mixing methods are exactly the same as with negative developers and need not be repeated here. What should be emphasized is that it is very dangerous to attempt to memorize developer formulas; because they are so similar, confusion is bound to result.

Several new developing agents are introduced here. One is Glycin. In proper formula-

tion, and on certain papers, it is capable of producing tones ranging from warm black, through brown, to a definite red color. Glycin is used alone, or in combination with hydroquinone for even warmer tones.

Another useful developing agent for producing warm tones on paper is chlorhydroquinone, also known as Adurol. A formula for its use is given in this lesson.

It has already been pointed out that the developer has little or no effect upon the contrast of paper prints. Nonetheless, several formulas have been published which claim to control the contrast of a print. These work (sometimes) only to a limited extent. If this limited control is useful, then one or another of these formulas may come in handy in emergencies. They include Ansco Developer 120, which is a soft portrait developer, the obsolete Kodak Developer D-64 which has a limited range of correction both above and below normal contrast, and the Dr. Beers formula, which also claims to have a high and low contrast formulation. Only the Ansco 120 formula is given here but the others may be found in the references.

Prints must be properly fixed if they are to be permanent. Using a two-bath fixer is probably the best method, but a single bath will do if it is not overworked.

One way of avoiding the fixing problem, at least for prints that are needed only for immediate use, is the "stabilization" process. This transforms the silver salts in the paper to a form which is not light-sensitive, but these prints eventually stain and become useless. Newer methods of rapid print processing are now coming into use which employ special papers and highly concentrated developers in various types of processing machines. One of these produces a dry print of nearly archival permanence in just 55 seconds.

Another way of varying the tone of a silver image is by toning. This consists in changing the silver image to a sulfide or seleno-sulfide,

or by substituting some other metal such as gold or iron, for the silver. Currently, the most popular toning method is that using selenium. However, if a heated bath is not a difficulty, then the old hypo-alum formula is still a good one. This toner produces very permanent tones ranging from dark brown to sepia, but it works only on warm-toned papers.

Cold-toned papers such as Kodabromide and DuPont Velour Black usually can be toned only by the bleach-and-redevelop method.

Gold toning is unusual in that two widely different colors are available. If the gold toner is used on a sepia-toned print, it changes the color from brown to red, which is very pleasing for some subjects. Applied to a black-and-white print which has *not* been toned, the gold toning bath produces a variety of deep-blue tones, but this works only on fine-grained, warm-toned papers. Gold toning has little or no effect on papers such as Koda-bromide and DuPont Velour Black.

Gold toning can also produce brown to sepia tones directly on some papers by use of the Nelson formula given in this lesson.

LESSON 9
COPYING, REVERSAL, AND
HIGH-CONTRAST PROCESSING

Copying appears to be a simple matter; all that seems necessary is to set up the picture to be copied and photograph it with your camera. There are, however, some pitfalls that must be overcome. The ordinary camera lens does not perform at its best at close focusing ranges. A "macro" lens or an enlarger lens will usually be a better choice for copying.

Even when you have a good, well-focused image, a copy negative is apt to be disappointing. Loss of highlight detail and a dull gray tone over the whites are the most common faults. These must be attributed, not to any fault in the copying technique, but to the original print. A good, wide-range crisp print seldom copies well.

If you have the original negative, and need a duplicate for some other purpose, the best way to overcome the problem is to make a print especially for copying; such a print will be softer and darker than a normal print, with a definite gray tone over the highlights. There should be no white paper showing anywhere. If the print has a range of tones only from light gray in the highlights to dark gray (*not black*) in the shadows, it will copy well as the low contrast can be made up easily in developing the copy negative.

Special films are available, which have higher contrast in the highlights, while the middletones and shadows have less contrast. Such films are very useful for copying normal prints, when a special copy print cannot be made, or when the original negative has been lost. The copy negative made on Kodak Professional Copy Sheet Film 4125 is denser and more contrasty than an original negative. This is necessary to preserve the scale of the original. Good prints from this copy negative can be made on No. 1 papers.

When the original negative is available, there are other ways of duplicating it. For example, a positive transparency can be made on film, and then a copy negative made from the transparency. Again, the transparency must not look like one made for display or projection; it should be denser and softer than a lantern slide, and with no clear areas or solid blacks visible anywhere.

Reversal processing is a special procedure by which a film may be developed directly to a positive without a printing stage. It involves first developing the film to a negative image in a special developer containing a silver solvent. The film is then bleached, cleared, and exposed to light to expose the remaining silver halides. After this, the film is developed in a strong developer, then fixed, and washed and dried in the usual way.

The exposure to light may be eliminated by

the use of a developer containing a fogging agent; this is supplied in the kits available for processing Kodak Direct Positive Panchromatic Film. This kit can also be used for processing Kodak Panatomic-X Film where only an occasional direct positive is needed.

Obviously, reversal processing can also be used to copy negatives, and will produce a negative of good quality from another negative in a single step. For those who prefer to mix their own chemicals, formulas are given in this lesson.

Copies of line objects, such as printed matter, drawings, and other subjects containing only black and white, call for a different procedure. Here we want the highest possible contrast; special films and special developers are needed. The films are called "litho" films, and produce very dense blacks in a short time. The "litho" developers used with these films have the property of cutting off development very sharply in the unexposed areas, so there is no trace of fog over the clear parts of the negative. Where maximum contrast is not essential, these films can be developed in a strong black-and-white developer such as undiluted Kodak Dektol or D-72. Fixing and washing is the same as with any other film.

LESSON 10
MISCELLANEOUS

Now and then a salvage operation is called for on a valuable negative. The two major operations used are called reduction and intensification.

Where a negative is much too dense to print, reduction is used. There are three different types of reducer, and the choice depends upon why the negative is too dense. For example, if a negative is more or less normally developed, but was overexposed to begin with, the result will be great density and a lack of contrast. Such a negative will often be only a little denser than normal in the highlights, but the shadows will be nearly as dense. What we need is a reducer which takes off more density in the lighter parts of the negative. This is called a "cutting" reducer. Since it does attack the thinner parts without much effect on the heavier densities, the result will be a definite increase in contrast without much reduction of highlights.

On the other hand, we have a normally exposed negative which has been overdeveloped. In this case, there is not much excess of density in the shadows, but the highlights are so dense that they cannot be printed. What we need is a reducer which attacks the highest densities first, without taking much out of the shadows or thin parts of the negative. Such a reducer is called "superproportional" because its effect is greatest upon the heaviest densities.

Finally, we have the most difficult of all cases—a negative which is both overexposed and overdeveloped. It is excessively dense and also too contrasty. What is needed is a reducer which removes density in proportion to the amount that exists. In effect, it is reversing the action of the developer.

Cutting reducers are typified by the well-known Howard Farmer formula which contains potassium ferricyanide and sodium thiosulfate. Superproportional reducers are mostly based upon ammonium persulfate or potassium persulfate. There is really no such thing as a true proportional reducer, but the effect can be approximated by a mixture of a permanganate reducer (which has a cutting action similar to the Farmer formula) and a persulfate reducer.

Intensification is the opposite of reduction. Its purpose is to add density to a negative which is too weak to print well. Since no intensifier can put detail in an image where the exposure was insufficient to record it, intensification is mainly useful for adding density and contrast to an underdeveloped negative that is thin but full of detail.

In general, intensification is carried out either by adding another metal to the silver image, or by changing the color of the image to one that is more opaque to blue light, thereby making the negative print better on normal, color-blind papers.

The most common intensifier is the chromium type. The negative is first bleached in a bichromate bath, then the bleached image is redeveloped in a regular developer, which not only restores the original silver image, but also adds a certain amount of chromium to it.

Color intensifiers include the Agfa Copper Intensifier, which turns the image red, and the ordinary sepia toning bath, which produces a brown silver sulfide image having considerably greater printing density.

Other intensifiers, such as ones containing mercury, were formerly used, but the intensified image was not very stable and eventually faded.

Both reduction and intensification can be done in small areas of a negative by using a cotton swab or brush to apply the chemicals. In some cases, no change in actual image density is required; what we need is a kind of permanent dodging, and this is done by brushing on a pale coat of pink dye such as New Coccine (Crocein Scarlet). Local reduction of very small areas is sometimes done by applying an abrasive paste with a swab or toothpick. This is safer and more controllable than trying to apply Farmer's Reducer with a brush.

Background elimination is done in one of two ways. First, the background can be bleached out completely on the negative, producing a black background on the print. Alternatively, the background on a negative can be covered with a red or black watercolor paint known as "opaque," this will produce a white background on the print.

If necessary, combinations of all these procedures can be used to handle difficult cases.

GLOSSARY

The following glossary is not intended as a complete dictionary of photographic terms; it is limited to the most used terms, all of which have been used in the preceding lessons. Those who wish a more complete dictionary of photographic terms are referred to one of the many such lexicons available from photographic dealers.

Acetic acid. A clear liquid with a strong vinegar odor used in photographic stop baths and fixing baths. It is commercially available in two strengths: 99% ("glacial") acetic acid, and 28% ("No. 8") acetic acid.

Agitation. Movement of either the film or the solution to obtain change at the surface of a material being processed.

Apron. A strip of plastic with corrugated or dimpled edges used as a separator in some inexpensive developing tanks.

Bleach. A solution that converts a silver image to a bromide or chloride so that it may be treated in a toner or other after-treatment.

Burning-in. Giving additional exposure to one or more areas of a print to secure local darkening of that area.

Celsius. Correct name of a thermometer scale used in scientific and photographic work; with this scale, the freezing point of water is taken as zero degrees and the boiling point as 100 degrees.

Centigrade. The old and now obsolete name of the Celsius thermometer scale.

Changing bag. A large bag, made of opaque cloth, with a zipper closure at one end and two sleeves at the other. It is used for loading film holders, developing tanks, and other photographic devices when a darkroom is not available.

Chromogenic developer. A developer that forms an image composed partly of silver and partly of dye.

Cold-toned paper. A printing paper that produces cold-black or blue-black images.

Contact paper. A printing paper of low speed that is used almost entirely for making prints by contact with a fairly strong exposing light.

Contact printer. A device for making contact prints; it consists of a box containing a light source, a glass top, and a platen to obtain tight contact between the negative and the sensitive paper.

Contact printing. Making photographic prints by exposing the sensitive paper through a negative in tight contact.

Contrast. The difference in density between the lightest and darkest portions of a negative; sometimes it also describes a print or a subject.

Contrast, paper. In the case of printing papers, contrast refers to the difference between the darkest and lightest parts of the negative to be printed thereon, not to those of the paper itself.

Cropping. Trimming or masking off superfluous parts of a picture, usually during the printing or enlarging operation.

Cubic centimetre. The volume of a cube, one centimetre in each dimension. It was formerly used to describe a liquid measure, 1/1000 of a litre, but the current term for the latter is now *millilitre*. There is a small and practically unimportant difference between the two, but for practical purposes, they may be considered the same thing.

Darkroom. A chamber that is either totally dark or illuminated only by safelight, in which photographic processing is done.

Dektol. A Kodak trademark for a popular paper developer similar (but not identical) to Kodak Developer D-72, DuPont 53-D, and others.

Density. A measure of the darkness or blackness of a photographic image; it is mathematically related to the quantity of silver present but in ordinary usage is loosely taken to mean the light-stopping power of the image.

Developer. A chemical bath that converts exposed silver chloride or silver bromide to metallic silver without affecting the unexposed parts of the coating.

Developing-out paper. Photographic printing paper that requires development to bring out the image (see also *Printing-out paper*).

Diaphragm, lens. A mechanical device inside the mount of a lens that adjusts the diameter of the aperture to any desired degree. In enlarging lenses, it serves mainly to control exposure time.

Dish. Term used in British publications for what we call a *tray*.

Dodger. A black object at the end of a long thin handle used to shade small areas of a projected image while exposing an enlargement.

Dodging. Shading part of the projected image while enlarging to produce a lighter tone in that particular area.

Double-toning. Changing the color of a printed image by treating for part of the time in a given toner and the remainder of the time in a different toner.

Double-weight. A heavy paper used as the base of a photographic paper when the final print must stand considerable handling and is not to be mounted.

Dye toning. Changing the color of a photographic image by depositing a dye upon it or by substituting a dye for the silver image.

Easel. A device consisting of a baseboard and a set of hinged masking bands to hold enlarging paper flat while printing and to produce clean white margins on the print.

Emulsion. The sensitive coating of a film or paper; it contains silver bromide, silver chloride, or a mixture of both, suspended in gelatin.

Enlarger. A projector used to produce larger (sometimes smaller) images of a negative upon a sensitized paper. It is sometimes called *projection printer*.

Enlarging. Making a large print from a smaller negative by projecting the image of the negative upon the sensitive paper.

Enlarging paper. A sensitized paper of moderate to high speed intended for printing by projecting the image of the negative upon it. It can also be used for contact printing by suitably reducing the strength of the exposing light.

Exposure scale. A better term for the *contrast* grade of a printing paper; essentially, the ratio of the amount of light needed to produce a just visible image and the amount needed to produce the maximum black of which the paper is capable.

Fahrenheit. The commonly used thermometer scale in which the freezing point of water is taken as 32 degrees and its boiling point as 212 degrees.

Filter. A piece of colored gelatin, glass, or plastic used to modify the color of light for various purposes. Thus a safelight filter is one which allows only that light to pass which will not affect a photographic emulsion. Variable-contrast filters are used to control the light affecting the two different emulsions of a variable-contrast paper. Other filters are used on camera lenses for various purposes.

Fixer. A bath principally composed of sodium thiosulfate that has the property of removing the undeveloped silver salts from the emulsion of a film or paper without affecting the developed silver image.

Gold toning. Treating a silver image by adding gold to the silver, thereby producing a bluish colored image, or by substituting gold for the silver image, producing red to brown images.

Graduate. A measuring cup or jar for liquids.

Highlight. The brightest part of a subject, hence the darkest area in a negative and the lightest area of a print.

Holding bath. A tray of plain water in which prints are allowed to remain after fixing until it is convenient to wash them.

Hypo. An old term for sodium thiosulfate (formerly called "sodium hyposulfite"), and by extension, the slang term for a fixing bath.

Litre. The metric unit of liquid measure, formerly 1000 cubic centimetres, but now redefined and slightly different. It is roughly equal to a quart in American customary measure (actually 33.81 ounces).

Medium-weight. A paper base slightly heavier than single-weight but lighter than double-weight. It is the weight most commonly found in RC (resin-coated) papers.

Middletone. Any shade of gray between the highest light and deepest shadow of a subject, negative, or print.

Millilitre. One one-thousandth of a litre, formerly called a *cubic centimetre*. The two are not quite equal, but the difference is trifling.

Negative. Any photographic image in which the highlights of the subject are represented by the black areas and the shadows by white or transparent areas.

Negative carrier. The device in an enlarger that holds the negative flat and in focus.

Photofinisher. A professional business organization that does developing and printing for others. Some are large, highly automated plants that handle the work picked up from a great many small retail outlets such as drugstores; others are smaller organizations that do custom finishing for professionals.

Positive. A photographic image on film or paper in which the highlights of the subject are represented by white or transparent areas and the shadows by black areas.

Print. A positive image, usually on paper, made from a negative by either contact printing or projection.

Printing frame. A frame, usually of wood, with a glass front and a removable back with pressure springs for holding a negative or negatives in contact with sensitive paper for printing.

Printing-out paper. A type of printing paper on which a visible image appears by exposure to light without development. It is practically obsolete today but is used by professionals for making the familiar reddish-colored proofs.

Print tongs. Tongs made of bamboo, stainless steel, or plastic and used for handling prints in the various processing baths.

Print washer. A large tray or tub with a water inlet and overflow arrangement for washing prints in quantity.

Projection printing. Making prints from negatives by projecting the image of the negative upon the sensitized paper. Usually, the print made is larger than the negative, but the method is also used for making small prints from large negatives.

Proof sheet. A sheet of prints made from a group of negatives in a single exposure; it is usually made for filing purposes or for deciding in advance which negatives to enlarge.

Redeveloper. A bath used in print toning for restoring a bleached image while changing the color from black to brown, blue, or some other tint.

Reel. A device for holding film in a developing tank so the developer can reach all parts of the emulsion. Usually made of stainless steel wire but sometimes of plastic.

Resin-coated papers. Printing papers that have an emulsion coated upon a special paper base impregnated with a plastic so that it does not absorb water.

Safelight. A light fixture containing an incandescent lamp and a filter that produces illumination which will not fog photographic materials being handled under it.

Shadow. The darkest part of a subject, hence the lightest or most transparent part of a negative and the blackest part of a print.

Silver bromide. A silver salt, technically known as a "halide," that is sensitive to light. Silver bromide is used in highly sensitive film emulsions and makes up part of the emulsion of fast enlarging papers.

Silver chloride. Another silver salt, also a halide, that is sensitive to light but much less so than silver bromide. It is used in contact-printing papers and makes up part of the emulsion of most enlarging papers as well.

Single-weight. The normal, rather thin paper base used in photographic papers of smaller sizes and in large sizes that are to be mounted.

Siphon. A plastic device containing a combined water inlet and outlet that is attached to any large tray to convert it into a print washer.

Soft. Lacking in contrast; a negative or print having little difference in density between highlight and shadow. Also applied to a printing paper that has a long exposure scale and thus produces prints of low contrast from negatives of high contrast.

Solution. Any liquid, usually containing water, in which a chemical or chemicals have been dissolved.

Stock solution. A fairly concentrated solution intended for further dilution with water before use.

Stop bath. A mild acid bath for neutralizing a developer and stopping its action before a print is placed in the fixer. Sometimes but incorrectly called a "shortstop."

Sulfide toner. One of a number of toning baths that converts a silver image into silver sulfide. The resulting image varies in color from dark-brown to sepia, depending upon the type of toner and the kind of paper used.

Sepia. A yellowish-brown color usually resulting from treatment of a black silver image in a toner.

Tank, developing. Usually a lighttight steel or plastic cup containing a reel (also steel or plastic) for developing films. A tank is generally loaded in darkness but all the remaining

steps can be done in full room light.

Test strip. A trial exposure made upon a small piece of paper of an important part of the negative image and processed to determine the correct exposure for a full-size print.

Timer. A device used in the darkroom for timing development and printing. Development timers usually ring a bell at the end of the preset interval; printing timers are often arranged to turn the enlarger lamp on and off automatically.

Toner. A bath intended to produce a color other than the natural black of a silver image. It works either by converting the silver image to a sulfide by replacing the silver image with another metal, such as iron (for blue), gold (for red), or selenium (for brown), or by replacing the silver image with a dye and producing images of just about any color.

Toning. Changing the color of a silver image by treatment in a toner.

Tray. A shallow vessel used for developing papers.

Variable-contrast paper. A paper, generally coated with a mixture of hard and soft emulsions and sensitized so that either or both may be used in different proportions by changing the color of the exposing light with a filter.

Viscose sponge. An artificial sponge made of cellulose rayon fibers and used for removing excess moisture from films or papers.

Warm-toned paper. A paper that produces brown-black or even brown tones by direct development without toning.

Wetting agent. A chemical used in the final rinse of films, which prevents the formation of water droplets and makes it unnecessary to wipe the film with a sponge to avoid spotting.

Suggested Reading

The following books will give you additional information, more advanced techniques, and more formulas. They are available from your dealer.

Amphoto Editorial Board. *Developing, Printing, and Enlarging Simplified.* (Amphoto)

Carroll, John S. *Photographic Lab Handbook.* (Amphoto)

Cooper, Joseph D. and Abbott, Joseph C. *Special Effects, Shooting Situations, and Darkroom Techniques* (The Nikon Handbook Series). (Amphoto)

Feininger, Andreas. *Darkroom Techniques,* 2 vols. (Amphoto)

Feininger, Andreas. *Total Picture Control.* (Amphoto)

Fineman, Mark B. *The Home Darkroom.* (Amphoto)

Hertzberg, Robert. *Elementary Developing and Printing.* (Amphoto)

Hertzberg, Robert. *Photo Darkroom Guide.* (Amphoto)

Kelley, Jain (ed.). *Darkroom 2.*

Lewis, Eleanor (ed.). *Darkroom.*

Litzel, Otto. *Darkroom Magic.* (Amphoto)

Lootens, J.G. *Lootens on Photographic Enlarging and Print Quality.* Revised by Lester H. Bogen. (Amphoto)

Manella, Douglas. *Amphoto Guide to Black-and-White Processing and Printing.* (Amphoto)

Nadler, Bob. *The Advanced Black-and-White Darkroom Book.* (Amphoto)

Nibbelink, Don, and Anderson, R. *Bigger and Better Enlarging.* (Amphoto)

Picker, Fred. *The Fine Print.* (Amphoto)

Picker, Fred. *The Zone VI Workshop.* (Amphoto)

Ruggles, Joanne and Philip. *Darkroom Graphics.* (Amphoto)

Saltzer, Joseph. *A Zone System for All Formats.* (Amphoto)

Saltzer, Joseph. *Zone System Calibration Manual.* (Amphoto)

Walker, Sandy, and Rainwater, Clarence. *Solarization.* (Amphoto)

Wall, E.J. and Jordan, F.I. *Photographic Facts and Formulas.* Revised by John S. Carroll. (Amphoto)

West, Kitty. *Modern Retouching Manual.* (Amphoto)

Index